ART HISTORY
PORTABLE EDITION THIRD EDITION

Medieval Art

MARILYN STOKSTAD

Judith Harris Murphy Distinguished Professor of Art History Emerita
The University of Kansas

CONTRIBUTOR

D. Fairchild Ruggles

PEARSON

Prentice Hall

Upper Saddle River, NJ 07458

Editor-in-Chief: Sarah Touborg
Sponsoring Editor: Helen Ronan
Editorial Assistant: Christina DeCesare
Editor in Chief, Development: Rochelle Diogenes
Development Editors: Jeannine Ciliotta, Margaret Manos,
 Teresa Nemeth, and Carol Peters
Media Editor: Alison Lorber
Director of Marketing: Brandy Dawson
Executive Marketing Manager: Marissa Feliberty
AVP, Director of Production and Manufacturing: Barbara Kittle
Senior Managing Editor: Lisa Iarkowski
Production Editor: Barbara Taylor-Laino
Production Assistant: Marlene Gassler
Senior Operations Specialist: Brian K. Mackey
Operations Specialist: Cathleen Peterson
Creative Design Director: Leslie Osher
Art Director: Amy Rosen
Interior and Cover Design: Anne DeMarinis
Layout Artist: Gail Cocker-Bogusz
Line Art and Map Program Management: Gail Cocker-Bogusz,
 Maria Piper

Line Art Studio: Peter Bull Art Studio
Cartographer: DK Education, a division of Dorling Kindersley, Ltd.
Pearson Imaging Center: Corin Skidds, Greg Harrison, Robert
 Uibelhoer, Ron Walko, Shayle Keating, and Dennis Sheehan
Site Supervisor, Pearson Imaging Center: Joe Conti
Photo Research: Laurie Platt Winfrey, Fay Torres-Yap, Mary Teresa
 Giancoli, and Christian Peña, Carousel Research, Inc.
Director, Image Resource Center: Melinda Patelli
Manager, Rights and Permissions: Zina Arabia
Manager, Visual Research: Beth Brenzel
Manager, Cover Visual Research and Permissions: Karen Sanatar
Image Permission Coordinator: Debbie Latronica
Manager, Cover Research and Permissions: Gladys Soto
Copy Editor: Stephen Hopkins
Proofreaders: Faye Gemmellaro, Margaret Pinette, Nancy Stevenson,
 and Victoria Waters
Composition: Prepare, Inc.
Portable Edition Composition: Black Dot
Cover Printer: Phoenix Color Corporation
Printer/Binder: R. R. Donnelley

Maps designed and produced by DK Education, a division of Dorling Kindersley, Limited, 80 Strand London WC2R 0RL.
DK and the DK logo are registered trademarks of Dorling Kindersley Limited.

Credits and acknowledgements borrowed from other sources and reproduced, with permission, in this textbook appear on the
appropriate page within text or on the credit pages in the back of this book.

Cover Photo:
Jamb figures (Isaiah, Jeremiah, Simeon with Jesus, St. John the Baptist and St. Peter) from right side of central portal, north transept,
Chartres cathedral, 13th century. Photo: Courtesy of Helen Ronan.

Pearson Education LTD.
Pearson Education Australia PTY, Limited
Pearson Education Singapore, Pte. Ltd
Pearson Education North Asia Ltd

Pearson Education, Canada, Ltd
Pearson Educación de Mexico, S.A. de C.V
Pearson Education—Japan
Pearson Education Malaysia, Pte. Ltd

10 9 8 7 6 5 4 3 2

ISBN 0-13-605405-6
ISBN 978-0-13-605405-4

CONTENTS

17

FOURTEENTH-CENTURY ART IN EUROPE 552

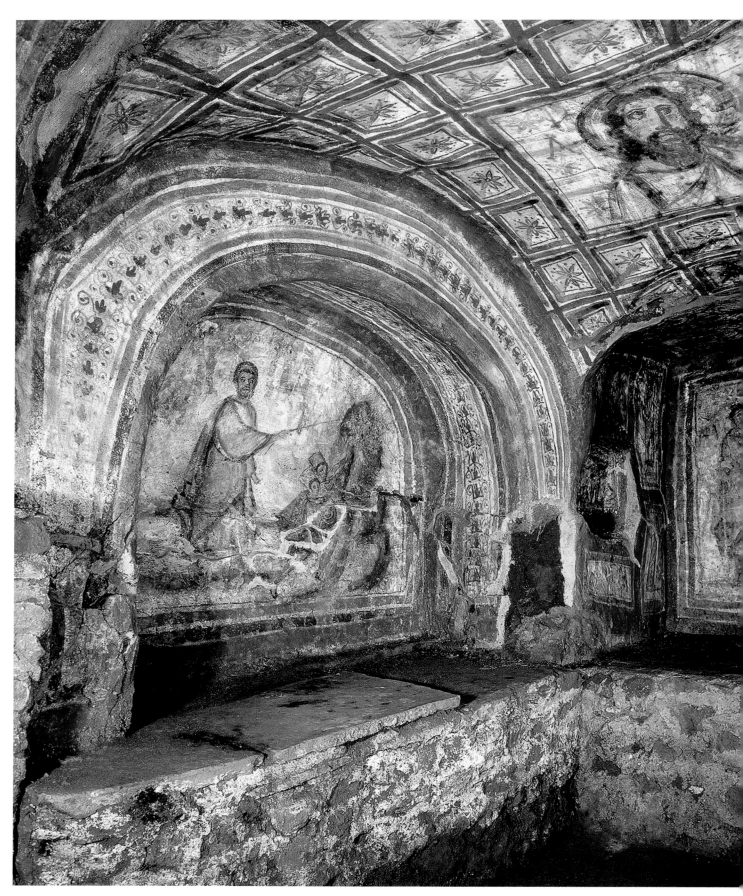

7-1 | **CUBICULUM OF LEONIS, CATACOMB OF COMMODILLA** Near Rome. Late 4th century.

JEWISH, EARLY CHRISTIAN, AND BYZANTINE ART

7

In ancient Rome, gravediggers were the architects of the underground. Where subsoil conditions were right, they tunneled out streets and houses in a city of the dead—a **necropolis**—with as many as five underground levels. Working in dark, narrow galleries as much as 70 feet below the surface, they dug out corridors, shelves, and small burial rooms to create **catacombs**. Aboveground, the gravediggers acted as guards and gardeners. Some of them may have been artists too, for even the earliest catacombs contained paintings—initially very simple inscriptions and symbols.

Burials were always outside the city walls, so that the dead would not defile the city. Catacombs were not secret nor were they ever used as hiding places—such stories spring from the imaginations of nineteenth-century romantic writers. Burial in catacombs became common in the early third century CE and ended by about 500. Although Rome's Christian catacombs are the most famous today, people of other faiths—Jews, devotees of Isis, followers of Bacchus and other mystery religions, pagan traditionalists—were interred in their own communal catacombs, which were decorated with symbols of their faith.

In the third century CE, Christian catacombs were painted with images of salvation based on prayers for the dead. By the fourth century, painting had become even more

elaborate, as in this catacomb which depicts saints having a particular connection to Rome (FIG. 7–1). In the center of a small burial room's ceiling—between alpha and omega—the Greek letters signifying the beginning and end—the head of Christ appears in a circle (a halo). Facing the door is Christ with the Roman martyrs Felix (d. 274) and Adauctus (d. 303). At the right, a painting depicts Peter in the hours before the cock crowed, when he denied that he knew Jesus (Matthew 26:74–75). On the left, Peter miraculously brings forth water from a rock in Rome's Mamertine Prison to baptize his fellow prisoners and their jailers. Here the painter has copied the traditional Jewish scene of Moses striking water from the rock (Exodus 17:1–7). Were it not for the painting's Christian context, it would be indistinguishable from Jewish art.

CHAPTER-AT-A-GLANCE

- **JEWS, CHRISTIANS, AND MUSLIMS** Early Jewish Art Early Christian Art
- **IMPERIAL CHRISTIAN ARCHITECTURE AND ART** Architecture: The Church and Its Decoration Architecture: Ravenna Sculpture
- **EARLY BYZANTINE ART: THE FIRST GOLDEN AGE** The Golden Age of Justinian Objects of Veneration and Devotion Icons and Iconoclasm
- **MIDDLE BYZANTINE ART** Architecture and Mosaics Objects of Veneration and Devotion The Special Case of Sicily
- **LATE BYZANTINE ART** Constantinople Moscow: The Third Rome
- **IN PERSPECTIVE**

JEWS, CHRISTIANS, AND MUSLIMS

Three religions that arose in the Near East dominate the spiritual life of the Western world today: Judaism, Christianity, and Islam. All three are monotheistic—followers hold that only one god created and rules the universe. Jews believe that God made a covenant, or pact, with their ancestors, the Hebrews, and that they are God's chosen people. They await the coming of a savior, the Messiah, "the anointed one." Christians believe that Jesus of Nazareth was that Messiah (the name *Christ* is derived from the Greek term meaning "Messiah"). They believe that God took human form, preached among men and women, suffered execution, then rose from the dead and ascended to heaven after establishing the Christian Church under the leadership of the apostles (his closest disciples). Muslims, while accepting the Hebrew prophets and Jesus as divinely inspired, believe Muhammad to be the last and greatest prophet of God (Allah), the Messenger of God through whom Islam was revealed some six centuries after Jesus's lifetime.

All three are "religions of the book," that is, they have written records of God's will and words: the Hebrew Scriptures; the Christian Bible, which includes the Hebrew Scriptures as its Old Testament as well as the Christian New Testament; and the Muslim Qur'an, believed to be the Word of God as revealed in Arabic directly to Muhammad through the archangel Gabriel.

Both Judaism and Christianity existed within the Roman Empire, along with various other religions devoted to the worship of many gods. The variety of religious buildings found in present-day Syria at the abandoned Roman outpost of Dura-Europus, a Hellenistic fortress taken over by the Romans in 165 CE, illustrates the cosmopolitan character of Roman society, as well as places of worship, in the second and third centuries. Although Dura-Europus was destroyed in 256–57 CE by the Sassanid Persians, important parts of the stronghold have been excavated, including a Jewish house-synagogue, a Christian house-church, shrines to the Persian gods Mithras and Zoroaster, and temples to Greek and Roman gods, including Zeus, Artemis, and Adonis. The Jewish and Christian structures were preserved because they had been built beside the wall of the southwest rampart. When the desperate citizens attempted to strengthen this fortification in futile preparation for the final attack, they buried these buildings. The entire site was later abandoned and rediscovered in 1920 by a French army officer.

This chapter concentrates on the religions of the Roman Empire: We consider Jewish and Early Christian and Byzantine art, including some of the later art of the Eastern Orthodox Church.

Early Jewish Art

The Jewish people trace their origin to a Semitic people called the Hebrews, who lived in the land of Canaan. Canaan, known from the second century CE by the Roman name Palestine, was located along the eastern edge of the Mediterranean Sea (MAP 7–1). According to the Torah, the first five books of the Hebrew Scriptures, God promised the patriarch

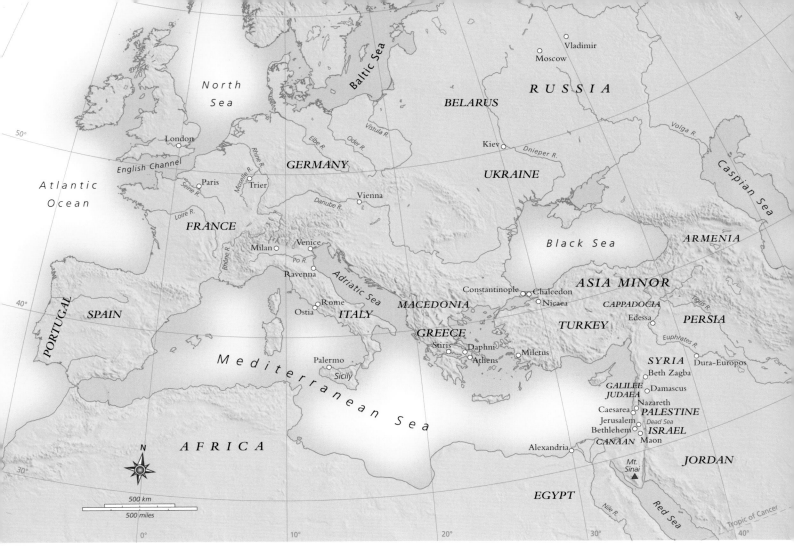

MAP 7–1 | JEWISH, EARLY CHRISTIAN, AND BYZANTINE WORLDS

The eastern Mediterranean lands of Canaan and Judaea were centers of Jewish settlement. Rome was a major center of early western Christianity. Byzantine culture took root in Constantinople and flourished throughout the Eastern Roman, or Byzantine, Empire and extended into northern areas such as Russia and Ukraine.

Abraham that Canaan would be a homeland for the Jewish people (Genesis 17:8), a belief that remains important among Jews to this day.

Jewish settlement of Canaan probably began sometime in the second millennium BCE. According to Exodus, the second book of the Torah, the prophet Moses led the Hebrews out of slavery in Egypt to the promised land of Canaan. At one crucial point during the journey, Moses climbed alone to the top of Mount Sinai, where God gave him the Ten Commandments, the cornerstone of Jewish law. The commandments, inscribed on tablets, were kept in a gold-covered wooden box, the Ark of the Covenant.

Jewish law forbade the worship of idols, a prohibition that often made the representational arts—especially sculpture in the round—suspect. Nevertheless, artists working for Jewish patrons depicted both symbolic and narrative Jewish subjects; and as they did so they looked to both Near Eastern and classical Greek and Roman art for inspiration.

SOLOMON: THE FIRST TEMPLE IN JERUSALEM. In the tenth century BCE, the Jewish king Solomon built a temple in Jerusalem to house the Ark of the Covenant. He sent to nearby Phoenicia for cedar, cypress, and sandalwood, and for a superb artisan to supervise construction of the Temple, later known as the First Temple (2 Chronicles 2:2–15). The Temple was the spiritual center of Jewish life. It consisted of courtyards, two bronze pillars, an entrance hall, a main hall, and the Holy of Holies, the innermost chamber that housed the Ark and its guardian cherubim, or attendant angels (perhaps resembling the winged guardians of Assyria, seen in FIG. 2–1).

In 586 BCE, the Babylonians, under King Nebuchadnezzar II, conquered Jerusalem. They destroyed the Temple, exiled the Jews, and carried off the Ark of the Covenant. When Cyrus the Great of Persia conquered Babylonia in 539 BCE, he permitted the Jews to return to their homeland (Ezra 1:1–4) and rebuild the Temple, which became known as the Second Temple. When Canaan became part of the Roman Empire,

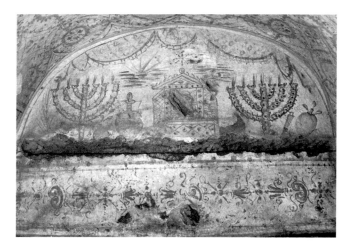

7–2 | MENORAHS AND ARK OF THE COVENANT
Wall painting in a Jewish catacomb, Villa Torlonia, Rome. 3rd century. 3'11" × 5'9" (1.19 × 1.8 m).

The menorah form probably derives from the ancient Near Eastern Tree of Life, symbolizing for the Jewish people both the end of exile and the paradise to come.

Herod the Great (the king of Judaea, 37–4 BCE), restored the Second Temple. In 70 CE, Roman forces led by the general and future emperor Titus destroyed the Second Temple and all of Jerusalem, an exploit the Romans commemorated on the Arch of Titus (SEE FIG. 6–39). The conspicuous representation of the menorah looted from the Second Temple kept the memory of the Jewish treasures alive. The site of the Second Temple, the Temple Mount, is also an Islamic holy site, the Haram al-Sharif, and is now occupied by the shrine called the Dome of the Rock (SEE FIGS. 8–2, 8–3).

JEWISH CATACOMB ART IN ROME. Most of the earliest surviving examples of Jewish art date from the Hellenistic and Roman periods. Six Jewish catacombs, discovered in the outskirts of Rome and in use from the first to fourth centuries CE, display wall paintings with Jewish themes. In one example, from the third century CE, two *menorahs* (seven-branched lamps), flank the long-lost Ark of the Covenant (FIG. 7–2).

SYNAGOGUES. Judaism has always emphasized religious learning. Jews gather in synagogues for study and worship, so a synagogue can be any large room where the Torah scrolls are kept and read publicly. Some synagogues were located in private homes or in buildings originally constructed like homes. The first Dura-Europus synagogue consisted of an assembly hall, a separate alcove for women, and a courtyard. After a remodeling of the building, completed in 244–45 CE, men and women shared the hall, and residential rooms were added. Two architectural features distinguished the assembly hall: a bench along its walls and a niche for the Torah scrolls (FIG. 7–3).

Scenes from Jewish history and the story of Moses, as recorded in Exodus, unfold in a continuous narrative around

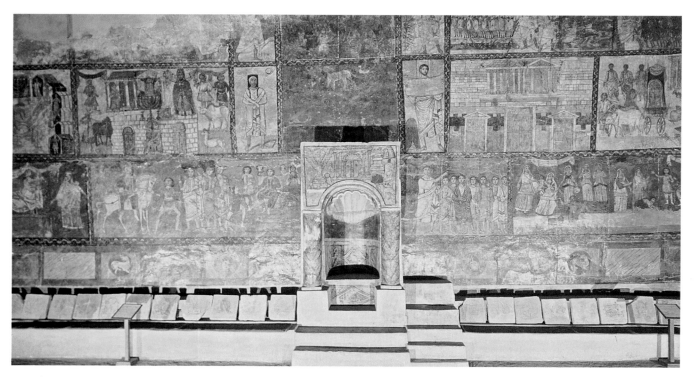

7–3 | WALL WITH TORAH NICHE
From a house-synagogue, Dura-Europos, Syria. 244–45. Tempera on plaster, section approx. 40' (12.19 m) long. Reconstructed in the National Museum, Damascus, Syria.

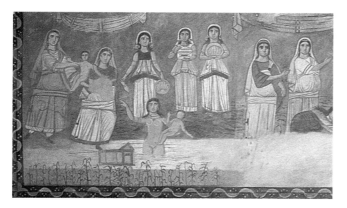

7–4 | THE FINDING OF THE BABY MOSES
Detail of a wall painting from a house-synagogue, Dura-Europos, Syria. 244–45. Copy in tempera on plaster. Dura-Europos Collection. Yale University Art Gallery, New Haven, Connecticut.

the room. This vivid depiction of events follows the Roman tradition of historical narrative. In **THE FINDING OF THE BABY MOSES (FIG. 7–4),** Moses's mother has set him afloat in a reed basket in the shallows of the Nile in an attempt to save him from the pharaoh's decree that all male Jewish infants be put to death (Exodus 1:8–2:10). The pharaoh's daughter finds him and claims him as her own child.

The painting shows the story unfolding in a narrow foreground space. At the right, the princess sees the child hidden in the bulrushes; at the center, she or a servant wades nude into the water to save him; and at the left, she hands him to a nurse (actually his own mother). Individual paintings are inspired by Near Eastern sources. They are done in a style in which static, two-dimensional figures seem to float against a neutral background. The frontal poses, strong outlines, and flat colors are also features of later Byzantine art, an art perhaps derived from the same sources that inspired these images.

In addition to house-synagogues, Jews built synagogues designed on the model of the ancient Roman basilica. A typical basilica synagogue had a central nave; an aisle on both sides, separated from the nave by a line of columns; a semicircular apse in the wall facing Jerusalem; and perhaps an atrium and porch, or **narthex**. A very grand synagogue might have a mosaic floor.

A fragment of a mosaic floor from a sixth-century synagogue at the site of ancient Menois (present-day Maon) features traditional Jewish symbols along with a variety of stylized plants, birds, and animals (**FIG. 7–5**). Two lions of Judah flank a menorah. Beneath it is the ram's horn (*shofar*), blown on ceremonial occasions, and three citrons (*etrogs*) used to celebrate the harvest festival of Sukkot. Other Sukkot emblems—including palm trees and the *lulav*, a sheaf of palm, myrtle, and willow branches, and an *etrog*—symbolize the bounty of the earth and unity of all Jews. The variety of

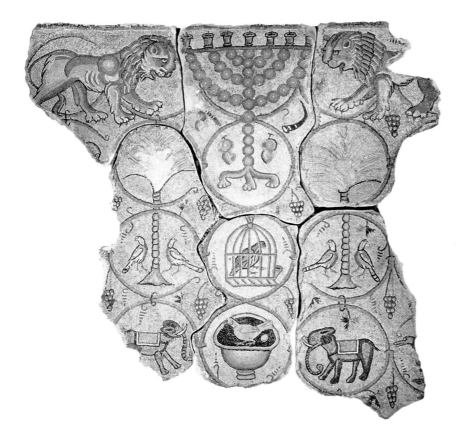

7–5 | SYNAGOGUE FLOOR
Maon (ancient Menois). c. 530. Mosaic. The Israel Museum, Jerusalem.

Myth and Religion
CHRISTIAN SYMBOLS

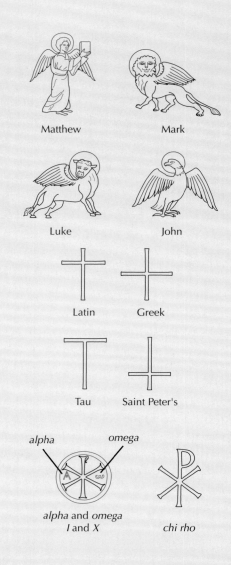

Matthew Mark

Luke John

Latin Greek

Tau Saint Peter's

alpha *omega*

alpha and *omega*
I and *X* *chi rho*

Symbols have always played an integral role in Christian art. Some were devised just for Christianity, but most were borrowed from pagan and Jewish traditions and adopted for Christian use. The Old Testament **dove** is a symbol of purity, representing peace when it is shown bearing an olive branch. In Christian art, a white dove is the symbolic embodiment of the Holy Spirit. The **fish** was one of the earliest symbols for Jesus Christ. The first letters of Jesus Christ, Son of God, Savior, spelled "fish" in Greek. Because of its association with baptism in water, it came to stand for all Christians. The **lamb**, an ancient sacrificial animal, symbolizes Jesus's sacrifice on the Cross as the Lamb of God. A flock of sheep represents the apostles—or all Christians—cared for by their Good Shepherd, Jesus Christ. The Evangelists, who were believed to have written the New Testament Gospels, are traditionally associated with the following creatures: Saint Matthew, a man (or angel); Saint Mark, a lion; Saint Luke, an ox; and Saint John, an eagle.

THE CROSS. The primary Christian emblem, the cross, symbolizes the suffering and triumph of Jesus's Crucifixion and Resurrection. It also stands for Jesus Christ himself, as well as the Christian religion as a whole. Crosses have taken various forms; the two most common are the Latin cross and the Greek cross.

MONOGRAMS. Alpha (the first letter of the Greek alphabet) and omega (the last) signify God as the beginning and end of all things. This symbolic device was popular from Early Christian times through the Middle Ages. The initials **I** and **X** are the first letters of Jesus and Christ in Greek. The Greek letters **XP**, known as the *chi rho*, were the first two letters of the word Christos. These emblems are sometimes enclosed by a halo or wreath of victory.

placid animals may represent the universal peace prophesied by Isaiah (11:6–9; 65:25). The pairing of images around a central element—as in the birds flanking the palm trees or the lions facing the menorah—is characteristic of Near Eastern art.

Early Christian Art

Christians believe in one God manifest in three persons: the Trinity of Father (God), Son (Jesus Christ), and Holy Spirit. According to Christian belief, Jesus was the Son of God by a human mother, the Virgin Mary. At the age of 30, Jesus gathered a group of disciples, male and female, and began to preach love and charity, a personal relationship with God, the forgiveness of sins, and the promise of life after death. After his ministry on earth, he was crucified (and after three days he rose from the dead). The core of Christian belief was formalized at the first ecumenical council of the Christian Church, called by Constantine I at Nicaea (present-day Iznik, Turkey) in 325.

THE CHRISTIAN BIBLE. The Christian Bible has two parts: the Old Testament (the Hebrew Scriptures), and the New Testament. The life and teachings of Jesus of Nazareth were recorded between about 70 and 100 CE in the New Testament books attributed to the Four Evangelists: Matthew, Mark, Luke, and John, the order arranged by Saint Jerome, an early Church father who made a translation of the books into Latin. They are known as the Gospels (from an Old English translation of a Latin word derived from the Greek *evangelion*, meaning "good news").

In addition to the Gospels, the New Testament includes an account of the Acts of the Apostles and the epistles, twenty-one letters of advice and encouragement to Christian communities in cities and towns in Greece, Asia Minor, and other parts of the Roman Empire. Thirteen of these letters are attributed to a Jewish convert, Saul, who took the Christian name Paul. The final book is the Apocalypse (the Revelation), a series of enigmatic visions and prophecies concern-

ing the eventual triumph of God at the end of the world, written about 95 CE.

THE EARLY CHURCH. Jesus limited his ministry primarily to Jews; the twelve apostles, as well as followers such as Paul, then took his teachings to non-Jews. Despite sporadic persecutions, Christianity persisted and spread throughout the Roman Empire. The government formally recognized the religion in 313 CE, and Christianity grew rapidly during the fourth century. As well-educated, upper-class Romans joined the Christian Church, they established an increasingly elaborate organizational structure along with ever more sophisticated doctrine.

Christian communities were organized by geographical units, called *dioceses*, along the lines of Roman provincial governments. Senior church officials called *bishops* served as governors of dioceses made up of smaller units, *parishes*, headed by priests. A bishop's church is a *cathedral*, a word derived from the Latin *cathedra*, which means "chair" but took on the meaning "bishop's throne." The bishop of Rome eventually became head of the Western church, with the title *pope*. The bishop of Constantinople became the head, or *patriarch*, of the Eastern church.

In spite of tensions between East and West, the Church remained united until 1054, when the Western pope and Eastern patriarch declared one another to be in error. The Church split in two, with the pope becoming the supreme authority in the Western or Catholic church, and the patriarch, with his metropolitans (equivalent to archbishops), governing the Eastern or Orthodox church.

Communal Christian worship focused on the central "mystery," or miracle, of the Incarnation of Jesus Christ and the promise of salvation. At its core was the ritual consumption of bread and wine, identified as the Body and Blood of Christ, which Jesus Christ had inaugurated at the Last Supper, a Passover meal with his disciples. Around these acts developed an elaborate religious ceremony, or *liturgy*, called the Eucharist (also known as Holy Communion or the Mass). Christians adopted the grapevine and grape cluster of the Roman god Bacchus to symbolize the wine of the Eucharist, and the Blood of Christ (see "Christian Symbols," page 238).

CATACOMB PAINTINGS. Christian rites prompted the development of special buildings—churches and baptistries—as well as specialized equipment. Christians began to use the visual arts to instruct worshipers as well as to glorify God. Almost no examples of specifically Christian art exist before the early third century, and even then it drew its styles and imagery from Jewish and classical traditions.

In this process, known as **syncretism**, artists assimilate images from other traditions and give them new meanings. The borrowings can be unconscious or quite deliberate. For example, **orant** figures—worshipers with arms outstretched—can be pagan, Jewish, or Christian, depending on the context in which they occur. Perhaps the most important

of these syncretic images is the Good Shepherd. In pagan art, he was Apollo, or Hermes the shepherd, or Orpheus among the animals. He became the Good Shepherd of the Psalms and Gospels to the Jews and Christians.

Christians, like Jews, used catacombs for burials and funeral services even before Constantine I granted their religion official recognition. In the Christian Catacomb of Commodilla, dating from the fourth century, long rectangular niches in the walls, called *loculi*, each held two or three bodies. Affluent families created small rooms, or *cubicula*, off the main passages to house sarcophagi (SEE FIG. 7–1). The cubicula were hewn out of tufa, soft volcanic rock, then plastered and painted with imagery related to their owners' religious beliefs. The finest Early Christian catacomb paintings resemble murals in houses such as those preserved at Rome and Pompeii (SEE FIGS. 6–34, 6–35). However, the aesthetic quality of the paintings is secondary to the message they convey.

One fourth-century Roman catacomb contained remains, or relics, of Saints Peter and Marcellinus, two third-century Christians martyred for their faith. Here, the ceiling of a cubiculum is partitioned by a central **medallion**, or round ornament, and four **lunettes**, semicircular wall areas framed by an arch (**FIG. 7–6**). At the center is a Good

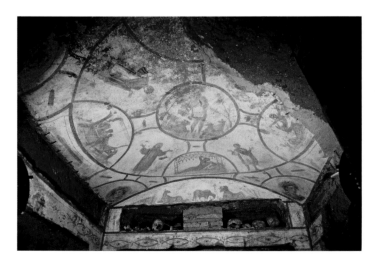

7–6 | **GOOD SHEPHERD, ORANTS, AND STORY OF JONAH**
Painted ceiling of the Catacomb of Saints Peter and Marcellinus, Rome. Late 3rd–early 4th century.

Shepherd, whose pose has roots in classical sculpture. In its new context, the image was a reminder of Jesus's promise "I am the good shepherd. A good shepherd lays down his life for the sheep" (John 10:11), as well as the Good Shepherd of the Psalms (Psalm 23:1).

The semicircular compartments at the ends of the arms of the cross tell the Old Testament story of Jonah and the sea monster (Jonah 1–2), in which God caused Jonah to be thrown overboard, swallowed by a monster, and released, repentant and unscathed, three days later. Christians reinterpreted this story as a parable of Christ's death and resurrection—and hence of the everlasting life awaiting true believers—and it was a popular subject in Christian catacombs. On the left, Jonah is thrown from the boat; on the right, the monster spits him up; and at the center, Jonah

reclines in the shade of a vine, a symbol of Paradise. Orant figures stand between the lunettes.

SCULPTURE. Sculpture that is clearly Christian from before the time of Constantine is even rarer than painting. What there is consists mainly of sarcophagi and small statues and reliefs, many of them Good Shepherd images. A remarkable set of small marble figures, probably made in the third century in Asia Minor, depicts the Good Shepherd (FIG. 7–7). Because it was found with sculptures depicting Jonah, it is probably from a Christian home.

Large workshops devoted to carving tomb chests existed in most urban centers. The sculptors worked on special orders and also kept a supply of finished sarcophagi carved with subjects suitable for a variety of beliefs (FIG. 7–8). Figures of the

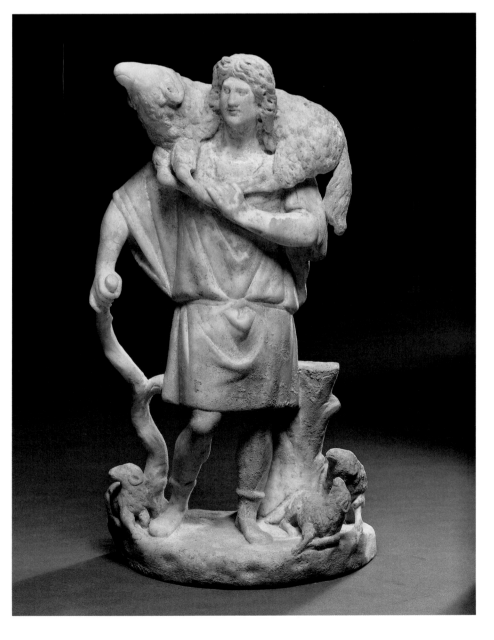

7–7 | **THE GOOD SHEPHERD**
Eastern Mediterranean, probably Anatolia (Turkey). Second half of the 3rd century. Marble, height 19¾" (50.2 cm), width 16" (15.9 cm). The Cleveland Museum of Art.
John L. Severance Fund, 1965.241

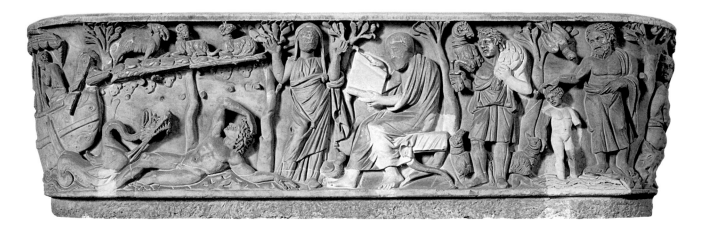

7–8 | *SARCOPHAGUS OF THE CHURCH OF SANTA MARIA ANTIQUA*
Rome. c. 270. Marble. 1′11¼″ × 7′2″ (5.45 × 2.2 m).

deceased needed only to have the individual face carved to complete the work. On the sarcophagus found in the Roman Church of Santa Maria Antiqua the natural poses of the figures, the solid modeling of the figures, and the revealing drapery all indicate the sculpture's classical roots.

The subject of the sculpture would be appropriate for either a pagan or Christian family. In the center stands a figure with hands raised in the age-old gesture of prayer. At one side a bearded man reads a scroll (a teacher or philosopher), a shepherd brings in a sheep, and an older man places his hand on the head of a youth who stands in a river. On the other side, a youth, menaced by a monster, lies under an arbor in the standard classical pose of sleep. Three sheep fill out the landscape, and a ship sails off at the far left. Nothing represented here could offend pagan sensibilities. But to the informed Christian, the orant is the Christian soul, the seated man is the teaching Christ, followed by Christ the Good Shepherd and a scene of baptism. The sleeping youth is Jonah, resting after his ordeal, and the monster is in the classical form of a dog-headed serpent.

HOUSE-CHURCHES. At first, Christians, like Jews, gathered in the homes of members of the community. In Dura-Europus, a house-church stands only about 300 yards from the house-synagogue (SEE FIG. 7–3). The building was a typical Roman house, with rooms around a courtyard and a second-floor apartment for the owner. A small red cross painted above the main entrance alerted Christians that the building was a gathering place. Two of the five ground-floor rooms—a large assembly hall and a room with a water tank—were adapted for Christian use.

The water tank indicates a baptistry, a special place for the baptismal rite. (Baptism washes away sin, leaving the initiate reborn as a member of the community of the faithful.) One end of the room had a niche equipped with a water basin, above which were images of the Good Shepherd and of Adam and Eve (FIG. 7–9). These murals reminded new Christians that humanity fell from grace when the first man and woman disobeyed God and ate fruit from the tree of knowledge, but the Good Shepherd (Jesus Christ) came to earth to carry his sheep (Christians) to salvation and eternal life.

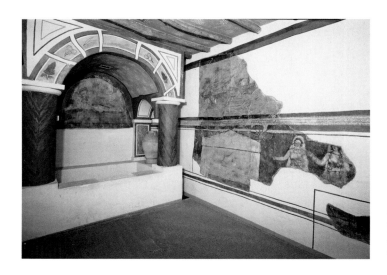

7–9 | **MODEL OF WALLS AND BAPTISMAL FONT**
Baptistry of a Christian house-church, Dura-Europos, Syria.
c. 240, destroyed 256. Dura-Europos Collection.
Yale University Art Gallery, New Haven, Connecticut.

Elements of Architecture
BASILICA-PLAN AND CENTRAL-PLAN CHURCHES

The forms of early Christian buildings were based on two classical prototypes: rectangular Roman **basilicas** (SEE FIG. 6-48) and round-domed structures— **rotundas**—such as the Pantheon (SEE FIGS. 6-52, 6-53).

As in Old Saint Peter's in Rome (SEE FIG. 7-10), basilica-plan churches are characterized by a forecourt, the **atrium**, leading to a porch, the **narthex**, which spans one of the building's short ends. Doorways—known collectively as the church's **portal**—lead from the narthex into the **nave**. Rows of columns separate the high-ceilinged nave from the **aisles** on either side. The nave is lit by windows of the **clerestory**, which rises above the side aisles' roofs. At the opposite end of the nave from the narthex is a semi-circular **apse**. The apse functions as the building's focal point, where the altar, raised on a platform, is located. Sometimes there is also a **transept**, a wing that crosses the nave in front of the

apse, making the building T-shaped (SEE FIG. 7-10); this is known as the *tau* plan. When additonal space (a choir) comes between the transept and the apse, the plan is known as a Latin cross.

Central-plan buildings were first used by Christians as tombs, baptism centers, and shrines to martyrs. The **Greek-cross plan**, in which two similarly sized "arms" intersect at their centers, is a type of central plan (FIG. 7-44). Like basilicas, central-plan churches generally have an atrium, a narthex, and an apse. But instead of the longitudinal axis of basilica-plan churches, which draws worshipers forward toward the apse, central-plan churches such as Ravenna's San Vitale (SEE FIGS. 7-28, 7-29) have a more vertical axis. This makes worshipers focus on the dome, the symbolic "vault of heaven." The space where the liturgy is performed, containing the central dome, sanctuary, and apse, is called the **naos**.

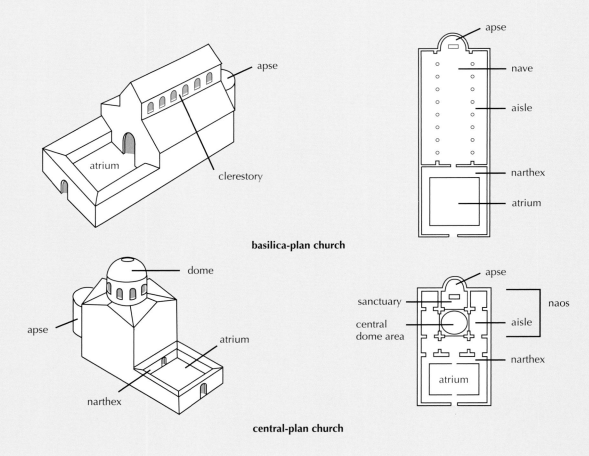

basilica-plan church

central-plan church

IMPERIAL CHRISTIAN ARCHITECTURE AND ART

In 313, Constantine I issued the Edict of Milan, granting all people in the Roman Empire freedom to worship whatever god they wished. This religious toleration, combined with Constantine's active support, allowed Christianity to enter a

new phase. In the fourth and fifth centuries, a sophisticated philosophical and ethical system developed, using many ideas from Greek and Roman thought. Church scholars edited and commented on the Bible, and the papal secretary who would become Saint Jerome (c. 347–420) undertook a new translation from Hebrew and Greek versions into Latin, the language of the Western church.

Completed about 404, this so-called Vulgate became the official version of the Bible. (The term *Vulgate* has the same root as the word *vulgar*, the Latin *vularis*, meaning "common" or "popular.") Christians also gained political influence in this period. The Christian writer Lactantius, for example, tutored Constantine I's son. Eusebius, bishop of Caesarea, was a trusted imperial adviser from about 315 to 339. These transformations in the philosophical and political arenas coincided with a dramatic increase in the size and splendor of Christian architecture.

Architecture: The Church and Its Decoration

The Christian community had special architectural needs. A Greek or Roman temple served as the house and treasury of the god and formed a backdrop for ceremonies that took place at altars in the open air. In Christianity, as in some of the Mystery religions (SEE FIG. 6–27), the entire community gathered inside the building to participate in the rites. Christians also needed places or buildings for activities such as education, the initiation of new members, private prayer, and burials. The pagan basilica provided a model for the congregational church and the tholos tomb provided a model for the baptistry and martyr's shrine.

THE BASILICA CHURCH. Christian congregations needed large, well-lit spaces for worship, and the Roman basilica provided a perfect model (see "Basilica-Plan and Central-Plan Churches," page 242). But rather than an entrance through the long side of the building into a columnar hall, with an apse at each end (see the basilica Ulpia, FIG. 6–48), the early Christian basilica had its entrance from an atrium on the short side of the building and a single apse at the opposite end, like the contemporary secular hall in Trier (SEE FIG. 6–71). The place where the altar stood was the place that in a pagan basilica was reserved for the judge or presiding official. The nave with aisles on the two long sides created an ample central space for processions and a place for the congregation. If the clergy needed to partition space, they used screens or curtains around the altar or in the side aisles.

In Rome, Constantine and his family sponsored a vast building program for the Church. For the bishop of Rome (the pope), Constantine built a residence on the site of the imperial Lateran palace as well as a baptistry and a basilican church. The Church of Saint John Lateran remains the cathedral of Rome to this day, although the pope's residence has been the Vatican since the thirteenth century. Perhaps as early as 320, the emperor also ordered the construction of a large new basilica to replace the humble monument marking the place where Christians believed Saint Peter was buried (c. 64 CE).

OLD SAINT PETER'S CHURCH. The new basilica—now known as Old Saint Peter's because it was replaced by a new building in the sixteenth century—would protect the tomb of Peter, and make the site accessible to the faithful (FIG. 7–10). Our knowledge of Old Saint Peter's is based on written descriptions, drawings made before and while it was

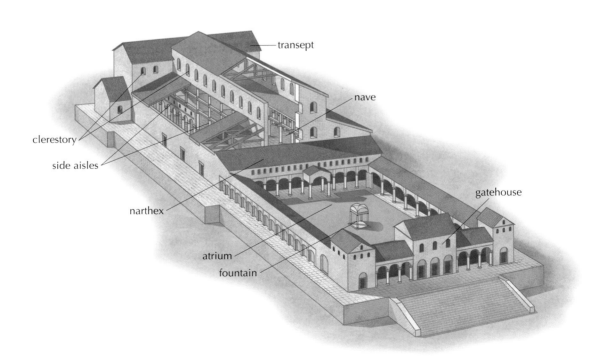

7–10 | **RECONSTRUCTION DRAWING OF OLD SAINT PETER'S BASILICA**
Rome. c. 320-27; atrium added in later 4th century. Approx. 394′ (120 m) long and 210′ (64 m) wide.

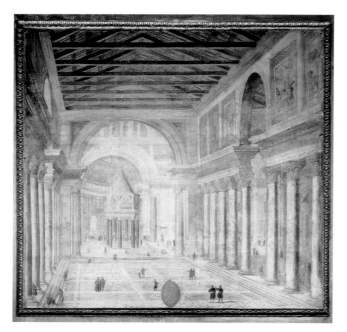

7–11 | **OLD ST. PETER'S, PAINTING OF THE INTERIOR**
Painting in San Martino ai Monte, Rome. 16th century.

being dismantled, the study of other churches inspired by it, and modern archaeological excavations at the site (FIG. 7–11).

Old Saint Peter's was an unusual basilica church in having double side aisles instead of one aisle on each side of the nave. A narthex across the width of the building provided a place for people who had not yet been baptized. Five doorways—a large, central portal into the nave and two portals on each side—gave access to the church. Columns supporting an entablature lined the nave, forming what is called a nave colonnade. However, the columns dividing the double side aisles supported round arches. In turn, these arches carried the open wood rafters roofing the nave and aisles. Sarcophagi and tombs also lined the side aisles.

Constantine's architects devised a new element for the basilica plan. At the apse end of the nave, they added a **transept**, a large hall that crossed in front of the apse. It created a T form that anticipated the later Latin-cross church plan, seen in the reconstruction in FIGURE 7–10. This area provided additional space for the large number of clergy serving the church, and it also accommodated pilgrims visiting the tomb of Saint Peter. Transept windows lit the high altar directly.

Saint Peter's bones supposedly lie below the altar, marked by a permanent, pavilionlike structure supported on four columns, called a *ciborium*. A Roman cemetery, partly destroyed and covered by the foundations of Constantine's basilica, lay beneath the church. Eventually a large *crypt*, or underground vault, giving access to the tomb of Peter and providing additional space for important burials, was built on the site. It is still used today for the burial of the popes.

Old Saint Peter's thus served a variety of functions. It was a burial site, a pilgrimage shrine commemorating Peter's martyrdom and containing his relics, and a congregational church. It could hold at least 14,000 worshipers, and it remained the largest Christian church until the eleventh century.

SANTA SABINA. Most early Christian churches have been rebuilt, some many times, but the Church of Santa Sabina in Rome, constructed by Bishop Peter of Ilyria between 422 and 432, appears much as it did in the fifth century (FIG. 7–12). The basic elements of the basilica church are clearly visible inside and out: a nave lit by clerestory windows, flanked by side aisles, and ending in a rounded apse. (Compare the Audience Hall at Trier; SEE FIG. 6–71.)

Santa Sabina's exterior is the typical simple brickwork. In contrast, the church's interior displays a wealth of marble

7–12 | **CHURCH OF SANTA SABINA**
Rome. Exterior view from the Southeast.
c. 422–32.

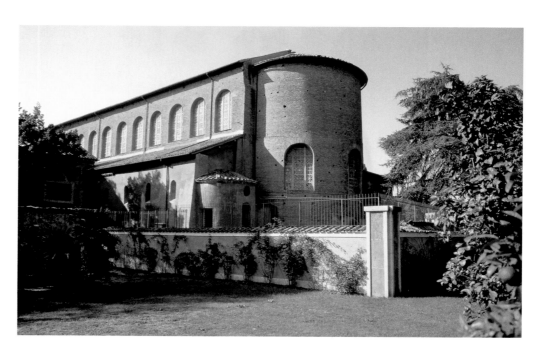

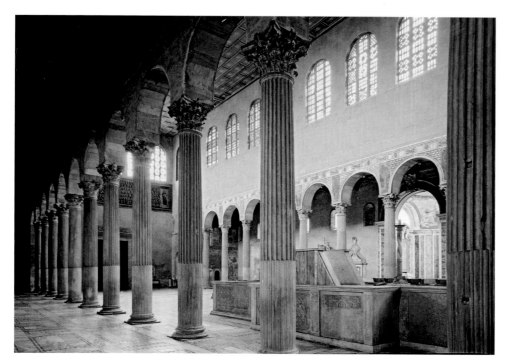

7–13 | **INTERIOR, CHURCH OF SANTA SABINA**
View from the south aisle near the sanctuary to the entrance. c. 422–32.

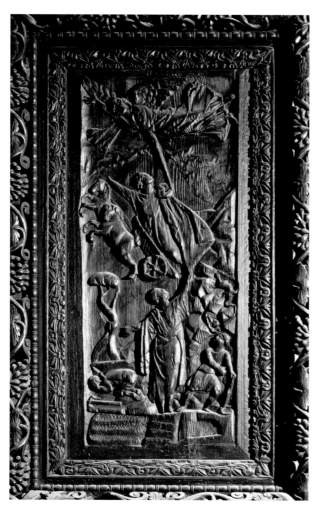

7–14 | **THE ASCENSION OF ELIJAH**
Panel from the doors of the Church of Santa Sabina. 420s. Cypress wood.

veneer and twenty-four fluted marble columns with Corinthian capitals acquired from a second-century building (FIG. 7–13). (Material reused from earlier buildings is known as *spolia*, Latin for "spoils.") The columns support round arches, creating a nave arcade, in contrast to the nave colonnade in Saint Peter's. The spandrels are inlaid with marble images of the *chalice* (the wine cup) and *paten* (the plate that holds the bread)—the essential equipment for the Eucharistic rite that took place at the altar. The blind wall between the arcade and the clerestory typically had paintings or mosaics with scenes from the Old Testament or the Gospels. The decoration of the upper walls is lost, and a paneled ceiling covers the rafter roof.

Sheltered by the narthex, the principal entrance to the church still has its fifth-century wooden doors (FIG. 7–14), which were in place for the consecration of the church by Pope Sixtus III (432–40 CE). Framed panels are carved with scenes from the Old and New Testaments. Only eighteen out of twenty-eight panels survive, making any analysis of the iconography highly speculative, but some relationship between Old and New Testament themes seems to have been intended. The Ascension of Elijah (2 Kings 2:11) could have been related to the Ascension of Christ, for example. The prophet soars upward in the chariot of fire sent for him by God and guided by an angel, to the amazement of his followers. An angel with a long wand guides his ascent.

SANTA MARIA MAGGIORE. Another kind of decoration, mosaic panels, still survives in the Church of Santa Maria Maggiore, which was built between 432 and 440. The church was the first to be dedicated to the Virgin Mary after the Council of Ephesus in 431 declared her to be Theotokos,

"Bearer of God." The mosaics of the Church of Santa Maria Maggiore reflect a renewed interest in the earlier classical style of Roman art that arose during the reign of Pope Sixtus III. The mosaics along the nave walls, in framed panels high above the worshipers, illustrate Old Testament stories of the Jewish patriarchs and heroes—Abraham, Jacob, Moses, and Joshua—whom Christians believe foretold the coming of Christ and his activities on earth. These panels were not simply intended to instruct the congregation. Instead, as with most of the decorations in great Christian churches from this time forward, they were also meant to praise God through their splendor, to make churches symbolic embodiments of the Heavenly Jerusalem that awaits believers in the afterlife.

Some of the most effective compositions are those in which a few large figures dominate the space, as in the **PARTING OF LOT AND ABRAHAM** (FIG. 7–15), a story told in the first book of the Old Testament (Genesis 13:1–12). The people of Abraham and his nephew Lot, dwelling together, had grown too numerous, so the two agreed to separate and lead their followers in different directions. On the right, Lot and his daughters turn toward the land of Jordan, while Abraham and his wife stay in the land of Canaan. Abraham was the founder of Israel and an ancestor of Jesus. (Judaism, Christianity, and Islam are sometimes referred to as Abrahamic religions.)

The toga-clad men share a parting look as they gather their robes about them and turn decisively away from each other. The space between them in the center of the composition emphasizes their irreversible decision to part. Clusters of heads in the background represent their followers, an artistic convention used effectively here. The earlier Roman realistic style can be seen in the solid three-dimensional rendering of foreground figures, the hint of perspective in the building, and the landscape setting, with its flocks of sheep, bits of foliage, and touches of blue sky. To Roman stone and marble mosaics, Christian artists added tesserae of colored glass and clear glass in which gold leaf was embedded. The use of graduated colors creates shading from light to dark, producing three-dimensional effects that are offset by strong outlines. These outlines, coupled with the sheen of the gold tesserae, tend to flatten the forms and emphasize a quality of otherworldly splendor.

SANTA COSTANZA. A second type of ancient building—the *tholos*, a round structure with a central plan and vertical axis—also served Christian builders as a model for tombs, martyrs' churches, and baptistries (see "Basilica-Plan and Central-Plan Churches," page 242). One of the earliest surviving central-plan Christian buildings is the mausoleum of Constantina, the daughter of Constantine. The tomb was built outside the walls of Rome just before 350 (FIG. 7–16). The mausoleum was consecrated as a church in 1256 and is now dedicated to Santa Costanza (the Italian form of Constantina). The building consists of a tall rotunda with an

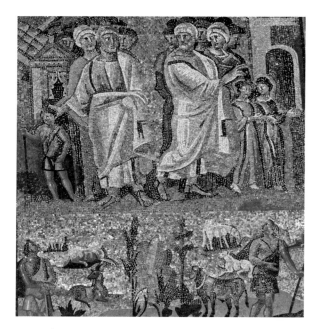

7–15 | **PARTING OF LOT AND ABRAHAM**
Mosaic in the nave arcade of the Church of Santa Maggiore, Rome. 432–40. Panel approx. 4'11" × 6'8" (1.2 × 2 m).

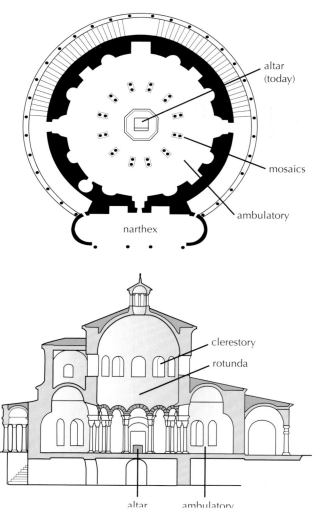

altar (today)

mosaics

ambulatory

narthex

clerestory

rotunda

altar ambulatory

7–16 | **PLAN AND SECTION, CHURCH OF SANTA COSTANZA**
Rome. c. 350.

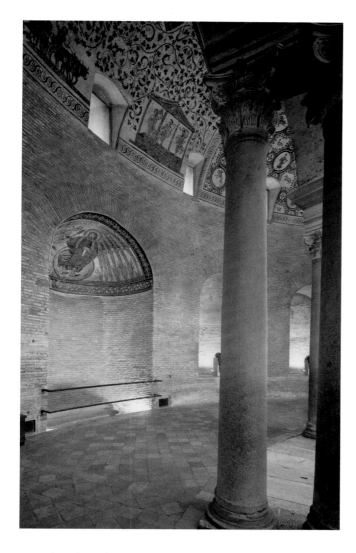

7–17 | CHURCH OF SANTA COSTANZA
Rome. c. 350. Ambulatory with harvesting mosaic (see Fig. 7-18). Niche at left with mosaic of Christ. In the apse, the Lord handing over the tablets of the law to Moses (mosaic, later 4th century).
Canali Photobank, Capriolo (BS)

with a tangle of grapevines filled with **putti**—naked male child-angels, or cherubs, derived from classical art—who vie with the birds to harvest the grapes (FIG. **7–18**). Along the bottom edges on each side, putti drive wagonloads of grapes toward pavilions housing large vats in which more putti trample the grapes into juice. The technique, subject, and style are Roman, but the meaning has been altered. The scene would have been familiar to the pagan followers of Bacchus, but in a Christian context, the grape juice becomes the wine of the Eucharist. Constantina's pagan husband, however, may have appreciated the double allusion.

Architecture: Ravenna

As Rome's political importance dwindled, that of the northern Italian cities of Milan and Ravenna grew. In 395, Emperor Theodosius I split the Roman Empire into eastern and western divisions, each ruled by one of his sons. Heading the Western Roman Empire, Honorius (ruled 395–423) first established his capital at Milan. When Germanic settlers laid siege to Milan in 402, Honorius moved his government to Ravenna on the east coast. Its naval base, Classis (present-day Classe), had been important since the early days of the empire. In addition to military security, Ravenna offered direct access by sea to Constantinople. Ravenna flourished, and when Italy fell in 476 to the Ostrogoths, the city became one of their headquarters. It still contains a remarkable group of well-preserved fifth- and sixth-century buildings.

THE MAUSOLEUM OF GALLA PLACIDIA. One of the earliest surviving Christian structures in Ravenna is a funerary chapel that was once attached to the narthex of the church of the imperial palace (now Santa Croce, meaning "Holy Cross"). Built about 425–26, the chapel was constructed when

encircling barrel-vaulted passageway called an **ambulatory** (FIG. **7–17**). A double ring of paired columns with Composite capitals and richly molded entablature blocks supports the arcade and dome. Originally, the interior was entirely sheathed in mosaics and fine marble.

Mosaics in the ambulatory vault recall the syncretic images in the catacombs. One section, for example, is covered

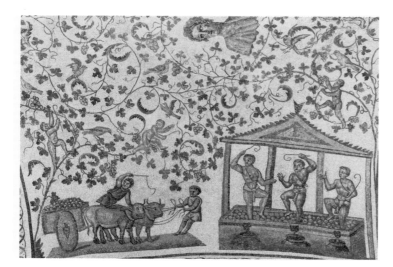

7–18 | HARVESTING OF GRAPES
Ambulatory vault, Church of Santa Costanza, Rome. c. 350. Mosaic.

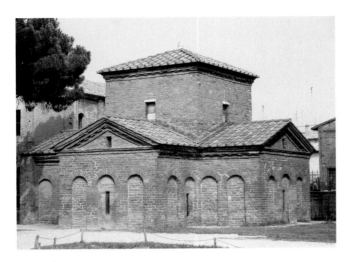

7–19 | **MAUSOLEUM OF GALLA PLACIDIA**
Ravenna. c. 425-26.

Honorius's half-sister, Galla Placidia, ruled the West (425–c. 440) as regent for her son. The chapel came to be called the **MAUSOLEUM OF GALLA PLACIDIA** because she and her family were once believed to be buried there **(FIG. 7–19)**.

This small building is **cruciform**, or cross-shaped; a barrel vault covers each of its arms, and a **pendentive dome**—a dome continuous with its pendentives—covers the space at the intersection of the arms (see "Pendentives and Squinches," page 257). The interior of the chapel contrasts markedly with the unadorned exterior, a transition designed to simulate the passage from the real world into a supernatural one **(FIG. 7–20)**. The worshiper looking from the western entrance across to the eastern bay of the chapel sees a brilliant, abstract pattern of mosaic that suggests a starry sky filling the barrel vault. Panels of veined marble sheathe the walls below. Bands of luxuriant foliage and floral designs derived from funerary garlands cover the four central arches, and the walls above them are filled with the figures of standing apostles, gesturing like orators. Doves flanking a small fountain between the apostles symbolize eternal life in heaven.

In the lunette below, a mosaic depicts the third-century martyrdom of Saint Lawrence, to whom the building may have been dedicated. The saint holds a cross and gestures toward the fire and metal grill on which he was literally roasted (thereby becoming the patron saint of bakers). At the left stands a tall cabinet containing the Gospels, signifying the faith for which he died (see a detail showing the contents of the cabinet in "Early Forms of the Book," page 251).

Opposite Saint Lawrence, in a lunette over the entrance portal, is a mosaic of the Good Shepherd **(FIG. 7–21)**. A comparison of this version with a fourth-century depiction of the

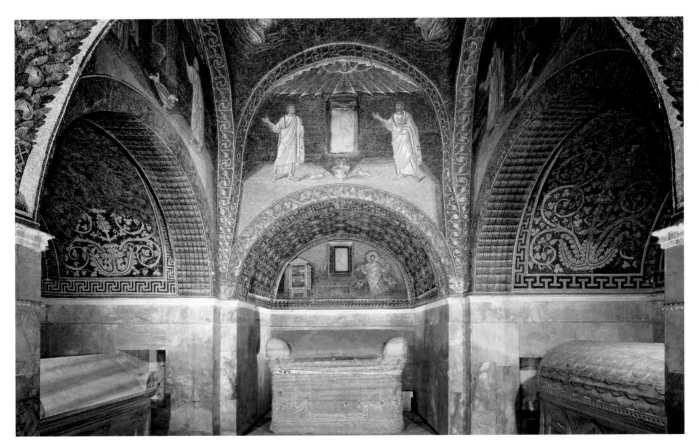

7–20 | **MAUSOLEUM OF GALLA PLACIDIA**
Ravenna. View from entrance, barrel-vaulted arms housing sarchophagi, lunette mosaic of the Martyrdom of Saint Lawrence. c. 425-26.

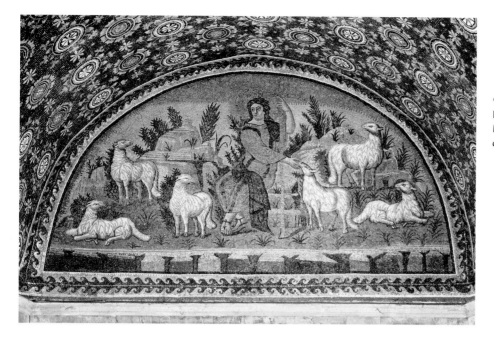

7–21 | **GOOD SHEPHERD**
Lunette over the entrance,
Mausoleum of Galla Placidia.
c 425–26. Mosaic.

same subject (SEE FIG. 7–6) reveals significant changes in content and design. The Ravenna mosaic contains many familiar classical elements, such as shading suggesting a single light source acting on solid forms, cast shadows, and a hint of landscape in rocks and foliage. The conception of Jesus the Shepherd, however, has changed.

In the fourth-century painting, he was a simple shepherd boy carrying an animal on his shoulders. In the Ravenna mosaic, he is a young adult with a golden halo, wearing imperial robes of gold and purple and holding a long golden staff that ends in a cross instead of a shepherd's crook. The stylized elements of a natural landscape are arranged more rigidly than before. Individual plants at regular intervals fill the spaces between animals, and the rocks are stepped back into a shallow space that rises from the foreground plane and ends in foliage. The rocky band at the bottom of the lunette scene, resembling a cliff face riddled with clefts, separates the divine image from worshipers.

BAPTISTRY OF THE ORTHODOX. Just as the political role of Ravenna changed in the fourth and fifth centuries, so did the religious beliefs of its leaders. The early Christian Church faced many philosophical and doctrinal controversies, some of which resulted in serious splits, called *schisms*, within the Church. When this happened, Church leaders gathered in councils to decide on the orthodox, or official, position, while denouncing other positions as heretical. For example, they rejected Arianism, an early form of Christianity that questioned the doctrine of the Trinity and held that Jesus was not fully divine. The first church council, called by Constantine at Nicaea in 325, made the doctrine of the Trinity the official Christian belief. In 451, the Council of Chalcedon,

near Constantinople, declared Jesus to be of two natures—human and divine—united in one.

In Ravenna, two baptistries, orthodox and Arian, still stand as witness to these disputes. The Baptistry of the Orthodox, constructed next to the cathedral of Ravenna in the early fourth century, is the more splendid of the two. It was renovated and refurbished between 450 and 460 when the original wooden ceiling was replaced with a dome and splendid interior decoration added in marble, stucco, and mosaic (FIG. 7–22). On the clerestory level, a blind arcade frames figures of Old Testament prophets in stucco relief. This arcading suggests that the domed ceiling is a huge canopy tethered to the columns.

In the dome itself, concentric rings of decoration draw the eye upward to a central image: the baptism of Jesus by John the Baptist. The lowest ring depicts fantastic architecture, similar to that seen in ancient secular wall painting. Eight circular niches contain alternating altars holding gospel books and empty thrones that symbolize Christ's Second Coming (Matthew 25:31–36). In the next ring, toga-clad apostles stand holding crowns, the rewards of martyrdom. Stylized golden plant forms divide the deep blue ground between them. Although the figures cast dark shadows on the pale green grass, their cloudlike robes, shot through with golden rays, give them an otherworldly presence. The landscape setting of the *Baptism of Jesus* in the central **tondo**—a circular image—exhibits classical roots, and the personification of the Jordan River recalls pagan imagery. The background, however, is not the blue of the earthly sky but the gold of paradise. Already in the mid-fifth century, artists working for the Christian Church had begun to reinterpret and transform Roman realism into an abstract style better suited to their patrons' spiritual goals.

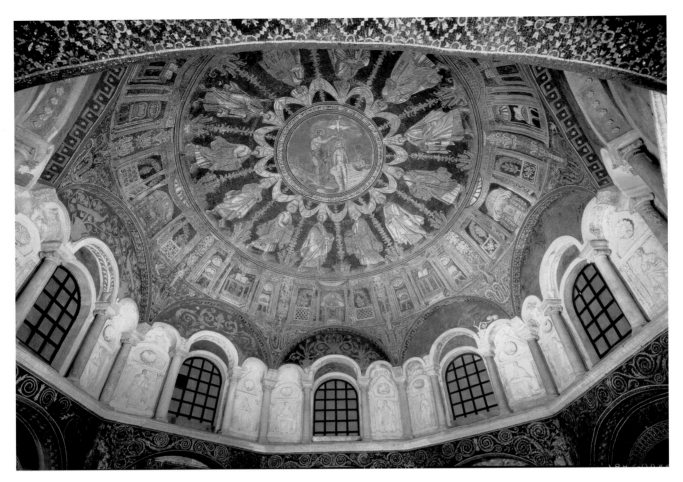

7–22 | CLERESTORY AND DOME BAPTISM OF CHRIST AND PROCESSION OF
APOSTLES, GOSPELS AND THRONES, THE PROPHETS. BAPTISTRY OF THE ORTHODOX
Ravenna. Italy. Early 5th century; dome remodeled c. 450–60.

Sculpture

In sculpture, as in architecture, Christians adapted Roman forms for their own needs, especially monumental stone sarcophagi such as the elaborately carved **SARCOPHAGUS OF JUNIUS BASSUS** (FIG. 7–23), as imposing as the pagan Roman Battle Sacarphogus (SEE FIG. 6–69). Junius Bassus was a Roman official who, as the inscription here tells us, was "newly baptized" and died on August 25, 359, at the age of 42. On the front panel, columns, entablatures, and gables divide the space into individual scenes. Details of architecture, furniture, and foliage suggest the earthly setting for each scene.

In the center of both registers, columns carved with putti producing wine frame the triumphal Christ. In the upper register, he appears as a teacher-philosopher flanked by Saints Peter and Paul. In a reference to the pagan past, Christ rests his feet on the head of Aeolus, the classical god of the winds, who also represents the Cosmos (shown with a veil billowing behind him). To Christians, Aeolus personified the skies, so that Christ is meant to be seen as seated in heaven. He is giving the Christian law to his disciples, imitating the Hebrew Scriptures' account of God dispensing the Law to Moses. In the bottom register, the earthly Jesus makes his triumphal entry into Jerusalem like a Roman emperor entering a conquered city. However, he rides on a humble animal.

The earliest Christian art, such as that in catacomb paintings and on the *Sarcophagus of Junius Bassus*, unites the imagery of Old and New Testaments in elaborate allegories; Old Testament themes foreshadow and illuminate events in the New Testament. On the top left, Abraham passes the test of faith and need not sacrifice his son Isaac. Christians saw in this story a sign of God's sacrifice of his son, Jesus, on the cross. Under the triangular gable on the lower right, the Old Testament story of Daniel saved by God from the lions prefigures Christ's Resurrection. The figure of Daniel has been replaced. Originally nude, he balanced the nude Adam and Eve. In the lower left frame on the far left, God tests the faith of Job, who provides a model for the sufferings of Christian

Art in Its Context
EARLY FORMS OF THE BOOK

Since people began to write some 5,000 years ago, they have kept records on a variety of materials, including clay or wax tablets, pieces of broken pottery, papyrus, animal skins, and paper. Books have taken two forms: scroll and codex.

Scribes made **scrolls** from sheets of papyrus glued end to end or from thin sheets of cleaned, scraped, and trimmed sheep- or calfskin, a material known as **parchment** or, when softer and lighter, **vellum**. Each end of the scroll was attached to a rod; the reader slowly unfurled the scroll from one rod to the other. Scrolls could be written to be read either horizontally or vertically.

At the end of the first century CE, the more practical and manageable **codex** (plural, *codices*)—sheets bound together like the modern book—replaced the scroll. The basic unit of the codex was the eight-leaf **quire**, made by folding a large sheet of parchment twice, cutting the edges free, then sewing the sheets together up the center. Heavy covers kept the sheets of a codex flat.

Until the invention of printing in the fifteenth century, all books were manuscripts—that is, written by hand. Manuscripts often included illustrations, called **miniatures**, from *minium*, the Latin word for a reddish lead pigment. Manuscripts decorated with gold and colors were said to be **illuminated**.

The thickness and weight of parchment and vellum made it impractical to produce a very large manuscript, such as an entire Bible, in a single volume. As a result, individual sections were made into separate books. These weighty tomes were stored flat on shelves in cabinets like the one holding the Gospels shown here and visible in the mosaic of Saint Lawrence in the Mausoleum of Galla Placidia.

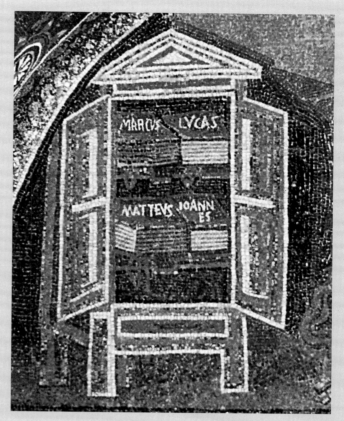

BOOKCASE WITH THE GOSPELS IN CODEX FORM Detail of a mosaic in the eastern lunette, *Mausoleum of Galla Placidia*, Ravenna (FIG. 7–20).

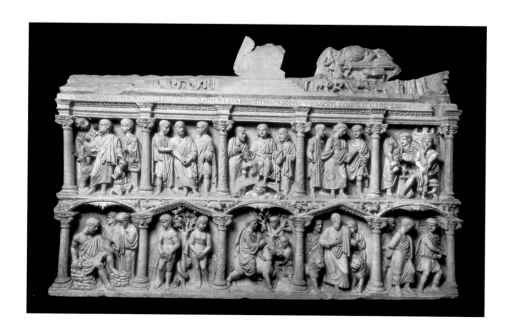

7–23 | **SARCOPHAGUS OF JUNIUS BASSUS**
Grottoes of Saint Peter, Vatican, Rome. c. 359. Marble, 4 × 8′ (1.2 × 2.4 m).

Myth and Religion
ICONOGRAPHY OF THE LIFE OF JESUS

conography is the study of subject matter in art. It involves identifying both what a work of art represents—what it depicts—and the deeper significance of what is represented—its symbolic meaning. Stories about the life of Jesus, grouped in "cycles," form the basis of Christian iconography. What follows is an outline of those cycles and the main events of each.

The Incarnation Cycle and the Childhood of Jesus

Events surrounding the conception and birth of Jesus.

The Annunciation: The archangel Gabriel informs the Virgin Mary that God has chosen her to bear his son. A dove represents the Incarnation, her miraculous conception of Jesus through the Holy Spirit.

The Visitation: The pregnant Mary visits her older cousin Elizabeth, pregnant with the future Saint John the Baptist. Elizabeth is the first to acknowledge the divinity of Mary's child.

The Nativity: Jesus is born to Mary in Bethlehem. The Holy Family—Jesus, Mary, and her husband, Joseph—is shown in a house, a stable, or, in Byzantine art, a cave.

The Annunciation to the Shepherds and the Adoration of the Shepherds: An angel announces Jesus's birth to humble shepherds who hurry to Bethlehem to honor him.

The Adoration of the Magi: Wisemen from the "East" follow a bright star to Bethlehem to honor Jesus as King of the Jews. They present him with precious gifts: gold (kingship), frankincense (divinity), and myrrh (death). In the European Middle Ages, the Magi were identified as three kings.

The Presentation in the Temple: Mary and Joseph bring the infant Jesus to the Temple in Jerusalem, where he is presented to the high priest. It is prophesied that Jesus will redeem humankind and that Mary will suffer great sorrow.

The Massacre of the Innocents and the Flight into Egypt: An angel warns Joseph that King Herod—to eliminate the threat of a newborn rival king—plans to murder all the male infants in Bethlehem. The Holy Family flees to Egypt.

Jesus among the Doctors: In Jerusalem to celebrate Passover, Joseph and Mary find the twelve-year-old Jesus in serious discussion with Temple scholars, a sign of his coming ministry.

The Public Ministry Cycle

In which Jesus preaches and performs miracles (signs of God's power).

The Marriage at Cana: Jesus turns water into wine at a wedding feast, his first public miracle. Later the event was interpreted as prefiguring the Eucharist.

The Cleansing of the Temple: Jesus, in anger, drives money changers and animal traders from the Temple.

The Baptism: At age thirty, Jesus is baptized by John the Baptist in the Jordan River. He sees the Holy Spirit and hears a heavenly voice proclaiming him God's son. His ministry begins.

Jesus and the Samaritan Woman at the Well: Jesus rests by a spring called Jacob's Well. Jews and Samaritans did not associate, but Jesus asks a local Samaritan woman for water.

The Miracles of Healing: Jesus performs miracles of healing the blind, the possessed (mentally ill), the paralytic, and lepers. He also resurrects the dead.

The Miraculous Draft of Fishes: At Jesus's command Peter lowers the nets and catches so many fish that James and John have to help him bring them into the boat. Jesus promises that they soon will be "fishers of men."

Jesus Walking on the Water; Storm at Sea: The apostles, in a storm-tossed boat, see Jesus walking toward them on the water. Peter tries to go out to meet Jesus, but begins to sink, and Jesus saves him.

The Calling of Levi (Matthew): Passing the customhouse, Jesus sees Levi, a tax collector, and says, "Follow me." Levi complies, becoming the apostle Matthew.

Raising of Lazarus: Jesus brings his friend Lazarus back to life four days after his death. Lazarus emerges from the tomb wrapped in his shroud.

Jesus in the House of Mary and Martha: Mary, representing the contemplative life, sits listening to Jesus while Martha, representing the active life, prepares food. Jesus praises Mary.

The Transfiguration: Jesus reveals his divinity in a dazzling vision on Mount Tabor in Galilee, as his closest disciples—Peter, James, and John—look on. A cloud envelops them, and a heavenly voice proclaims Jesus to be God's son.

The Tribute Money: Challenged to pay the temple tax, Jesus sends Peter to catch a fish, which has the required coin in its mouth.

The Delivery of the Keys to Peter: Jesus designates Peter as his successor, symbolically turning over to him the keys to the kingdom of heaven.

The Passion Cycle

Events surrounding Jesus's death and Resurrection. (*Passio* is Latin for "suffering.")

Entry into Jerusalem: Jesus, riding an ass, and his disciples enter Jerusalem in triumph. Crowds honor them, spreading clothes and palm fronds in their path.

The Last Supper: During the Passover meal, Jesus reveals his impending death to his disciples. Instructing them to drink wine (his Blood) and eat bread (his Body) in remembrance of him, he lays the foundation for the Christian Eucharist (Mass).

Jesus Washing the Apostles' Feet: After the Last Supper, Jesus washes the apostles' feet to set an example of humility. Peter, embarrassed, protests.

The Agony in the Garden: In the Garden of Gethsemane on the Mount of Olives, Jesus struggles between his human fear of pain and death and his divine strength to overcome them (*agon* is Greek for "contest"). The apostles sleep nearby, oblivious.

Betrayal (The Arrest): Judas Iscariot, a disciple, accepts a bribe to point Jesus out to his enemies. Judas brings an armed crowd to Gethsemane and kisses Jesus (a prearranged signal). Peter attempts to defend Jesus from the Roman soldiers who seize him.

The Denial of Peter: Jesus is taken to the Jewish high priest, Caiaphas, to be interrogated for claiming to be the Messiah. Peter follows, and there he three times denies knowing Jesus, as Jesus had predicted.

Jesus before Pilate: Jesus is taken to Pontius Pilate, the Roman governor of Judaea, and charged with treason for calling himself King of the Jews. He is sent to Herod Antipas, ruler of Galilee, who scorns him. Pilate proposes freeing Jesus but is shouted down by the mob, which demands that Jesus be crucified. Pilate washes his hands before the mob to signify that Jesus's blood is on their hands, not his.

The Flagellation (The Scourging): Jesus is whipped by his Roman captors.

Jesus Crowned with Thorns (The Mocking of Jesus): Pilate's soldiers torment Jesus. They dress him in royal robes, crown him with thorns, and kneel before him, sarcastically hailing him as King of the Jews.

The Bearing of the Cross (Road to Calvary): Jesus bears the cross from Pilate's house to Golgotha, where he is executed. This event and its accompanying incidents came to be called the Stations of the Cross: (1) Jesus is condemned to death; (2) Jesus picks up the cross; (3) Jesus falls; (4) Jesus meets his grieving mother; (5) Simon of Cyrene is forced to help Jesus carry the cross; (6) Veronica wipes Jesus's face with her veil; (7) Jesus falls again; (8) Jesus admonishes the women of Jerusalem; (9) Jesus falls a third time; (10) Jesus is stripped; (11) Jesus is nailed to the cross; (12) Jesus dies on the cross; (13) Jesus is taken down from the cross; (14) Jesus is entombed.

The Crucifixion: The earliest representations of the Crucifixion show either a cross alone or a cross and a lamb. Later depictions include some or all of the following details: two criminals (one penitent, the other not) are crucified alongside Jesus; the Virgin Mary, John the Evangelist, Mary Magdalen, and others mourn at the foot of the cross; Roman soldiers torment Jesus—one extends a sponge on a pole with vinegar instead of water for him to drink, another stabs him in the side with a spear, and others gamble for his clothes; a skull identifies the execution ground as Golgotha, "the place of the skull," where Adam was buried, symbolizing the promise of redemption.

The Descent from the Cross (The Deposition): Jesus's followers take his body down from the cross. Joseph of Arimathea and Nicodemus wrap it in linen with myrrh and aloe. Also present are the grief-stricken Virgin, John the Evangelist, and (in some accounts) Mary Magdalen, other disciples, and angels.

The Lamentation (Pietà): Jesus's sorrowful followers gather around his body. An image of the Virgin mourning alone with Jesus across her lap is known as a **pietà** (from the Latin *pietas*, "compassion").

The Entombment: Jesus's mother and friends place his body in a nearby sarcophagus, or rock tomb. This is done hastily because the Jewish Sabbath is near.

The Descent into Limbo (The Harrowing of Hell/ Anastasis): No longer in mortal form, Jesus, now called Christ, descends into limbo, or hell, to free deserving souls, among them Adam, Eve, and Moses.

The Resurrection: Three days after his death, Christ walks from his tomb while the soldiers guarding it sleep.

The Marys at the Tomb (The Holy Women at the Sepulcher): Christ's female followers—usually including Mary Magdalen and Mary the mother of the apostle James—discover his empty tomb. An angel announces Christ's Resurrection. The soldiers guarding the tomb look on terrified.

Noli Me Tangere ("Do Not Touch Me"), The Supper at Emmaus, and Doubting Thomas: Christ makes a series of appearances to his followers in the forty days between his Resurrection and his Ascension. He first appears to Mary Magdalen as she weeps at his tomb. She reaches out to him, but he warns her not to touch him. Christ tells her to tell the Apostles of his Resurrection. At Emmaus, Christ and his disciples share a meal. Christ invites Thomas, who doubts his Resurrection, to touch the wound in his side in order to convince him.

The Ascension: Christ ascends to heaven from the Mount of Olives, disappearing in a cloud. His disciples, often accompanied by the Virgin, watch.

martyrs. Next, Adam and Eve have set in motion the entire Christian story. Lured by the serpent, they have eaten the forbidden fruit, have become conscious of their nakedness, and are trying to hide their genitals with leaves. This fall from grace will be redeemed by Christ.

On the upper right side are two scenes from Christ's Passion (see "Iconography of the Life of Jesus," page 252), his arrest and his appearance before Pontius Pilate, who is about to wash his hands, symbolizing that he denies responsibility for Jesus's death. The Crucifixion is not represented: It rarely was in early Christian art. After the death of Jesus, the apostle Peter is arrested for preaching. In the last frame, Paul is arrested. The images in the upper central frame are of Paul and Peter, whose martyrdoms in Rome represented the continuing power of Christ and his disciples, and also symbolized the power of the Roman Church.

EARLY BYZANTINE ART: THE FIRST GOLDEN AGE

Byzantine art can be thought of broadly as the art of Constantinople (whose ancient name, before Constantine renamed it after himself, was Byzantium) and the regions under its influence. In this chapter, we focus on Byzantine art's three "golden ages." The Early Byzantine period, most closely associated with the reign of Emperor Justinian I (527–65), began in the fifth century CE and ended in 726, the onset of the iconoclast controversy that led to the destruction of religious images. The Middle Byzantine period began in 843, when Empress Theodora (c. 810–67) reinstated the veneration of icons. It lasted until 1204, when Christian Crusaders from the West occupied Constantinople. The Late Byzantine period began with the restoration of Byzantine rule in 1261 and ended with the empire's fall to the Ottoman Turks in 1453. Russia succeeded Constantinople as the "Third Rome" and the center of the Eastern Orthodox Church. Late Byzantine art continued to flourish into the eighteenth century in the Ukraine, Russia, and much of southeastern Europe.

The Golden Age of Justinian

During the fifth and sixth centuries, while invasions and religious controversy wracked the Italian peninsula, the Eastern Empire prospered. Byzantium became the "New Rome." The city of Constantine was called Constantinople (present-day Istanbul). Constantine had chosen the site of his new capital city well. The small Greek port of Byzantium lay at the crossroads of the overland trade routes between Asia and Europe and the sea route connecting the Black Sea and the Mediterranean.

In the sixth century, Byzantine political power, wealth, and culture reached its height under Emperor Justinian I and his wife, Theodora. Imperial forces held northern Africa, Sicily, much of Italy, and part of Spain. Ravenna became the Eastern empire's administrative capital in the West. Rome remained under nominal Byzantine control until the eighth century, and the pope remained head of the Western Church. But the pope rejected the Byzantine policy of *caesaropapism*, whereby the emperor was head of both church and state, and the pope was thereby required to pay homage to the powers in Constantinople. As Slavs and Bulgars moved into the Balkan peninsula in southeastern Europe, they too came under Constantinople's influence. Only on the frontier with the Persian Empire to the east did Byzantine armies falter, and there Justinian bought peace with tribute.

Control of land and sea routes between Europe and Asia made many people wealthy. The patronage of the affluent citizenry, as well as that of the imperial family, made the city an artistic center. Greek literature, science, and philosophy continued to be taught in its schools. Influences from the regions under the empire's control—Syria and Palestine—gradually combined to create a distinctive Byzantine culture.

CONSTANTINOPLE: THE WALLS. The secret of Byzantine success was its invulnerable capital. At the beginning of the fifth century, during the reign of Theodosius II, the Byzantines built a new defensive system consisting of a moat and double walls with huge towers (FIG. 7–24). The walls were about 4½ miles long along the city's only vulnerable stretch of land, and the defensive system about 180 feet deep.

An enemy approaching the city encountered a 60-foot stone-lined **moat** (a water-filled ditch), then a towered wall, a terrace, and finally the powerful inner wall, 36 feet high and

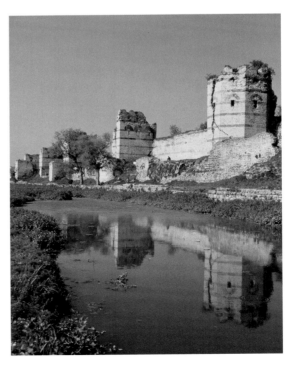

7–24 **LAND WALLS OF CONSTANTINOPLE**
Begun 412-13.
Photo: Josephine Powell, Rome

16 feet wide. The inner wall was high enough that defenders could shoot over the heads of those on the outer wall and even reach the moat with their missiles. The builders used both stone (for strength) and brick (for flexibility) in leveling and bonding the facing to a solid core of rubble and concrete. This masonry created stripes of different colors and textures, an effect that was used decoratively by later builders who copied the walls. Ninety-six huge towers, each an independent unit, defended the inner wall. Double towers flanked the few gateways into the city. For more than a thousand years—from 412–13 to 1453—the people of Constantinople lived secure behind their walls.

CONSTANTINOPLE: HAGIA SOPHIA. Justinian and Theodora embarked on a building and renovation campaign in Constantinople that overshadowed any in the city since the reign of Constantine two centuries earlier. Their massive undertaking would more than restore the city, half of which had been destroyed by rioters in 532. But little now remains of their architectural projects or of the old imperial capital itself.

A magnificent exception is the **CHURCH OF HAGIA SOPHIA**, meaning "Holy Wisdom" (**FIG. 7-25**). It replaced a fourth-century church destroyed when crowds, spurred on by Justinian's foes, set the old church on fire. The empress Theodora, a brilliant, politically shrewd woman, is said to have goaded Justinian to resist the rioters by saying "Purple makes a fine shroud"—meaning that she would rather die an empress (purple was the royal color) than flee for her life. Taking up her words as a battle cry, imperial forces crushed the rebels and restored order in 532.

To design a church that embodied imperial power and Christian glory, Justinian chose two scholar-theoreticians, Anthemius of Tralles and Isidorus of Miletus. Anthemius was a specialist in geometry and optics, and Isidorus a specialist in physics who had also studied vaulting. They developed a daring and magnificent design. And they had a trained and experienced work force to carry out their ideas. Builders had refined their masonry techniques building the towers and domed rooms within them that were part of the city's defenses. So when Justinian ordered the construction of domed churches, and especially Hagia Sophia, master masons with a trained and experienced work force stood ready to give permanent form to the architects' dreams.

The new Hagia Sophia was not constructed by the miraculous intervention of angels, as was rumored, but by mortal builders in only five years (532–37). The architects, engineers, and masons who built it benefited from the accumulated experience of a long tradition of great architecture. Procopius of Caesarea, who chronicled Justinian's reign, claimed poetically that Hagia Sophia's gigantic dome seemed to hang suspended on a "golden chain from Heaven." Legend has it that Justinian himself, aware that architecture can be a potent symbol of earthly power, compared his accomplish-

ment with that of the legendary builder of the First Temple in Jerusalem, saying "Solomon, I have outdone you."

Hagia Sophia is based on a central plan with a dome inscribed in a square (**FIG. 7-26**). To form a long nave for

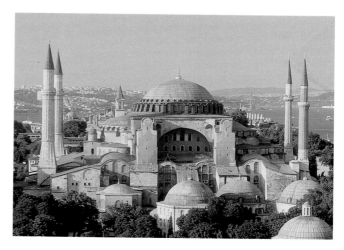

7-25 | **ANTHEMIUS OF TRALLES AND ISIDORUS OF MILETUS. CHURCH OF HAGIA SOPHIA**
Istanbul. 532–37. View from the southwest.

The body of the original church is now surrounded by later additions, including the minarets built after 1453 by the Ottoman Turks. Today the building is a museum.

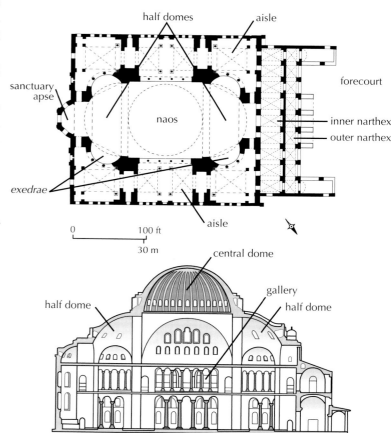

7-26 | **PLAN AND SECTION OF THE CHURCH OF HAGIA SOPHIA**

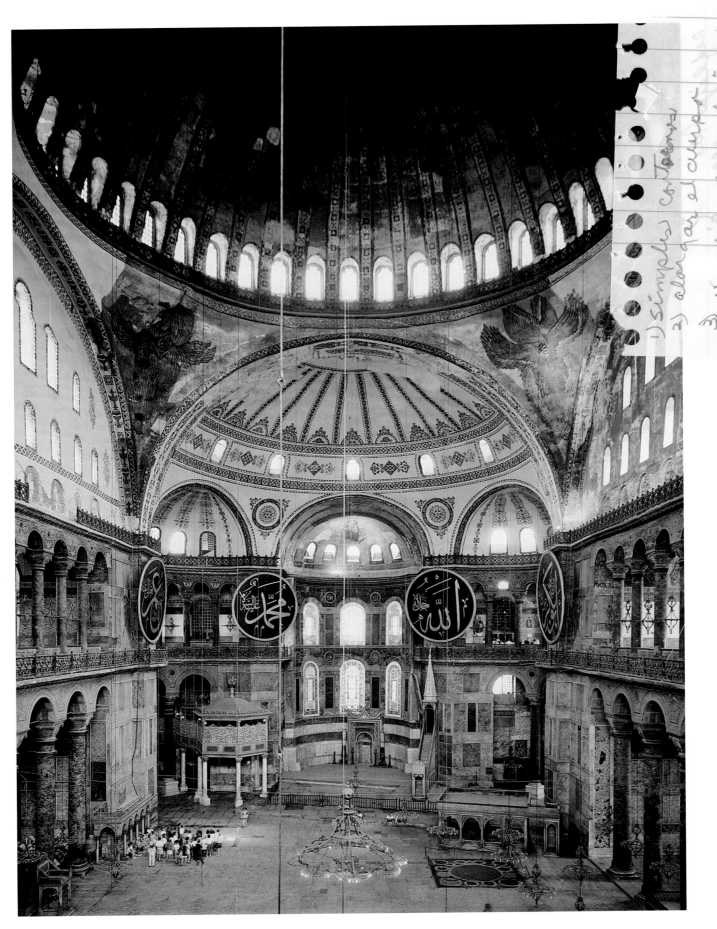

7–27 | **CHURCH OF HAGIA SOPHIA. INTERIOR**

Elements of Architecture
PENDENTIVES AND SQUINCHES

Pendentives and squinches are two methods of supporting a round dome or its drum over a square space. They convert the square formed by walls or arches into a circle. **Pendentives** are spherical triangles between arches that rise to form openings on which a dome rests (SEE FIG. 7–44). **Squinches** are lintels placed across the upper corner of the wall and supported by an arch or a series of corbeled arches that give it a nichelike or trumpet shape. Because squinches create an octagon, which is close in shape to a circle, they provide a solid base for a dome. A **drum** (a circular wall) may be inserted between the squinches and the dome or between the pendentives and the dome. Byzantine builders used both pendentives and squinches. Western Europeans and Muslims usually used squinches.

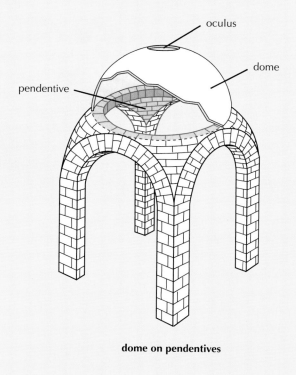

dome on pendentives

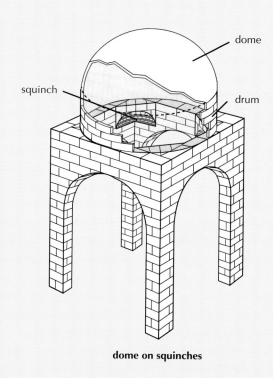

dome on squinches

processions, half domes expand outward from the central dome to connect with the narthex on one end and the half dome of the sanctuary apse on the other. Side aisles flank this central core, called the **naos** in Byzantine architecture; **galleries**, or stories open to and overlooking the naos, are located above the aisles. The main weight-bearing interior supports in the Hagia Sophia are the piers, which are pushed back into the darkness of the aisles. The massiveness of both piers and walls is minimized by covering them with mosaics and marble veneers. Exterior buttresses give additional support, invisible in the interior.

The main dome of Hagia Sophia is supported on **pendentives**, triangular curving vault sections built between the four huge arches that spring from piers at the corners of the dome's square base (see "Pendentives and Squinches," above). The Church of Hagia Sophia represents the earliest use of the dome on pendentives in a major building. Here two half domes flanking the main dome rise above **exedrae** with their own smaller half domes at the four corners of the nave.

Unlike the Pantheon's dome, which rises uninterrupted from the walls to an oculus at the top (SEE FIG. 6–53), Hagia Sophia's dome has a band of forty windows around its base. This daring concept challenged architectural logic by apparently weakening the masonry support, but it created the all-important circle of light that makes the dome appear to float (FIG. 7–27). The architects stretched the building materials to

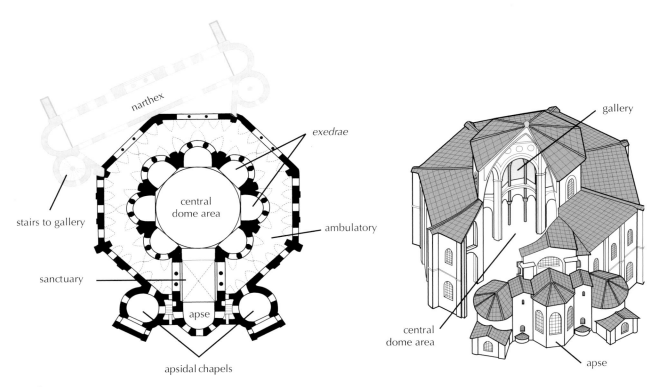

7–28 | **PLAN AND CUTAWAY DRAWING, CHURCH OF SAN VITALE**
Ravenna. Under construction from c. 520; consecrated 547; mosaics, c. 546–48.

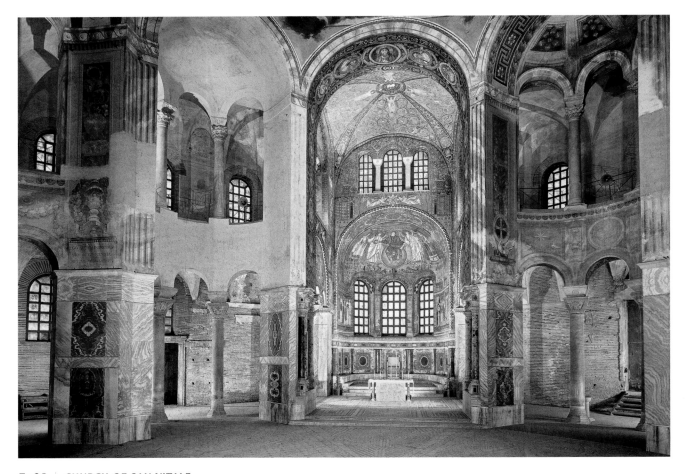

7–29 | **CHURCH OF SAN VITALE**
Ravenna. Interior view across the central space toward the sanctuary apse with mosaic showing Christ enthroned, flanked by Saint Vitalis and Bishop Ecclesius. Consecrated 547.

their physical limits, denying the physicality of the building in order to emphasize its spirituality. In fact, when the first dome fell in 558, it did so because a pier and pendentive shifted and because the dome was too shallow and exerted too much outward force at its base, not because of the windows. Confident of their revised technical methods, the architects designed a steeper dome that raised the summit 20 feet higher. They also added exterior buttressing. Although repairs had to be made in 869, 989, and 1346, the church has since withstood numerous earthquakes.

As in a basilica, worshipers moved along a central axis as they entered Hagia Sophia through a forecourt and outer and inner narthexes. Once through the portals, their gaze was drawn upward by the succession of curving spaces to the central dome and then forward to the distant sanctuary. The dome of the church provided a vast, golden, light-filled canopy high above a processional space for the many priests and members of the imperial court who assembled there to celebrate the Eucharist. With this inspired design, Anthemius and Isidorus had reconciled an inherent conflict in church architecture between the desire for a soaring heavenly space and the need to focus attention on the altar and the liturgy.

The liturgy used in Hagia Sophia in the sixth century has been lost, but it presumably resembled the rites described in detail for the church in the Middle Byzantine period. The celebration of the Mass took place behind a screen—at Hagia Sophia a crimson curtain embroidered in gold, in later churches an **iconostasis**, a wall hung with devotional paintings called **icons** (meaning "images" in Greek). The emperor was the only layperson permitted to enter the sanctuary; men stood in the aisles and women in the galleries. Processions of clergy moved in a circular path from the sanctuary into the nave and back five or six times during the ritual. The focus of the congregation was on the iconostasis and the dome rather than the altar and apse. This upward focus reflects the interest of Byzantine philosophers, who viewed meditation as a way to rise from the material world to a spiritual state. Worshipers standing on the church floor must have felt just such a spiritual uplift as they gazed at the mosaics of saints, angels, and, in the golden central dome, heaven itself.

RAVENNA: SAN VITALE. In 540, Byzantine forces captured Ravenna from the Arian Christian Ostrogoths who had taken it from the Romans in 476. Much of our knowledge of the art of this turbulent period comes from the well-preserved monuments at Ravenna.

In 526, Ecclesius, bishop of Ravenna, commissioned two new churches, one for the city and one for its port, Classis, as well as other churches and baptistries. Construction began on a central-plan church dedicated to the fourth-century Roman martyr Saint Vitalis (**FIG. 7–28**) in the 520s, but it was not finished until after Justinian had conquered Ravenna and established it as the administrative capital of Byzantine Italy.

The design of San Vitale is basically a central-domed octagon extended by exedralike semicircular bays, surrounded in turn by an ambulatory and gallery, all covered by vaults. A rectangular sanctuary and semicircular apse project from one of the sides of the octagon, and in typical Byzantine fashion circular rooms flank the apse. A separate oval narthex, set off-axis, joined church and palace and also led to cylindrical stair towers that gave access to the second-floor gallery. This sophisticated design has distant roots in Roman buildings such as Santa Costanza (SEE FIG. 7–16).

The floor plan of San Vitale only hints at the effect of the complex interior spaces of the church, an effect that was enhanced by the offset narthex, with its double sets of doors leading into the church. People entering from the right saw only arched openings, whereas those entering from the left approached on an axis with the sanctuary, which they saw straight ahead of them. Eight large piers frame the exedrae and the sanctuary. These two-story exedrae open through arches into the outer aisles on the ground floor and into galleries on the second floor. Squinches rather than pendentives support the dome.

The round dome, hidden on the exterior by an octagonal shell and a tile-covered roof, is a light, strong structure ingeniously created out of interlocking ceramic tubes mortared together. The interior is light and airy, a sensation reinforced by the liberal use of gold tesserae in the mosaic surface decoration. The structure seems to dissolve into shimmering light and color (**FIG. 7–29**).

In the half dome of the sanctuary apse, an image of Christ enthroned is flanked by Saint Vitalis and Bishop Ecclesius, who presents a model of the church to Christ (**FIG. 7–30**). The other sanctuary images relate to its use for the celebration of the Eucharist. Pairs of lambs flanking a cross decorate blocks above the intricately interlaced carving of the marble column capitals. The lunette on the south wall shows an altar table set with a chalice for wine and two patens, to which the high priest Melchizedek on the right brings an offering of bread, and Abel, on the left, carries a sacrificial lamb. Their identities are known from the inscriptions above their heads.

The prophets Isaiah (right) and Moses (left) appear in the spandrels. Moses is shown twice: The lower image depicts the moment when, while tending his sheep, he heard the voice of an angel of God coming from a bush that was burning with a fire that did not destroy it. Just above, Moses is shown reaching down to remove his shoes, a symbolic gesture of respect in the presence of God or on holy ground. In the gallery zone of the sanctuary the Four Evangelists are depicted, two on each wall, and in the vault the Lamb of God, supported by four angels, appears in a field of vine scrolls.

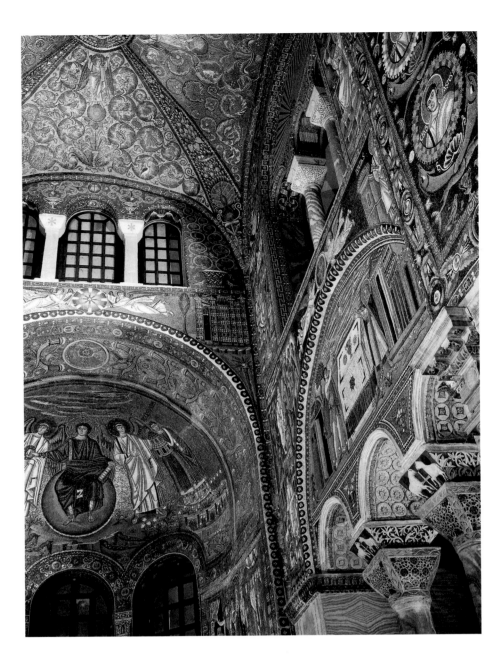

7–30 | **CHURCH OF SAN VITALE, SOUTH WALL OF THE SANCTUARY**
Abel and Melchizedek shown in the lunette (at right), and Christ enthroned, flanked by Saint Vitalis and Bishop Ecclesius in the half dome. Consecrated 547.

Justinian and Theodora did not attend the dedication ceremonies for the Church of San Vitale, conducted by Archbishop Maximianus in 547. They may never have set foot in Ravenna, but two large mosaic panels that face each other across its apse still stand in their stead. Justinian (FIG. 7–31), on the north wall, carries a large golden paten for the Host and stands next to Maximianus, who holds a golden, jewel-encrusted cross. The priestly celebrants at the right carry the Gospels, encased in a golden, jeweled book cover, symbolizing the coming of the Word, and a censer containing burning incense to purify the altar prior to the Mass.

On the south wall, Theodora, standing beneath a fluted shell canopy and singled out by a gold halolike disk and elaborate crown, carries a huge golden chalice studded with jewels (FIG. 7–32). She presents the chalice both as an offering for the Mass and as a gift of great value for Christ. With it she emulates the Magi (see "Iconography of the Life of Jesus," page 252), depicted in embroidery at the bottom of her purple cloak, who brought valuable gifts to the infant Jesus. A

courtyard fountain stands to the left of the panel and patterned draperies adorn the openings at left and right. Theodora's huge jeweled and pearl-hung crown nearly dwarfs her delicate features, yet the empress dominates these worldly trappings by the intensity of her gaze.

The mosaic decoration in the Church of San Vitale combines imperial ritual, Old Testament narrative, and Christian liturgical symbolism. The setting around Theodora—the implied shell form, the fluted pedestal, the open door, and the swagged draperies—are classical illusionistic devices, yet unlike the ancient Romans, the mosaicists deliberately avoid making them space-creating elements. Byzantine artists accepted the idea that objects exist in space, but they no longer conceived pictorial space the way Roman artists had, as a view of the natural world seen through a "window." In Byzantine art, invisible rays of sight joined eye and image so that pictorial space extended forward from the picture plane to the eye of the beholder and included the real space between them. Parallel lines

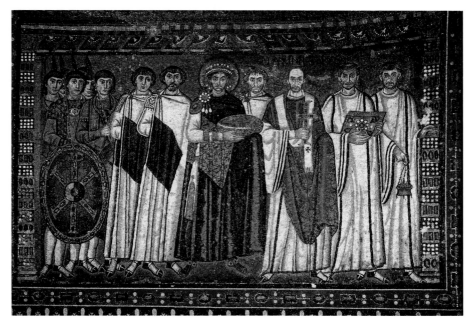

7–31 | **EMPEROR JUSTINIAN AND HIS ATTENDANTS, NORTH WALL OF THE APSE**
Church Of San Vitale. Consecrated 547. Mosaic, 8'8" × 12' (2.64 × 3.65 m).

As head of state, Justinian wears a huge jeweled crown and a purple cloak; as head of church, he carries a large golden paten to hold the Host, the symbolic body of Jesus Christ. The church officials at his left hold a jeweled cross and a Gospel book symbolizing Christ and his Church. Justinian's soldiers stand behind a shield decorated with the *chi rho*, the Greek letter monogram for "Christ." On the opposite wall, Empress Theodora, also dressed in royal purple, offers a golden chalice for the liturgical wine (SEE FIG. 7-32).

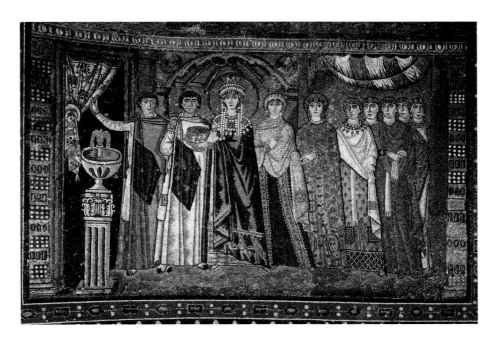

7–32 | **EMPRESS THEODORA AND HER ATTENDANTS, SOUTH WALL OF THE APSE**
Church Of San Vitale. Consecrated 547. Mosaic 8'8" × 12' (2.64 × 3.65 m).

The mosaic suggests the richness of Byzantine court costume. Both men and women dressed in layers, beginning with a linen or silk tunic, over which men wore another tunic and a long cloak fastened on the right shoulder with a *fibula* (brooch) and decorated with a rectangular panel (*tablion*). Women wore a second, fuller long-sleeved garment over their tunics. Over all their layers, women wore a large rectangular shawl, usually draped over the head. Justinian and Theodora wear imperial purple cloaks with gold-embroidered *tablions* held by *fibulae*. Embroidered in gold at the hem of Theodora's cloak is the scene of the Magi bringing gifts to Jesus. Her elaborate jewelry includes a wide collar of embroidered and jeweled cloth worn on the shoulders. A pearled crown, hung with long strands of pearls (thought to protect the wearer from diseases) frames her face. Theodora died not long after this mosaic was completed.

appear to diverge as they get farther away and objects seem to tip up in a representational system known as **reverse perspective**.

THE MOSAICS OF SANT'APOLLINAIRE IN CLASSE. At the same time he was building the Church of San Vitale, Bishop Ecclesius ordered a basilica-plan church in the port of Classis dedicated to Saint Apollinaris, the first bishop of Ravenna. As usual, the basilica's brick exterior gives no hint of the richness within. Nothing interferes visually with the movement forward from the entrance to the raised sanctuary (FIG. 7–33), which extends directly from a triumphal-arch opening into the semicircular apse.

The apse mosaic depicts the Transfiguration—Jesus's revelation of his divinity. An array of men and sheep stand in a

stylized landscape below a jeweled cross with the face of Christ at its center. The hand of God and the Old Testament figures Moses and Elijah appear in the heavens to legitimize the new religion and attest to the divinity of Christ. The apostles Peter, James, and John, who witness the event, are

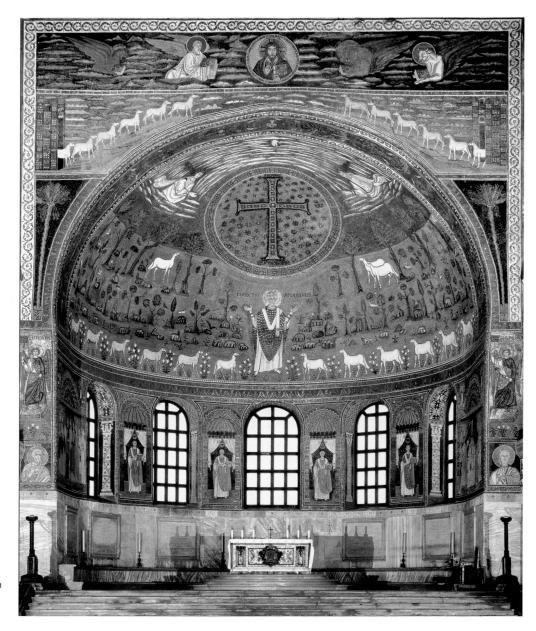

7–33 | THE TRANSFIGURATION OF CHRIST WITH SANT'APOLLINARE, FIRST BISHOP OF RAVENNA
Church of Sant'Apollinare in Classe. Consecrated 549. Mosaics: apse, 6th century; wall above apse, 7th and 9th centuries; side panels, 7th century.

represented here by the three sheep with raised heads. Below the cross, Bishop Apollinaris raises his hands in prayer and blessing, flanked by twelve lambs who represent the apostles. Stalks of blooming lilies, along with tiny trees and other plants, birds, and oddly shaped rocks, fill the green mountain landscape. Unlike the landscape in the Good Shepherd lunette of the Mausoleum of Galla Placidia (SEE FIG. 7–21), these highly stylized forms bear little resemblance to nature. The artists eliminated any suggestion of a naturalistic landscape by making the trees and lambs at the top of the golden sky larger than those at the bottom.

In the mosaics on the wall above the apse, which were added in the seventh and ninth centuries, Christ, now portrayed as a man with a cross inscribed in his halo and flanked by symbols representing the Four Evangelists, blesses and holds the Gospels. Sheep (the apostles) emerge from gateways and climb golden rocks toward their leader and teacher.

The formal character of the Transfiguration of Christ mosaic reflects an evolving approach to representation that began with imperial Roman art of the third century. As the character of imperial rule changed, the emperor became an increasingly remote figure surrounded by pomp and ceremony. In official art such as the Arch of Constantine (SEE FIG. 6–74), abstraction displaced the naturalism and idealism of the Greeks. The Roman interest in capturing the visual appearance of the material world gave way in Christian art to a new style that sought to express essential religious meaning rather than exact external appearance. Geometric simplification of forms, an expressionistic abstraction of figures, use of reverse perspective, and standardized conventions to portray individuals and events characterized the new style.

Objects of Veneration and Devotion

The court workshops of Constantinople excelled in the production of gold work, carved ivory, and textiles. The Byzantine elite also sponsored major **scriptoria** (writing rooms for **scribes**—professional document writers) for the production of **manuscripts** (handwritten books).

THE ARCHANGEL MICHAEL DIPTYCH. The commemorative ivory **diptych**—two carved panels hinged together—originated with Roman politicians elected to the post of consul. The new consuls sent notices of that event to friends and colleagues inscribed in wax on the inner sides of a pair of carved ivory panels. Christians adapted the practice for religious use, inscribing a diptych with the names of people to be remembered with prayers during Mass.

The panel depicting the archangel Michael was half of a diptych (FIG. 7–34). In his beauty, physical presence, and elegant setting, the archangel is comparable to the priestess of Bacchus in the Symmachus panel (SEE FIG. 6–79). His relation to the architectural space and the frame around him, how-

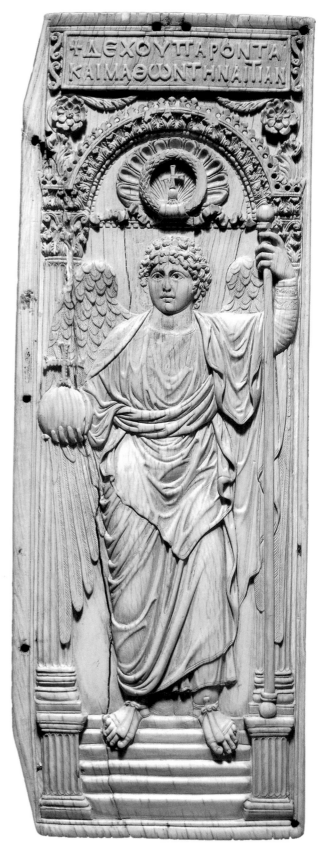

7–34 | **ARCHANGEL MICHAEL**
Panel of a diptych, probably from the court workshop at Constantinople. Early 6th century. Ivory, 17 × 15½" (43.3 × 14 cm). The British Museum, London.

7–35 | **REBECCA AT THE WELL**
Page from the Book of Genesis (known as *The Vienna Genesis*). Syria or Palestine. Early 6th century. Tempera, gold, and silver paint on purple-dyed vellum, 13½ × 9⅞″ (33.7 × 25 cm). Österreichische Nationalbibliothek, Vienna.

THE BOOK OF GENESIS. Byzantine manuscripts were often made with very costly materials. Sheets of purple-dyed **vellum** (a fine writing surface made from calfskin) and gold and silver inks were used in a book known as the **VIENNA GENESIS** (FIG. 7–35). It was probably made in Syria or Palestine, and the purple vellum indicates that it may have been done for an imperial patron (costly purple dye, made from the shells of murex mollusks, was usually restricted to imperial use). The *Vienna Genesis* is in **codex** form and is written in Greek (see "Early Forms of the Book," page 251). Illustrations appear below the text at the bottom of the pages.

The illustration of the story of Rebecca at the Well (Genesis 24) shown here appears to be a single scene, but it actually mimics the continuous narrative of a scroll. Events that take place at different times in the story follow in succession. Rebecca, the heroine of the story, appears at the left walking away from the walled city of Nahor with a large jug on her shoulder to fetch water. She walks along a miniature colonnaded road toward a spring, personified by a reclining pagan water nymph who holds a flowing jar. In the foreground, Rebecca, her jug now full, encounters a thirsty camel driver and offers him water to drink. The man is Abraham's servant, Eliezer, in search of a bride for Abraham's son Isaac. Her generosity leads to her marriage with Isaac. Although the realistic poses and rounded, full-bodied figures in this painting reflect an earlier Roman painting tradition, the unnatural purple of the background and the glittering metallic letters of the text remove the scene from the everyday world.

THE RABBULA GOSPELS. An illustrated Gospel book, signed by a monk named Rabbula and completed in February 586 at the Monastery of Saint John the Evangelist in Beth Zagba, Syria, illustrates a different approach to religious art. Church murals and mosaics may have inspired its illustrations, which are intended not only to depict biblical events, but also to present the Christian story through complex, multileveled symbolism.

A full-page illustration of the Crucifixion provides a detailed picture of Christ's death and the Resurrection (FIG. 7–36). He appears twice, on the cross in the center of the upper register and with the two Marys—the mother of James and Mary Magdalen—at the right in the lower register. In Byzantine art of this period Christ is a living king who triumphs over death. He is shown as a mature, bearded figure, not the youthful shepherd depicted in the catacombs (SEE FIG. 7–6). Even on the cross he is dressed in a long, purple robe that signifies his royal status. (In many Byzantine images he also wears a jeweled crown.)

At his sides are the repentant and unrepentant thieves who were crucified with him. Beside the thief at the left stand the Virgin and John the Evangelist; beside the thief at the right are the holy women. Beneath the cross soldiers

ever, has changed. His heels rest on the top step of a stair that clearly lies behind the columns and pedestals, but the rest of his body projects in front of them.

The angel is shown here as a divine messenger, holding a staff of authority in his left hand and a sphere symbolizing worldly power in his right, a message reinforced by repetition: Within the arch is a cross-topped orb, framed by a wreath, against the background of a scallop shell. This image floats in an indefinite space, unrelated to either the archangel or the message. The lost half of this diptych would have completed the Greek inscription across the top, which reads: "Receive these gifts, and having learned the cause . . ." Perhaps the other panel contained the portrait of the emperor or another high official who presented the panels as a gift to an important colleague, acquaintance, or family member.

7–36 | **THE CRUCIFIXION AND RESURRECTION**
Page from the *Rabbula Gospels*, from Beth Zagba, Syria. 586.
13½ × 10½″ (33.7 × 26.7 cm). Biblioteca Medicea Laurenziana,
Florence.

7–37 | **THE ASCENSION**
Page from the *Rabbula Gospels*, from Beth Zagba, Syria. 586.
13½ × 10½″ (33.7 × 26.7 cm). Biblioteca Medicea
Laurenziana, Florence.

throw dice for Jesus's clothes. A centurion stands on either side of the cross. One of them pierces Jesus's side with a lance; the other gives him vinegar to drink from a sponge. The small disks in the heavens represent the sun and moon.

In the lower register, directly under Jesus on the cross, stands his tomb, with its open door and stunned or sleeping guards. The angel reassures the holy women at the left, and Christ himself appears to them at the right. All these events (described in Matthew 28) take place in an otherworldly setting indicated by the glowing bands of color in the sky. The bare mountains behind the crosses give way to the lush foliage of the garden around the tomb.

Another page shows the Ascension of Christ into heaven (**FIG. 7–37**), which the New Testament describes this way: "[A]s they [his apostles] were looking on, he was lifted up, and a cloud took him from their sight" (Acts of the Apostles 1:9). But now the cloud has been transformed

into an almond-shaped area of light called a **mandorla** supported by two angels. Two other angels hold victory crowns in fringed cloths. The image directly under the mandorla combines fiery wheels and the four creatures seen by the Hebrew prophet Ezekiel in a vision (Ezekiel 1). Those four, which also appear in the Book of Revelation, are associated with the Four Evangelists: Matthew, an angel; Mark, a lion; Luke, an ox; and John, an eagle. Below this imagery, the Virgin Mary stands calmly in the pose of an orant, while angels at her side confront the astonished apostles. One angel gestures at the departing Christ and the other appears to be offering an explanation of the event to attentive listeners (Acts of the Apostles 1:10–11). The prominence accorded Mary here can be interpreted as a result of her status of Theotokos, God-bearer. She may also represent the Christian community on earth, that is, the Church.

Icons and Iconoclasm

Eastern Christians prayed to Christ, Mary, and the saints while looking at images of them on icons (from the Greek *eikon*, meaning "image") that were thought to have miraculous powers. The first miraculous image was believed to have been a portrait Jesus sent to King Abgar of Edessa and was known as the Mandylion. It was in Constantinople in the tenth century, and was taken to the West by Crusaders. Later it became identified with the scarf with which Saint Veronica wiped Christ's face as he carried the cross to the execution ground.

Church doctrine toward the veneration of icons was ambivalent. Christianity, like Judaism and Islam, has always been uneasy with the power of religious images. Key figures of the Eastern Church, such as Basil the Great of Cappadocia (c. 329–79) and John of Damascus (c. 675–749), distinguished between idolatry—the worship of images—and the veneration of an idea or holy person depicted in a work of art. The Eastern Church prohibited the worship of icons but accepted them as aids to meditation and prayer, as intermediaries between worshipers and the holy personages they depicted. They were often displayed in churches on a screen called the **iconostasis**.

Discomfort about the rituals associated with the icons grew into a major controversy in the Eastern Church, and in 726 Emperor Leo III launched a campaign of **iconoclasm** ("image breaking"). In the decades that followed, Iconoclasts undertook widespread destruction of devotional pictures. Those who defended these images were persecuted. Then in 843 Empress Theodora, widow of Theophilus, last of the iconoclastic emperors, reversed her husband's policy. But it was too late for much of the art: Most early icons were destroyed in the iconoclasm, making those that have survived especially precious.

A few very beautiful examples were preserved in the Monastery of Saint Catherine on Mount Sinai, among them the **VIRGIN AND CHILD WITH SAINTS AND ANGELS** (FIG. 7–38). As Theotokos, Mary was viewed as the powerful, ever-forgiving intercessor, appealing to her divine son for mercy on behalf of repentant worshipers. She was also called the Seat of Wisdom, and many images of the Virgin and Child, like this one, show her holding Jesus on her lap in a way that suggests that she represents the throne of Solomon. The Christian warrior-saints Theodore (left) and George (right)—both legendary figures said to have slain dragons, representing the triumph of the Church over the "evil serpent" of paganism—stand at each side. Angels behind them look heavenward. The Christ Child, the Virgin, and the angels were painted with a Roman-derived technique and are almost realistic. The male saints are much more stylized than the other figures; the richly patterned textiles of their cloaks barely hint at the bodies beneath.

Kievan Rus artists (see page 268) copied and recopied icons brought from Constantinople. The revered icon of Mary and Jesus known as the **VIRGIN OF VLADIMIR** (FIG. 7–39) was such a painting. This distinctively humanized image suggests the growing desire for a more immediate and personal religion. Paintings of this type, known as the Virgin of Compassion, show Mary and the Christ Child pressing their cheeks together and gazing tenderly at each other. It was widely believed that St. Luke was the first to paint such a portrait following a vision he had of the Nativity.

Almost from its creation (probably in Constantinople), the *Virgin of Vladimir* was thought to protect the people of the city where it resided. It arrived in Kiev sometime between

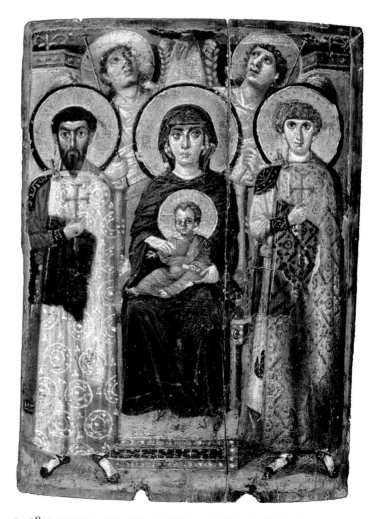

7–38 | **VIRGIN AND CHILD WITH SAINTS AND ANGELS**
Icon. Second half of the 6th century. Encaustic on wood, 27 × 18⅞" (69 × 48 cm). Monastery of Saint Catherine, Mount Sinai, Egypt.

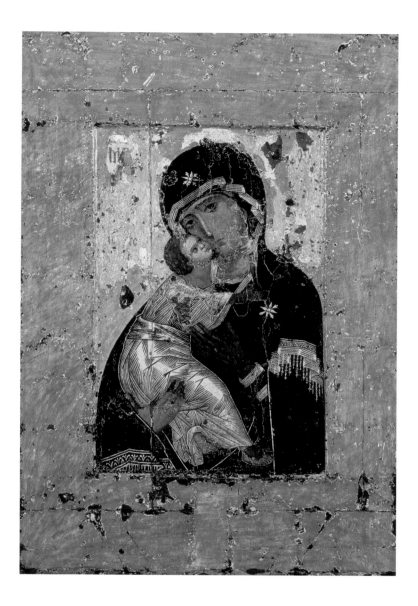

7–39 VIRGIN OF VLADIMIR
Icon, probably from Constantinople. Faces, 11th–12th century; the figures have been retouched. Tempera on panel, height approx. 31″ (78 cm). Tretyakov Gallery, Moscow.

1131 and 1136 and was taken to the city of Suzdal and then to Vladimir in 1155. In 1480 it was moved to the Cathedral of the Dormition in the Moscow Kremlin. Today, even in a museum, it inspires prayers.

MIDDLE BYZANTINE ART

The *Virgin of Vladimir* belongs to the period now called Middle Byzantine. Early Byzantine civilization had been centered in lands along the rim of the Mediterranean Sea that had been within the Roman Empire. During the Middle Byzantine period, Constantinople's scope was reduced to present-day Turkey and other areas by the Black Sea, as well as the Balkan peninsula, including Greece, and southern Italy. The influence of Byzantine culture also extended into Russia and Ukraine, and to Venice, Constantinople's trading partner in northeastern Italy, at the head of the Adriatic Sea.

Under the Macedonian dynasty (867–1056) initiated by Basil I, the empire prospered and enjoyed a cultural rebirth. Middle Byzantine art and architecture, visually powerful and stylistically coherent, reflect the strongly spiritual focus of the period's autocratic, wealthy leadership. From the mid-eleventh century, however, other powers entered Byzantine territory. The empire stabilized temporarily under the Comnenian dynasty (1081–1185), extending the Middle Byzantine period well into the time of the Western Middle Ages. Then, in 1204, Western Christian Crusaders seized and looted Constantinople.

Architecture and Mosaics

Comparatively few Middle Byzantine churches in Constantinople have survived intact, but many central-plan domed churches, favored by Byzantine architects, survive in

Ukraine, to the northeast, and in Sicily, to the southwest. These structures reveal the builders' taste for a multiplicity of geometric forms, verticality, and rich decorative effects both inside and out.

Kievan Rus: Santa Sophia in Kiev. Outside Constantinople, the rulers of Ukraine, Belarus, and Russia adopted Orthodox Christianity and Byzantine culture. These lands had been settled by Eastern Slavs in the fifth and sixth centuries, but later were ruled by Scandinavian Vikings who had sailed down the rivers from the Baltic to the Black Sea. In Constantinople, the Byzantine emperor hired the Vikings as his personal bodyguards. In the ninth century, Viking traders established a headquarters in the upper Volga region and in the city of Kiev, which became the capital of the area under their control, known as Kievan Rus.

The first Christian member of the Kievan ruling family was Princess Olga (c. 890–969), who was baptized in Constantinople by the patriarch himself, with the Byzantine emperor as her godfather. Her grandson Grand Prince

Vladimir (ruled 980–1015) established Orthodox Christianity as the state religion in 988. Vladimir sealed the pact with the Byzantines by accepting baptism and marrying Anna, the sister of the powerful Emperor Basil II (ruled 976–1025).

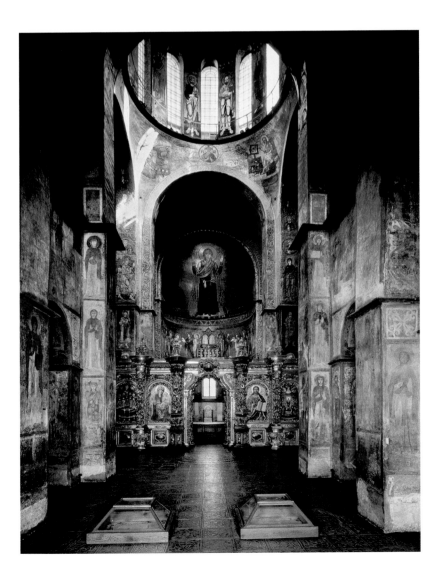

7–40 INTERIOR, CATHEDRAL OF SANTA SOPHIA
Kiev. 1037–46. Apse mosaic: *Orant Virgin and Communion of the Apostles.*

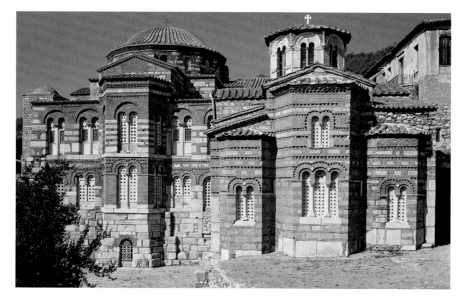

7–41 | MONASTERY CHURCHES AT HOSIOS LOUKAS
Greece (view from the east); Katholikon (left) early 11th century, and Church of the
Theotokos Cristy. Late 10th century.
Henri Stierlin, Geneva

Vladimir's son Grand Prince Yaroslav (ruled 1036–54) founded the Cathedral of Santa Sophia in Kiev. The church originally had a typical Byzantine multiple-domed cross design, but the building was expanded with double side aisles, leading to five apses. It culminated in a large central dome surrounded by twelve smaller domes. The small domes were said to represent the twelve apostles gathered around the central dome, representing Christ the Pantokrator, Ruler of the Universe. The central domed space of the crossing focuses attention on the nave and the main apse. Nonetheless, the many individual bays create an often confusing and compartmentalized interior.

The walls glow with lavish decoration: Mosaics glitter from the central dome, the apse, and the arches of the crossing. The remaining surfaces are painted with scenes from the lives of Christ, the Virgin, the apostles Peter and Paul, and the archangels.

The Kievan mosaics established a system of iconography that came to be followed in all Russian Orthodox churches. The Pantokrator fills the center of the dome (not visible above the window-pierced drum in FIG. 7–40). At a lower level, the apostles stand between the windows of the drum, with the Four Evangelists in the pendentives. The Virgin Mary, an orant, seems to float in a golden heaven, filling the half dome and upper wall of the apse. In the mosaic on the wall below the Virgin, Christ appears not once, but twice, to offer bread and wine. He celebrates Mass at an altar under a canopy, a theme known as the Communion of the Apostles. Accompanied by angels who act as deacons, he distributes communion to the apostles, six on each side of the altar. With this extravagant use of costly mosaic, Prince Yaroslav made a powerful political declaration about his own—and the Kievan church's—wealth and importance.

GREECE: HOSIOS LOUKAS. Although an outpost, Greece lay within the Byzantine Empire in the tenth and eleventh centuries and its architecture and art followed the trends toward multiplicity and intricacy seen in the capital. The **KATHO-LIKON OF THE MONASTERY OF HOSIOS LOUKAS**, built a few miles from the village of Stiris, Greece, in the eleventh century, is an excellent example of the architecture of the Middle Byzantine age. It stands next to the ear lier Church of the Theotokos (FIG. 7–41). The church has a compact central plan with a dome, supported by squinches, rising over an octagonal core (see "Basilica-Plan and Central-Plan Churches," page 242, and "Pendentives and Squinches," page 257). On the exterior, the rising forms of apses, walls, and roofs disguise the vaults of the interior.

Outside and in, the buildings revolve around a lofty, central, tile-covered dome on a tall drum. Alternating courses of brick and stone, seen in the defensive walls of Constantinople, bond the wall surface and create an intricate masonry pattern. The Greek builders added to the decorative effect by outlining the stones with bricks set both vertically and horizontally. Ornamental courses of bricks set diagonally form saw-toothed moldings that also enhance the decorative quality rather than the supporting function of the walls. Inside the churches, the high central space of the dome carries the eye

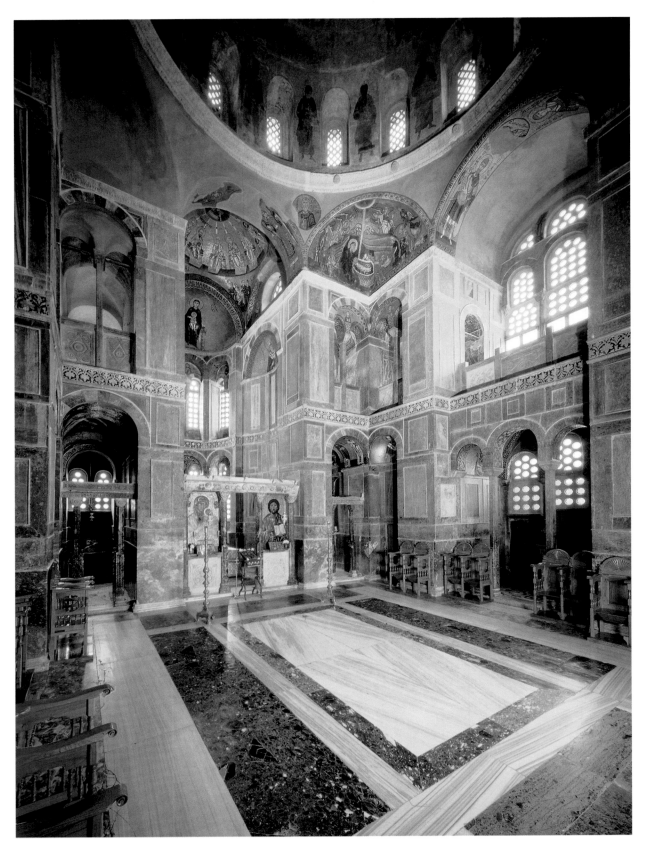

7–42 | **CENTRAL DOMED SPACE AND APSE (THE NAOS), KATHOLIKON**
Monastery of Hosios Loukas. Near Stiris, Greece. Early 11th century and later.

Visible are mosaics of the Virgin and Child Enthroned in the apse; apostles in the sanctuary dome; the Nativity and several standing saints in the vaults. The iconostasis held large paintings of the Virgin and Child (left) and Christ (right). The icons were stolen and have been replaced.

of the worshiper upward into the main dome, which soars above a ring of tall arched windows (FIG. 7–42).

Unlike Hagia Sophia, with its clear, sweeping geometric forms, the Katholikon has a complex variety of forms, including domes, groin vaults, barrel vaults, pendentives, and squinches, all built on a relatively small scale. The barrel vaults and tall sanctuary apse with flanking rooms further complicate the space. Single, double, and triple windows create intricate and unusual patterns of light, illuminating a painting (originally a mosaic) of *Christ Pantokrator* in the center of the main dome. The secondary, sanctuary dome of the Katholikon is decorated with a mosaic of the *Lamb of God* surrounded by the *Twelve Apostles*, and the apse half dome has a mosaic of the *Virgin and Child Enthroned*. Scenes from the Old and New Testaments and figures of saints fill the interior with brilliant color and dramatic images.

GREECE: MOSAICS OF THE CHURCH OF THE DORMITION AT DAPHNI. Eleventh-century mosaicists in Greece looked with renewed interest at models from the past. They conceived their compositions in terms of an intellectual rather than a physical ideal. While continuing to represent the human figure and narrative subjects, artists eliminated all details to focus on the essential elements of a scene to convey its mood and message.

The mosaics of the Church of the Dormition at Daphni, near Athens, provide an excellent example of this moving but elegant style. (Dormition, meaning "sleep," refers to Mary's bodily assumption into heaven.) The mosaic of the **CRUCIFIXION** (FIG. 7–43), like the *Virgin of Vladimir*, illustrates the emotional appeal to individuals in Middle Byzantine art: Jesus is shown with bowed head and sagging body, his eyes closed in death. Gone is the alert, living figure in a royal robe seen in the sixth-century *Rabbula Gospels* (SEE FIG. 7–36); now a nearly nude figure hangs on the cross. Also unlike the earlier scene, where a crowd reacts with anguish, indifference, or hostility, this image shows just two isolated mourning figures, Mary and the young apostle John, to whom Jesus had entrusted the care of his mother. The simplification of contours and the reduction of forms to essentials add to the emotional power of the image. The figures inhabit an otherworldly space, a golden universe anchored to the material world by a few flowers, which suggest the promise of new life.

This interpretation of the Crucifixion unites the Old and New Testaments. The mound of rocks and the skull at the bottom of the cross represent Golgotha, the "place of the skull," the hill outside ancient Jerusalem where Adam was thought to be buried and where the Crucifixion was said to have taken place. To the faithful, Jesus Christ was the new Adam sent by God to save humanity through his own sacrifice from the sins brought into the world by Adam and Eve. The arc of blood and water springing from Jesus's side refers to the rites of the

CRUCIFIXION
Church of the Dormition, Daphni, Greece. East wall of the north arm, Late 11th century. Mosaic.

Eucharist and the Baptism. As Paul wrote in his First Letter to the Corinthians: "For just as in Adam all die, so too in Christ shall all be brought to life" (1 Corinthians 15:22). The timelessness and simplicity of this image were meant to aid the Christian worshiper seeking to achieve a mystical union with the divine through prayer and meditation.

VENICE: THE CATHEDRAL OF SAINT MARK. The northeastern Italian city of Venice, set on the Adriatic at the crossroads of Europe and Asia Minor, was a major center of Byzantine art in Italy. Venice had been subject to Byzantine rule in the sixth and seventh centuries. Until the tenth century, the city's ruler, the *doge*, had to be ratified by the emperor. (*Doge* means "Duke" in the Venetian dialect.) At the end of the tenth century, when Constantinople granted Venice a special trade status that allowed its merchants to control much of the commerce between East and West, the city became very wealthy. Increased exposure to Eastern cultures is reflected in its art and architecture.

Venetian architects looked to the Byzantine domed church for inspiration in 1063, when the doge commissioned a church to replace the palace chapel, which had

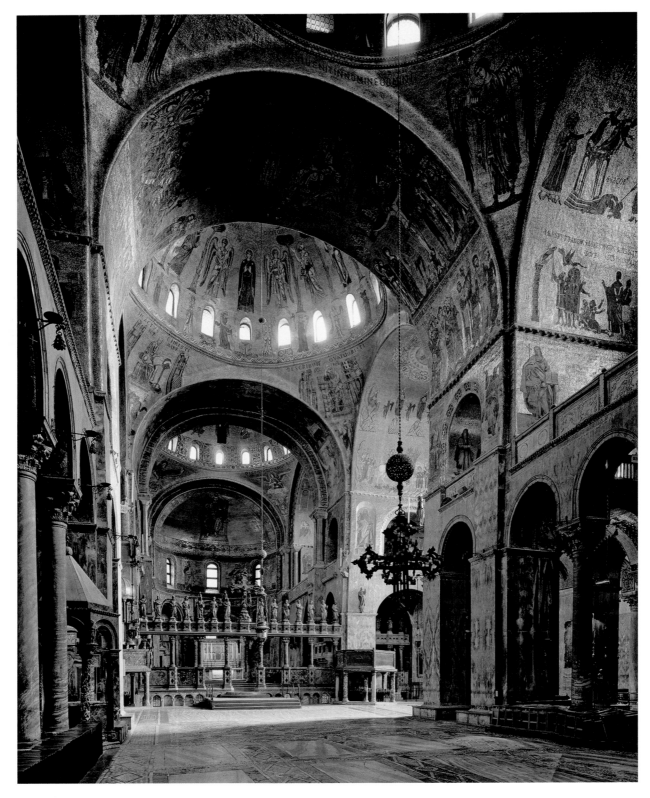

7–44 | **CATHEDRAL OF SAINT MARK**
Venice. Present building begun 1063. View looking toward apse.

This church is the third one built on the site. It was both the palace chapel of the doge and the burial place for the bones of the patron of Venice, Saint Mark. The church was consecrated as a cathedral in 1807. Mosaics have been reworked continually to the present day.

served since the ninth century to hold the relics of Saint Mark the Apostle. The relics had been brought to Venice from Alexandria in 828/29. The Cathedral of Saint Mark has a Greek-cross plan, each square unit of which is covered by a dome, that is, five great domes in all, separated by barrel vaults and supported by pendentives. (See "Multiple-Dome Church Plans," page 275). Unlike Hagia Sophia in Constantinople, where the space seems to flow from the narthex up into the dome and through the nave to the apse, Saint Mark's domed compartments produce a complex space in which each dome has its own separate vertical axis (FIG. 7–44). Marble veneer covers the lower walls, and golden mosaics glimmer above on the vaults, pendentives, and domes. The dome seen in FIGURE 7–44 depicts the Pentecost, the descent of the Holy Spirit on the apostles. A view of Saint Mark's as it would have appeared in premodern times can be seen in a painting by the fifteenth-century Venetian artist Giovanni Bellini (FIG. 19–14).

Objects of Veneration and Devotion

During the second Byzantine golden age, artists of great talent and high aesthetic sensibility produced small luxury items of a personal nature for members of the court as well as for the church. Many of these items were commissioned by rulers and secular and church functionaries as official gifts for one another. They had to be portable, sturdy, and exquisitely refined. In style these works tended to combine classical elements with iconic compositions, successfully joining simple beauty and religious meaning. Ivory carving, gold and enamel work, and fine books were especially prized.

THE HARBAVILLE TRIPTYCH. Dating from the mid-eleventh century, the small ivory devotional piece known as the **HARBAVILLE TRIPTYCH** represents Christ flanked by Mary and Saint John the Baptist, a group known as **THE DEËSIS** (FIG. 7–45). *Deesis* means "entreaty" in Greek, and here Mary and John intercede for the people, pleading with Christ for forgiveness and salvation. The Deesis was an important new theme in keeping with personalized religious art. Directly below Christ, Saint Peter stands gesturing toward him. Inscriptions identify Saints James, John, Paul, and Andrew. The figures in the outer panels are military saints and martyrs. All the figures exist in a neutral space given definition only by the small bases under their feet. Although conceived as essentially frontal and rigid, the figures have rounded shoulders, thighs, and knees that suggest physical substance beneath their linear, decorative drapery.

METALWORK. The refined taste and skillful work that characterize the arts of the tenth through twelfth centuries were also expressed in precious materials such as silver and gold. A silver-gilt and enamel icon of the archangel Michael was one of the prizes the Crusaders took back to Venice in 1204, after sacking Constantinople (see "The Archangel Michael," page 276). The icon was presumably made in the late tenth or early eleventh century in an imperial workshop. The archangel appears here in essentially the same frontal pose and with the same idealized and timeless youthfulness with which he was portrayed in a sixth-century ivory panel (SEE FIG. 7–34). His head and hands, executed in relief, are surrounded by intricate relief and enamel decoration. Halo, wings, and garments

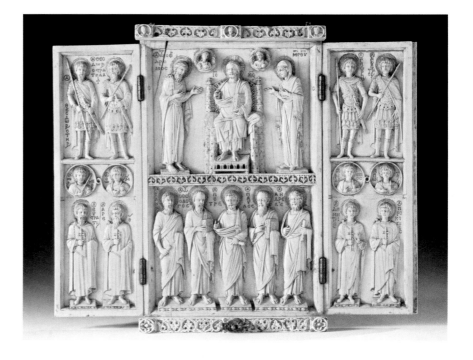

7–45 | **HARBAVILLE TRIPTYCH**
Mid-11th century. Ivory, closed 11 × 9½″ (28 × 24.1 cm); open 11 × 19″ (28 × 48.2 cm). Musée du Louvre, Paris.

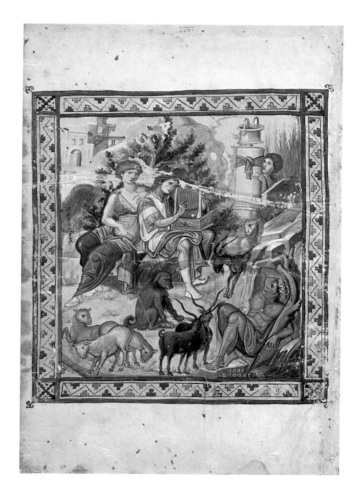

7–46 | **DAVID THE PSALMIST**
Page from the *Paris Psalter*. Second half of the 10th century. Paint and gold on vellum, sheet size 14 × 10½" (35.6 × 26 cm). Bibliothèque Nationale, Paris.

are in jewels, colored glass, and delicate **cloisonné**. (Cloisonné enamel is produced by soldering fine wires in the desired pattern to a metal plate and then filling the resulting spaces, the cells—the *cloisons*—with powdered colored glass. When the plate is heated, the glass powder melts and fuses onto the surface to create small, jewel-like sections.) The outer frame, added later, is inset with enamel roundels.

THE PARIS PSALTER. As was true of the artists who decorated church interiors, the illustrators of luxuriously illustrated manuscripts combined intense religious expression, aristocratic elegance, and a heightened appreciation of rich decoration.

The **PARIS PSALTER** from the second half of the tenth century was a luxurious production with fourteen full-page paintings (**FIG. 7–46**). About a third of the Old Testament was written in poetry, and among its most famous poems are those in the Book of Psalms. According to ancient tradition, the author of the Psalms was Israel's King David, who as a young shepherd and musician saved the people by killing the giant Goliath. In Christian times, the Psalms were copied into a book called a **psalter**, used for private reading and meditation. The words "psalm" and "psalter" refer to the song sung to the harp or to the action of playing a stringed instrument.

Like the earlier *Rabbula Gospels* (SEE FIGS. 7–36, 7–37), the *Paris Psalter* artist framed his scenes on pages without text. The first of the full-page illustrations depicts David seated in a land-

scape playing his harp. The massive, idealized figures occupy a spacious landscape filled with lush foliage, a meandering stream, and a distant city. The image seems to have been transported directly from an ancient Roman wall painting. The ribbon-tied memorial column is a convention in Greek and Roman funerary art, and in the ancient manner, the illustrator has personified abstract ideas and landscape features: Melody, a female figure, leans casually on David's shoulder, while another woman, perhaps the nymph Echo, peeks out from behind the column. The reclining youth in the lower foreground is a personification of Mount Bethlehem, as we learn from his inscription. The image of the dog watching over the sheep and goats while his master strums the harp suggests the classical subject of Orpheus charming wild animals with music. The subtle modeling of forms, the integration of the figures into a three-dimensional space, and the use of atmospheric perspective all enhance the classical flavor of the painting.

The Special Case of Sicily

A unique mixing of Byzantine, classical Greek and Roman, Muslim, and western Christian culture took place during this period on the island of Sicily. Sicily had been a Greek colony and then part of the Roman Empire. Muslims had ruled it from 827 to the end of the eleventh century, when it fell to the Normans, descendants of the Viking settlers of northern France. The Norman Roger II was crowned King of Sicily in

Elements of Architecture
MULTIPLE-DOME CHURCH PLANS

The construction of a huge single dome, such as Hagia Sophia's (SEE FIGS. 7–26, 7–27), presented almost insurmountable technical challenges. Byzantine architects found it more practical to cover large interior spaces with several domes. Justinian's architects devised the five-dome Greek-cross plan, which was copied in the West at Saint Mark's in Venice, (a) and see FIGURE 7–44. Middle Byzantine builders preferred smaller, more intricate spaces, and multiple-dome churches were very popular. The five domes of the Greek cross would often rise over a nine-bay square (b). The most favored plan was the **quincunx**, or cross-in-square, in which barrel vaults cover the arms of a Greek cross around a large central dome, with domes or groin vaults filling out the corners of a nine-bay space (c). Often the vaults and secondary domes are smaller than the central dome. Any of these arrangements can be made into an expanded quincunx (d) by additional domed aisles, as at the Cathedral of Saint Sophia in Kiev (SEE FIG. 7–40).

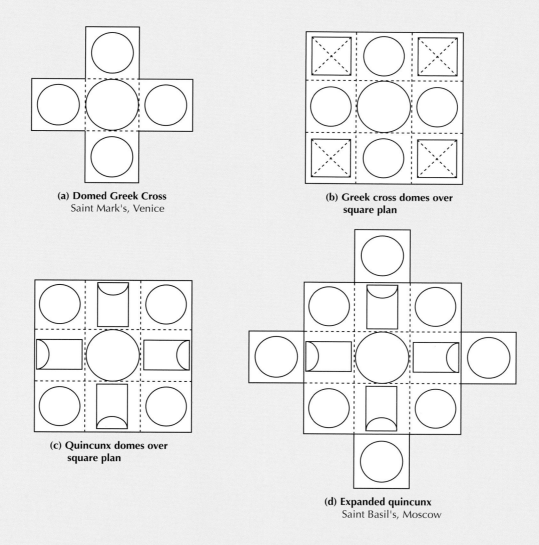

(a) Domed Greek Cross
Saint Mark's, Venice

(b) Greek cross domes over square plan

(c) Quincunx domes over square plan

(d) Expanded quincunx
Saint Basil's, Moscow

Palermo in 1130 and ruled until 1154. The pope, who assumed ecclesiastical jurisdiction over Sicily for "God and Saint Peter," was forced to endorse his rule while held captive. In the twelfth century, Sicily was one of the wealthiest and most enlightened kingdoms in Europe. Roger extended religious toleration to a diverse population, which included Western Europeans, Greeks, Arabs, and Jews. He involved all factions in his government, permitted everyone to participate equally in the kingdom's economy, and issued official documents in Latin, Greek, and Arabic.

THE ARCHANGEL MICHAEL

Icons speak to us today from computer screens—tiny images leading us from function to function in increasingly sophisticated hierarchies. Allusive images formed of light and color, these present-day icons—as with the religious icons (meaning "images" in Greek) that came before—speak to those who almost intuitively understand their suggestive form of communication.

The earliest icons had a mostly religious purpose—they were holy images that mediated between people and their God. Icons in the early Church were thought to be miracle workers, capable of defending petitioners from evil. One icon made more than a thousand years ago, possibly from the front and back covers of a book, depicts the archangel

Michael. The Protector of the Chosen, who defends his people from Satan and conducts their souls to God, Michael is mentioned in Jewish, Christian, and Islamic scriptures. On the front of this icon, Michael blesses petitioners with upraised hand; on the back is a relief in silver of the Cross, symbolizing Christ's victory over death.

When it was created, this icon would have spoken to believers of how archangels and angels mediate between God and humans—as when they announced Jesus's birth or mourned his death. They are not matter: They occupy no space, and their presence is felt, not seen. They are known intuitively, not by human reason.

Intuitive understanding is the core of Christian mysticism, according to the

sixth-century theologian Dionysus the Pseudo-Areopagite. As he explained, humans may, in stages, leave their sensory perception of the material world and rational thought and move to a mystical union with God. In icons, enamels, mosaics, and stained glass, artists tried to convey a sense of the divine with colored light. For them, matter becomes pure color and light as it becomes pure spirit. Believers thus would have interpreted the archangel Michael icon as an image formed by the golden light of heaven—it is his presence that is felt, not his body. When believers then and now behold icons like the archangel Michael, they intuit the image of the Heavenly Jerusalem.

7–43 | ARCHANGEL MICHAEL
Icon. Late 10th or early 11th century. Silver gilt with enamel, 19 × 14″ (48 × 36 cm). Treasury of the Cathedral of Saint Mark, Venice.

7–47 | **PALATINE CHAPEL**
Palermo, Sicily. Mid-12th century.
View toward the east.

A rich mixture of influences from East and West define art and architectural forms under his rule. He overtly emulated the culture of Byzantine empire, and his artistic patrimony offers a partial clue to the lost glory of imperial Constantinople in the twelfth century.

PALERMO: THE PALATINE CHAPEL. Roger's court in his capital of Palermo was a brilliant cultural mixture as reflected in the Palatine ("Palace") Chapel. The Western basilica-plan church has a Byzantine dome on squinches over the crossing, and an Islamic timber *muqarnas* ceiling in the nave. Its lower walls and floor are of inlaid marble, and the upper walls are decorated with mosaic. Christ holding an open book fills the half dome of the apse; a Christ Pantokrator surrounded by angels, the dome; the Annunciation, the arches of the crossing. The mosaics in the transept have scenes from the Gospels. The tall, well-proportioned figures are clothed in form-defining garments whose jagged, flying ends bear no relation to gravity. The artists often relied on strong juxtapositions of light and

dark areas instead of modeling forms with subtle tonal gradations. All these elements combine into a colorful, exotic whole (FIG. 7–47).

PALERMO: KING ROGER'S CHAMBER. A room in the Norman Palace at Palermo, made for William I (ruled 1154–66), known as King Roger's chamber, gives an idea of secular Byzantine art (FIG. 7–48). The floor, lower walls, and door frames have individual marble panels framed by strips inlaid with geometric patterns of colored stones. Mosaics cover the upper walls and vault. Against a continuous gold surface are two registers of highly stylized trees and paired lions, leopards, peacocks, centaurs, and hunters. The mosaics in the vault combine Islamic geometric patterns with very stylized vine scrolls and imperial symbols— lions, eagles, and griffons. The interior glistens with reflected light and color. The idea of a garden room, so popular in Roman houses, remains, but the artists have turned it into a stylized fantasy on nature—a world as formalized as the rituals that had come to dominate life in the imperial and royal courts.

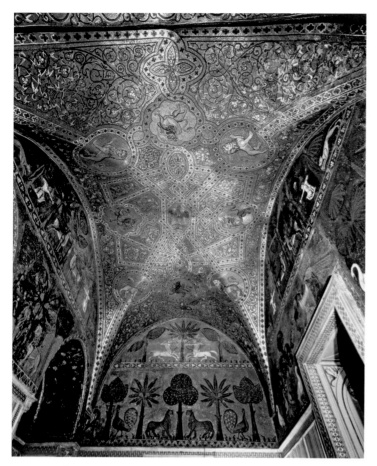

7–48 | **CHAMBER OF KING ROGER, NORMAN PALACE**
Palermo, Sicily. Mid-12th century.

The Palermo palace is especially important because the loss of buildings makes the study of Byzantine domestic architecture almost impossible. Byzantine palaces must have been spectacular. Descriptions of the imperial palace in Constantinople tell of extraordinarily rich marbles and mosaics, silk hangings, and golden furniture, including a throne surrounded by mechanical singing birds and roaring lions. Palaces and houses evidently followed the pattern established by the Romans—a series of rooms around open courts. The great palace of the Byzantine emperors may have resembled Hadrian's Villa, with different buildings for domestic and governmental functions set in gardens, which were walled off from the city.

LATE BYZANTINE ART

The third great age of Byzantine art began in 1261, after the Byzantines expelled the Christian Crusaders who had occupied Constantinople for nearly sixty years, and it lasted until the city fell to the Turks in 1453. Although the empire had been weakened and its realm decreased to small areas of the Balkans and Greece, its arts underwent a resurgence. The

patronage of emperors, wealthy courtiers, and the Church stimulated renewed church building. In this new work, the physical requirements of the clergy and the liturgy took precedence over costly interior decorations. Nevertheless, the buildings reflect excellent construction skills as well as elegant and refined design.

Constantinople

In Constantinople, many small, existing churches were expanded with new ambulatory aisles, narthexes, and side chapels. Among these is the former Church of the Monastery of Christ in Chora, now the Kariye Camii Museum in Istanbul. The expansion of this church was one of several projects that Theodore Metochites, a humanist poet and scientist, and the administrator of the Imperial Treasury at Constantinople, sponsored between c. 1316 and 1321. To its church he added a two-story annex on the north side, two narthexes on the west side, and a funerary chapel on the south side. These structures contain the most impressive interior decorations remaining in Constantinople from the Late Byzantine period.

The funerary chapel is entirely painted with themes appropriate to such a setting (FIG. 7–49). For example, the *Last Judgment* is painted on the vault of the nave, and the *Anastasis*, Christ's descent into limbo to rescue Adam, Eve, and other virtuous people from Satan, is depicted in the half dome of the apse. Large figures of the church fathers (a group of especially revered early Christian writers of the history and teachings of the Church), saints, and martyrs line the walls below. Sarcophagi, surmounted by portraits of the deceased, once stood in side niches. **Trompe l'oeil** ("fool the eye") painting simulates marble paneling in the dado.

In the **ANASTASIS** (FIG. 7–50), Christ appears as a savior in white, moving with a force that is captured by his star-studded mandorla. He has trampled down the doors of hell; tied Satan into a helpless bundle; and shattered locks, chains, and bolts, which lie scattered over the ground. He drags the elderly Adam and Eve from their open sarcophagi with such force that their bodies seem airborne. Behind him are Old Testament prophets and kings, as well as his cousin John the Baptist.

Moscow: The Third Rome

In the fifteenth and sixteenth centuries, architecture of the Late Byzantine style flourished outside the borders of the empire in regions that had adopted Eastern Orthodox Christianity. After Constantinople's fall to the Ottoman Turks in 1453, leadership of the Orthodox Church shifted to Russia, whose rulers declared Moscow to be the "Third Rome" and themselves the heirs of Caesar (the *czar*).

The practice of venerating icons continued in Russia. A remarkable icon from this time is **THE OLD TESTAMENT TRINITY (THREE ANGELS VISITING ABRAHAM)**, a large panel created sometime between 1410 and 1420 by the famed

artist-monk Andrey Rublyov (FIG. 7–51). It was commissioned in honor of the abbot Sergius of the Trinity-Sergius Monastery, near Moscow. This icon clearly illustrates how Late Byzantine artists relied on mathematical conventions to create ideal figures, as did the ancient Greeks. But unlike the Greeks, who based their formulas on close observation of nature, Byzantine artists invented an ideal geometry and depicted human forms and features accordingly.

Here, as is often the case, the circle forms the underlying geometric figure, emphasized by the form of the haloed heads. Despite the formulaic approach, talented artists like Rublyov managed to create a personal, expressive style. Rublyov relied on typical conventions—simple contours, elongation of the body, and a focus on a limited number of figures—to capture the sense of the spiritual in his work, yet distinguished his art by imbuing it with a sweet, poetic ambience. In this artist's hands, the Byzantine style took on new life.

The Byzantine tradition would continue in the art of the Eastern Orthodox Church and is carried on to this day in Greek and Russian icon painting. But in Constantinople, the three golden ages of Byzantine art—and the empire itself—came to an end in 1453. When the forces of the Ottoman sultan Mehmed II overran the capital, the Eastern Empire became part of the Islamic world, with its own very rich aesthetic heritage.

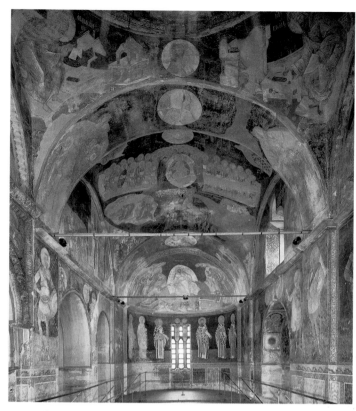

7–49 | **FUNERARY CHAPEL, CHURCH OF THE MONASTERY OF CHRIST**
In Chora, Constantinople. (Present-day Kariye Mazesi, Istanbul, Turkey.) c. 1310–21.

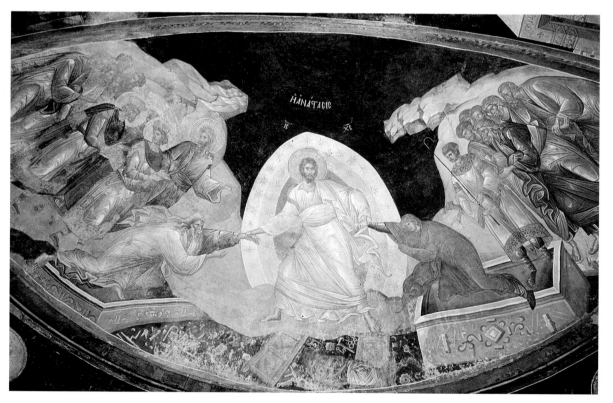

7–50 | **ANASTASIS**
Apse of the funerary chapel, Church of the Monastery of Christ in Chora. Painting.
Getty Research Library, Los Angeles. Wim Swaan Photograph Collection, 96.P.21

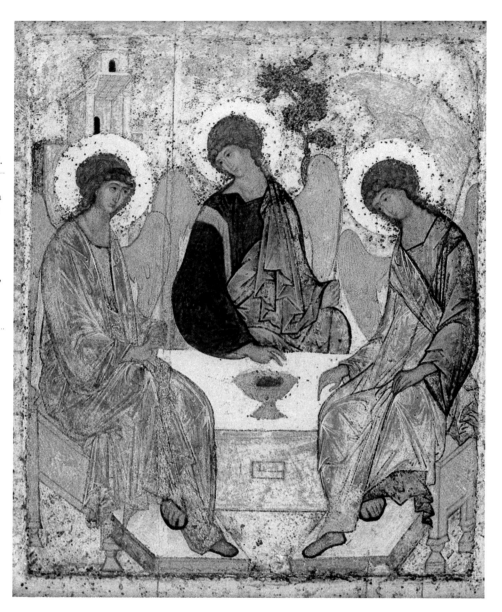

7–51 | Andrey Rublyov **THE OLD TESTAMENT TRINITY (THREE ANGELS VISITING ABRAHAM)**
Icon. c. 1410–25. Tempera on panel, 55½ × 44½″ (141 × 113 cm).

Representing the dogma of the Trinity—one God in three beings—was a great challenge to artists. One solution was to depict God as three identical individuals. Rublyov used that convention to illustrate the Old Testament story of the Hebrew patriarch Abraham and his wife, Sarah, who entertained three divine messengers in the guise of three strangers.

IN PERSPECTIVE

People in widely different times and places have sought answers to the fundamental questions of life and death, and in so doing they have tried to explain their relationship to a spiritual world. The arts reflect such searches for eternal truths. Artists appropriate, adapt, or reject earlier styles as they seek new modes of visual expression appropriate to their beliefs.

Jews, Christians, and Muslims believe in a single god. Jewish law, however, forbade the worship of idols—a prohibition that often made the representational arts suspect. Nevertheless, artists working for Jewish patrons depicted both symbolic and narrative Jewish subjects, and they looked to Near Eastern and classical Greek and Roman art for inspiration. Christians adopted the Jewish Scriptures as their Old Testament. Believing that God came to earth as a man in Jesus Christ, they created a powerful figurative art using human beings as expressive symbols. Early Christians were Romans, and their art and architecture were essentially Roman in style and technique.

Byzantine art—the art of the Orthodox Church—was centered in Constantinople (present-day Istanbul) and lasted for a thousand years. The Byzantine elite sponsored major scriptoria, or writing rooms, where scribes produced handwritten books, along with workshops for the production of ivory carvings and painted icons. Architects of the Byzantine era perfected churches in which glittering domes formed vast, light-filled canopies. Regardless of a building's appearance, the final product in each case is a reflection and an expression both of the spiritual beliefs and the worldly aspirations of the people who oversaw its construction and who gathered within its walls.

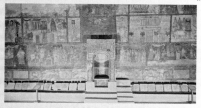

SYNAGOGUE DURA EUROPAS
244–45

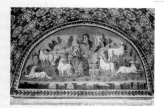

GOOD SHEPHERD MOSAIC
c. 425–6

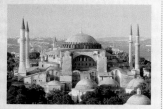

**ANTHEMIUS OF TRALLES
AND ISIDORUS OF MILETUS,
HAGIA SOPHIA**
532–37

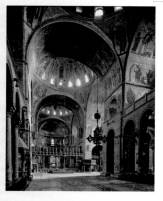

CATHEDRAL OF SAINT MARK
1063

OLD TESTAMENT TRINITY
c. 1410–25

100 BCE

100 CE

300

500

700

900

1500

JEWISH, EARLY CHRISTIAN AND BYZANTINE ART

◀ **Destruction of Jerusalem** 70 CE

◀ **Early Christian** 100–6th century CE

◀ **Imperial Christian** 313–476 CE
◀ **Council of Nicaea** 325 CE

◀ **Early Byzantine** c. 5th century–726 CE

◀ **End of Western
Roman Empire** 476 CE

◀ **Justinian Emperor** 527–65 CE

◀ **Iconoclastic Controversy** 726–843 CE

◀ **Middle Byzantine** 843–1204 CE

◀ **Russia Becomes Christian** 988 CE
◀ **Division of Christian Church into
Catholic and Orthodox** 1054 CE
◀ **Crusades Begin** 1095 CE
◀ **Western Rule of Constantinople**
1204–61 CE
◀ **Late Byzantine** 1261–1453 CE
◀ **Fall of Constantinople to
Turks** 1453 CE

281

8–1 | **THE KAABA, MECCA** The Kaaba represents the center of the Islamic world. Its cubical form is draped with a black textile that is embroidered with a few Qur'anic verses in gold.

ISLAMIC ART

In the desert outside of Mecca in 610 CE, an Arab merchant named al-Amin sought solitude in a cave. On that night, which Muslims call "The Night of Destiny," an angel appeared to al-Amin and commanded him to recite revelations from God (Allah). In that moment, al-Amin became Muhammad ("Messenger of God"). His revelations form the foundation of the religion called Islam ("submission to God's will"), whose adherents are Muslims ("those who have submitted to God"). For the rest of his life, Muhammad recited revelations in cadenced verses to his followers who committed them to memory. After his death, they transcribed the verses and organized them in chapters called *surahs*, thus compiling the holy book of Islam: the Qur'an ("Recitation").

The first person to accept Muhammad as God's Prophet was his wife, Khadija, followed soon thereafter by other family members. But many powerful Meccans were hostile to the message of the young visionary, and he and his companions were forced to flee in 622. Settling in an oasis town, later renamed Medina ("City"), Muhammad built a house that became a gathering place for the converted and thus the first Islamic mosque.

In 630, Muhammad returned to Mecca with an army of ten thousand, routed his enemies, and established the city

as the spiritual capital of Islam. After his triumph, he went to the Kaaba (FIG. 8–1), a cubical shrine said to have been built for God by the biblical patriarch Abraham and long the focus of pilgrimage and polytheistic worship. He emptied the shrine, repudiating its accumulated pagan idols, while preserving the enigmatic cubical structure itself and dedicating it to God.

The Kaaba is the symbolic center of the Islamic world, the place to which all Muslim prayer is directed and the ultimate destination of Islam's obligatory pilgrimage, the Hajj. Each year, huge numbers of Muslims from all over the world travel to Mecca to circumambulate the Kaaba during the month of pilgrimage. The exchange of ideas that occurs during the intermingling of these diverse groups of pilgrims has been a primary source of Islamic art's cultural eclecticism.

CHAPTER-AT-A-GLANCE

- **ISLAM AND EARLY ISLAMIC SOCIETY**
- **ART DURING THE EARLY CALIPHATES** | Architecture | Calligraphy | Ceramics and Textiles
- **LATER ISLAMIC ART** | Architecture | Portable Arts | Manuscripts and Painting
- **THE OTTOMAN EMPIRE** | Architecture | Illuminated Manuscripts and *Tugras*
- **THE MODERN ERA**
- **IN PERSPECTIVE**

ISLAM AND EARLY ISLAMIC SOCIETY

Seemingly out of nowhere, Islam arose in seventh-century Arabia, a land of desert oases with no cities of great size, sparsely inhabited by tribal nomads. Yet, under the leadership of its founder, the Prophet Muhammad (c. 570–632 CE), and his successors, Islam spread rapidly throughout northern Africa, southern and eastern Europe, and much of Asia, gaining territory and converts with astonishing speed. Because Islam encompassed geographical areas with a variety of long-established cultural traditions, and because it admitted diverse peoples among its converts, it absorbed and combined many different techniques and ideas about art and architecture. The result was a remarkable eclecticism and artistic sophistication.

Muslims date their history as beginning with the hijira ("emigration"), the flight of the Prophet Muhammad in 622 from Mecca to Medina. In less than a decade Muhammad had succeeded in uniting the warring clans of Arabia under the banner of Islam. Following his death in 632, four of his closest associates in turn assumed the title of caliph ("successor").

Muhammad's act of emptying the Kaaba of its pagan idols confirmed the fundamental concept of **aniconism** (avoidance of figural imagery) in Islamic art. Following his example, the Muslim faith discourages the representation of figures, particularly in religious contexts. Instead, Islamic artists elaborated a rich vocabulary of nonfigural ornament, including complex geometric designs and scrolling vines

sometimes known as **arabesques**. Islamic art revels in surface decoration, in manipulating line, color, and especially pattern, often highlighting the interplay of pure abstraction, organic form, and script.

According to tradition, the Qur'an assumed its final form during the time of the third caliph, Uthman (ruled 644–56). As the language of the Qur'an, the Arabic language and script have been a powerful unifying force within Islam. From the eighth through the eleventh centuries, Arabic was the universal language among scholars in the Islamic world and in some Christian lands as well. Inscriptions frequently ornament works of art, sometimes written clearly to provide a readable message, but in other cases written as complex patterns simply to delight the eye.

The accession of Ali as the fourth caliph (ruled 656–61) provoked a power struggle that led to his assassination and resulted in enduring divisions within Islam. Followers of Ali, known as Shi'ites (referring to the party or *shi'a* of Ali), regard him alone as the Prophet's rightful successor. Sunni Muslims, in contrast, recognize all of the first four caliphs as "rightly guided." Ali was succeeded by his rival Muawiya (ruled 661–80), a close relative of Uthman and the founder of the Umayyad dynasty (661–750).

Islam expanded dramatically. In just two decades, seemingly unstoppable Muslim armies conquered the Sasanian Persian Empire, Egypt, and the Byzantine provinces of Syria and Palestine. By the early eighth century, under the Umayyads, they had reached India, conquered northern

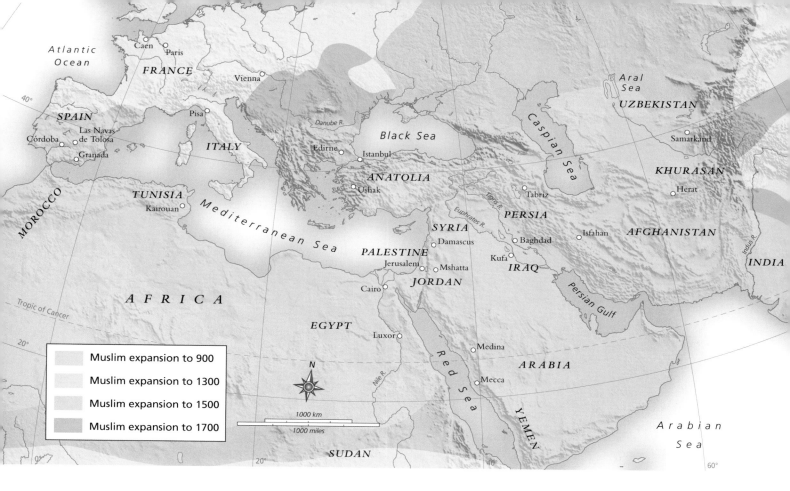

MAP 8–1 | **THE ISLAMIC WORLD**

Within 200 years after 622 CE, the Islamic world expanded from Mecca to India in the east, and to Morocco and Spain in the west.

Africa and Spain, and penetrated France to within 100 miles of Paris before being turned back (MAP 8–1). In these newly conquered lands, the treatment of Christians and Jews who did not convert to Islam was not consistent, but in general, as "People of the Book"—followers of a monotheistic religion based on a revealed scripture—they enjoyed a protected status. However, they were also subject to a special tax and restrictions on dress and employment.

Muslims participate in congregational worship at a **mosque** (*masjid*, "place of prostration"). The Prophet Muhammad himself lived simply and instructed his followers in prayer at a mud-brick house, now known as the Mosque of the Prophet, where he resided in Medina. This was a square enclosure that framed a large courtyard. Facing the courtyard along the east wall were small rooms where Muhammad and his family lived. Along the south wall, a thatched portico supported by palm-tree trunks sheltered both the faithful as they prayed and Muhammad as he spoke from a low platform. This simple arrangement inspired the design of later mosques.

Lacking an architectural focus such as an altar, nave, or dome, the space of this prototypical mosque reflected the founding spirit of Islam in which the faithful pray directly to God without the intermediary of a priesthood.

ART DURING THE EARLY CALIPHATES

The caliphs of the Umayyad dynasty (661–750), which ruled from Damascus in Syria, built mosques and palaces throughout the Islamic Empire. These buildings projected the authority of the new rulers and reflected the growing acceptance of Islam. In 750 the caliphs of the Abbasid dynasty replaced the Umayyads in a coup d'etat, ruling until 1258 in the grand manner of the ancient Persian emperors. Their capital was Baghdad in Iraq, and their art patronage reflected Persian and Turkic traditions. Their long and cosmopolitan reign saw achievements in medicine, mathematics, the natural sciences, philosophy, literature, music, and art. They were generally

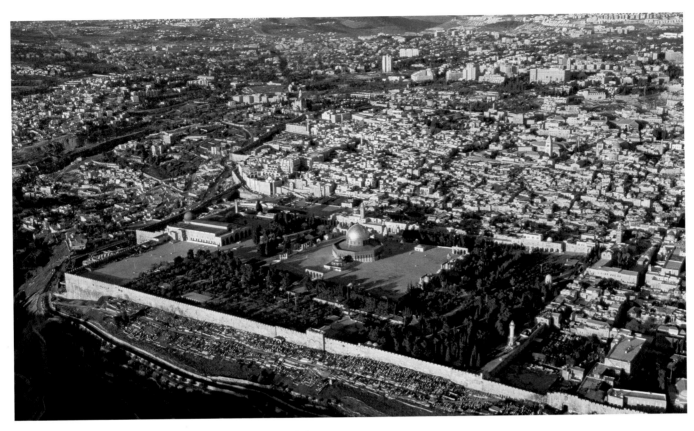

8–2 | **AERIAL VIEW OF HARAM AL-SHARIF, JERUSALEM**

The Dome of the Rock occupies a place of visual height and prominence in Jerusalem and, when first built,
strikingly emphasized the arrival of Islam and its community of adherents in that ancient city.

tolerant of the ethnically diverse populations in the territo-
ries they subjugated, and they admired the past achievements
of Roman civilization and the living traditions of Byzantium,
Persia, India, and China, freely borrowing artistic techniques
and styles from all of them.

Architecture

While Mecca and Medina remained the holiest Muslim cities,
under the Umayyad caliphs the political center moved away
from the Arabian peninsula to the Syrian city of Damascus.
Here, inspired by the Roman and Byzantine architecture of
the eastern Mediterranean, the Muslims became enthusiastic
builders of shrines, mosques, and palaces. The simple congre-
gational mosque with hypostyle columns eventually gave way
to new types, such as cruciform and centrally planned
mosques. Although tombs were officially discouraged in Islam,
they proliferated from the eleventh century onward, in part
due to funerary practices imported from the Turkic northeast,
and in part due to the rise of Shi'ism with its emphasis on
genealogy and particularly ancestry through Muhammad's
daughter, Fatima. The Umayyads launched the practice of
building both urban palaces and rural estates; under later
dynasties such as the Abbasids, the Spanish Umayyads, and

their successors, these were huge, sprawling complexes with
an urban infrastructure of mosques, bathhouses, reception
rooms, kitchens, barracks, gardens, and road networks.

THE DOME OF THE ROCK. The Dome of the Rock is the
first great monument of Islamic art. Built in Jerusalem, it is
the third most holy site in Islam. In the center of the city rises
the Haram al-Sharif ("Noble Sanctuary") (FIG. 8–2), a rocky
outcrop from which Muslims believe Muhammad ascended
to the presence of God on the "Night Journey" described in
the Qur'an. Jews and Christians variously associate the same
site with Solomon's Temple, the site of the creation of Adam,
and the place where the patriarch Abraham prepared to sacri-
fice his son Isaac at the command of God. In 691–2, the
Umayyads had completed the construction of a shrine over
the rock (FIGS. 8–3, 8–4) using Syrian artisans trained in the
Byzantine tradition. By appropriating a site holy to the Jew-
ish and Christian faiths, the Dome of the Rock is the first
architectural manifestation of Islam's view of itself as com-
pleting the prophecies of those faiths and superseding them.

Structurally, the Dome of the Rock imitates the centrally
planned form of Early Christian and Byzantine **martyria**.
However, unlike its models, with their plain exteriors, it is

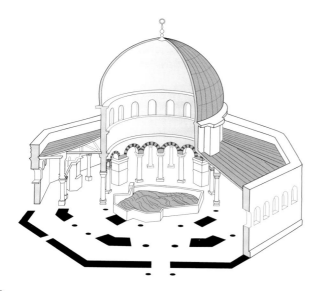

8–3 | CUTAWAY DRAWING OF THE DOME OF THE ROCK

arcades of alternating **piers** and **columns**, covers the central space containing the rock (FIG. 8–3). These arcades create concentric **aisles** (**ambulatories**) that permit devout visitors to circumambulate the rock. Inscriptions from the Qur'an interspersed with passages from other texts, including information about the building itself, form a **frieze** around the inner wall. As the pilgrim walks around the central space to read the inscriptions in brilliant gold mosaic on turquoise green ground, the building communicates both as a text and as a dazzling visual display. These passages of text are especially notable because they are the oldest surviving written Qur'an verses and the first use of monumental Qur'anic inscriptions in architecture. Below the frieze are walls covered with pale marble, the veining of which creates abstract symmetrical patterns, and columns with shafts of gray marble and gilded capitals. Above the calligraphic frieze is another mosaic frieze depicting thick, symmetrical vine scrolls and trees in turquoise, blue, and green, embellished with imitation jewels, over a gold ground. The mosaics are variously thought to represent the gardens of Paradise and trophies of Muslim victories offered to God. The decorative program is extraordinarily rich, but remarkably enough, the focus of the building is neither art nor architecture but the plain rock within it.

crowned with a golden dome that dominates the Jerusalem skyline, and it is decorated with opulent marble veneer and **mosaics** inside its exterior tiles. The dome, surmounting an octagonal **drum** pierced with windows and supported by

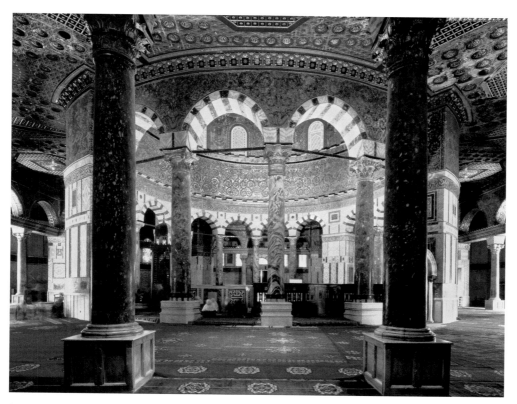

8–4 | DOME OF THE ROCK, JERUSALEM
691–2. Interior.

The arches of the inner and outer face of the central arcade are encrusted with golden mosaics.
The carpets and ceiling are modern but probably reflect the original patron's intention.

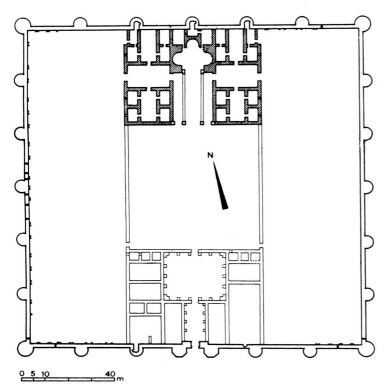

8–5 | **PLAN OF THE PALACE AT MSHATTA, JORDAN**
743-4.

MSHATTA PALACE. The Umayyad caliphs built profusely decorated palatial hunting retreats on the edge of the desert where local chieftains could be entertained and impressed. One such palace was built at Mshatta, near present-day Amman, Jordan (probably in 743–4). Although the east and west sides of Mshatta seem never to have been completed, this square, stone-walled complex is nevertheless impressively monumental (FIG. 8–5). It measured 472 feet on each side, and its outer walls and gates were guarded by towers and bastions reminiscent of a Roman fort. Inside, around a large central court, were a mosque, a domed audience hall, and private apartments.

Unique among surviving palaces, Mshatta was decorated with a frieze that extended in a band about 16 feet high across the base of its façade. This frieze was divided by a zigzag molding into triangular compartments, each punctuated by a large **rosette** carved in high relief (FIG. 8–6). The compartments were filled with intricate carvings in low relief that included interlacing scrolls inhabited by birds and other animals, urns, and candlesticks. Beneath one of the rosettes, two facing lions drink at an urn from which grows the Tree of Life, an ancient Persian motif. However, where the frieze runs across the outer wall of the mosque, to the right of the entrance, animal and bird imagery is conspicuously absent, in close observance of the strictures against icons.

THE GREAT MOSQUE OF KAIROUAN. Mosques provide a place for regular public worship. The characteristic elements of the **hypostyle** (multicolumned) mosque developed during the Umayyad period (see "Mosque Plans," right). The Great Mosque of Kairouan, Tunisia (FIG. 8–7), built in the ninth century, reflects the early form of the mosque but is elaborated with new additions. Its large rectangular plan is divided between a courtyard and a flat-roofed hypostyle prayer hall oriented toward Mecca. The system of repeated bays and aisles can easily be extended as the congregation grows in size—one of the hallmarks of the hypostyle plan. New is the huge tower (the **minaret**, from which the faithful are called to prayer) that rises from one end of the courtyard and that stands as a powerful sign of Islam's presence in the city.

The **qibla** wall, marked by a centrally positioned **mihrab** niche, is the wall of the prayer hall that is closest to Mecca. In the Great Mosque of Kairouan, the *qibla* wall is given heightened importance by a raised roof, a dome over the *mihrab*, and an aisle that marks the axis that extends from the *mihrab* to the minaret. The *mihrab* belongs to the tradition of niches that signify a holy place—the shrine for the Torah scrolls in a synagogue, the frame for the sculpture of a god or ancestor in Roman architecture, the apse in a church.

The **maqsura**, an enclosure in front of the *mihrab* for the

8–6 | **FRIEZE, DETAIL OF FAÇADE OF THE PALACE AT MSHATTA**
Stone. Staatliche Museen zu Berlin, Preussischer Kulturbesitz, Museum für Islamische Kunst.

Elements of Architecture
MOSQUE PLANS

Following the model of the Mosque of the Prophet in Medina, the earliest mosques were columnar **hypostyle halls**. The Great Mosque of Cordoba (SEE FIG. 8–8) was approached through an open courtyard, its interior divided by rows of columns leading, at the far end, to the *mihrab* niche of a *qibla* wall indicating the direction of Mecca.

A second type, the **four-*iwan* mosque**, such as the Masjid-i Jami at Isfahan, was developed in Iran. The *iwans*—huge barrel-vaulted halls with wide-open, arched entrances—faced each other across a central courtyard; the inner façade of this courtyard was thus given cross-axial emphasis, height, and greater monumentality (SEE FIG. 8–14).

Centrally planned mosques, such as the Sultan Selim Mosque at Edirne (SEE FIG. 8–27), were strongly influenced by Byzantine church plans, such as the Hagia Sophia (SEE FIG. 7–26) and are typical of the Ottoman architecture of Turkey. The interiors are dominated by a large domed space uninterrupted by structural supports. Worship is directed, as in other mosques, toward a *qibla* wall and *mihrab* opposite the entrance.

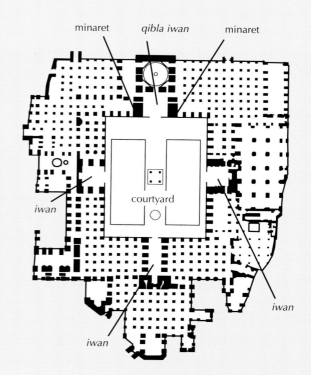

four-iwan mosque
Congregational Mosque, Isfahan

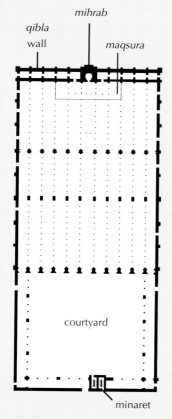

hypostyle mosque
Great Mosque, Cordoba,
after extension by
al-Hakam II

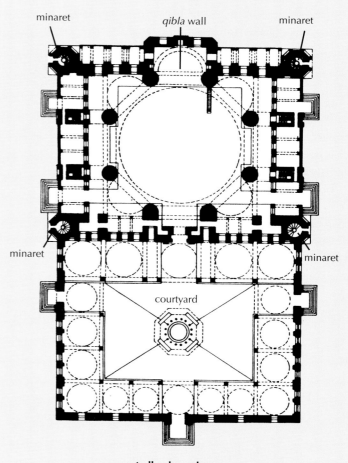

centrally-planned mosque
Sultan Selim Mosque, Edirne

(Plans are not to scale)

289

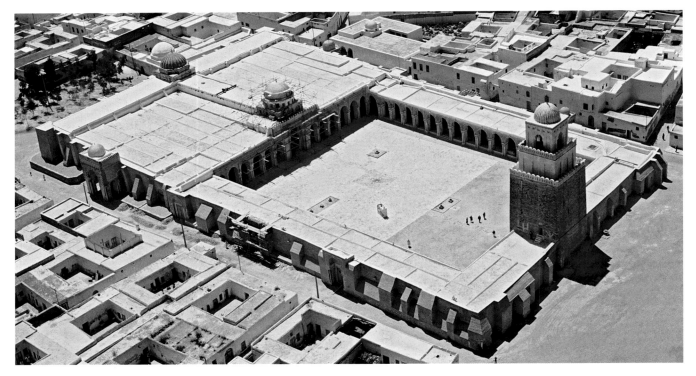

8–7 | **THE GREAT MOSQUE, KAIROUAN, TUNISIA**
836–75.

ruler and other dignitaries, became a feature of the principal congregational mosque after an assassination attempt on one of the Umayyad rulers. The **minbar**, or pulpit, stands by the *mihrab* as the place for the prayer leader and as a symbol of authority (for a fourteenth-century example of a *mihrab* and a *minbar*, SEE FIG. 8–16).

THE GREAT MOSQUE OF CORDOBA. When the Abbasids overthrew the Umayyads in 750, a survivor of the Umayyad dynasty, Abd al-Rahman I (ruled 756–88), fled across North Africa into southern Spain (known as *al-Andalus* in Arabic) where, with the support of Muslim settlers, he established himself as the provincial ruler, or *emir*. While the caliphs of the Abbasid dynasty ruled the eastern Islamic world from Baghdad for five centuries, the Umayyad dynasty ruled in Spain from their capital in Cordoba (756–1031). The Umayyads were noted patrons of the arts, and one of the finest surviving examples of Umayyad architecture is the Great Mosque of Cordoba (see "Mosque Plans," page 289).

In 785, the Umayyad conquerors began building the Cordoba mosque on the site of a Christian church built by the Visigoths, the pre-Islamic rulers of Spain. The choice of site was both practical—for the Muslims had already been borrowing space within the church—and symbolic, an appropriation of place (similar to the Dome of the Rock) that affirmed their presence. Later rulers expanded the building three times, and today the walls enclose an area of about 620 by 460 feet, about a third of which is the court-

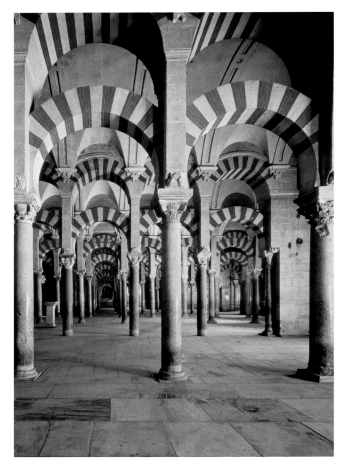

8–8 | **PRAYER HALL, GREAT MOSQUE, CORDOBA, SPAIN.**
Begun 785-86.

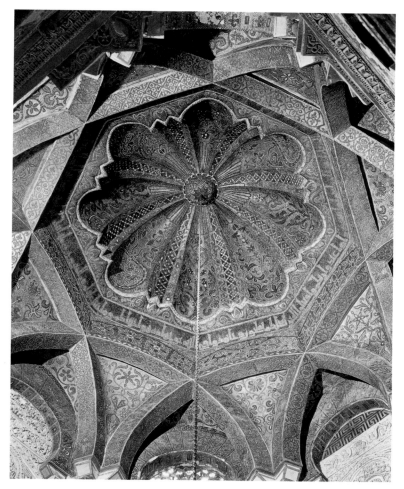

8–9 | **DOME IN FRONT OF THE *MIHRAB*, GREAT MOSQUE**
965.

yard. This patio was planted with fruit trees beginning in the early eighth century; today orange trees seasonally fill the space with color and scent. Inside, the proliferation of pattern in the repeated columns and double flying arches is colorful and dramatic. The marble columns and capitals in the hypostyle prayer hall were recycled from the Christian church that had formerly occupied the site, as well as from classical buildings in the region, which had been a wealthy Roman province. **FIG. 8–8** shows the mosque's interior with columns of slightly varying heights. Two tiers of arches, one over the other, surmount these columns; the upper tier springs from rectangular posts that rise from the columns. This double-tiered design effectively increases the height of the interior space and provides excellent air circulation as well as a sense of monumentality and awe. The distinctively shaped **horseshoe arches**—a form known from Roman times and favored by the Visigoths—came to be closely associated with Islamic architecture in the West (see "Arches and Muqarnas," page 292). Another distinctive feature of these arches, also adopted from Roman and Byzantine precedents, is the alternation of white stone and red brick **voussoirs** forming the curved arch.

In the final century of Umayyad rule, Cordoba emerged as a major commercial and intellectual hub and a flourishing center for the arts, surpassing Christian European cities economically and also in science, literature, and philosophy. As a sign of this new prestige and power, Abd al-Rahman III (ruled 912–61) boldly reclaimed the title of caliph in 929. He and his son al-Hakam II (ruled 961–76) made the Great Mosque a focus of patronage, commissioning costly and luxurious renovations such as a new *mihrab* with three bays in front of it. The melon-shaped, ribbed dome over the central bay seems to float upon a web of criss-crossing arches (**FIG. 8–9**). The complexity of the design, which differs from the geometric configuration of the domes to either side, reflects the Islamic interest in mathematics and geometry, not purely as abstract concepts but as sources for artistic inspiration. Lushly patterned mosaics with inscriptions, geometric motifs, and stylized vegetation clothe both this dome and the *mihrab* below in brilliant color and gold. These were installed by a Byzantine master who was sent by the emperor in Constantinople, bearing boxes of the small glazed ceramic and glass pieces (**tesserae**). Such artistic exchange is emblematic of the interconnectedness of the medieval Mediterranean—through trade, diplomacy, and competition.

Elements of Architecture
ARCHES AND MUQARNAS

Islamic builders explored structure in innovative ways. They explored the variations and possibilities of the horseshoe arch (SEE FIG. 8-8) (which had a very limited use before the advent of Islam) and the pointed arch (SEE FIG. 8-14). There are many variations of each, some of which disguise their structural function beneath complex decoration.

Unique to Islam, *muqarnas* are small nichelike component that is usually stacked and used in multiples as interlocking, successive, non-load-bearing, vaulting units. Over time they became increasingly intricate (and non-structural) so that they dazzled the eye and confused the rational mind (SEE FIG. 8-18). They are frequently used to fill the hoods of *mihrabs* and portals and, on a larger scale, to vault domes, softening or even masking the transition from the vertical plane to the horizontal.

horseshoe arch

pointed arch

muqarnas

Calligraphy

Muslim society holds **calligraphy** (the art of fine hand lettering) in high esteem. Since the Qur'an is believed to reveal the word of God, its words must be written accurately, with devotion and embellishment. Writing was not limited to books and documents but was displayed on the walls of buildings, on metalwork, textiles, and ceramics. Since pictorial imagery developed relatively late in Islamic art (and there was no figural imagery at all in the religious context), inscription became the principal vehicle for visual communication. The written word thus played two roles: It could convey verbal information about a building or object, describing its beauty or naming its patron, while also delighting the eye in an entirely aesthetic sense. Arabic script is written from right to left, and each letter usually takes one of three forms depending on its position in a word. With its rhythmic interplay between verticals and horizontals, the system lends itself to many variations. Formal **Kufic** script (after Kufa, a city in Iraq) is blocky and angular, with strong upright strokes and long horizontals. It may have developed first for carved or woven inscriptions where clarity and practicality of execution were important.

Most early Qur'ans had large Kufic letters and only three to five lines per page, which had a horizontal orientation. The visual clarity was necessary because one book was often shared by multiple readers simultaneously. A page from a ninth-century Syrian Qur'an exemplifies the style common from the eighth to the tenth century (**FIG. 8–10**). Red diacritical marks (pronunciation guides) accent the dark brown ink; the *surah* ("chapter") title is embedded in the burnished ornament at the bottom of the sheet. Instead of page numbers, the brilliant gold of the framed words and the knoblike projection in the left-hand margin are a distinctive means of marking chapter breaks.

Calligraphers enjoyed the highest status of all artists in Islamic society. Included in their numbers were a few princes and women. Apprentice scribes had to learn secret formulas for inks and paints; become skilled in the proper ways to sit, breathe, and manipulate their tools; and develop their individual specialties. They also had to absorb the complex literary traditions and number symbolism that had developed in Islamic culture. Their training was long and arduous, but unlike other craft practitioners who were generally anonymous in the early centuries of Islam, outstanding calligraphers received public recognition.

By the tenth century, more than twenty cursive scripts had come into use. They were standardized by Ibn Muqla (d. 940), an Abbasid official who fixed the proportions of the letters in each and devised a method for teaching the calligraphy that is still in use today. The Qur'an was usually written on **parchment** (treated animal skin) and **vellum** (calfskin or a fine parchment). Paper was first manufactured in Central Asia during the mid-eighth century, having been

8–10 | **PAGE FROM THE QUR'AN**
(Surah II: 286 and title Surah III) in
Kufic script, from Syria, 9th century.
Black ink pigments, and gold on vellum,
8⅜ × 11⅛″ (21.8 × 29.2 cm).
The Metropolitan Museum of Art,
New York.
Rogers Fund, 1937 (37.99.2)

8–11 | **ARABIC MANUSCRIPT PAGE**
Attributed to Galinus. Iraq. 1199.
Headings are in ornamental Kufic
script with a background of scrolling
vines, while the text—a medical trea-
tise—is written horizontally and verti-
cally in Naskhi script.
Bibliothèque Nationale, Paris.

introduced earlier by Buddhist monks. Muslims learned
how to make high-quality, rag-based paper, eventually
establishing their own paper mills. By about 1000, paper
had largely replaced the more costly parchment, encourag-
ing the proliferation of increasingly elaborate and decora-
tive cursive scripts, which generally superseded Kufic by

the thirteenth century. Of the major styles, one extraordi-
narily beautiful form, known as *naskhi,* was said to have
been revealed and taught to scribes in a vision. Even those
who cannot read Arabic can enjoy the flowing beauty of its
lines, which are often interlaced with swirling vine scrolls
(FIG. 8–11).

Ceramics and Textiles

On objects made of ceramics, ivory, and metal, as well as textiles, calligraphy was prominently displayed. It was the only decoration on a type of white pottery made in the ninth and tenth centuries in and around the region of Khurasan (also known as Nishapur, in present-day northeastern Iran) and Samarkand (in present-day Uzbekistan). Now known as Samarkand ware, these elegant pieces are characterized by the use of a clear lead glaze applied over a black inscription on a white slip-painted ground. In FIG. 8–12 the script's horizontals and verticals have been elongated to fill the bowl's rim. The inscription translates: "Knowledge: the beginning of it is bitter to taste, but the end is sweeter than honey," an apt choice for tableware and appealing to an educated patron. Inscriptions on Samarkand ware provide a storehouse of such popular sayings.

A Kufic inscription appears on a tenth-century piece of silk from Khurasan (FIG. 8–13): "Glory and happiness to the Commander Abu Mansur Bukhtakin. May God prolong his prosperity." Such good wishes were common in Islamic art, appearing as generic blessings on ordinary goods sold in the marketplace or, as here, personalized for the patron. Texts can sometimes help determine where and when a work was made, but they can also be frustratingly uninformative when little is known about the patron, and they are not always truthful. Stylistic comparisons—in this case with other textiles, with the way similar subjects appear in other mediums, and with other Kufic inscriptions—sometimes reveal more than the inscription alone.

This silk must have been brought from the Near East to France by knights at the time of the First Crusade. Known as the Shroud of Saint Josse, the silk was preserved in the Church of Saint-Josse-sur-Mer, near Caen in Normandy. Textiles were an actively traded commodity in the medieval Mediterranean region and formed a significant portion of dowries and inheritances. Because of this, textiles were an important means of disseminating artistic styles and techniques. This fragment shows two elephants with rich ornamental coverings facing each other on a dark red ground, each with a mythical griffin between its feet. A caravan of two-humped Bactrian camels linked with rope moves up the left side, part of the elaborately patterned borders. The inscription at the bottom is upside-down, suggesting that the missing portion of the textile was a fragment from a larger and more complex composition. The weavers used a complicated loom to produce repeated patterns. The technique and design derive from the sumptuous pattern-woven silks of Sasanian Iran (Persia). The Persian weavers had, in turn, adapted Chinese silk technology to the Sasanian taste for paired heraldic beasts and other Near Eastern imagery. This tradition, with modifications—the depiction of animals, for example, became less naturalistic—continued after the Islamic conquest of Iran.

LATER ISLAMIC ART

The Abbasid caliphate began a slow disintegration in the ninth century, and thereafter power in the Islamic world became fragmented among more or less independent regional rulers. During the eleventh century, the Saljuqs, a Turkic people, swept from north of the Caspian Sea into Khurasan and took Baghdad in 1055, becoming the virtual rulers of the Abbasid Empire. The Saljuqs united most of Iran and Iraq, establishing a dynasty that endured from 1037/38 to 1194. A branch of the dynasty, the Saljuqs of Rum, ruled much of Anatolia (Turkey) from the late eleventh to the beginning of the fourteenth century. The Islamic world suffered a dramatic rift in the early thirteenth century when the nomadic Mongols—non-Muslims led by Genghiz Khan (ruled 1206–27) and his successors—attacked northern China, Central Asia, and ultimately Iran. The Mongols captured Baghdad in 1258 and encountered weak resistance until they reached Egypt. There, the young Mamluk dynasty (1250–1517), founded by descendants of slave soldiers (*mamluk* means "slave"), firmly defeated the Mongols. In Spain, the borders of Islamic territory were gradually pushed back by Christian forces and Muslim rule ended altogether in 1492.

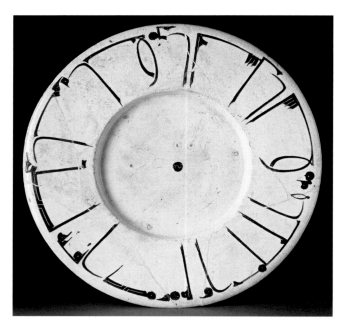

8–12 | BOWL WITH KUFIC BORDER
Samarkand, Uzbekistan. 9th–10th century. Earthenware with slip, pigment, and lead glaze, diameter 14½" (37 cm).
Musée du Louvre, Paris.

The white ground of this piece imitated prized Chinese porcelains made of fine white kaolin clay. Both Samarkand and Khurasan were connected to the Silk Road, the great caravan route to China (Chapter 10), and were influenced by Chinese culture.

8–13 | TEXTILE WITH ELEPHANTS AND CAMELS
Known today as the Shroud of Saint Josse, from Khurasan or Central Asia. Before 961. Dyed silk, largest fragment
20½ × 37″ (94 × 52 cm). Musée du Louvre, Paris.

Silk textiles were both sought-after luxury items and a medium of economic exchange. Government-controlled factories, known as *tiraz*, produced cloth for the court as well as for official gifts and payments. A number of fine Islamic fabrics have been preserved in the treasuries of medieval European churches, where they were used for priests' ceremonial robes, altar cloths, and to wrap the relics of Christian saints.

Although the religion of Islam remained a dominant and unifying force throughout these developments, the history of later Islamic society and culture reflects largely regional phenomena. Only a few works have been selected here and in Chapter 23 to characterize the art of Islam, and they by no means provide a comprehensive history of Islamic art.

Architecture

The Saljuq Dynasty and its successors built on a grand scale, expanding their patronage from mosques and palaces to include new functional buildings, such as tombs, **madrasas** (colleges for religious and legal studies), public fountains, urban hostels, and remote caravanserais (inns) for traveling merchants in order to encourage long-distance trade. They developed a new mosque plan organized around a central courtyard framed by four large *iwans* (large vaulted halls with rectangular plans and monumental arched openings); this four-*iwan* plan was already being used for schools and palaces.

Furthermore, they amplified the social role of architecture so that multiple building types were combined in large and diverse complexes, supported by perpetual endowments that funded not only the building, but its administration and maintenance. Increasingly, these complexes included the patron's own tomb, thus giving visual prominence to the act of individual patronage and the expression of personal identity.

THE GREAT MOSQUE OF ISFAHAN. The Masjid-i Jami ("Congregational mosque") of Isfahan (the Saljuq capital in Iran) was modified in this period from its original form as a simple hypostyle mosque to a more complex plan. Specifically, two great brick domes were added in the late eleventh century, one of them marking the *mihrab*, and in the twelfth century the mosque was reconfigured as a four-*iwan* plan. The massive *qibla iwan* on the southwest side is a twelfth-century structure to which a vault filled with **muqarnas** (stacked niches) was added in the fourteenth-century (see "Arches and Muqarnas," page 292). Its twin minarets and the façade of brilliant blue, glazed tile that wraps around the entire

THE ◉BJECT SPEAKS

A MAMLUK GLASS OIL LAMP

Made of ordinary sand and ash, glass is the most ethereal of materials. The Egyptians produced the first glassware during the second millennium BCE, yet the tools and techniques for making it have changed little since then. During the thirteenth and fourteenth centuries CE, glassmakers in Syria, Egypt, and Italy derived a new elegant thinness through blowing and molding techniques. Mamluk glassmakers especially excelled in the application of enameled surface decoration in gold and various colors.

This mosque lamp was suspended from chains attached to its handles, although it could also stand on its high footed base. Exquisite glass was also used for beakers and vases, but lamps, lit from within by oil and wick, must have glowed with special richness. A mosque required hundreds of lamps, and there were hundreds of mosques—glassmaking was a booming industry in Egypt and Syria.

Blue, red, and white enamel and gilding cover the surface of the lamp in vertical bands that include swirling vegetal designs and cursive inscriptions interrupted by roundels containing iconic emblems. The inscription on the vessel's flared neck is a Qur'anic quotation (Surah 24:35) commonly found on mosque lamps: "God is the light of the heavens and the earth. His light is as a niche wherein is a lamp, the lamp in a glass, the glass as a glittering star." The emblem, called a blazon, identifies the patron—on this cup, it is the sign of Sayf al-Din Shaykhu al-'Umari, who built a mosque and a Sufi lodge in Cairo. The blazon resembles European heraldry. It was a "symbolic/emblematic language of power [that] passed to Western Europe beginning in the early twelfth century as the result of the Crusades, where it evolved into the genealogical system we know as heraldry" (Redford "A Grammar of Rūm Seljuk Ornament," *Mésogeois* 25–26 [2005]: 288). These emblems, which appear in Islamic glass, metalwork, and architecture, reflect an increasing interest in figural imagery that coincided with the increased production of illustrated books.

MAMLUK GLASS OIL LAMP
Syria or Egypt. c. 1355. Glass, polychrome enamel, and gold, height 12″ (30.5 cm). Corning Museum of Glass, Corning, New York.
(52.1.86)

8–14 | **COURTYARD, MASJID-I JAMI, ISFAHAN** Iran
11th–18th century.
14th-century *iwan* vault,
17th-century minarets.

courtyard belong to the seventeenth century (**FIG. 8–14**). The many changes made to this mosque reflect its ongoing importance to the community it served.

A TILE MIHRAB. A fourteenth-century tile *mihrab*, originally from a *madrasa* in Isfahan but now in the Metropolitan Museum of Art in New York, is one of the finest examples of early architectural ceramic decoration in Islamic art (**FIG. 8–15**). More than 11 feet tall, it was made by painstakingly cutting each individual piece of tile, including the pieces making up the letters on the curving surface of the niche. The color scheme—white against turquoise and cobalt blue with accents of dark yellow and green—was typical of this type of decoration, as were the harmonious, dense, contrasting patterns of organic and geometric forms. The cursive inscription of the outer frame quotes Surah 9, verses 18–20, from the Qur'an, reminding the faithful of their duties. It is rendered in elegant white lettering on a blue ground, while the Kufic inscription bordering the pointed arch reverses these colors for a pleasing contrast.

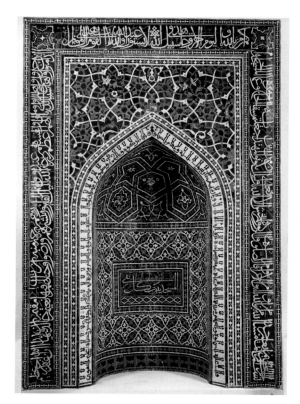

8–15 | **TILE MOSAIC** *MIHRAB*
Madrasa Imami, Isfahan, Iran. Founded 1354. Glazed and cut tiles,
11′3″ × 7′6″ (3.43 × 2.29 m). The Metropolitan Museum of Art, New York.
Harris Brisbane Dick Fund (39.20)

This *mihrab* has three inscriptions: the outer inscription, in cursive, contains Qur'anic verses (Surah 9) that describe the duties of believers and the Five Pillars of Islam. Framing the niche's pointed arch, a Kufic inscription contains sayings of the Prophet. In the center, a panel with a line in Kufic and another in cursive states: "The mosque is the house of every pious person."

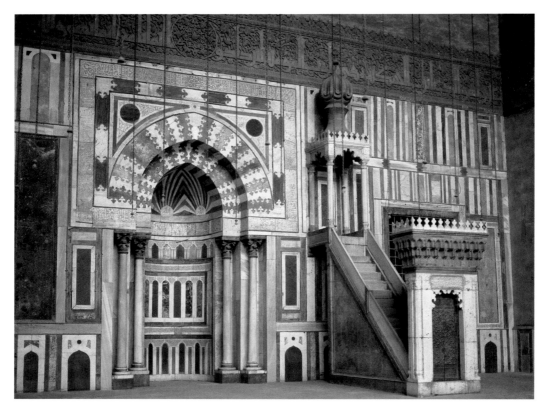

8–16 | *QIBLA* **WALL WITH** *MIHRAB* **AND** *MINBAR*, **SULTAN HASAN** *MADRASA*-**MAUSOLEUM-MOSQUE COMPLEX**
Main *iwan* (vaulted chamber) in the mosque, Cairo, Egypt. 1356–63.

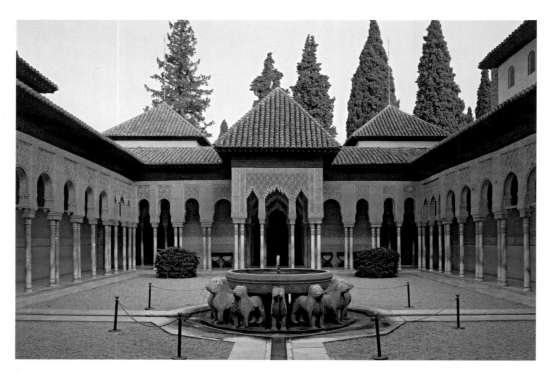

8–17 | **COURT OF THE LIONS, ALHAMBRA, GRANADA, SPAIN.**
1354–91.

An ample water supply had long made Granada a city of gardens. This fountain fills the courtyard with the sound of its life-giving abundance, while channel-lined walkways form the four-part *chahar bagh*. Channeling water has a practical role in the irrigation of the garden, and here it is raised to the level of an art form.

THE *MADRASA-MAUSOLEUM-MOSQUE* IN CAIRO. Beginning in the eleventh century, Muslim rulers and wealthy individuals endowed hundreds of charitable complexes, including many *madrasas*. These were public displays of piety as well as personal wealth and status. The combined *madrasa*-mausoleum-mosque complex established in mid–fourteenth-century Cairo by the Mamluk Sultan Hasan (**FIG. 8–16**) is such an example. With a four-*iwan* plan, each *iwan* served as a classroom for a different branch of study, the students housed in a multistoried cluster of tiny rooms around each one. Standing just beyond the *qibla iwan*, the patron's monumental domed tomb attached his identity ostentatiously to the architectural complex. The sumptuous *qibla iwan* served as the prayer hall for the complex. Its walls are ornamented with colorful marble paneling, typical of Mamluk patronage, that culminates in a doubly recessed *mihrab* framed by slightly pointed arches on columns. The marble blocks of the arches are ingeniously joined in interlocking pieces of alternating colors called **joggled *voussoirs***. The paneling is surmounted by a wide band of Kufic inscription in stucco set against a background of scrolling vines. Next to the *mihrab* stands an elaborate thronelike *minbar*. The Sultan Hasan complex is excessive in its vast scale and opulent decoration, but money was not an object: The project was financed by the estates of victims of the bubonic plague that had raged in Cairo in 1348–50.

THE ALHAMBRA. Muslim architects also created luxurious palaces set in gardens. The Alhambra in Granada, in southeastern Spain, is an outstanding example of beautiful and refined Islamic palace architecture. Built on the hilltop site of a pre-Islamic fortress, this palace complex was the seat of the Nasrids (1232–1492), the last Spanish Muslim (Moorish) dynasty, Islamic territory having shrunk from most of the Iberian Peninsula to the region around Granada. To the conquering Christians at the end of the fifteenth century, the Alhambra represented the epitome of luxury. Thereafter, they preserved the Alhambra as much to commemorate the defeat of Islam as for its beauty. Literally a small town extending for about half a mile along the crest of a high hill overlooking Granada, it included government buildings, royal residences, gates, mosques, baths, servants' quarters, barracks, stables, a mint, workshops, and gardens. Most of what one sees at the site today was built in the fourteenth century or in later centuries by Christian patrons.

The Alhambra was a sophisticated citadel whose buildings offered dramatic views to the settled valley and snow-capped mountains around it, while enclosing gardens within its courtyards. One of these is the Court of the Lions which stood at the heart of the so-called Palace of the Lions, the private retreat of Sultan Muhammad V (ruled 1354–59 and 1362–91). The Court of the Lions is divided evenly into four parts by cross-axial walkways that meet at a central marble fountain held aloft on the backs of twelve stone lions (**FIG. 8–17**). An Islamic garden divided thus into quadrants is called a *chahar bagh*. The

courtyard is encircled by an arcade of stucco arches supported on single columns or clusters of two and three. Second-floor **miradors**—windows that frame specifically intentioned views—look over the courtyard, which was planted with aromatic citrus and flowers. From these windows, protected by latticework screens, it is quite likely that the women of the court, who did not appear in public, would watch the activities of the men below. At one end of the Palace of the Lions, a particularly magnificent *mirador* looks out onto a large, lower garden and the plain below. From here, the sultan literally oversaw the fertile valley that was his kingdom.

On the south side of the Court of the Lions, the lofty Hall of the Abencerrajes was designed as a winter reception hall and music room. In addition to having excellent acoustics, its ceiling exhibits dazzling geometrical complexity and exquisitely carved stucco (FIG. 8–18). The star-shaped vault is formed by a honeycomb of clustered *muqarnas* arches that alternate with corner **squinches** that are filled with more *muqarnas*. The square room thus rises to an eight-pointed star, pierced by eighteen windows, that culminates in a burst of *muqarnas* floating high overhead, perceived and yet ultimately unknowable, like the heavens themselves.

Portable Arts

Islamic society was cosmopolitan, with pilgrimage, trade, and a well-defined road network fostering the circulation of marketable goods. In addition to the import and export of basic foodstuffs and goods, luxury arts brought particular pleasure and status to their owners and were visible signs of cultural refinement. These art objects were eagerly exchanged and collected from one end of the Islamic world to the other, and they were sought by European patrons as well.

METAL. Islamic metalworkers inherited the techniques of their Roman, Byzantine, and Sasanian predecessors, applying this heritage to new forms, such as incense burners and water pitchers in the shape of birds and animals. An example of this delight in fanciful metalwork is an unusually large and stylized griffin, perhaps originally used as a fountain (FIG. 8–19). Now in Pisa, Italy, it is probably Fatimid work from Egypt, and it may have arrived as booty from Pisan victories over the Egyptian fleet in 1087. The Pisans displayed it atop their cathedral from about 1100 to 1828. Made of cast bronze, it is decorated with incised representations of feathers, scales, and silk trappings. The decoration on the mighty creature's thighs includes animals in medallions; the bands across its chest and back are embellished with Kufic lettering and scale and circle patterns.

The Islamic world was administered by educated functionaries who often commissioned personalized containers for their pens, ink, and blotting sand. One such container, an inlaid brass box, belonged to the grand vizier, or chief minister, of Khurasan in the early thirteenth century (FIG. 8–20). The artist cast, engraved, embossed, and inlaid the box with consummate

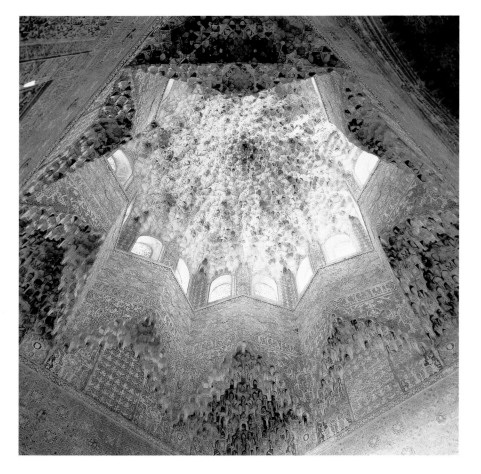

8–18 | **MUQARNAS DOME, HALL OF THE ABENCERRAJES, PALACE OF THE LIONS, ALHAMBRA**
Built between 1354–91.

8–19 | GRIFFIN
Islamic Mediterranean, probably Fatimid, Egypt. 11th century. Bronze, height 42⅛″ (107 cm). Museo dell' Opera del Duomo, Pisa.

CERAMICS. In the ninth century, potters developed a technique to produce a lustrous metallic surface on their ceramics. They may have learned the technique from Islamic glassmakers who had produced luster-painted vessels a century earlier. First the potters applied a paint laced with silver, copper, or gold oxides to the surface of already fired and glazed tiles or vessels. In a second firing with relatively low heat and less oxygen, these oxides burned away to produce a reflective shine. The finished **lusterware** resembled precious metal. At first the potters covered the entire surface with luster, but soon they began to use luster to paint dense, elaborate patterns using geometric design, foliage, and animals in golden brown, red, purple, and green. Lusterware tiles, dated 862–3, decorated the *mihrab* of the Great Mosque at Kairouan.

The most spectacular lusterware pieces are the double-shell fritware, in which an inner solid body is hidden beneath a densely decorated and perforated outer shell. A jar in the Metropolitan Museum of Art known as **THE MACY JUG** (after a previous owner) exemplifies this style **(FIG. 8–21)**. The black

skill. Scrolls, interlacing designs, and human and animal figures enliven its calligraphic inscriptions. A silver shortage in the mid-twelfth century prompted the development of inlaid brasswork like this that used the more precious metal sparingly. Humbler brassware was also available to those of lesser rank than the vizier.

8–21 | THE MACY JUG
Iran. 1215–16. Composite body glazed, painted fritware and incised (glaze partially stained with cobalt), with pierced outer shell, 6⅝ × 7¾″ (16.8 × 19.7 cm). The Metropolitan Museum of Art, New York.
Fletcher Fund, 1932 (32.52.1)

Fritware was used to make beads in ancient Egypt and may have been rediscovered there by Islamic potters searching for a substitute for Chinese porcelain. Its components were one part white clay, ten parts quartz, and one part quartz fused with soda, which produced a brittle white ware when fired. The colors on this double-walled ewer and others like it were produced by applying mineral glazes over black painted detailing. The deep blue comes from cobalt and the turquoise from copper. Luster, a thin, transparent glaze with a metallic sheen, was applied over the colored glazes.

8–20 | PEN BOX
By Shazi, from Iran or Afghanistan. 1210–11. Brass with inlaid silver, copper, and black organic material; height 2″, length 12⅜″, width 2½″ (5 × 31.4 × 6.4 cm). Freer Gallery of Art, Smithsonian Institution, Washington, D.C.
(F1936.7)

The inscriptions on this box include some twenty honorific phrases extolling its owner, al-Mulk. The *naskhi* script on the lid calls him the "luminous star of Islam." The largest inscription, written in animated *naskhi* (an animated script is one with human or animal forms in it), asked twenty-four blessings for him from God. Shazi, the designer of the box, signed and dated it in animated Kufic on the side of the lid, making it one of the earliest signed works in Islamic art. The owner enjoyed his box for only ten years; he was killed by Mongol invaders in 1221.

underglaze-painted decoration represents animals and pairs of harpies and sphinxes set into an elaborate "water-weed" pattern. The outer shell is covered with a turquoise glaze, enhanced by a deep cobalt-blue glaze on parts of the floral decoration and finally a luster overglaze that gives the entire surface a metallic sheen. An inscription includes the date AH 612 (1215–16 CE).

TEXTILES. The tradition of silk weaving that passed from Sasanian Persia to Islamic artisans in the early Islamic period (SEE FIG. 8–13) was kept alive in Muslim Spain. Spanish designs reflect a new aesthetic, with an emphasis beginning in the thirteenth century on forms that had much in common with architectural ornament. An eight-pointed star forms the center of a magnificent silk and gold banner (FIG. **8–22**). The calligraphic panels continue down the sides and a second panel crosses the top. Eight lobes with gold crescents and white

8–23 | MEDALLION RUG, VARIANT STAR USHAK STYLE
Anatolia (present-day Turkey). 16th century. Wool, 10'3" × 7'6 ¼" (313.7 × 229.2 cm). The St. Louis Art Museum. Gift of James F. Ballard.

8–22 | BANNER OF LAS NAVAS DE TOLOSA
Detail of center panel, from southern Spain. 1212–50. Silk tapestry-weave with gilt parchment, 10'9 ⅞" × 7'2 ⅝" (3.3 × 2.2 m). Museo de Telas Medievales, Monasterio de Santa María la Real de Las Huelgas, Burgos, Spain.

This banner was a trophy taken by the Christian king Ferdinand III, who gave it to Las Huelgas, the Cistercian convent outside Burgos, the capital city of Old Castile and the burial place of the royal family. This illustration shows only a detail of the center section of the textile. The calligraphic panels continue down the sides, and a second panel crosses the top.

inscribed parchment medallions form the lower edge of the banner. In part, the text reads: "You shall believe in God and His Messenger. . . . He will forgive you your sins and admit you to gardens underneath which rivers flow, and to dwelling places goodly in Gardens of Eden; that is the mighty triumph."

The Qur'an describes paradise as a shady garden with four rivers, and many works of Islamic art evoke both paradisiac and garden associations. In particular, Persian and Turkish carpets were often embellished with elegant designs of flowers and shrubs inhabited by birds. Laid out on the floor of an open-air hall and perhaps set with bowls of ripe fruit and other delicacies, such carpets brought the beauty of nature indoors. Written accounts indicate that elaborate patterns appeared on Persian carpets as early as the seventh century. In one fabled royal carpet, garden paths were rendered in real gold, leaves were modeled with emeralds, and highlights on flowers, fruits, and birds were created from pearls and jewels.

A carpet from Ushak in western Anatolia (Turkey), created in the first half of the sixteenth century, retains its vibrant colors (FIG. **8–23**). Large, deeply serrated quatrefoil medallions establish the underlying star pattern but arabesques flow in every direction. This "infinite arabesque," as it is called (the pattern repeats infinitely in all directions), is characteristic of Ushak carpets. Carpets were usually at least three times as long as they were wide; the asymmetry of this carpet may indicate that it was cut and shortened.

Technique
CARPET MAKING

Because textiles are made of organic materials that are destroyed through use, very few carpets from before the sixteenth century have survived. There are two basic types of carpets: flat-weaves and pile, or knotted, carpets. Both can be made on either vertical or horizontal looms.

The best-known flat-weaves today are kilims, which are typically woven in wool with bold, geometric patterns and sometimes with brocaded details. Kilim weaving is done with a **tapestry** technique called slit tapestry (see diagram a).

Knotted carpets are an ancient invention. The oldest known example, excavated in Siberia and dating to the fourth or fifth century BCE, has designs evocative of Achaemenid art, suggesting that the technique may have originated in Central Asia. In knotted carpets, the pile—the plush, thickly tufted surface—is made by tying colored strands of yarn, usually wool but occasionally silk for deluxe carpets, onto the vertical elements (the **warp**) of a yarn grid (see diagram b or c). These knotted loops are later trimmed and sheared to form the plush pile surface of the carpet. The **weft** strand (crosswise threads) are shot horizontally, usually twice, after each row of knots is tied, to hold the knots in place and to form the horizontal element common to all woven structures. The weft is usually an undyed yarn and is hidden by the colored knots of the warp. Two common knot tying techniques are the asymmetrical knot, used in many carpets from Iran, Egypt, and Central Asia (formerly termed the Sehna knot), and the symmetrical knot (formerly called the Gördes knot) more commonly used in Anatolian Turkish carpet weaving. The greater the number of knots, the shorter the pile. The finest carpets can

have as many as 2,400 knots per square inch, each one tied separately by hand.

Although royal workshops produced luxurious carpets (SEE FIG. 8–23), most knotted rugs have traditionally been made in tents and homes. Either women or men, depending on local custom, wove carpets. The photograph in this box shows two women, sisters in Çanakkale province in Turkey, weaving a large carpet in a typical Turkish pattern. The woman in the foreground pushes a row of knots tightly against the row below it with a wood comb called a beater. The other woman pulls a dark red weft yarn against the warp threads before tying a knot. Working between September and May, these women may weave five carpets, tying up to 5,000 knots a day. A Çanakkale rug will usually have only 40–50 knots per square inch. Generally, an older woman works with a young girl, who learns the art of carpet weaving at the loom and eventually passes it on to the next generation.

a. Kilim weaving pattern used in flat-weaving

b. Symmetrical knot, used extensively in Iran

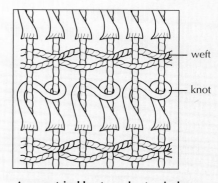

c. Asymmetrical knot, used extensively in Turkey

Rugs have long been used for Muslim prayer, which involves repeatedly kneeling and touching the forehead to the floor before God. While individuals often had their own small prayer rugs, with representations of niches to orient the faithful in prayer, many mosques were furnished with wool-pile rugs received as pious donations (see, for example, the rugs on the floor of the Sultan Selim Mosque in FIG. 8–28). In Islamic houses, people sat and slept on cushions and thick mats laid directly on the floor, so that cushions took the place of the fixed furnishings of Western domestic environments.

From the late Middle Ages to today, carpets and textiles are one of the predominant Islamic arts, and the Islamic art form best known in the West. Historically, rugs from Iran, Turkey, and elsewhere were highly prized among Westerners, who often displayed them on tables rather than floors.

Manuscripts and Painting

The art of book production flourished from the first century of Islam. Islam's emphasis on the study of the Qur'an promoted a high level of literacy among both women and men,

and calligraphers were the first artisans to emerge from anonymity and achieve individual distinction and recognition for their skill. Books on a wide range of secular as well as religious subjects were available, although hand-copied books—even on paper—always remained fairly costly. Libraries, often associated with *madrasas*, were endowed by members of the educated elite. Books made for royal patrons had luxurious bindings and highly embellished pages, the result of workshop collaboration between noted calligraphers and illustrators. New scripts were developed for new literary forms.

The manuscript illustrators of Mamluk Egypt (1250–1517) executed intricate nonfigural geometric designs for the Qur'ans they produced. Geometric and botanical ornamentation contributed to unprecedented sumptuousness and complexity. As in architectural decoration, the exuberant ornament was underlaid by strict geometric organization. In an impressive frontispiece originally paired with its mirror image on the facing left page, the design radiates from a sixteen-pointed starburst, filling the central square (FIG. 8–24). The surrounding ovals and medallions are filled with interlacing foliage and stylized flowers that provide a backdrop for the holy scripture. The page's resemblance to court carpets was not coincidental. Designers worked in more than one medium, leaving the execution of their efforts to specialized artisans. In addition to religious works, scribes copied and recopied famous secular texts—scientific treatises, manuals of all kinds, stories, and especially poetry. Painters supplied illustrations for these books and also created individual small-scale paintings—**miniatures**—that were collected by the wealthy and placed in albums.

THE HERAT SCHOOL. One of the great royal centers of miniature painting was at Herat in western Afghanistan. A school of painting and calligraphy was founded there in the early fifteenth century under the highly cultured patronage of the Timurid dynasty (1370–1507). In the second half of the fifteenth century, the leader of the Herat school was Kamal al-Din Bihzad (c. 1450–1514). When the Safavids supplanted the Timurids in 1506–7 and established their capital at Tabriz in northwestern Iran, Bihzad moved to Tabriz and briefly resumed his career there. Bihzad's paintings, done around 1494 to illustrate the *Khamsa* (Five Poems), written by Nizami, demonstrate his ability to render human activity convincingly. He set his scenes within complex, stagelike architectural spaces that are stylized according to Timurid conventions, creating a visual balance between activity and architecture. In **THE CALIPH HARUN AL-RASHID VISITS THE TURKISH BATH** (FIG. 8–25), the bathhouse, its tiled entrance leading to a high-ceiling dressing room with brick walls, provides the structuring element. Attendants wash long, blue towels and hang them to dry on overhead clotheslines. A worker reaches for one of the towels with a long pole, and a client prepares to wrap himself discreetly in a towel before removing his outer garments. The blue door on the left leads to a room where a barber grooms the caliph while attendants bring water for his bath. The asym-

metrical composition depends on a balanced placement of colors and architectural ornaments within each section.

An illustrated copy of the *Khamsa* (FIG. 8–26) from Herat in slightly earlier period contains a romantic scene in a landscape setting. The painting shows the gold-crowned princess Shirin at the moment when she sees a portrait of Khusrau hanging in a tree and falls in love with him. She is shown at the moment of discovery, holding the portrait before her, as one of her dismayed attendants grabs her cloak as if to hold her back from destiny. The background consists of an ochre-colored arid landscape that rises to two ranges of hills from which emerge two trees. Almost hidden in the upper left, a man observes the scene. This is Shapur, the painter of Khusrau's portrait and his friend, but at the same time the inclusion of this figure makes witty reference to the painter of the manuscript page. In contrast to the plain background, in the foreground, a rock-bordered stream—its silvery surface now tarnished to gray—winds its way through a meadow of flowers and a tree. Overhead, a cloud painted in a Chinese style seems to reflect the agitation in her heart. By the beginning of the seventeenth century, this manuscript was in the hands of the Mughal rulers of India, evidence of the enduring appreciation for Timurid painting and of the cultural exchanges that took place as both artists and art moved to new courts and collections.

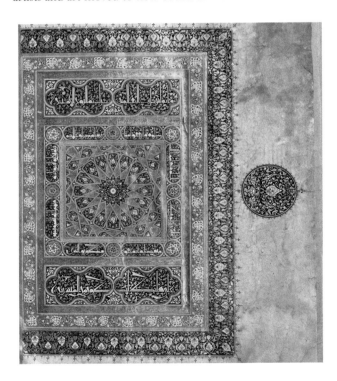

8–24 | **QUR'AN FRONTISPIECE (RIGHT HALF OF TWO-PAGE SPREAD)** Cairo, Egypt. c. 1368. Ink, pigments, and gold on paper, 24 × 18″ (61 × 45.7 cm). National Library, Cairo. Ms. 7.

The Qur'an to which this page belonged was donated in 1369 by Sultan Shaban to the *madrasa* established by his mother. A close collaboration between illuminator and scribe can be seen here and throughout the manuscript.

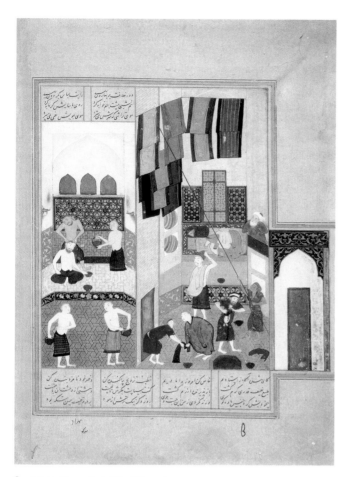

8–25 | Kamal al-Din Bihzad **THE CALIPH HARUN AL-RASHID VISITS THE TURKISH BATH**
From a copy of the 12th-century *Khamsa (Five Poems)* of Nizami. Herat, Afghanistan. c. 1494. Ink and pigments on paper, approx. 7 × 6″ (17.8 × 15.3 cm). The British Library, London.
Oriental and India Office Collections (Ms. Or. 6810, fol. 27v)

Despite early warnings against it as a place for the dangerous indulgence of the pleasures of the flesh, the bathhouse (*hammam*), adapted from Roman and Hellenistic predecessors, became an important social center in much of the Islamic world. The remains of an eighth-century *hammam* still stand in Jordan, and a twelfth-century *hammam* is still in use in Damascus. *Hammams* had a small entrance to keep in the heat, which was supplied by steam ducts running under the floors. The main room had pipes in the wall with steam vents. Unlike the Romans, who bathed and swam in pools of water, Muslims preferred to splash themselves from basins, and the floors were slanted for drainage. A *hammam* was frequently located near a mosque, part of the commercial complex provided by the patron to generate income for the mosque's upkeep.

THE OTTOMAN EMPIRE

With the breakdown of Saljuq power in Anatolia at the end of the thirteenth century, another group of Muslim Turks seized power in the early fourteenth century in the northwestern part of that region, having migrated there from their homeland in Central Asia. Known as the Ottomans, after an early leader named Osman, they pushed their territorial boundaries westward and, in spite of setbacks inflicted by the Mongols, ulti-

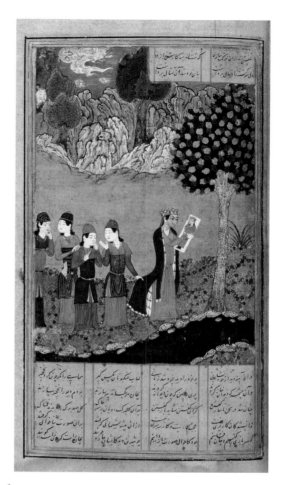

8–26 | **THE PORTRAIT OF KHUSRAU SHOWN TO SHIRIN**
From a copy of the 12th-century *Khamsa (Five Poems)* of Nizami. Herat, Afghanistan, 1442. Ink, pigments, and gold on paper. The British Library, London.

mately created an empire that extended over Anatolia, western Iran, Iraq, Syria, Palestine, western Arabia (including Mecca and Medina), northern Africa (excepting Morocco), and part of eastern Europe. In 1453, they captured Constantinople, ultimately renaming it Istanbul, and brought the Byzantine Empire to an end. The Ottoman Empire lasted until 1918.

Architecture

Upon conquering Istanbul, the rulers of the Ottoman Empire converted the great Byzantine church of Hagia Sophia into a mosque, framing it with two graceful Turkish-style minarets in the fifteenth century and two more in the sixteenth century (SEE FIG. 7–25). In conformance with Islamic aniconism, the church's mosaics were destroyed or whitewashed. Huge calligraphic disks with the names of God, Muhammad, and the early caliphs were added to the interior in the mid–nineteenth century (SEE FIG. 7–27). At present, Hagia Sophia is neither a church nor a mosque but a state museum.

THE ARCHITECT SINAN. Ottoman architects had already developed the domed, **centrally planned mosque** (see

"Mosque Plans," page 289), but this great Byzantine structure of Hagia Sophia inspired them to strive for a more ambitious scale. For the architect Sinan (c. 1489–1588) the development of a monumental centrally planned mosque was a personal quest. Sinan began his career in the army and served as engineer in the Ottoman campaign at Belgrade, Vienna, and Baghdad. He rose through the ranks to become, in 1528, chief architect for Suleyman "the Magnificent," the tenth Ottoman sultan (ruled 1520–66). Suleyman's reign marked the height of Ottoman power, and the sultan sponsored a building program on a scale not seen since the days of the Roman Empire. Serving Suleyman and his successor, Sinan is credited with more than 300 imperial commissions, including palaces, *madrasas* and Qur'an schools, tombs, public kitchens and hospitals, caravanserais, treasure houses, baths, bridges, viaducts, and 124 large and small mosques.

Sinan's crowning accomplishment, completed about 1579, when he was over 80, was a mosque he designed in the provincial capital of Edirne for Suleyman's son Selim II (ruled 1566–74) (FIG. 8–27). The gigantic hemispheric dome that tops this structure is more than 102 feet in diameter, larger than the dome of Hagia Sophia, as Sinan proudly pointed out. The dome crowns a building of extraordinary architectural coherence. The transition from square base to the central dome is accomplished by corner half-domes that enhance the spatial plasticity and openness of the vast interior of the prayer hall (FIG. 8–28). The eight massive piers that bear the dome's weight are visible both within and without—on the exterior they resolve in pointed towers that encircle the main dome—revealing the structural logic of the building and clarifying its form. In the arches that support the dome and span from one pier to the next—and indeed at every level—light pours from windows into the interior, a space at once soaring and serene.

In addition to the mosque, the complex housed a *madrasa* and other educational buildings, a cemetery, a hospital, and charity kitchens, as well as the income-producing covered market and baths. Framed by the vertical lines of four minarets and raised on a platform at the city's edge, the Selimiye mosque dominates the skyline.

The interior was clearly influenced by Hagia Sophia—an open expanse under a vast dome floating on a ring of light—but it lacks Hagia Sophia's longitudinal pull from entrance to sanctuary. The Selimiye mosque is truly centrally planned structure and a small fountain covered by a platform (visible in the lower right OF FIG. 8–28) emphasizes this centralization.

Illuminated Manuscripts and *Tugras*

A combination of abstract setting with realism in figures and details characterizes Ottoman painting. Ottoman painters adopted the style of the Herat school (as influenced by Timurid conventions) for their miniatures, enhancing its decorative aspects with an intensity of religious feeling. At the Ottoman court of Sultan Suleyman in Istanbul, the imperial workshops produced even more remarkable illuminated manuscripts.

Following a practice begun by the Saljuqs and Mamluks, the Ottomans put calligraphy to political use, developing the design of imperial ciphers—*tugras*—into a specialized art form. Ottoman *tugras* combined the ruler's name and title with the motto "Eternally Victorious" into a monogram denoting the authority of the sultan and of those select officials who were also granted an emblem. *Tugras* appeared on seals, coins, and buildings, as well as on official documents called *firmans*, imperial edicts supplementing Muslim law. Suleyman issued hundreds of edicts, and a high court official supervised specialist calligraphers and illuminators who produced the documents with fancy *tugras* (FIG. 8–29).

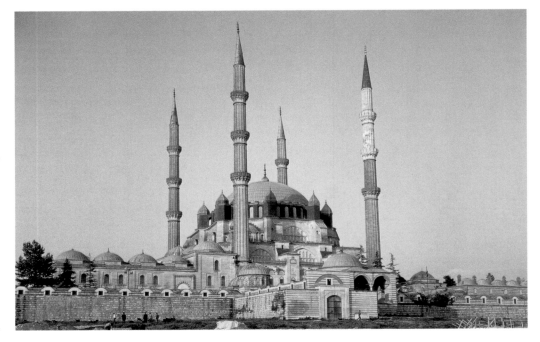

8–27 | MOSQUE OF SULTAN SELIM, EDIRNE
Turkey. 1568–75.

The minarets that pierce the sky around the prayer hall of this mosque, their sleek, fluted walls and needle-nosed spires soaring to more than 295 feet, are only 12½ feet in diameter at the base, an impressive feat of engineering. Only royal mosques were permitted multiple minarets, and having more than two was unusual.

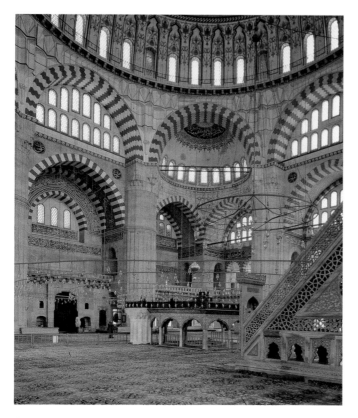

8–28 | **INTERIOR, MOSQUE OF SULTAN SELIM**

Tugras were drawn in black or blue with three long, vertical strokes (*tug* means "horsetail") to the right of two concentric horizontal teardrops. Decorative foliage patterns fill the space. Fill decoration became more naturalistic by the 1550s and in later centuries spilled outside the emblems' boundary lines. The rare, oversized *tugra* in FIG. 8-29 has a sweeping, fluid line drawn with perfect control according to set proportions. The color scheme of the delicate floral inter-

lace enclosed in the body of the *tugra* may have been inspired by Chinese blue-and-white ceramics; similar designs appear on Ottoman ceramics and textiles.

THE MODERN ERA

For many years the largest and most powerful political entity in the Islamic World, the Ottoman Empire lasted until the end of World War I. It was not until 1918 that modern Turkey was founded in Anatolia, the former heart of the empire. The twentieth century saw the dissolution of the great Islamic empires and the formation of smaller nation-states in their place. The question of identity and its expression in art changed significantly as Muslim artists and architects sought training abroad and participated in an international movement that swept away many of the visible signs that formerly expressed their cultural character and difference. The abstract work of the architect Zaha Hadid (SEE FIG. 32–80), who was born in Baghdad and studied and practiced in London, is exemplary of the new internationalism. But earlier, when architects in Islamic countries were debating whether modernity promised opportunities for new expression or simply another form of Western domination, the Egyptian Hasan Fathy (1900–89) asked whether abstraction could serve the cause of social justice. He revived traditional, inexpensive, and locally obtainable materials such as mud brick and forms such as wind scoops (an inexpensive means of catching breezes to cool a building's interior) to build affordable housing for the poor. For architects around the world, Fathy's New Gourna Village (designed 1945–47) in Luxor, Egypt, was a model of environmental sustainability realized in pure geometric forms that resonated with references to Egypt's architectural past (FIG. 8–30). In their simplicity, his watercolor paintings are as beautiful as his buildings.

8–29 | **ILLUMINATED *TUGRA* OF SULTAN SULEYMAN**
Istanbul, Turkey. c. 1555–60. Ink, paint, and gold on paper, removed from a *firman* and trimmed to 20½ × 25⅛" (52 × 64.5 cm). The Metropolitan Museum of Art, New York.
Rogers Fund, 1938 (38.149.1).

The *tugra* shown here is from a document endowing an institution in Jerusalem that had been established by Suleyman's wife, Hurrem.

8–30 | HASAN FATHY MOSQUE AT NEW GOURNA
Luxor, Egypt, 1945–47. Gouache on paper, 22½ × 17⅞″ (52.8 × 45.2 cm).
Collection: Aga Khan Award for Architecture, Geneva, Switzerland.

One of many buildings designed for the Egyptian Department of Antiquities for a village relocation project. Seven thousand
people were removed from their village near pharaonic tombs and resettled on agricultural land near the Nile. Fathy's
emphasis on both the traditional values of the community and the individualism of its residents was remarkably different from
the abstract and highly conformist character of other modern housing projects of the period.

IN PERSPECTIVE

In Islamic art, a proscription against figural imagery in religious
contexts gave rise instead to the development of a rich vocab-
ulary of ornament and pattern using abstract geometrical fig-
ures and botanically inspired design. Motifs readily circulated
in the Islamic world via portable objects in the hands of pil-
grims and traveling merchants. Textiles and carpets especially
were widely traded both within the Islamic world and
between it and its neighbors. The resulting eclecticism of motif
and technique is an enduring characteristic of Islamic art.

As with geometric and floral ornament, writing played a
central role in Islamic art. Since the lessons of the Qur'an were
not to be presented pictorially, instead the actual words of the
Qur'an were incorporated in the decoration of buildings and
objects to instruct and inspire the viewer. As a result, calligraphy
emerged as the most highly valued form of art, maintaining its
prestige even after manuscript painting grew in importance
under court patronage from the thirteenth century onward.

Architecture also played an important role in Islam and
reveals the flexibility and innovation of Islamic culture. The
mosque began as a simple space for congregational gathering
and prayer but grew in complexity. The individual mosque,
whether hypostyle, domical, or four-*iwan*, was eventually
combined with other functional types (such as schools,
tombs, and public fountains), culminating with the vast com-
plexes of the Ottoman era. The Islamic world's awareness of
history is especially evident in its architecture, as for instance
in the Mosque of Selim II—an homage to the Hagia
Sophia—or as seen in Hasan Fathy's self-conscious evocation
of vernacular Egyptian architecture.

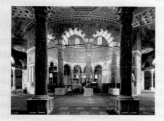

DOME OF THE ROCK
BEGUN 691–92

GRIFFIN 11TH CENTURY

**PRAYER HALL, GREAT MOSQUE
CORDOBA,**
BEGUN 785–86

MAMLUK GLASS LAMP
c. 1355

**ILLUMINATED TUGRA
OF SULTAN SULEYMAN**
c. 1555–60

600

800

1000

1200

1400

2000

ISLAMIC ART

◀ **Founding of Islam** 622 CE
◀ **Early Caliphs** 633–61 CE
◀ **Umayyad Dynasty** c. 661–750 CE

◀ **Abbasid Dynasty** c. 750–1258 CE
◀ **Spanish Umayyad Dynasty**
c. 756–1031 CE

◀ **Fatimid Dynasty**
c. 909–1171 CE

◀ **Saljuq Dynasty**
c. 1037–1194 CE
◀ **Saljuq Dynasty of Rum**
late 11th–early 14th century CE

◀ **Spanish Nasrid Dynasty**
c. 1232–1492 CE
◀ **Egyptian Mamluk Dynasty**
c. 1250–1517 CE
◀ **Ottoman Empire**
c. 1281–1918 CE
◀ **Timurid Dynasty**
c. 1370–1507 CE

◀ **Fall of Constantinople
to Ottoman Turks**
1453 CE

◀ **Modern Turkey Founded**
1918 CE

14–1 | **CHI RHO IOTA PAGE FROM THE BOOK OF KELLS** Matt. 1:18. Probably made at Iona, Scotland. Late 8th or early 9th century. Oxgall inks and pigments on vellum, 12¾ × 9½″ (325 × 24 cm). The Board of Trinity College, Dublin.
MS 58, fol. 34r.

EARLY MEDIEVAL ART IN EUROPE

14

According to legend, the Irish prince Colum Cille (c. 521–97), scholar, scribe, and churchman, who was canonized as Saint Columba, caused a war by secretly copying a psalter (psalm book). After King Finnian, the owner of the original, found out and petitioned for possession of the copy, and even after the king ruled, "To every cow its calf, to every book its copy," Colum Cille still refused to relinquish it. Instead he incited his kinsmen to fight for the precious book. Whether fleeing from his enemies or to atone for his actions (the legend is unclear), Colum Cille left Ireland forever in self-imposed exile in 563. He established a monastery on Iona, an island off the western coast of Scotland.

As described by the eighth-century Anglo-Saxon historian Bede, such remote monasteries stood "among craggy and distant mountains, which looked more like lurking places for robbers and retreats for wild beasts than habitation for men." Nevertheless, they became centers of Celtic Christendom—their monks as famous for writing and copying books as for their missionary fervor. But, wealthy, isolated, and undefended, they fell victim to Viking attacks beginning at the end of the eighth century. Only the stormy seas could save the treasures of the monasteries. As one monk wrote:

> Bitter is the wind tonight,
> It tosses the ocean's white hair:
> Tonight I fear not the fierce warriors of Norway
> Coursing on the Irish Sea.
>
> (translated by Kuno Meyer, *Selections from Ancient Irish Poetry.*
> London: Constable, 1959 [1911])

In 806, the monks, fleeing Viking raids on Iona, established a refuge at Kells on the Irish mainland. They may have brought with them the Gospel book now known as the **BOOK OF KELLS** (FIG. 14–1). To produce this illustrated version of the Gospels entailed a lavish expenditure: Four scribes and three major illuminators worked on it (modern scribes take about a month to complete a page comparable to the one illustrated here), 185 calves were slaughtered to make the vellum, and the colors for the paintings came from as far away as Afghanistan.

Throughout the Middle Ages monasteries were the centers of art and learning. While religious services remained their primary responsibility, some talented monks and nuns also spent many hours as painters, jewelers, carvers, weavers, and embroiderers. These arts, used in the creation of illustrated books and liturgical equipment, are often called the "cloister crafts." Few cloisters could claim a work of art like the *Book of Kells*.

The twelfth century priest Gerald of Wales aptly described just such a Gospel book when he wrote:

> Fine craftsmanship is all about you, but you might not notice it. Look more keenly at it, and you will penetrate to the very shrine of art. You will make out intricacies, so delicate and subtle, so exact and compact, so full of knots and links, with colors so fresh and vivid, that you might say that all this was the work of an angel, and not of a man.
>
> (cited in Henderson, page 195)

THE EARLY MIDDLE AGES

As the Roman Empire declined in the fourth century and came to an end in the fifth, its authority was supplanted by "barbarians," people from outside the empire who could only "barble" Greek or Latin.

At this point we have seen these "barbarians" only through Greek and Roman eyes—as the defeated Gauls at Pergamon (FIG. 5–63), on the Gemma Augustea (FIG. 6–24), or on the Ludovisi Sarcophagus (FIG. 6–69). Trajan's Column (FIG. 6–50) shows only Roman triumphs in the barbarians' homeland beyond the Danube River. Hadrian's Wall (FIG. 6–57), built to defend the northern frontier in Britain, marks the extent of the empire. But by the fourth century many Germanic tribes were allies of Rome. In fact, most of Constantine's troops in the decisive battle with Maxentius (page 226) were Germans.

A century later the situation was entirely different. In 410 the Visigoths under Alaric besieged and captured Rome. The adventures of the Byzantine princess Galla Placidia, whom we have met as a patron of the arts (FIG. 7–19), bring the situation vividly to life. She had the misfortune to be in Rome when Alaric and the Visigoths sacked the city (the emperor and pope were living safely in Ravenna). Carried off as a prize of war by the Goths, Galla Placidia had to join their migrations through France and Spain and eventually married the Gothic king, who was soon murdered. Back in Italy, married and widowed yet again, Galla Placidia ruled the Western Empire as regent for her son from 425 to 437/8. She died in 450, before having to endure yet another sack of Rome, this time by the Vandals, in 455. The fall of Rome shocked the Christian world, although the wounds were more psychological than physical. Saint Augustine was inspired to write *The City of God,* a cornerstone of Christian philosophy, as an answer to people who claimed that the Goths represented the vengeance of the pagan gods on people who had abandoned them for Christianity.

Who were these people living outside the Mediterranean orbit? Their wooden architecture is lost to fire and decay, but their metalwork and use of animal and geometric ornament is well established. The people were hunters and fishermen, shepherds and farmers living in villages with a social organization based on extended families and tribal loyalties. They engaged in the essential crafts—pottery, weaving, woodwork—and they fashioned metals into weapons, tools, and jewelry. We saw examples of Bronze and Iron Age (Celtic) art in Chapter 1.

The Celts controlled most of Europe, and the Germanic people—Goths and others—lived around the Baltic Sea. Increasing population evidently forced the Goths to begin to move south, into better lands and climate around the Mediterranean and Black Seas, but the Romans had extended the borders of their empire across the Rhine and Danube rivers. Seeking the relative security and higher standard of living they saw in the Roman Empire, the Germanic people crossed the borders and settled within the empire.

The tempo of migration speeded up in the fifth century when the Huns from central Asia swept down on western Europe. Only the death of their leader Attila in 453 saved Europe. The Arian Ostrogoths (Eastern Goths) moved into Italy, and in 476 they deposed the last Roman emperor. They made Ravenna their capital until they were in turn defeated by the Byzantines. The Visigoths (Western Goths) ended their wanderings in Spain. The Burgundians settled in Switzerland and eastern France; the Franks in Germany, France, and Belgium. Meanwhile the Vandals moved through France and Spain, crossed over into Africa, making Carthage their headquarters, and then returned back to Italy, sacking Rome in 455.

At first Christianity was not a unifying force. As early as 345 the Goths adopted Arian Christianity, beliefs considered heretical by the Church in Rome. Not until 589 did they accept Roman Christianity. In contrast to the Arian Goths, the Franks under Clovis (ruled 481–511), influenced by his Burgundian wife Clotilda, converted to Roman Christianity in 496, beginning a fruitful alliance between French rulers and the popes.

Bewildering as the period seems, the Europe we know today was beginning to take shape. Relationships of patronage and dependence between powerful men and their retainers remained important, ultimately giving rise to a political and economic system based on family and clan ties, on

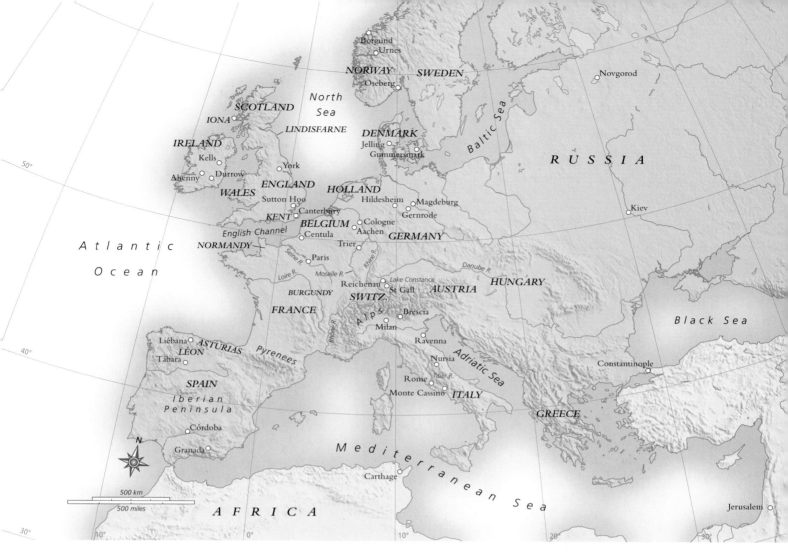

MAP 14–1 | **EUROPE OF THE EARLY MIDDLE AGES**

On this map, modern names have been used for medieval regions in northern and western Europe to make sites of artworks easier to locate.

personal loyalty and mutual support, and on the exchange of personal service and labor for protection. This system became formalized as *feudalism*.

Mutual support also developed between secular and religious leaders. Kings and nobles defended the claims of the Roman Church, and the pope, in turn, validated their authority. As its wealth and influence increased throughout Europe, the Church emerged as the principal patron of the arts to fulfill growing needs for buildings and liturgical equipment, including altars, altar vessels, crosses, candlesticks, containers for the remains of saints **(reliquaries),** vestments (ritual garments), images of Christian figures and stories, and copies of sacred texts such as the Gospels.

The Art of People Associated with the Roman Empire

As Christianity spread north beyond the borders of what had been the Western Roman Empire, northern artistic traditions similarly worked their way south. Out of a tangled web of themes and styles originating from inside and out of the

empire, from pagan and Christian beliefs, from urban and rural settlements, brilliant new artistic styles were born.

THE VISIGOTHS. Among the many people who had lived outside the Roman Empire and then moved within its borders, the Visigoths migrated across southern France and by the sixth century had settled in Spain, where they became an elite group ruling the indigenous population. They adopted Latin for writing, and in 589 they accepted Roman Christianity. Saint Isidore, patron saint of historians (including art historians), was a Visigothic bishop.

Following the same late–Roman-Germanic tradition they shared with other Gothic peoples, the Visigoths were superior metalworkers and created magnificent colorful jewelry. In the eagle brooch (**FIG. 14–2**), the artist rendered the bird in flight with outspread wings and tail, profile head with curved beak, and large round eye. This brooch displays a rich assortment of gems. Besides the red garnets interspersed with blue and green stones, the circle that represents the eagle's body has a *cabochon* (polished but unfaceted) crystal at the

Art and Its Context
DEFINING THE MIDDLE AGES

The roughly 1,000 years of European history between the collapse of the Western Roman Empire in the fifth century and the Italian Renaissance in the fifteenth are known as the Middle Ages, or the medieval period. These terms reflect the view of Renaissance humanists who regarded the period that preceded theirs as a "dark age" of ignorance, decline, and barbarism, standing in the *middle* and separating their own "golden age" from the golden ages of ancient Greece and Rome. Although we now recognize the Middle Ages as a period of great richness, complexity, and innovation, the term has endured.

Art historians commonly divide the Middle Ages into three periods: Early Medieval (ending in the early eleventh century), Romanesque (eleventh and twelfth centuries), and Gothic (extending from the mid-twelfth into the fifteenth century). We shall look at only a few of the many cultures that make up the Early Medieval period. For convenience, we will use modern geographical names (MAP 14–1)—in fact, the nations we know today did not yet exist.

14–2 | **EAGLE BROOCH**
One of a pair. Spain. 6th century. Gilt, bronze, crystal, garnets, and other gems. Height 5⅝" (14.3 cm). The Walters Art Museum, Baltimore.

center. Round amethyst in a white meerschaum frame forms the eyes. Pendant jewels originally hung from the birds' tail. The eagle remained one of the most popular motifs in Western art, owing in part to its continuing significance—first as an ancient sun symbol, then as a symbol of imperial Rome, and later as the emblem of Saint John the Evangelist.

THE LOMBARDS. Among those who established kingdoms in the heart of what had been the Roman Empire in Italy were the Lombards. The Lombards had moved from their northern homeland into the Hungarian plain and then traveled west into Italy, where they became a constant threat to Rome. Like other migrating people, the Lombards excelled in fine metalwork. The huge jeweled cross in Brescia (east of Milan) shows their skillful use of precious metals and spectacular jewels (FIG. 14–3). The cross has a Byzantine form—equal arms widening at the ends joined by a central disc with a relief figure of Christ enthroned in a jeweled mandorla, indicating divine light emanating from the figure. More than 200 jewels, engraved gems, antique **cameos,** and glass pseudo-cameos adorn the cross. At the bottom of the cross is a gold glass Roman portrait medallion (SEE FIG. 6–68). According to tradition, the last Lombard king, Desiderius (ruled 757–74), gave the cross to the Church of Santa Giulia in Brescia. Scholars cannot agree on its date; they place the cross somewhere between the late seventh and early ninth centuries.

The patron who gathered this rich collection of jewels and ordered the cross to be made intended it to glorify God with glowing color and was evidently not concerned that nearly all the engraved gems and cameos have pagan subjects. The cross typifies this turbulent period in the Western European history of art. Made for a Western Christian church but having the form associated with the Byzantine East and using engraved jewels and cameos from the ancient world (even when they had to fake some in glass), the makers of the cross achieve an effect of extraordinary splendor.

The Art of People Outside
the Roman Sphere of Influence

In Scandinavia (present-day Denmark, Norway, and Sweden), which was never part of the Roman Empire, people spoke variants of the Norse language and shared a rich mythology with other Germanic peoples. In the British Isles, where the Romans had built Hadrian's Wall to mark the boundaries between civilization and the wilds of Scotland, the ancient Celtic culture flourished.

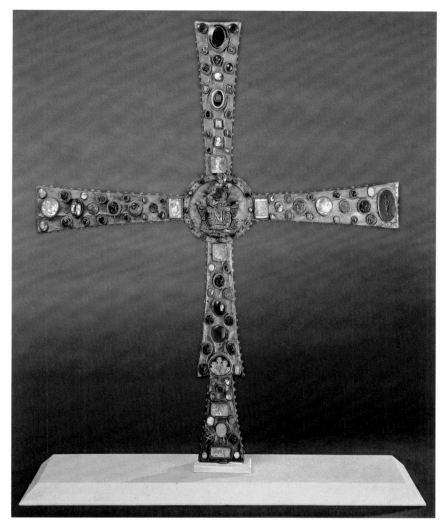

I4–3 | **CROSS**
Church of Saint Giulia, Brescia, Italy. Late 7th–early 9th century. Gilded silver,
wood, jewels, glass, cameos, and gold-glass medallion of the third century, 50 ×
39″ (126 × 99 cm). Museo di Santa Giulia, Brescia.

At the beginning of the fifth century the Roman army abandoned Britain. The economy faltered, and large towns lost their commercial function and declined as Romanized British leaders vied for dominance with the help of Germanic mercenary soldiers from the Continent.

THE NORSE. Scandinavian artists had exhibited a fondness for abstract patterning from early prehistoric times. During the first millennium BCE, trade, warfare, and migration had brought a variety of jewelry, coins, textiles, and other portable objects into northern Europe. The artists incorporated the solar disks and stylized animals on these objects into their already rich artistic vocabulary (SEE FIG. 1–20).

By the fifth century CE, the so-called **animal style** dominated the arts, displaying an impressive array of serpents, four-legged beasts, and squat human figures, as can be seen in

their metalwork. The **GUMMERSMARK BROOCH** (FIG. I4–4), for example, is a large silver gilt pin dating from the sixth century CE in Denmark. This elegant ornament consists of a large, rectangular panel and a medallionlike plate covering the safety pin's catch connected by an arched bow. The surface of the pin seethes with human, animal, and geometric forms. An eye-and-beak motif frames the rectangular panel; a man is compressed between dragons just below the bow; and a pair of monster heads and crouching dogs with spiraling tongues frame the covering of the catch.

Certain underlying principles govern works with animal style design: The compositions are generally symmetrical, and artists depict animals in their entirety either in profile or from above. Ribs and spinal columns are exposed as if they had been x-rayed; hip and shoulder joints are pear-shaped; tongues and jaws extend and curl, and legs end in large claws.

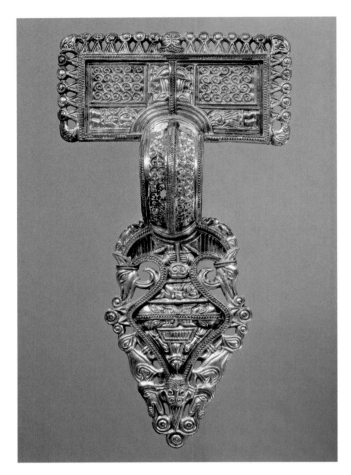

14-4 | **GUMMERSMARK BROOCH**
Denmark. 6th century. Silver gilt, height 5¾″ (14.6 cm).
Nationalmuseet, Copenhagen.

The northern jewelers carefully crafted their molds to produce a glittering surface on the cast metal, turning a process intended to speed production into an art form of great refinement.

THE CELTS AND ANGLO-SAXONS. After the Romans departed, Angles and Saxons from Germany and the Low Lands and Jutes from Denmark crossed the sea to occupy southeastern Britain. Gradually they extended their control northwest across the island. Over the next 200 years, the arts made a brilliant recovery as the fusion of Celtic, Romanized British, Germanic, and Norse cultures generated a new culture and style of art, known as Hiberno-Saxon (from the Roman name for Ireland, *Hibernia*). Anglo-Saxon literature is filled with references to splendid and costly jewelry and weapons made of or decorated with gold and silver.

The Anglo-Saxon epic *Beowulf*, composed perhaps as early as the seventh century, describes its hero's burial with a hoard of treasure in a grave mound near the sea. Such a burial site was discovered near the North Sea coast in Suffolk at a site called Sutton Hoo (*hoo* means "hill" or "headland"). The

grave's occupant had been buried in a ship whose traces in the earth were recovered by the careful excavators. The wood—and the hero's body—had disintegrated, and no inscriptions record his name. He has sometimes been identified with the ruler Redwald, who died about 625. The treasures buried with him confirm that he was, in any case, a wealthy and powerful man.

The burial ship at Sutton Hoo was 90 feet long and designed for rowing, not sailing. In it were weapons, armor, other equipment to provide for the ruler's afterlife, and many luxury items, including Byzantine silver bowls. Also found was a large purse filled with coins. Although the leather of the pouch and the bone or ivory of its lid have disintegrated, the gold and garnet fittings survive (FIG. 14-5). The artist, using the **cloisonné** technique (cells formed from gold wire to hold shaped pieces of garnet or glass), frequently seen in Byzantine enamels, created figures of gold, garnets, and blue-checkered glass (known as *millefiore glass*). Polygons decorated with purely geometric patterns flank a central plaque of four animals with long interlacing legs and jaws. Below, large hawks attack ducks, and men are spread-eagled between two rampant beasts.

Themes, techniques, and styles from many places are represented on the purse cover. The motif of a human being flanked by a pair of animals is widespread in ancient Near Eastern art and in the Roman world (as is the motif of the predator vanquishing the prey). The hawks with rectangular eyebrows and curving beaks, twisted wings and square tails are Norse in style, and the interlacing four-legged, long-jawed animals characterize the Germanic animal style. The use of bright color—especially red and gold—reflects an Eastern European tradition. All in all, the purse displays the rich blend of motifs that marks the complex Hiberno-Saxon style that flourished in Britain and Ireland during the seventh and eighth centuries.

The Coming of Christianity to the British Isles

Although the Anglo-Saxons who settled in Britain had their own gods and myths, Christianity survived the pagan onslaught. Monasteries flourished in the Celtic north and west, and Christians from Ireland founded influential missions in Scotland and northern England. Cut off from Rome, these Celtic Christians developed their own liturgical practices, church calendar, and distinctive artistic traditions. Then, in 597, Pope Gregory the Great (ruled 590–604) dispatched missionaries from Rome to the Anglo-Saxon king Ethelbert of Kent, whose Christian wife Bertha was sympathetic to their cause. The head of this successful mission, the monk Augustine (Saint Augustine, d. 604), became the archbishop of Canterbury in 601. The Roman Christian authorities and the Irish monasteries, although allied in the effort to Christianize the British Isles, came into conflict over their divergent practices. The Roman Church eventually triumphed and brought British Christians under its authority. Local traditions, however, continued to influence their art.

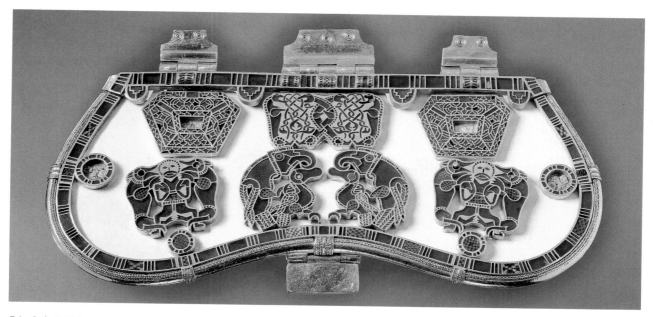

14–5 | **PURSE COVER, FROM THE SUTTON HOO BURIAL SHIP**
Suffolk, England. First half of 7th century. Cloisonné plaques of gold, garnet, and checked millefiore glass, length 8″ (20.3 cm). The British Museum, London.

Only the decorations on this purse cover are original. The lid itself, of a light tan ivory or bone, deteriorated and disappeared centuries ago, and the white backing is a modern replacement. The purse was designed to hang at the waist. The leather pouch held thirty-seven coins, struck in France, the latest dated in the early 630s.

ILLUSTRATED BOOKS. Among the richest surviving artworks of the period were the beautifully written, illustrated, and bound manuscripts, especially the Gospel books. Gospel books were essential for the missionary activities of the Church throughout the early Middle Ages, not only for the information they contained—the "good news" of Christianity—but also as instruments to glorify the Word of God. Often bound in gold and jeweled covers, they were placed on the altars of churches and carried in processions. Thought to protect parishioners from enemies, predators, diseases, and all kinds of misfortune, these books were produced by monks in local monastic workshops called *scriptoria* (see "The Medieval *Scriptorium*," page 448).

One of the many elaborately decorated Gospels of the period is the **GOSPEL BOOK OF DURROW,** dating to the second half of the seventh century (FIG. 14–6). The format and text of the book reflect Roman Christian models, but its paintings are an encyclopedia of contemporary design. Each of the four Gospels is introduced by a page with the symbol of its evangelist author, followed by a page of pure ornament and finally the decorated letters of the first words of the text *(the incipit).*

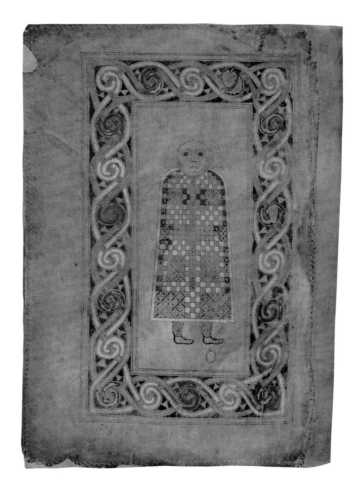

14–6 | **PAGE WITH MAN, GOSPEL BOOK OF DURROW**
Gospel of Saint Matthew. Probably made at Iona, Scotland, or northern England, second half of 7th century. Ink and tempera on parchment, 9⅗ × 6⅛″ (24.4 × 15.5 cm). The Board of Trinity College, Dublin.
MS 57 fol, 21v.

Art in Its Context
THE MEDIEVAL *SCRIPTORIUM*

Today books are made with the aid of computer software that can lay out pages, set type, and insert and prepare illustrations. Modern presses can produce hundreds of thousands of identical copies in full color. In Europe in the Middle Ages, however, before the invention there of printing from movable type in the mid-1400s, books were made by hand, one at a time, with ink, pen, brush, and paint. Each one was an important, time-consuming, and expensive undertaking. Medieval books were usually made by monks and nuns in a workshop called a *scriptorium* (plural *scriptoria*) within the monastery. As the demand for books increased, lay professionals joined the work, and great rulers set up palace workshops supervised by well-known scholars. Books were written on animal skin—either **vellum,** which was fine and soft, or **parchment,** which was heavier and shinier. (Paper did not come into common use in Europe until the early 1400s.) Skins for vellum were

cleaned, stripped of hair, and scraped to create a smooth surface for the ink and water-based paints, which themselves required time and experience to prepare. Many pigments—particularly blues and greens—had to be imported and were as costly as semiprecious stones. In very rich books, artists also used gold leaf or gold paint.

Sometimes work on a book was divided between a scribe, who copied the text, and one or more artists, who did the illustrations, large initials, and other decorations. Although most books were produced anonymously, scribes and illustrators signed and dated their work on the last page, called the **colophon** (SEE FIG. 14–9). One scribe even took the opportunity to warn the reader: "O reader, turn the leaves gently, and keep your fingers away from the letters, for, as the hailstorm ruins the harvest of the land, so does the injurious reader destroy the book and the writing" (cited in Dodwell, page 247).

In the *Gospel Book of Durrow* the Gospel of Matthew is preceded by his symbol, the man, but a man such as to be seen only in jeweled images made by an Irish or Scandinavian metalworker. A colorful checkered pattern resembling the millefiore glass inlays of Sutton Hoo forms the rectangular, armless body. Had the artist seen Byzantine figures wearing colorful brocades, or was he thinking of gold-framed jewels? In Saint Matthew's symbol a startling unshaven face stares glumly from rounded shoulders. The hair framing the man's high forehead follows the tonsure (the ceremonial hairstyle that distinguishes monks from laymen) of the early Celtic church. The figure seems to float with dangling feet against a neutral ground, which is surrounded by a wide border filled with a curling interlacing ribbon. Although the ribbon is continuous, its color changes from segment to segment, establishing yet another pattern. On other pages the ribbons turn into serpents.

The Gospel book known as the *Book of Kells* is one of the most beautiful, original, and inventive of the surviving Hiberno-Saxon Gospel books. A close look at its most celebrated page—the page introducing Matthew (1:18–25) that begins the account of Jesus's birth (SEE FIG. 14–1)—seems at first glance a tangle of colors and lines. But for those who would "look more keenly," there is so much more—human and animal forms—in the dense thicket of spiral and interlace patterns derived from metalwork.

The *Kells* style is especially brilliant in the monogram page with which we opened this chapter (FIG. 14–1). The artists reaffirm their Celtic heritage with the spirals and trumpet shapes that they combine with Germanic animal

interlaces to embellish the monogram of Christ (the three Greek letters XPI, *chi rho iota*) and the words *Christi autem generatio* ("now this is how the birth of Jesus Christ came about" [Matt. 1:18]). A giant *chi* establishes the basic composition of the page. The word *autem* appears as a Latin abbreviation resembling an *h;* and *generatio* is spelled out.

The illuminators outlined each letter, and then they subdivided the letters into panels filled with interlaced animals and snakes, as well as extraordinary spiral and knot motifs. The spaces between the letters form an equally complex ornamental field, dominated by spirals. In the midst of these abstractions, the painters inserted numerous pictorial and symbolic references to Christ—including his initials, a fish (the Greek word for "fish," *ichthus,* comprises in its spelling the first letters of *Jesus Christ, Son of God, Savior),* moths (symbols of rebirth), the cross-inscribed wafer of the Eucharist, numerous chalices and goblets, and possibly in two human faces, one at the top of the page and one at the end of the Greek letter *P (rho).* Three angels along the left edge of the stem of the Greek letter *X (chi)* are reminders that angels surrounded the Holy Family at the time of the Nativity, thus introducing Matthew's story while supporting the monogram of Christ.

In a particularly intriguing image, to the right of the Greek letter *chi*'s tail, two cats pounce on a pair of mice nibbling the Eucharistic wafer, and two more mice torment the vigilant cats (FIG. 14–7). As well as being a metaphor for the struggle between good (cats) and evil (mice), the image may also remark upon the perennial problem of keeping the monks' food and the sacred Host safe from rodents.

14-7 | **CATS AND MICE WITH HOST, DETAIL OF FIG. 14-1**
Chi Rho Iota page, Book of Kells, Matt.1:18. Probably made at Iona, Scotland. Late 8th or early 9th century. Oxgall inks and pigments on vellum. 12¾ × 9½" (325 × 24 cm). The Board of Trinity College, Dublin.
MS 58, fol. 34r.

14-8 | **SOUTH CROSS, AHENNY**
County Tipperary, Ireland. 8th century. Stone.

IRISH HIGH CROSSES. Metalwork's influence is seen not only in manuscripts, but also in the monumental stone crosses erected in Ireland during the eighth century. In Irish high crosses, so called because of their size, a circle encloses the arms of the cross. This Celtic ring has been interpreted as a halo or a glory (a ring of heavenly light) or as a purely practical support for the arms of the cross. The **SOUTH CROSS OF AHENNY**, in County Tipperary, is an especially well-preserved example of this type (**FIG. 14-8**). It seems to have been modeled on metal ceremonial or reliquary crosses, that is, cross-shaped containers for holy relics. It is outlined with ropelike, convex moldings and covered with spirals and interlace. The large **bosses** (broochlike projections), which form a cross within the cross, resemble the jewels that were similarly placed on metal crosses.

THE MUSLIM CHALLENGE IN SPAIN

In 711, Islamic invaders conquered Spain, ending Visigothic rule. The invaders brought a new art as well as a new religion and government into Spain (see Chapter 8). Muslim armies swept over the Iberian Peninsula. Bypassing a small Christian kingdom on the north coast, Asturias, they crossed the Pyrenees Mountains into France, but in 732 Charles Martel and the Frankish army stopped them before they reached Paris. The Muslims retreated back across the mountains, and the Christians, led by the Asturians, slowly drove them southward. Even so, the Moors, as they were known in Spain, remained for nearly 800 years, until the fall of the last Moorish kingdom, Granada, to the Christians in 1492.

Mozarabic Art

With some exceptions, Christians and Jews who acknowledged the authority of the new rulers and paid the taxes required of non-Muslims were left free to follow their own religious practices. The Iberian Peninsula became a melting pot of cultures in which Muslims, Christians, and Jews lived and worked together, all the while officially and firmly separated. Christians in the Muslim territories were called Mozarabs (from the Arabic *mustarib*, meaning "would-be Arab").

The conquest resulted in a rich exchange of artistic influences between the Islamic and Christian communities. Christian artists adapted many features of Islamic art, creating a unique, colorful new style known as *Mozarabic*. When the Mozarabic communities migrated to northern Spain, which returned to Christian rule not long after the initial Islamic invasion, they took this Mozarabic style with them.

BEATUS MANUSCRIPTS. One of the most influential books of the eighth century was the *Commentary on the Apocalypse*, compiled by Beatus, abbot of the Monastery of San Martín at Liébana in the northern kingdom of Asturias. Beatus described the end of the world and the Last Judgment of the Apocalypse,

14–9 Emeterius and Senior **COLOPHON PAGE, COMMENTARY ON THE APOCALYPSE BY BEATUS AND COMMENTARY ON DANIEL BY JEROME**
Made for the Monastery of San Salvador at Tábara, León, Spain. Completed July 27, 970. Tempera on parchment, 14¼ × 10⅛" (36.2 × 25.8 cm).
Archivo Histórico Nacional, Madrid.
MS 1079B f. 167.v.

The colophon provides specific information about the production of a book. In addition to identifying himself and Senior on this colophon, Emeterius praised his teacher, "Magius, priest and monk, the worthy master painter," who had begun the manuscript prior to his death in 968. Emeterius also took the opportunity to comment on the profession of bookmaking: "Thou lofty tower of Tábara made of stone! There, over thy first roof, Emeterius sat for three months bowed down and racked in every limb by the copying. He finished the book on July 27th in the year 1008 [970, by modern dating] at the eighth hour" (cited in Dodwell, page 247).

as first depicted in the Revelation to John in the New Testament, which vividly describes Christ's final, fiery triumph.

In 970, the monk Emeterius and a scribe-painter named Senior completed a copy of Beatus's **COMMENTARY** (FIG. 14–9). They worked in the *scriptorium* of the Monastery of San Salvador at Tábara in the Kingdom of León. Unlike most monastic scribes at this time, Mozarabic scribes usually signed their work and occasionally offered the reader their own comments and asides (see "The

Medieval *Scriptorium*," page 448). On the **colophon** (the page at the end of a book with information about its production) is a picture of the five-story tower of the Tábara monastery and the two-story *scriptorium* attached to it, the earliest known depiction of a medieval *scriptorium* and an unusual representation of a bell tower.

The tower and the workshop have been rendered in a cross section that reveals the interior and exterior of the buildings simultaneously. In the *scriptorium*, Emeterius on the right and Senior on the left, identified by inscriptions over their heads, work at a small table. A helper in the next room cuts sheets of **parchment** or **vellum** for book pages. A monk standing at the ground floor of the tower pulls the ropes attached to the bell in the turret while three other men climb ladders between the floors, apparently on their way to the balconies on the top level. Brightly glazed tiles in geometric patterns and horseshoe-arched openings are a common feature of Islamic architecture.

Another copy of Beatus's *Commentary* was produced five years later for Abbot Dominicus. The colophon identifies Senior as the scribe for this project. Emeterius and a woman named Ende (or simply En), who signed herself "painter and servant of God," shared the task of illustration. For the first time in the West, a women artist is identified by name with a specific surviving work of art. Using abstract shapes and brilliant colors recalling Visigothic jewel work, Emeterius and En illustrate a metaphorical description of the triumph of Christ over Satan (FIG. 14–10).

In the illustration, a peacock grasps a red and orange snake in its beak. The text tells us that a bird with a powerful beak and beautiful plumage (Christ) covers itself with mud to trick the snake (Satan). Just when the snake decides the bird is harmless, the bird swiftly attacks and kills the snake. "So Christ in his Incarnation clothed himself in the impurity of our [human] flesh that through a pious trick he might fool the evil deceiver. . . . [W]ith the word of his mouth [he] slew the venomous killer, the devil" (from the Beatus *Commentary*, cited in Williams, page 95). The Church often used such symbolic stories, or allegories, to convey ideals in combinations of recognizable images, making their implications accessible to people at any level of education. Elements of Mozarabic art lasted well into the twelfth century.

THE CAROLINGIAN EMPIRE

During the second half of the eighth century, while Christians and Muslims were creating a rich multicultural art in Spain, a new force emerged in Continental Europe. Charlemagne, or Charles the Great (*Carolus Magnus* is Latin for "Charles the Great"), established a dynasty and an empire known today as "Carolingian." The Carolingians were Franks, a Germanic people who had settled in northern Gaul (parts of present-day France and Germany) by the end of the fifth century. Under Charlemagne (ruled 768–814), the

14–10 | Emeterius and Ende, with the scribe Senior
**BATTLE OF THE BIRD AND THE SERPENT, COMMENTARY ON
THE APOCALYPSE BY BEATUS AND COMMENTARY ON DANIEL
BY JEROME, (DETAIL)**
Made for Abbot Dominicus, probably at the Monastery of San
Salvador at Tábara, León, Spain. Completed July 6, 975.
Tempera on parchment, 15¾ × 10¼" (40 × 26 cm).
Cathedral Library, Gerona, Spain.
MS 7[11], fol. 18v.

Carolingian realm reached its greatest extent, encompassing western Germany, France, the Lombard kingdom in Italy, and the Low Countries (present-day Belgium and Holland). Charlemagne imposed Christianity throughout this territory. In 800, Pope Leo III (papacy 795–816) crowned Charlemagne emperor in a ceremony in Saint Peter's Basilica in Rome, declaring him the rightful successor to Constantine, the first Christian emperor. This endorsement reinforced Charlemagne's authority and strengthened the bonds between the papacy and secular government in the West.

Charlemagne sought to restore the Western Empire as a Christian state and to revive the arts and learning. As inscribed on his official seal, Charlemagne's ambition was "the Renewal of the Roman Empire." To lead this revival, Charlemagne turned to the Benedictine monks and nuns. By the early Middle Ages, monastic communities had spread

across Europe. In the early sixth century, Benedict of Nursia (c. 480–547) wrote his *Rule for Monasteries*, a set of guidelines for monastic life that became the model for monastic orders. Benedictine monasticism soon displaced earlier forms, including the Celtic monasticism in the British Isles.

Both the Benedictines and Charlemagne emphasized education, and the Benedictine monks soon became Charlemagne's "cultural army." The court at Aachen, Germany, became one of the leading intellectual centers of Western Europe. Charlemagne's architects, painters, and sculptors looked to Rome and Ravenna for inspiration, but what they created was a new, northern version of the Imperial Christian style.

Carolingian Architecture

Functional plans inspired by Roman and Early Christian architecture were widely adopted by the Carolingian builders. Charlemagne's palace complex at Aachen provides an example of the Carolingian synthesis of Roman, Early Christian, and northern styles. Charlemagne, who enjoyed hunting and swimming, built a headquarters and palace complex amid the forests and natural hot springs of Aachen in the northern part of his empire and installed his court there about 794. The palace complex included a large audience hall and a chapel facing each other across a large square (as seen in a Roman forum), a monumental gateway supporting a hall of judgment, other administrative buildings, a palace school, homes for his circle of advisers and his large family, and workshops supplying all the needs of church and state.

THE PALACE CHAPEL AT AACHEN. Directly across from the royal audience hall on the north-south axis of the complex stood the **PALACE CHAPEL** (FIGS. 14–11, 14–12). This structure functioned as Charlemagne's private chapel, the church of his imperial court, a place for precious relics, and, after the emperor's death, the imperial mausoleum. To satisfy all these needs, the emperor's architects created a large, central-plan building similar to the Church of San Vitale in Ravenna (FIG. 7–28), which they reinterpreted in the distinctive Carolingian style.

The westwork—church entrances traditionally faced west—is a combined narthex (vestibule) and chapel joined by tall, cylindrical stair towers. The ground-level entrance accommodated the public. On the second level, a throne room opened onto the chapel rotunda, allowing the emperor to participate in the Mass from his private throne room. (The throne is visible through the arch.) At Aachen, this throne room could be reached from the palace audience hall and hall of justice by way of a gallery. The room also opened outside into a large walled forecourt where the emperor could make public appearances and speak to the assembled crowd. Relics were housed above the throne room on the third level. Spiral stairs in the twin towers joined the three levels. Originally designed to answer practical requirements

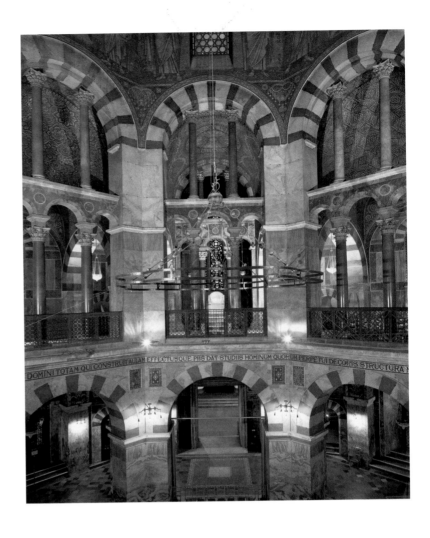

14–11 | **PALACE CHAPEL OF CHARLE-MAGNE**
Interior view, Aachen (Aix-la-Chapelle), Germany. 792–805.

Extensive renovations took place in the nineteenth century, when the chapel was reconsecrated as the Cathedral of Aachen, and in the twentieth century, after it was damaged in World War II.

14–12 | **RECONSTRUCTION DRAWING OF THE PALACE CHAPEL OF CHARLEMAGNE,** Aachen (Aix-la-Chapelle), Germany. 792–805.

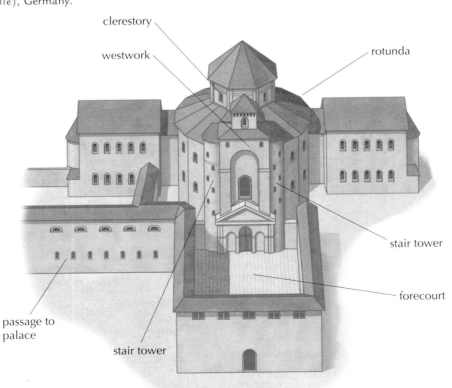

of protection and display, the soaring multitowered westwork came to function symbolically as the outward and very visible sign of an imperial building.

At Aachen, the core of the chapel is an octagon surrounded by an ambulatory and gallery in alternating square and triangular bays that produce a sixteen-sided outer wall. The central octagon rises to a clerestory above the gallery level and culminates in eight curving triangular segments that form an octagonal dome. In contrast, at the Byzantine Church of San Vitale, the central octagon was covered by a round dome and supported by half domes over the eight exedras (SEE FIG. 7–28). The chapel at Aachen has sharply defined spaces created by flat walls and angled piers. Byzantine Ravenna has curving surfaces and flowing spaces. In the gallery at Aachen, two tiers of Corinthian columns in the tall arched openings and bronze grills at floor level create a fictive wall that enhances the clarity and geometric quality of the design. The chapel's interior space is defined by eight panels that create a powerful upward movement from the floor of the central area to the top of the vault. Rich materials, some imported from Italy, and mosaics cover the walls. (The mosaic in the vault depicting the twenty-four Elders of the Apocalypse has been replaced with a modern interpretation.) This use of rich materials over every surface was inspired by Byzantine art, but the emphasis on verticality and the clear division of larger forms into separate parts are hallmarks of the new Carolingian style.

THE CHURCH OF SAINT RIQUIER. The Palace Chapel was a special building. Most Carolingian churches followed the basilican plan, often with the addition of a transept inspired by Old Saint Peter's in Rome. Charlemagne's biographer, Einhard, reported that the ruler, "beyond all sacred and venerable places . . . loved the church of the holy apostle Peter at Rome." Charlemagne's churches, however, were not simply imitations of Roman and Early Christian structures.

The Abbey Church of Saint Riquier, in the monastery at Centula in northern France, illustrates the Carolingian reinterpretation of the Early Christian basilica. Built by Angilbert, a lay abbot (781–814) and Frankish scholar at the court, the church was finished about 799. Destroyed by Viking raids in the ninth century, it is known today from archaeological evidence and a seventeenth-century engraving of a lost eleventh-century drawing (FIG. 14–13). For the abbey's more than 300 monks, the enclosure between the church and two freestanding chapels evidently served as a **cloister**—cloisters are arcaded courtyards linking the church and the living and working areas of the monastery. Three kinds of church buildings are represented. Simplest is the small, barnlike chapel (at the right in the print) dedicated to Saint Benedict. The more elaborate structure, a basilica with a rotunda ringed with chapels (lower left), was dedicated to the Virgin Mary and the Twelve Apostles. The interior probably had an altar to the Vir-

gin in the center, an ambulatory, and chapels with altars for each of the apostles against the outside walls.

The principal church, dedicated to Saint Riquier, displays a Carolingian variation of the basilica plan. The nave has side aisles and clerestory windows, and recent excavations have revealed a much longer nave than is indicated in the print. Giving equal weight to both ends of the nave are a multistory westwork including paired towers, a transept, and a crossing tower (at the left in the print), and, at the east end of the church (on the right), a crossing tower, which rises over the transept, and an extended sanctuary and apse.

The westwork served almost as a separate church. The main altar was dedicated to Christ the Savior and used for important church services. The boys' choir sang from its galleries, filling the church with "angelic music," and its ground floor had additional altars with important relics. Later the altar of the Savior was moved to the main body of the church, and the westwork was rededicated to the archangel Michael, whose chapel was usually located in a tower or other high place.

Saint Riquier's many towers would have been the building's most striking feature. The two tall towers at the crossing of the transepts soared upward from cylindrical bases through

14–13 | ABBEY CHURCH OF SAINT RIQUIER, MONASTERY OF CENTULA
France. Dedicated 799. Engraving dated 1612, after an 11th-century drawing. Bibliothèque Nationale, Paris.

three arcaded levels to cross-topped spires. They served a practical function as bell towers and played a symbolic role, designating an important building. Meant to be seen from afar, towers visually dominated the countryside. The vertical emphasis created by integrating towers into the basilican design was a northern contribution to Christian church architecture.

THE SAINT GALL PLAN. Monastic communities had special needs. The life of monks revolved around prayer and service in the church and work for the community. In the early ninth century, Abbot Haito of Reichenau developed an ideal plan for the construction of monasteries for his colleague Abbot Gozbert of Saint Gall near Lake Constance in Switzerland (FIG. 14–14). Abbot Haito laid out the plan on a square grid, as with an ancient Roman army camp, and indicated the size and position of the buildings and their uses.

Since Benedictine monks celebrate Mass as well as the eight "canonical" hours every day, they needed a church building with ample space for many altars, indicated in the plan as standing in the nave and aisles as well as chapels. In the Saint Gall plan, the church had large apses at both the east and west ends of the nave. North of the church were public buildings such as the abbot's house, the school, and guest-house. The south side was private—the cloister and the complex of monastic buildings surrounding it. The dormitory was built on the east side of the cloister, and for night services the monks entered the church directly from their dormitory. The refectory (dining hall) stood on the south of the cloister, with the kitchen, brewery, and bakery attached. A huge cellar (indicated on the plan by giant barrels) was on the west side. The Saint Gall plan indicates beds for seventy-seven monks in the dormitory and space for thirty-three more elsewhere. Practical considerations for group living include latrines attached to every unit—dormitory, guesthouse, and abbot's house. (The ratio of latrine holes to beds exceeds the standards of the U.S. Army today.) Six beds and places in the refectory were reserved for visiting monks. In the surrounding buildings, monks pursued their individual tasks. Scribes and painters, for example, spent much of their day in the *scrip-*

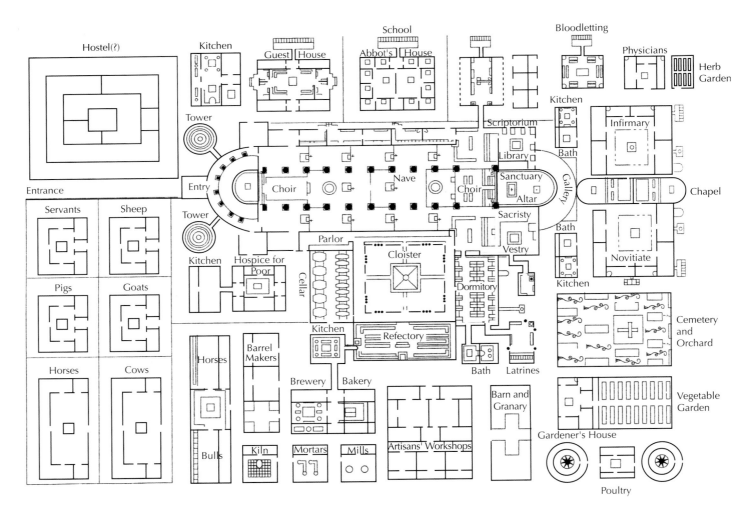

14–14 | **PLAN OF THE ABBEY OF SAINT GALL (REDRAWN)**
c. 817. Original in red ink on parchment, 28 × 44⅛″ (71.1 × 112.1 cm). Stiftsbibliothek, St. Gallen, Switzerland. Cod. Sang. 1092.

torium studying and copying books, and teachers staffed the monastery's schools and library. Saint Benedict had directed that monks extend hospitality to all visitors, and the large building in the upper left of the plan may indicate the guesthouse. The plan also included a hospice for the poor and an infirmary. Around this central core were the workshops, farm buildings, and housing for the lay community. Essentially self-supporting, the community needed barns for livestock, kitchen gardens (grain fields and vineyards lay outside the walls), and, of course, a cemetery. The monastery was often larger than the local villages.

The Scriptorium and Illustrated Books

Books played a central role in the efforts of Carolingian rulers to promote learning, propagate Christianity, and standardize Church law and practice. One of the main tasks of the imperial workshops was to produce authoritative copies of key religious texts, free of the errors introduced by tired, distracted, or confused scribes. The scrupulously edited versions of ancient and biblical texts that emerged are among the lasting achievements of the Carolingian period. The Anglo-Saxon scholar Alcuin of York, whom Charlemagne called to his court, spent the last eight years of his life producing a corrected copy of the Latin Vulgate Bible. His revision served as the standard text of the Bible for the remainder of the medieval period and is still in use.

Generations of copying had led to a shocking decline in penmanship. To create a simple, legible Latin script, the scribes and scholars developed uniform letters. Capitals *(majuscules)* based on ancient Roman inscriptions were used for very formal writing, titles and headings, and the finest manuscripts. *Minuscules* (now called *lower-case letters,* a modern printers' term) were used for more rapid writing and ordinary texts. The Caroline script is comparatively easy to read, although the scribes did not use punctuation marks or spaces between words.

Like the builders who transformed inherited classical types such as the basilican church into the new and different Carolingian monastic church, the scribes and illuminators revived and revitalized the Christian manuscript tradition. The human figure, which was absent or barely recognizable in early medieval books, returned to a central position.

Every monastic *scriptorium* developed its own distinctive forms in harmony with local artistic traditions and the books available as models in the library or treasury. The evangelist portraits (a man seated at a desk writing) in the three Gospel Books discussed here—the **GODESCALC GOSPEL LECTIONARY,** the **CORONATION GOSPELS,** and the **EBBO GOSPELS**—demonstrate the range and variety of Carolingian styles. Although the scribes intended to make exact copies of the texts and illustrations, they brought their own distinctive training to the work and so transformed the images into something new and different.

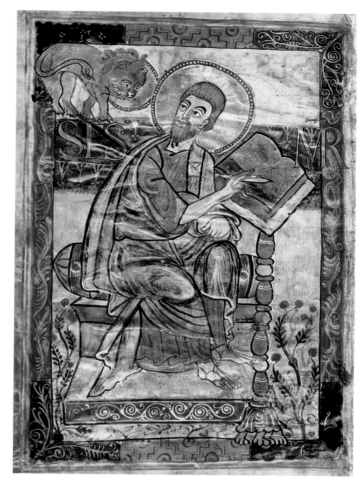

14–15 | **PAGE WITH MARK THE EVANGELIST, GODESCALC GOSPEL LECTIONARY**
Gospel of Mark. 781–83. Ink, gold, and colors on vellum, 12½ × 8½″ (32.1 × 21.8 cm). Bibliothèque Nationale, Paris. MS lat. 1203, fol. 16.

THE GODESCALC GOSPEL LECTIONARY. One of the earliest surviving manuscripts in the new script produced at Charlemagne's court was the **GODESCALC GOSPEL LECTIONARY** (FIG. **14–15**), a collection of selections from the Gospels to be read at Mass. Commissioned by Charlemagne and his wife Hildegard, perhaps to commemorate the baptism of their sons in Rome in 781, the *Godescalc Gospels* provided a model for later luxuriously decorated Gospel books.

The colophon indicates that the book was finished before the death of Hildegard in 783 and was made by the Frankish scribe Godescalc. This richly illustrated and sumptuously made book, with gold and silver letters on purple-dyed vellum, has a full-page portrait of the evangelist at the beginning of each Gospel. The style of these illustrations suggests that Charlemagne's artists were familiar with the author portraits of imperial Rome, as they had been preserved in Byzantine manuscripts.

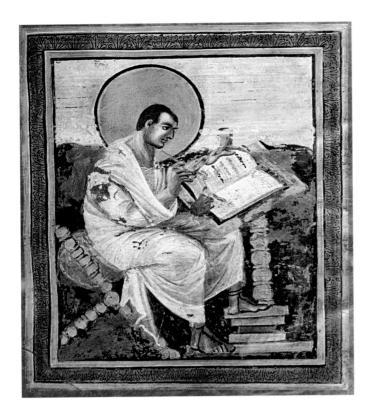

14-16 | PAGE WITH SAINT MATTHEW THE EVANGELIST, CORONATION GOSPELS
Gospel of Matthew. Early 9th century. 12¾ × 9⅞"
(36.3 × 25 cm). Kunsthistorische Museum, Vienna.

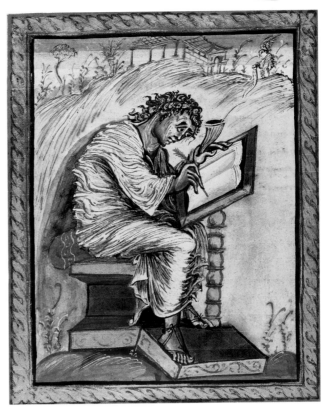

14-17 | PAGE WITH MATTHEW THE EVANGELIST, EBBO GOSPELS
Gospel of Matthew. Second quarter of 9th century. Ink, gold, and colors on vellum, 10¼ × 8¾" (26 × 22.2 cm). Bibliothèque Municipale, Épernay, France.
MS 1, fol. 18v.

Saint Mark is in the act of writing at a lectern tilted up to display his work. He appears to be listening to the small haloed lion in the upper left corner, the source of his inspiration and the iconographic symbol by which he is known. The artist has modeled Mark's arms, hips, and knees beneath his garment and has rendered the bench and lectern to hint at three-dimensional space despite the flat, banded background. Mark's round-shouldered posture and sandaled feet, planted on a platform decorated with a classical vine, contribute an additional naturalistic touch, but the illusion of a figure in space is disrupted by the impossible position of the left knee and the reverse perspective of the furniture.

THE GOSPELS OF CHARLEMAGNE, KNOWN AS THE *CORONATION GOSPELS*. Classical Early Christian and Byzantine art seem very close to the style of the **CORONATION GOSPELS** (FIG. 14-16), in which the Carolingian painters seem to have rediscovered Roman realistic painting. Ways of creating the illusion of figures in space may have been suggested by Byzantine manuscripts in the library, or an artist from Byzantium may have actually worked at the Carolingian court. (Charlemagne had hopes of marrying the Byzantine Empress

Irene. She turned him down—in her eyes he was a barbarian.) Tradition says that the book was placed in the tomb of Charlemagne and that in the year 1000 Emperor Otto III removed it (see page 464). It was used in the coronation of later German emperors. The evangelist portraits in this book show full-bodied, white-robed figures represented in brilliant light and shade and seated in a freely depicted naturalistic landscape. The frame enhances the classical effect of a view through a window.

THE GOSPELS OF ARCHBISHOP EBBO OF REIMS. Patronage of scribes and painters continued under Louis the Pious, Charlemagne's son and successor (ruled 814–840). Louis appointed his childhood friend Ebbo to be archbishop of Reims (ruled 816–35, 840–45). Ebbo was an important patron of the arts. A portrait of Matthew from a Gospel book made for the archbishop, either in Reims or a nearby *scriptorium*, illustrates the unique style associated with Reims (FIG. 14-17). The artist interprets the author's portrait with a frenetic intensity that turns the face, drapery, and landscape into swirling expressive colored lines. The author and his angelic inspiration (the tiny figure in the upper right corner) seem to

14–18 | **PAGE WITH PSALM 23, UTRECHT PSALTER.**

Second quarter of 9th century. Ink on vellum or parchment, 13 × 9⅞″ (33 × 25 cm). Universiteitsbibliotheek, Utrecht, Holland. MS 32, fol. 13r.

hover over a landscape so vibrant that both threaten to run off the page. Even the golden acanthus leaves in the frame seem windblown.

The artist uses the brush like a pen, focusing attention less on the evangelist's physical appearance than on his inner, spiritual excitement as he transcribes the Word of God coming to him from the distant angel, Matthew's symbol. Saint Matthew's head and neck jut out of hunched shoulders, and he grasps his pen and inkhorn. His twisted brow and prominent eyebrows lend his gaze an intense, theatrical quality. Swept up in Matthew's turbulent emotions, the saint's desk, bench, and footstool tilt every which way, as the top of the desk seems about to detach itself from the pedestal. Gold highlights the evangelist's hair and robe, the furniture, and the landscape. The accompanying text is written in magnificent golden capitals.

THE UTRECHT PSALTER. The most famous Carolingian manuscript, the **UTRECHT PSALTER,** or Old Testament Book of Psalms, is illustrated with ink drawings that have the same linear vitality as the paintings in Archbishop Ebbo's Gospel book. Psalms do not tell a straightforward story and so are exceptionally difficult to illustrate. The *Utrecht Psalter* artists solved this problem by interpreting individual words and images literally. Their technique can be likened to a game of charades in which each word must be acted out.

The words of the well-known Twenty-third Psalm are illustrated literally (FIG. **14–18**). "The Lord is my shepherd; I shall not want" (verse 1): The psalmist (traditionally King David) sits in front of a table laden with food; he holds a cup (verse 5). He is also portrayed as a shepherd in a pasture filled with sheep, goats, and cattle, "beside the still water" (verse 2). Perhaps the stream flows through "the valley of the shadow of death" (verse 4). An angel supports the psalmist with a "rod and staff" and anoints his head with oil (verses 4 and 5). "Thou prepares a table before me in the presence of mine enemies" (verse 5): The enemies gather at the lower right and shoot arrows, but the psalmist and angel ignore them and focus on the table and the House of the Lord. The basilica curtains are drawn back to reveal an altar and hanging votive crown: "I will dwell in the house of the Lord forever" (verse 6). Illustrations like this convey the characteristically close association between text and illustration in Carolingian art.

Carolingian Goldsmith Work

The magnificent illustrated manuscripts of the medieval period represented an enormous investment in time, talent, and materials, so it is not surprising that they were often protected with equally magnificent covers. But because these covers were themselves made of valuable materials—ivory, enamelwork, precious metals, and jewels—they were frequently reused or stolen. The elaborate book cover of gold

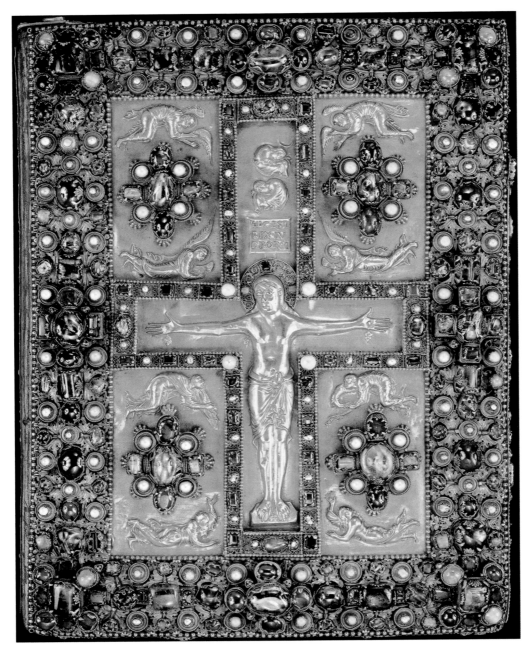

14–19 | **CRUCIFIXION WITH ANGELS AND MOURNING FIGURES, LINDAU GOSPELS.**
Outer cover. c. 870–80. Gold, pearls, sapphires, garnets, and emeralds, 13¾ × 10⅜"
(36.9 × 26.7 cm). The Pierpont Morgan Library, New York.
MS 1

and jewels, now the cover of the Carolingian manuscript known as the **LINDAU GOSPELS** (FIG. 14–19), was probably made between 870 and 880 at one of the monastic workshops of Charlemagne's grandson, Charles the Bald (ruled 840–77). Charles inherited the portion of Charlemagne's empire that corresponds roughly to modern France after the death of his father, Louis the Pious. It is not known what book the cover was made for, but sometime before the sixteenth century it became the cover of the *Lindau Gospels,* prepared at the Monastery of Saint Gall in the late ninth century.

The Cross and the Crucifixion were common themes for medieval book covers. The Crucifixion scene on the front cover of the *Lindau Gospels* is made of gold with figures in *repoussé* (low relief produced by pounding out the back of the panel to produce a raised front) surrounded by heavily jeweled frames. The jewels are raised on miniature arcades. By raising the jewels from the gold ground, the artist allowed reflected light to enter the gemstones from beneath, imparting a lustrous glow. Such luxurious gems are meant to recall the jeweled walls of the Heavenly Jerusalem.

Angels hover above the arms of the cross. Over Jesus's head, hiding their faces, are figures representing the sun and moon. The graceful, expressive poses of the mourners—Mary, John, Mary Magdalene, and Mary Cleophas—who seem to float around the jewels below the arms of the cross, reflect the expressive style of the *Utrecht Psalter* illustrations. Jesus, on the other hand, has been modeled in a rounded, naturalistic style suggesting the influence of classical sculpture. His erect posture and simplified drapery counter the emotional expressiveness of the other figures. Standing upright and wide-eyed with outstretched arms, he announces his triumph over death and welcomes believers into the faith.

In 843, the Carolingian empire was divided into three parts, ruled by three grandsons of Charlemagne. Although a few monasteries and secular courts continued to patronize the arts, intellectual and artistic activity slowed. Torn by internal strife and ravaged by Viking invaders, the Carolingian empire came to a bloody and inglorious end in the ninth century.

THE VIKING ERA

In the eighth century seafaring bands of Norse seamen known as Vikings (*Viken*, "people from the coves") descended on the rest of Europe. Setting off in flotillas of as many as 350 ships, they explored, plundered, traded with, and colonized a vast area during the ninth and tenth centuries. Frequently, their targets were wealthy isolated Christian monasteries. The earliest recorded Viking incursions were two devastating attacks: one in 793, on the religious community on Lindisfarne, an island off the northeast coast of England, and

another in 795, at Iona, off Scotland's west coast. In France they besieged Paris in 845 and later destroyed Centula as they harried the northern and western coasts of Europe.

Norwegian and Danish Vikings raided and settled a vast territory stretching from Iceland and Greenland, where they settled in 870 and 985, respectively, to Ireland, England, Scotland, and France. The Viking Leif Eriksson reached North America in 1000. In good weather a Viking ship could sail 200 miles in a day. In the early tenth century, the rulers of France bought off Scandinavian raiders (the Normans, or North men) with a large grant of land that became the duchy of Normandy. Swedish Vikings turned eastward and traveled down the Russian rivers to the Black Sea and Constantinople, where the Byzantine emperor recruited them to form an elite personal guard. Others, known as Rus, established settlements around Novgorod, one of the earliest cities in what would become Russia. They settled in Kiev in the tenth century and by 988 had become became Orthodox Christians (see Chapter 7).

The Oseberg Ship

Since prehistoric times Northerners had represented their ships as sleek sea serpents, and as we saw at Sutton Hoo they used them for burials as well as sea journeys. The ship of a dead warrior symbolized his passage to Valhalla, and Viking chiefs were sometimes cremated in a ship in the belief that this hastened their journey. Women as well as men were honored by ship burials. A 75-foot-long ship discovered in Oseberg, Norway, and dated 815–20 served as the vessel for two women on their journey to eternity in 834 (FIG. 14–20). Although the burial chamber was long ago looted of jewelry

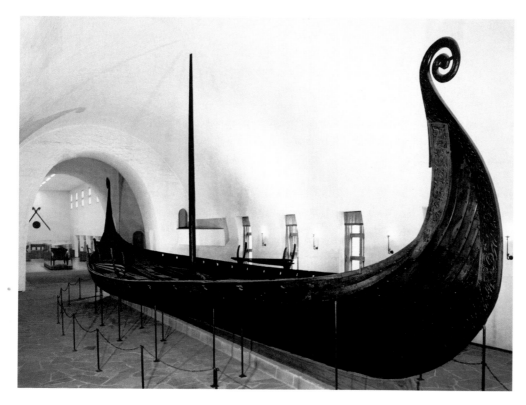

14–20 | QUEEN'S SHIP
Oseberg, Norway. c. 815-20; burial 834. Wood, length 75′6″ (23 m). Vikingskiphuset, Universitets Oldsaksamling, Oslo, Norway.

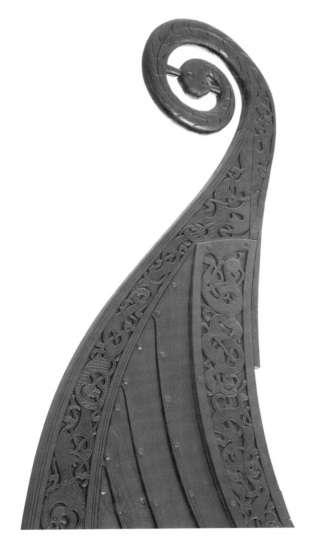

14–21 | **GRIPPING BEASTS, DETAIL OF OSEBERG SHIP**
c. 815–20. Wood. Vikingskiphuset, Universitets
Oldsaksamling, Oslo, Norway.

creatures with bulging eyes, short muzzles, snarling mouths, and large teeth. Their bodies are encrusted with geometric ornament. Images of these strange beasts adorned all sorts of Viking belongings—jewelry, houses, tent poles, beds, wagons, and sleds. Traces of color—black, white, red, brown, and yellow—indicate that the carved wood was painted.

All women, including the most elite, worked in the fiber arts. The Oseberg queen had her spindles, a frame for sprang (braiding), tablets for tablet weaving, as well as two upright looms. Her cabin walls had been hung with tapestries, fragments of which survive. Women not only produced clothing and embroidered garments and wall hangings, but they also wove the huge sails of waterproof unwashed wool that gave the ships a long-distance capability. The entire community—men and women—worked to create the ships, which represent the Viking's most important contribution to world architecture.

Picture Stones at Jelling

Both at home and abroad, the Vikings erected large memorial stones. Those covered mostly with inscriptions are called **rune stones**; those with figural decoration are called **picture stones**. Runes are twiglike letters of an early Germanic alphabet. Traces of pigments suggest that the memorial stones were originally painted in bright colors.

About 980 the Danish king Harald Bluetooth (c. 940–987) ordered a picture stone to be placed near the family burial mounds at Jelling (**FIG. 14–22**). Carved in runes on a boulder 8 feet high is the inscription, "King Harald had this memorial made for Gorm his father and Thyra his mother: that Harald who won for himself all Denmark and Norway and made the Danes Christians." (The prominent place of women in Viking society is noteworthy.) Harald and the Danes had accepted Christianity in c. 960, but Norway did not become Christian until 1015.

During the tenth century, a new style emerged in Scandinavia and the British Isles, one that combined simple foliage elements and coarse ribbon interlaces with animals that are more recognizable than the gripping beasts of the Oseberg ship. On one face of the Jelling Stone the sculptor carved the image of Christ robed in the Byzantine manner, with arms outstretched as if crucified. He is entangled in a double-ribbon interlace instead of a cross. A second side holds the runic inscriptions, and a third, a striding creature resembling a lion fighting a snake. The coarse, loosely twisting double-ribbon interlace covering the surface of the stone could have been inspired by Hiberno-Saxon art. New to the north, however, are bits of foliage that spring illogically from the animal—the Great Beast's tail, for example, is a rudimentary leaf. The Great Beast symbolizes the Lion of Judah, an Old Testament prefiguration of the militant Christ, and thus is wholly appropriate for a royal monument commemorating the conversion of the Danes and Harald's victorious dynasty.

and precious objects, the ship itself and its equipment attest to the wealth and prominence of the ship's owner.

This vessel, propelled by both sail and oars, was designed for travel in the relatively calm waters of fjords (narrow coastal inlets), not for voyages in the open sea. The burial chamber held the bodies of two women—a queen and her companion or servant. At least twelve horses, several dogs, and an ox had been sacrificed to accompany the women on their last journey. A cart and four sleds, all made of wood with beautifully carved decorations, were also stored on board. The cabin contained empty chests that no doubt once held precious goods.

The prow and stern of the Oseberg ship rise and coil, the spiraling prow ending in a tiny serpent's head. Bands of interlaced animals carved in low relief run along the ship's bow and stern. Viking beasts are broad-bodied creatures that clutch each other with sharp claws; in fact, these animals are known as "gripping beasts" (**FIG. 14–21**). They are grotesque catlike

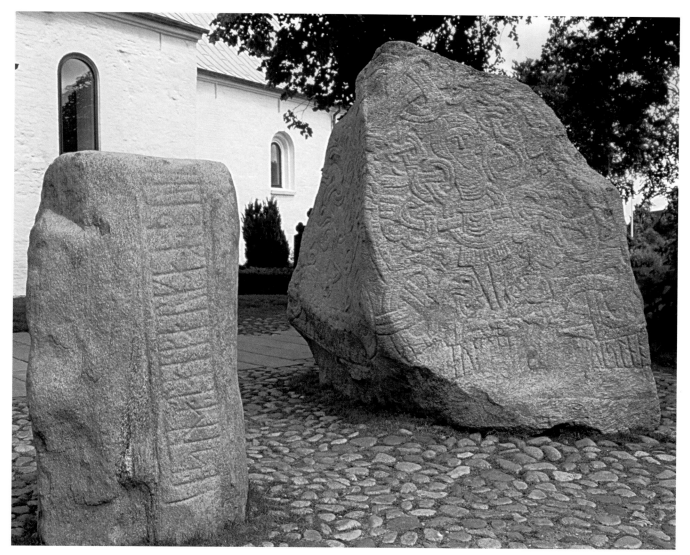

14–22 | ROYAL RUNE STONES
Left: Raised by Gorm the Old to honor his wife Thyra. Right: Raised by Harald Bluetooth to honor his parents Gorm and Thyra and to commemorate the conversion of the Danes to Christianity. Jelling, Denmark, 960-985, granite, height of Harald's stone about 8' (2.44 m). The stone church in the background dates c. 1100 and replaces a series of wooden churches on the site.

THE URNES CHURCH PORTAL. The penchant for carved relief decorations seen on the Oseberg ship endured in the decoration of Scandinavia's great halls and later churches. The façades of these structures often teem with intricate animal interlace. A church at Urnes, Norway, although entirely rebuilt in the twelfth century, preserved its original eleventh century doorway (FIG. 14–23), carved with an interlace of serpentine creatures snapping at each other like the vicious little gripping beasts of Oseberg. New in the Urnes style, however, is the satin-smooth carving of rounded surfaces, the contrast of thick and very thin elements, and the organization of the interlace into harmoniously balanced patterns, which have the effect of aesthetic elegance and technical control rather than the wild disarray of earlier carving.

The images on the Urnes doorway panels suggest the persistence of Scandinavia's mythological tradition even as Christianity spread through the country. The Great Beast standing at the left of the door, fighting serpents and dragons, continued to be associated with the Lion of Judah (as at Jelling) and with Christ, who fought Satan and the powers of darkness and paganism (like the peacock and snake image in Mozarabic art). With Christianity, the Great Beast became a positive, protective force.

Timber Architecture

In Scandinavia vast forests provided the materials for timber buildings of all kinds (FIG. 14–24). Two forms of timber construction evolved: one that stacked horizontal logs, notched at the ends, to form a rectangular building (the still popular log cabin); and the other that stood the wood on end to form a palisade or vertical plank wall, with timbers set directly in the ground or into a sill (a horizontal beam).

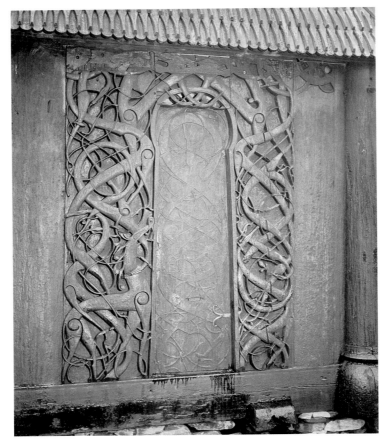

14–23 | **PORTAL, SET INTO WALL OF LATER STAVE CHURCH**
Urnes, Norway. 11th century.

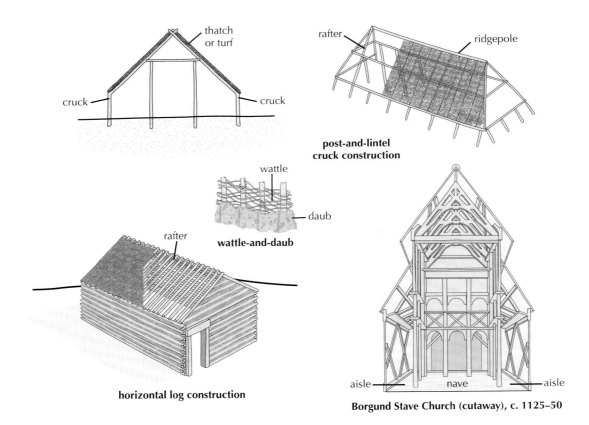

thatch or turf

cruck

cruck

post-and-lintel cruck construction

rafter

ridgepole

wattle

daub

wattle-and-daub

rafter

horizontal log construction

aisle

nave

aisle

Borgund Stave Church (cutaway), c. 1125–50

14–24 | **DIAGRAMS OF WOOD BUILDINGS IN NORTHERN EUROPE**
Horizontal log construction; wattle and daub used to plaster between timbers; stave church is a
highly crafted version of plank wall construction.

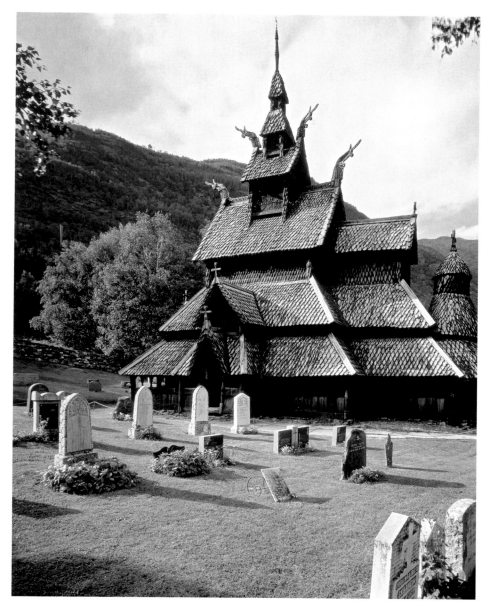

14–25 | **STAVE CHURCH, BORGUND, NORWAY**
c. 1125–50.

More modest buildings consisted of wooden frames filled with wattle-and-daub (woven branches covered with mud or other substances). Typical buildings had a turf or thatched roof supported on interior posts. The same basic structure was used for almost all building types—feasting and assembly halls, family homes (which were usually shared with domestic animals), workshops, barns, and sheds. The great hall had a central open hearth (smoke escaped through a louver in the roof) and an off-center door designed to reduce drafts. People secured their residences and trading centers by building massive circular earthworks topped with wooden palisades.

THE BORGUND STAVE CHURCH. Subject to decay and fire, early timber buildings have largely disappeared, leaving only post-

holes and other traces in the soil; however, a few timber churches survive in rural Norway. They are called stave churches, from the four huge timbers (staves) that form their structural core. Borgund Church, from about 1125–50 (FIG. 14–25), has four corner staves supporting the central roof, with additional interior posts that create the effect of a nave and side aisles, narthex, and choir. A rounded apse covered with a timber tower is attached to the choir. Upright planks slotted into the sills form the walls. A steep-roofed gallery rings the entire building, and steeply pitched roofs covered with wooden shingles protect the walls from the rain and snow. Openwork timber stages set on the roof ridge create a tower and give the church a steep pyramidal shape. On all the gables are both crosses and dragons to protect the church and its congregation from trolls and demons.

14–26 | **OTTO I PRESENTING MAGDEBURG CATHEDRAL TO CHRIST**

One of a series of seventeen ivory plaques known as the *Magdeburg Ivories,* possibly carved in Milan c. 962–68. Ivory, 5 × 4½" (12.7 × 11.4 cm). The Metropolitan Museum of Art, New York.

Bequest of George Blumenthal, 1941 (41.100.157)

The End of the Viking Era

The Vikings were not always victorious. Their colonies in Iceland and the Faeroe Islands survived, but in North America—in Canada—their trading posts eventually had to be abandoned. In Europe, south of the Baltic Sea, a new German dynasty challenged and then defeated the Vikings. During the eleventh century the Viking era came to an end.

OTTONIAN EUROPE

When Charlemagne's grandsons divided the empire in 843, Louis the German took the eastern portion. His family died out at the beginning of the tenth century, and a new Saxon dynasty came to power in lands corresponding roughly to present-day Germany and Austria. This dynasty was called Ottonian after its three principal rulers—Otto I (ruled 936–73), Otto II (ruled 973–83), and Otto III (ruled 994–1002; queens Adelaide and Theophanu had ruled as regents for him, 983–94). The Ottonian armies secured the territory by defeating the Vikings in the north and the Magyars (Hungarians) on the eastern frontier. Relative peace permitted increased trade and the growth of towns, making the tenth century a period of economic recovery. Then, in 951, Otto I gained control of northern Italy by marrying the wid-owed Lombard Queen Adelaide. He was crowned emperor by the pope in 962, and so reestablished Charlemagne's Christian Roman Empire. The Ottonians and their successors so dominated the papacy and appointments to other high Church offices that in the twelfth century this union of Germany and Italy under a German ruler came to be known as the Holy Roman Empire. The empire survived in modified form as the Habsburg Empire into the twentieth century.

The Ottonian Empire was of necessity a military state. Aware of the threat of the pagan Slavs, in the 960s Otto established a buffer zone on the border with its headquarters in Magdeburg, the site of a frontier monastery. In 968 the pope made Magdeburg his administrative center in the region as well. Otto brought the relics of Saint Maurice from Burgundy, in France, to Magdeburg in 960. Saint Maurice, an African Christian commander in third century Gaul, was executed with all his troops for refusing to sacrifice to pagan Roman gods (as commander of the Theban Legion, Maurice was often represented as an African, SEE FIG. 16–37). The warrior saint became the patron of the Ottonian Empire.

THE MAGDEBURG IVORIES. The unity of church and state is represented on an ivory plaque, one of several that may once have been part of the decoration of an altar or pulpit presented to the cathedral at the time of its dedication in 968. Saint Maurice wraps his arm protectively around Otto I, who with solemn dignity presents a model of the cathedral to Christ and Saint Peter (FIG. 14–26). Hieratic scale demands that the mighty emperor be represented as a tiny, doll-like figure, and that the saints and angels, in turn, be taller than Otto but smaller than Christ. The cathedral Otto holds is a basilica with prominent clerestory windows and rounded apse that are intended to recall the churches of Rome.

Ottonian Architecture

The Ottonian rulers, in keeping with their imperial status, sought to replicate the splendors of the Christian architecture of Rome. German officials knew the basilicas well, since the German court in Rome was located near the Early Christian Church of Santa Sabina. The buildings of Byzantium were another important influence, especially after Otto II married a Byzantine princess, cementing a tie with the East. But while Ottonian patrons saw, envied, and ordered buildings to rival the sophisticated architecture of imperial Rome and Byzantium, the locally trained masons and carpenters could only struggle to comply. They built large timber-roofed basilicas that were terribly vulnerable to fire. Magdeburg Cathedral burned in 1008, only forty years after its dedication; it was rebuilt in 1049, burned in 1207, and rebuilt yet again. In 1009, the Cathedral of Mainz burned down on the day of its consecration. The Church of Saint Michael at Hildesheim was destroyed in World War II. Luckily the convent Church of Saint Cyriakus at Gernrode, Germany, still survives.

14-27 | **CHURCH OF SAINT CYRIAKUS**
Gernrode, Germany. Begun 961; consecrated 973.

The apse seen here replaced the original portal of the westwork in the late twelfth century.

THE CHURCH OF SAINT CYRIAKUS, GERNRODE. During the Ottonian Empire, aristocratic women often held positions of authority, especially as the leaders of religious communities. When in 961 the provincial military governor Gero founded the convent and church of Saint Cyriakus, he made his widowed daughter-in-law the convent's first abbess. The church was designed as a basilica with a westwork, an architectural feature that took on greater importance with the increasing elaboration of the liturgy (FIG. 14–27). At Gernrode, the exterior appearance of the westwork was changed in the late twelfth century by the addition of an apse, although the two tall cylindrical towers continue to dominate the skyline. At the eastern end of the church a transept with chapels led to a choir with an apse built over a crypt. This development at both the east and west ends of the nave gave the building the "double-ended" look characteristic of major Ottonian churches. The nuns entered the church from the convent through modest side doors. Pilasters, joined by arches attached to the wall, form blind arcades, and windows also break the severity of the church's exterior.

The interior of Saint Cyriakus (FIG. 14–28) has three levels: an arcade separating the nave from the side aisles, a gallery with groups of six arched openings, and a clerestory. The flat ceiling is made of wood and must have been painted. Galleries over aisles were used in Byzantine architecture but rarely in the West, and their function in Ottonian architecture is uncertain.

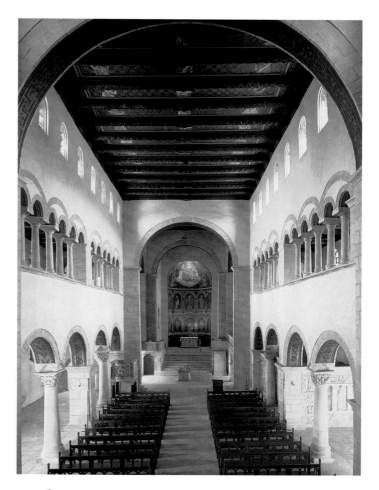

14-28 | **NAVE, CHURCH OF SAINT CYRIAKUS**

THE OBJECT SPEAKS

THE DOORS OF BISHOP BERNWARD

The design of the magnificent doors at Bishop Bernward's abbey church in Hildesheim, Germany, anticipated by centuries the great sculptural programs that would decorate the exteriors of European churches in the Romanesque period. The awesome monumentality of the towering doors—nearly triple a person's height—is matched by the intellectual content of their iconography. The doors spoke eloquently to the viewers of the day and still speak to us through a combination of straightforward narrative history and subtle interrelationships, in which Old Testament themes, on the left, illuminate New Testament events, on the right. Bernward must have designed the iconographical program himself, for only a scholar thoroughly familiar with Christian theology could have conceived it.

The Old Testament history begins in the upper left-hand panel with the Creation and continues downward to depict Adam and Eve's Expulsion from Paradise, their difficult and sorrowful life on earth, and, in the bottom panel, the tragic fratricidal story of their sons, Cain and Abel. The New Testament follows, beginning with the Annunciation at the lower right and reading upward through the early life of Jesus and his mother, Mary, through the Crucifixion to the Resurrection, symbolized by the three Marys at the tomb.

The way the Old Testament prefigured the New in scenes paired across the doors is well illustrated, for example, by the third set of panels, counting down from the top. On the left, we see the Temptation and Fall of Adam and Eve in the Garden of Eden, believed to be the source of human sin, suffering, and death. This panel is paired on the right with the Crucifixion of Jesus, whose suffering and sacrifice redeemed humankind, atoned for Adam and Eve's Original Sin, and brought the promise of eternal life. Another example is the recurring pairing of the "two Eves": Eve, who caused humanity's Fall and Expulsion from Paradise and whose son Cain committed the first murder; and Mary, the "new Eve," through whose son, Jesus, salvation will be granted. In one of the clearest juxtapositions, in the sixth pair down, Eve and Mary are almost identical figures, each holding her first-born son; thus, Cain and Jesus (evil and goodness) are also paired.

DOORS OF BISHOP BERNWARD Made for the Abbey Church of Saint Michael, Hildesheim, Germany. 1015. Bronze, height 16′6″ (5 m).

LEFT DOOR

read down ↓

OLD TESTAMENT
(Genesis)

THEMATIC
COMPARISONS

RIGHT DOOR

read up ↑

NEW TESTAMENT
(Gospels)

LIFE IN
PARADISE

Creation of Adam

PARADISE LOST
vs.
PARADISE GAINED

The Ascension

Eve presented
to Adam

GREETINGS

The Three Marys
at the Tomb

PROMISE
OF RETURN
TO PARADISE

THE FALL

Temptation
and Fall

TREE OF KNOWLEDGE
(SIN)
vs.
TREE OF LIFE
(THE CROSS, SALVATION)

The Crucifixion

Accusation and
Judgment of
Adam and Eve

JUDGMENT

Judgment of Christ
by Pilate

THE
PASSION

LIFE
IN THE
WORLD

Expulsion from
Paradise

SEPARATION
FROM GOD
vs.
REUNION WITH GOD

Presentation of
Jesus in Temple

Arduous life
on earth

FIRSTBORN SONS OF
EVE (CAIN) AND
MARY (JESUS);
POVERTY vs. WEALTH

Gifts of the Magi

INFANCY
OF JESUS

EVE'S
CHILDREN

Offerings by
Cain (grain)
and Abel (lamb)

ABEL'S SACRIFICIAL
LAMB
vs.
JESUS, LAMB OF GOD

The Nativity

Abel murdered
by Cain

DESPAIR, SIN, MURDER
vs.
HOPE AND
EVERLASTING LIFE

The Annunciation
(Incarnation)

MARY'S
CHILD

SCHEMATIC DIAGRAM OF THE MESSAGE OF THE DOORS OF BISHOP BERNWARD OF HILDESHEIM

I4–29 | GERO CRUCIFIX
Cologne Cathedral, Germany. c. 970. Painted and gilded wood, height of figure 6′2″ (1.88 m).

This life-size sculpture is both a crucifix to be suspended over an altar and a special kind of reliquary. A cavity in the back of the head was made to hold a piece of the Host, or communion bread, already consecrated by the priest. Consequently, the figure not only represents the body of the dying Jesus but also contains within it the body of Christ obtained through the Eucharist.

They may have provided space for choirs as music became more elaborate in the tenth century. They may have held additional altars. They may have been simply a mark of status.

The alternation of columns and rectangular piers in Saint Cyriakus creates a rhythmic effect more interesting than that of the uniform colonnades of the Early Christian churches. Saint Cyriakus is also marked by vertical shifts in visual rhythm, with two arches on the nave level surmounted by six arches on the gallery level, surmounted in turn by three windows in the clerestory. This seemingly simple archi-tectural aesthetic, with its rhythmic alternation of heavy and light supports, its balance of rectangular and round forms, and its combination of horizontal and vertical movement found full expression later in the Romanesque period.

Ottonian Sculpture

Ottonian artists worked in ivory, bronze, wood, and other materials rather than stone. Like their Early Christian and Byzantine predecessors, they and their patrons focused on church furnishings and portable art rather than architectural

sculpture. Drawing on Roman, Early Christian, Byzantine, and Carolingian models, they created large sculpture in wood and bronze that would have a significant influence on later medieval art.

THE GERO CRUCIFIX. The **GERO CRUCIFIX** is one of the few large works of carved wood to survive from the early Middle Ages (**FIG. 14–29**). Archbishop Gero of Cologne (ruled 969–76) commissioned the sculpture for his cathedral about 970. The figure of Christ is more than 6 feet tall and is made of painted and gilded oak. The focus here, following Byzantine models, is on Jesus's suffering. He is shown as a tortured martyr, not as the triumphant hero of the *Lindau Gospels* cover (SEE FIG. 14–19). Jesus's broken body sags on the cross and his head falls forward, eyes closed. The straight, linear fall of his golden drapery heightens the impact of his drawn face, emaciated arms and legs, sagging torso, and limp, bloodied hands. In this image of distilled anguish, the miracle and triumph of the Resurrection seem distant indeed.

THE HILDESHEIM BRONZES. Under the last of the Ottonian rulers, Henry II and Queen Kunigunde (ruled 1002–24), an important artist and patron was Bishop Bernward of Hildesheim. His biographer, the monk Thangmar, described Bernward as a skillful goldsmith who closely supervised the artisans working for him. Bronze doors made under his direction for the Abbey Church of Saint Michael in Hildesheim represented the most ambitious and complex bronze-casting project undertaken since antiquity (see "The Doors of Bishop Bernward," page 466). As tutor for Otto III, the bishop had lived in Rome, where he would have seen the carved wooden doors of the fifth-century Church of Santa Sabina, located near Otto's palace.

The doors' rectangular panels recall not only Santa Sabina (SEE FIG. 7–14) but also resemble the framed miniatures in Carolingian Gospel books. The style of the sculpture is reminiscent of illustrations in manuscripts such as the *Utrecht Psalter*. Animated small figures populate spacious backgrounds. Architectural elements and features of the landscape are depicted in very low relief, forming little more than a shadowy stage for the actors in each scene. The figures stand out prominently, in varying degrees of relief, with their heads fully modeled in three dimensions. The result is lively, visually stimulating, and remarkably spontaneous for so monumental an undertaking.

Illustrated Books

Book illustration in the Ottonian period is not as varied as it is in Carolingian manuscripts, although artists continued to work in widely scattered centers, using different models or sources of inspiration. The **LIUTHAR** (or **AACHEN**) **GOSPELS** (named for the scribe or patron) were made for Otto III around 996 in a monastic *scriptorium* near Reichenau. The dedication page (**FIG. 14–30**) is a work of imperial propa-

14–30 | PAGE WITH OTTO III ENTHRONED, LIUTHAR GOSPELS (AACHEN GOSPELS)
c. 996. Ink, gold, and colors on vellum, 10⅞ × 8½″ (27.9 × 21.8 cm). Cathedral Treasury, Aachen.

ganda meant to establish the divine underpinnings of Otto's authority and depicts him as a near-divine being himself. He is shown enthroned in heaven, surrounded by a mandorla and symbols of the evangelists. The hand of God descends from above to place a crown on his head, and Otto holds the Orb of the World surmounted by a cross in his right hand. His throne, in a symbol of his worldly dominion, rests on the crouching Tellus, the personification of earth. In what may be a reference to the dedication on the facing page—"With this book, Otto Augustus, may God invest thy heart"—the evangelists represented by their symbols hold a white banner across the emperor's breast. On each side of Otto, male figures bow their crowned heads as subordinate rulers acknowledging his sovereignty. The bannered lances they hold may allude to the Ottonians' most precious relic, the Holy Lance, believed to be the one with which the Roman soldier Longinus pierced Jesus's side. In the lower register, two warriors face two bishops, symbolizing the union of secular and religious power under the emperor.

A second Gospel book made for Otto III in the same *scriptorium* illustrates the painters' narrative skill. In an episode

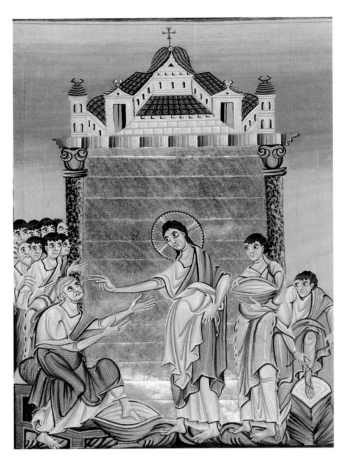

14–31 | **PAGE WITH CHRIST WASHING THE FEET OF HIS DISCIPLES, AACHEN GOSPELS OF OTTO III.**
c. 1000. Ink, gold, and colors on vellum, approx. 8 × 6″ (20.5 × 14.5 cm). Staatsbibliothek, Munich.
Nr. 15131, Clm 4453, fol 237r.

recounted in Chapter 13 of the Gospel according to John, Jesus, on the night before his Crucifixion, gathered his disciples together to wash their feet (FIG. 14–31). Peter, who felt unworthy, at first protested. The painting shows a towering Jesus in the center extending an elongated arm and hand in blessing toward the elderly apostle. Peter, his foot in a basin of water, reaches toward Jesus with similarly elongated arms. The two figures fix each other with wide-eyed stares. Gesture and gaze carry the meaning in Ottonian painting: A disciple on the far right unbinds his sandals, and another, next to him, carries a basin of water while the other disciples look on. The light behind Jesus has turned to gold, which is set off by buildings suggesting the Heavenly Jerusalem. The painter conveys a sense of spirituality and contained but deeply felt emotion, as well as the austere grandeur of the Ottonian court.

These manuscript paintings summarize the high intellectual and artistic qualities of Ottonian art. Ottonian artists drew inspiration from the past to create a monumental style for a Christian, German-Roman empire. From the groundwork laid during the early medieval period emerged the arts of the Romanesque and Gothic periods in Western Europe.

IN PERSPECTIVE

People living outside the Roman Empire had a heritage of both imaginative abstract art and well-observed animal images. They also had an exceptionally high level of technical skill in the crafts, especially metalwork, and in wooden architecture and sculpture. The Celts, Norse, Goths, and Saxons sought to capture the essence of forms in dynamic, colorful, linear art. From astonishingly complex geometric patterns and interlaces they created imaginary creatures. They loved light and color in the form of gold and jewels. As exchanges of intellectual and artistic influences took place among the diverse groups that populated Europe, an extraordinary amalgam of ancient classical forms and Celtic and Germanic styles took place. The new narrative and figurative art that emerged was also richly decorative and expressive.

As the Western Roman Empire disintegrated, the Christian Church assumed an ever greater social as well as spiritual role. Although the Roman Empire itself was no longer a vital entity, the idea of imperial Rome—both as a secular empire and as the headquarters of the Christian Church—remained strong in people's minds. Twice, charismatic leaders gathered disparate factions together into short-lived but powerful empires—the Carolingians at the end of the eighth and beginning of the ninth centuries, and the Ottonians in the tenth century. The pope in Rome emerged as the supreme leader of the Church, and the Germanic rulers reinforced their power by supporting Rome.

Carolingian artists following ancient models brought together the classical perception of human forms, of weight and mass, with the highly developed decorative sensibility and impeccable craftsmanship of Hiberno-Saxon artisans. The arts provided a splendid and symbolic setting for the Carolingian monarchs and served to advance their imperial ambitions. This flowering of art and scholarship as well as the Christian mission came to a halt during the devastating raids of Viking adventurers. The Vikings had their own cultural and artistic traditions, dating back to their Norse ancestors. Theirs was an animal art very different from the imperial and humanistic Mediterranean arts.

Otto the Great defeated the Vikings and created a new Germanic empire in Germany and Italy. Artists served both the empire and the revitalized Church where spiritual values were considered to be superior to the material world. They created a monumental art, with images of overwhelming solemnity. Their work has a directness that often hides complex meanings. Conservative in their reference to Early Christian, Byzantine, and Carolingian art and innovative in their subordination of earlier northern styles to the new imperial ideal, Ottonian artists reaffirmed the value of art and architecture to carry powerful secular and religious messages. As they brought monumentality, dignity, and grandeur to the art of the West, they paved the way for the mature Christian art in Western Europe.

GUMMERSMARK BROOCH
6TH CENTURY

GOSPEL BOOK OF DURROW,
PAGE WITH MAN
SECOND HALF 7TH CENTURY

LINDAU GOSPEL COVER
c. 870–80

EMERITUS AND ENDE.
BATTLE OF BIRD AND SERPENT,
BEATUS'S COMMENTARY
975

ROYAL RUNE STONE,
JELLING
c. 980

EARLY MEDIEVAL ART IN EUROPE

500

◀ **Rule of St. Benedict** c. 530 CE

600

◀ **Lombards in Italy** c. 568–774 CE
◀ **Visigoths in Spain Adopt Western Christianity** c. 589 CE
◀ **St. Augustine in England** 597 CE

700

◀ **Muslims Conquer Spain** 711 CE

800

◀ **Carolingian Empire** c. 768–887 CE
◀ **Viking Raids Begin** 793 CE
◀ **Charlemagne Crowned Emperor by the Pope in Rome** 800 CE

900

◀ **Cluny Founded** 910 CE
◀ **Ottonian Empire** c. 919–1024 CE

1000

◀ **Viking Settlement in North America** 1000 CE

1100

15–1 | CHRIST AND DISCIPLES ON THE ROAD TO EMMAUS Cloister of the Abbey of Santo Domingo, Silos,
Castile, Spain. Pier relief, figures nearly life-size. c. 1100.

ROMANESQUE ART

15

Three men, together under an arch supported by slender columns, seem to glide forward on tiptoe (FIG. 15–1). The leader turns back, reversing their forward movement. The men's bodies seem almost boneless, their legs cross in slow curves rather than vigorous strides; their shoulders, elbows, and finger joints seem to melt; draperies are reduced to delicate curving lines. Framed by haloes, three bearded faces—foreheads covered by locks of hair—stare out with large wide eyes under strong arched brows. The figures interrelate and interlock without exceeding the limits of the controlling architecture.

Captivated by tranquility, the viewer only gradually realizes that this panel is more than mere decoration. The leader is identified as Christ by his large size and cruciform halo. He wears a ribbed cap and carries a satchel and a short staff. The scene depicts Christ and two disciples on the road from Jerusalem to the village of Emmaus (Luke 24: 13–35). Christ has the distinctive attributes of a pilgrim—a hat, a satchel, and a walking stick. A final surprise rewards a close examination—a scallop shell on Christ's satchel. The scallop shell is the badge worn by the pilgrims to the shrine of Saint James in Santiago de Compostela, Spain. Early pilgrims reaching this destination in the far northwestern corner of the Iberian Peninsula continued to the coast to pick up a shell as evidence of their journey. Soon shells were gathered (or made from metal as brooches) and sold to the pilgrims by authorized persons—a lucrative business for both the sellers and the church. On the return home the shell became the pilgrim's passport.

The *Road to Emmaus* was carved on a corner pier in the cloister of the monastery of Santo Domingo de Silos, south of the pilgrimage road across Spain (see "The Pilgrim's Journey," page 480). Santo Domingo was the eleventh century abbot of Silos. The monastery had a flourishing *scriptorium* and metal smithing shops where artists as well as sculptors worked in a Mozarabic style.

The sculpture at Silos is filled with the spirit of the Romanesque. The art is essentially figurative, narrative, and didactic; it is based on Christian story and belief. It develops out of a combination of styles, not only ancient Roman art as the name might suggest. The sculpture is shaped by a new awakening. Pilgrimages to visit the scenes of Christ's life and the tombs of martyrs (those who died for their faith) inspired not only architecture and the arts. The conflict between Christians and Muslims—and the ensuing Christian Crusades to win back conquered territories and gain access to sacred places like Jerusalem—taught more than military tactics. Travel as a Crusader or a pilgrim opened the mind to a world beyond the familiar towns and agricultural villages of home. The distinctive style of the Romanesque signifies a new era in the social and economic life of Europe, an awakening of intellectual exploration.

EUROPE IN THE ROMANESQUE PERIOD

At the beginning of the eleventh century, Europe was still divided into many small political and economic units ruled by powerful families, such as the Ottonians in Germany (Chapter 14). The nations we know today did not exist, although for convenience we will use present-day names of countries. The king of France ruled only a small area around Paris known as the Ile-de-France. The southern part of modern France had close linguistic and cultural ties to northern Spain; in the north the Duke of Normandy (heir of the Vikings) and in the east the Duke of Burgundy paid the French king only token homage.

When in 1066 Duke William II of Normandy (ruled 1035–87) invaded England and, as William the Conqueror, became that country's new king, Norman nobles replaced the Anglo-Saxon nobility there, and England became politically and culturally allied with Normandy in France. As astute and skillful administrators, the Normans formed a close alliance with the Church, supporting it with grants of land and gaining in return the allegiance of abbots and bishops. Normandy became one of Europe's most powerful feudal domains.

In the eleventh century, the Holy Roman Empire (formerly the Ottonian empire), which encompassed much of Germany and northern Italy (Lombardy), became embroiled in a conflict with the papacy. In 1075, Pope Gregory VII (papacy 1073–85) declared that only the pope could appoint bishops and abbots; the emperor demanded the right for himself. Not only nobles, but cities took sides. In the power struggle between the Holy Roman emperor and the pope, the pope emerged victorious. The conflict persisted in the wars between the great German families, the Welfs of Saxony (known in Italy as the Guelfs), who supported the pope, and the Hohenstaufens of Swabia (or, in Italy, the Ghibellines), who backed the emperor.

Meanwhile, the Iberian Peninsula remained divided between Muslim rulers in the south and Christian rulers in the north. The power of the Christian rulers grew as they joined forces through marriage and inheritance and fought to extend their territory southward. By 1085, Alfonso VI of Castile and León (ruled 1065–1109) had conquered the Muslim stronghold of Toledo, a center of Islamic and Jewish culture in the kingdom of Castile. By this victory he acquired treasures, vast territories, and a skilled work force of Christians, Muslims, and Jews. Catalunya (Catalonia) emerged as a power along the Mediterranean coast.

By the end of the twelfth century, however, a few exceptionally intelligent and aggressive rulers began to create national states. The Capetians in France and the Plantagenets in England were especially successful. In Germany and northern Italy the power of local rulers and towns prevailed, and Germany and Italy remained politically fragmented until the nineteenth century.

Political and Economic Life

Although towns and cities with artisans and merchants gained importance, Europe remained an agricultural society, with land the primary source of wealth and power for a hereditary aristocracy. *Feudalism,* a system of mutual obligation and exchange of land for services that had developed in the early Middle Ages, governed social and political relations, especially in France and England. A landowning lord granted property and protection to a subordinate, called a vassal. In return, the vassal pledged allegiance and military service to the lord.

The economic foundation for this political structure was the manor, a self-sufficient agricultural estate where peasants worked the land in exchange for a place to live, military protection, and other services from the lord. Economic and political power depended on a network of largely inherited but constantly shifting allegiances and obligations among lords, vassals, and peasants.

THE WORCESTER CHRONICLE. The social and economic classes become vividly clear in the **WORCESTER CHRONICLE**, which depicts the three classes of medieval society: the king and nobles, the churchmen, and the peasant farmers (**FIG. 15–2**). The book is the earliest known illustrated record of contemporary events in England and was written by John, a monk of Worcester. He described the nightmares of King

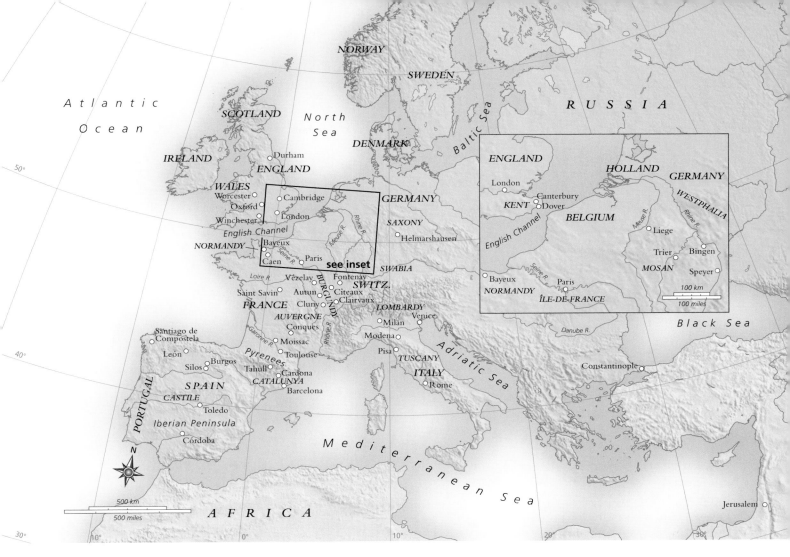

MAP 15–1 | EUROPE IN THE ROMANESQUE PERIOD

Although a few large political entities began to emerge in places like England and Normandy, Burgundy, and Leon-Castile, Europe remained a land of small economic entities. Pilgrimages and crusades acted as unifying international forces. Modern names of countries have been added for convenience.

Henry I (ruled 1100–35) in 1130 in which the people demanded tax relief. On the first night, angry farmers, still carrying their shovels, forks, and scythes, hold up their list of grievances; in the second dream, armed knights confront the king; and then on the third night, monks, abbots, and bishops challenge the sleeping king, who is observed by the royal physician Grimbald. Finally, the king is caught in a storm at sea and saves himself by promising to lower taxes for a period of seven years. Speech is indicated by pointing a finger; sleep, by propping the head on a hand or arm; and royal status, by the crown worn by the sleeping king. Since the goal of the artist was to communicate clearly, not to decorate the text, the illustrations give an excellent idea of the appearance of the people.

The Church

In the early Middle Ages, church and state had forged an often fruitful alliance. Christian rulers helped insure the spread of Christianity throughout Europe and supported monastic communities with grants of land. Bishops and abbots were often their relatives, younger brothers and cousins, who provided rulers with crucial social and spiritual support and supplied them with educated administrators. As a result, secular and religious authority became tightly intertwined.

PILGRIMAGES. Reinforcing the importance of religion were two phenomena of the period: pilgrimages and the Crusades. Pilgrimages to the holy places of Christendom—Jerusalem, Rome, and Santiago de Compostela—increased, despite the great financial and physical hardships they entailed (see "The Pilgrim's Journey," page 480). As difficult and dangerous as these journeys were, rewards awaited courageous travelers along the routes. Pilgrims could stop to venerate the relics of local saints and visit the places where miracles were believed to have taken place. They also learned about people and places far removed from their isolated village life.

CRUSADES. In the eleventh and twelfth centuries, Christian Europe, previously on the defensive against the expanding forces of Islam, became the aggressor. In Spain, Christian armies of the north were increasingly successful against the

15–2 | John of Worcester **THOSE WHO WORK; THOSE WHO FIGHT; THOSE WHO PRAY—THE DREAM OF HENRY I, WORCESTER CHRONICLE WORCESTER**
England. c. 1140. Ink and tempera on vellum, each page 12¾ × 9⅜" (32.5 × 23.7 cm). Corpus Christi College, Oxford.
CCC MS 157, pages 382–83

Islamic south. At the same time, despite the schism within the Church (SEE Chapter 7), the Byzantine emperor asked the pope for help in his war with the Muslims. The Western Church responded in 1095 by launching a series of military expeditions against Islamic powers known as the Crusades. The word *crusade* (from "crux") refers to the cross worn by Crusaders and pilgrims.

This First Crusade was preached by Pope Urban II (a Cluniac monk and pope from 1088 to 1099) and supported by the lesser nobility of France, who had economic and political as well as spiritual goals. The Crusaders captured Jerusalem in 1099 and established a short-lived kingdom. The Second Crusade in 1147, preached by Saint Bernard and led by France and Germany, accomplished nothing. The Muslim leader Saladin united the Muslim forces and captured Jerusalem in 1187, inspiring the Third Crusade, led by German, French, and English kings. (This is the period of Richard Lionheart and Robin Hood.) The Christians recaptured some territory, but not Jerusalem, and in 1192 they concluded a truce with the Muslims, permitting the Christians access to the shrines in Jerusalem. Crusades continued to be mounted against non-Christians and foes of the papacy. Today the word *crusade* still implies zealous devotion to a cause.

The crusading movement had far-reaching cultural and economic consequences. The Westerners' direct encounters with the more sophisticated material culture of the Islamic world and the Byzantine Empire created a demand for goods from the East. This in turn helped stimulate trade and with it an increasingly urban society during the eleventh and twelfth centuries.

Intellectual Life

The eleventh and twelfth centuries were a time of intellectual ferment as Western scholars rediscovered the classical Greek and Roman texts that had been preserved in Islamic Spain and the eastern Mediterranean. The first universities were established in the growing cities—Bologna (eleventh century) and Paris, Oxford, and Cambridge (twelfth century). Monastic communities continued to play a major role in the intellectual life of Romanesque Europe. Monks and nuns also provided valuable social services, including caring for the sick and destitute, housing travelers, and educating the people. Because monasteries were major landholders, abbots and priors were part of the feudal power structure. The children of aristocratic families who joined religious orders also helped forge links between monastic communi-

SAINT BERNARD AND THEOPHILUS: OPPOSING VIEWS ON THE ART OF THEIR TIME

n a letter to William of Saint-Thierry, Bernard of Clairvaux wrote,

But in the cloister, under the eyes of the Brethren who read there, what profit is there in those ridiculous monsters, in that marvellous and deformed comeliness, that comely deformity? To what purpose are those unclean apes, those fierce lions, those monstrous centaurs, those half-men, those striped tigers, those fighting knights, those hunters winding their horns? Many bodies are there seen under one head, or again many heads to a single body. Here is a four-footed beast with a serpent's tail; there, a fish with a beast's head. Here again the forepart of a horse trails half a goat behind it, or a horned beast bears the hinder quarters of a horse. In short, so many and so marvellous are the varieties of divers shapes on every hand, that we are more tempted to read in the marble than in our books, and to spend the whole day in wondering at these things rather than in meditating the law of God. For God's sake, if men are not ashamed of these follies, why at least do they not shrink from the expense?

(from Caecilia Davis-Weyer. *Early Medieval Art 300–1150: Sources and Documents*. New Jersey: Prentice-Hall, 1971, p. 170.)

"Theophilus" is the pseudonym used by a monk who wrote an artist's handbook, *On Divers Arts*, about 1100. The book gives detailed instructions for painting, glassmaking, and goldsmithing. In contrast to the stern warnings of Abbot Bernard, "Theophilus" assured artists that "God delights in embellishments" and that artists worked "under the direction and authority of the Holy Spirit."

He wrote

most beloved son, you should not doubt but should believe in full faith that the Spirit of God has filled your heart when you have embellished His house with such great beauty and variety of workmanship . . . Set a limit with pious consideration on what the work is to be, and for whom, as well as on the time, the amount, and the quality of work, and, lest the vice of greed or cupidity should steal in, on the amount of the recompense.

(Theophilus, page 43).

ties and the ruling elite. The dominant order had been the Benedictines, but as life in Benedictine communities grew increasingly comfortable, reform movements arose. Reformers claimed to return to the original austerity and spirituality of earlier times. The most important for the arts was the congregation of Cluny founded in the tenth century in Burgundy (in eastern-central France) and the Cistercians in the eleventh century.

ROMANESQUE ART

The word *Romanesque* means "in the Roman manner," and the term applies specifically to eleventh- and twelfth-century European architecture and art. The word was coined in the early nineteenth century to describe European church architecture, which often displayed the solid masonry walls and the rounded arches and vaults characteristic of imperial Roman buildings. Soon the term was applied to all the arts of the period from roughly the mid-eleventh to the late-twelfth century, even though the art reflects influences from many sources, including Byzantine, Islamic, and early medieval European art.

The eleventh and twelfth centuries were a period of great building activity in Europe. Castles, manor houses, churches, and monasteries arose everywhere. As one eleventh-century monk noted, "Each people of Christendom rivaled with the other, to see which should worship in the finest buildings. The world shook herself, clothed everywhere in a white garment of churches" (Radulphus Glaber, cited in Holt, *A Documentary History of Art*, vol. I, page 18). Increased prosperity in spite of frequent domestic warfare made the resources available to build monumental stone architecture. The desire to glorify the house of the Lord and his saints (whose earthly remains in the form of relics kept their presence alive in the minds of the people) increased throughout Christendom.

Both inside the church and outside, especially around the entrance, sculpture and paintings illustrated important religious themes; they served to instruct as well as fascinate the faithful. These awe-inspiring works of art and architecture had a Christian message and purpose. One monk wrote that by decorating the church "well and gracefully" the artist showed "the beholders something of the likeness of the paradise of God" (Theophilus, page 79). (See "Bernard and Theophilus," above.)

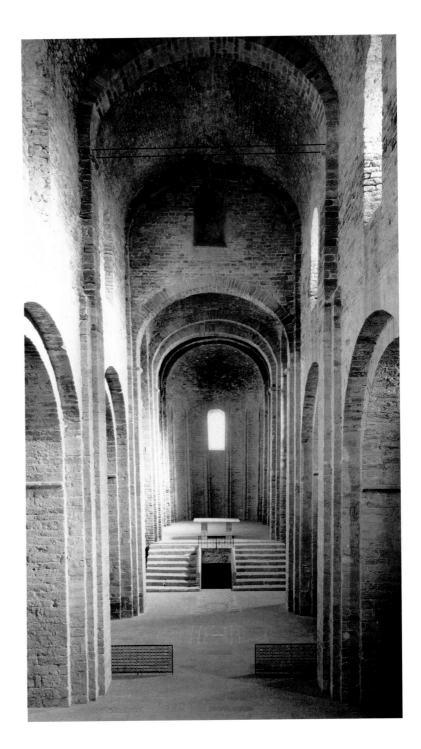

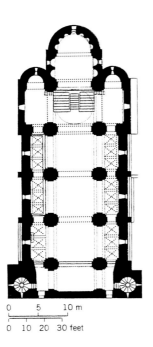

15–3 | INTERIOR, CHURCH OF SANT VINCENC, CARDONA
1020s–30s.

15–4 | PLAN OF CHURCH OF SANT VINCENC, CARDONA
1020s–30s.

ARCHITECTURE

Romanesque architecture and art are regional phenomena. Romanesque churches were the result of master builders solving the problems associated with each individual project with the resources at hand: its site, its purpose, the building materials, the work force available, the builders' own knowledge and experience, and the wishes of the patrons who provided the funding. The process of building could be slow, often requiring several different masters and teams of masons over the years.

In general, the basic form of the Romanesque church, like that of Carolingian churches, follows the plan arrived at by the builders of the early Christian basilicas; however, Romanesque builders made several key changes. They added apses or wide projecting transepts, creating complex sanctuaries. A variety of arrangements of ambulatories (walkways) and chapels accommodated the many altars and the crowds of worshipers. Although wooden roofs were still in widespread use, many builders adopted the stone masonry developed by Lombard and Catalan builders. Masonry vaults enhanced the acoustical properties of the building and the effect of the Gregorian chant (plainsong, named after Pope Gregory, papacy 590–604). Masonry also provided some protection against fire, a constant danger from candlelit altars and torchlight processions.

Tall towers marked the church as the most important building in the community. The two-towered west façade, derived in part from traditional fortified gateways, became not only the entrance into the church but also, by extension, the gateway to Paradise.

The Early Romanesque Style: The "First Romanesque"

By the year 1000—by which time the pope had crowned Otto III (page 464) and Radulphus Glaber commented on the rise of church building across the land—patrons and builders in Catalunya (Catalonia) in northeast Spain, southern France, and northern Italy were constructing masonry churches. Based on methods used by late Roman (SEE FIG. 6–71, Trier) and Early Christian (SEE FIG. 7–29, Ravenna) builders, the Catalan and Lombard masons developed a distinctive early Romanesque style. Many buildings still survive in Catalunya where the authorities had introduced the Benedictine Order into their territory.

THE CHURCH OF SANT VINCENC, CARDONA. One of the finest examples of these masonry buildings is the church of Sant Vincenc (Saint Vincent) in the castle of Cardona on the Catalan side of the Pyrenees Mountains (FIGS. 15–3, 15–4). Begun in the 1020s, it was consecrated in 1040. Castle residents entered the church through a two-story narthex into a nave with low narrow side aisles that permitted windows in the nave wall. The transept had two apses and a low crossing tower that emphasized the importance of the choir, large apse, and altar. The sanctuary was raised dramatically over an aisled crypt. The different sizes of the apses, caused by the difference in the widths of the nave and the narrower side aisles, created a stepped outline that came to be called the **Benedictine plan**. The masons hoped to build practical, sturdy, fireproof walls and vaults. Catalan and Lombard masons used local materials—small split stones, bricks, even river pebbles, and very strong mortar—to raise plain walls and round barrel vaults or groin vaults. Today we can admire their skillful stone work both inside and out, but the builders originally covered their masonry with stucco.

To strengthen the walls and vaults the masons added bands of masonry (called strip buttresses) joined by arches and additional courses of masonry (arched corbel tables) to counter the outward thrust of the vault and to enliven the wall. Late Roman and Early Christian builders had used these techniques, but the eleventh century masons went further. They turned strip buttresses and arched corbel tables into a regular decorative system. On the interior they added masonry strips to the piers and continued these bands across the vault (a transverse arch). They added bands on the underside of the arches of the nave arcade as well. The result was a simple compound pier. The compound piers and transverse

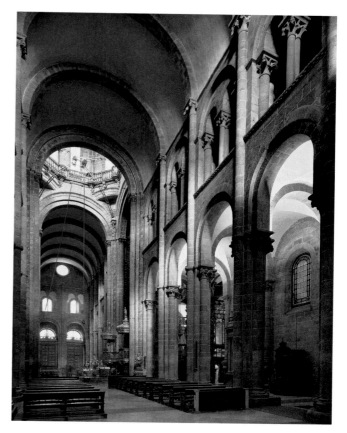

15–5 | TRANSEPT, CATHEDRAL OF SAINT JAMES, SANTIAGO DE COMPOSTELA
Galicia, Spain. View toward the crossing, 1078–1122.

arches dividing the nave into a series of bays that clarify and define the space became an essential element in Romanesque architecture.

The "Pilgrimage Church"

The growth of a cult of relics and the desire to visit shrines such as Saint Peter's in Rome or Saint James in Spain inspired people to travel on pilgrimages (see "The Pilgrim's Journey," page 480). Christian victories against Muslims also opened roads and encouraged travel. To accommodate the faithful and instruct them in Church doctrine, many monasteries on the major pilgrimage routes built large new churches and filled them with sumptuous altars and reliquaries.

THE CATHEDRAL OF SAINT JAMES IN SANTIAGO DE COMPOSTELA. One major goal of pilgrimage was the Cathedral of Saint James in Santiago de Compostela (FIG. 15–5), which held the body of Saint James, the apostle to the Iberian Peninsula. Builders of the Cathedral of St. James and other major churches along the roads leading through France to the shrine developed a distinctive church plan designed to accommodate the crowds of pilgrims and give them easy access to the relics (see "Relics and Reliquaries," page 484).

Art and Its Context
THE PILGRIM'S JOURNEY

Western Europe in the eleventh and twelfth centuries saw an explosive growth in the popularity of religious pilgrimages. The rough roads that led to the most popular destinations—the tomb of Saint Peter and the Constantinian churches of Rome, the Church of the Holy Sepulchre in Jerusalem, and the Cathedral of Saint James in Santiago de Compostela in the northwest corner of Spain—were often crowded with pilgrims. Their journeys could last a year or more; church officials going to Compostela were given sixteen weeks' leave of absence. Along the way the pilgrims had to contend with bad food and poisoned water, as well as bandits and dishonest innkeepers and merchants.

The stars of the Milky Way, it was said, marked the road to Santiago de Compostela (SEE FIGS. 15–5, 15–6). Still, a guidebook helped, and in the twelfth century the priest Aymery Picaud wrote one for pilgrims on their way to the great shrine through what is now France. Like travel guides today, Picaud's book provided advice on local customs, comments on food and the safety of drinking water, and a list of useful words in the Basque language. In Picaud's time, four main pilgrimage routes crossed France, merging into a single road in Spain at Puente la Reina and leading on from there through Burgos and León to Compostela. Conveniently spaced monasteries and churches offered food and lodging. Roads and bridges were maintained by a guild of bridge builders and guarded by the Knights of Santiago.

Picaud described the best-traveled routes and most important shrines to visit along the way. Chartres, for example, housed the tunic that the Virgin was said to have worn when she gave birth to Jesus. The monks of Vézelay had the bones of Saint Mary Magdalene, and at Conques, the skull of Sainte Foy was to be found. Churches associated with miraculous cures—Autun, for example, which claimed to house the relics of Lazarus, raised by Jesus from the dead—were filled with the sick and injured praying to be healed.

The great pilgrimage churches in Compostela, Toulouse, Limoges, and Conques became models of functional planning and traffic control. To the aisled nave the builders added aisled transepts with chapels leading to an ambulatory with additional radiating chapels around the apse (FIGS. 15–6, 15–7). This system of continuous aisles and ambulatory allowed worshipers to move around the church, visiting all the chapels and saying their own prayers, without disrupting services at the high altar. An octagonal windowed lantern tower over the crossing flooded the sanctuary with daylight, drawing the people forward to the shrines.

Building usually proceeded from east to west. Individual elements produce a series of simple geometric forms that express the internal arrangements of the church—chapels are attached to aisles and ambulatory; the ambulatory then circles the apse and choir, which in turn lead to the wide transept marked by a tall crossing tower. The nave culminates in western towers, an entrance porch, or a narthex. Each element of the building has a distinct geometric form; added together, they produce the powerful impression and solidity characteristic of Romanesque architecture.

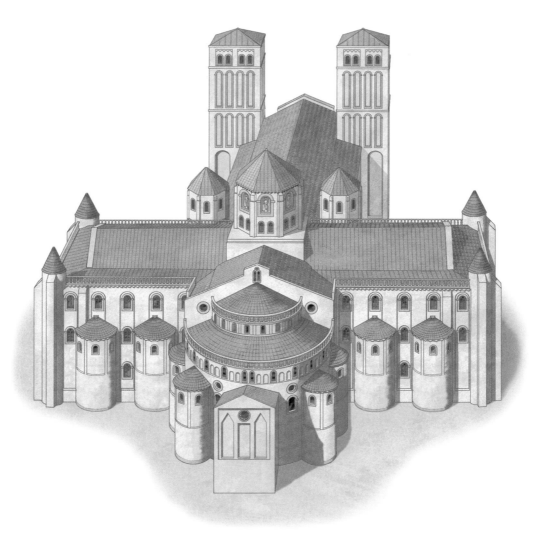

15–6 | **RECONSTRUCTION DRAWING (AFTER CONANT) OF CATHEDRAL OF SAINT JAMES, SANTIAGO DE COMPOSTELA** 1078–1122, western portions later.

Pilgrims usually entered the church through the large double doors at the ends of the transepts rather than through the western portal, which served ceremonial processions. Pilgrims from France entered the north transept portal; the approach from the town was through the south portal. They found themselves in a transept in which the design exactly mirrored the nave in size and structure. The nave and transept have two stories—an arcade and a gallery. Compound piers with attached half columns on all four sides support the immense ribbed barrel vault. The vaulted gallery over the aisles buttresses the nave vault for its entire length (FIG. 15–8). Quadrant vaults, each with an arc of one-quarter of a circle, strengthen the building by carrying the outward thrust of the high barrel vault to the outer walls and buttresses. The compound piers and transverse ribs give sculptural form to the interior as they mark off individual vaulted bays in which the sequence is as clear and regular as the ambulatory chapels of the choir. Three different kinds of vaults are used: ribbed

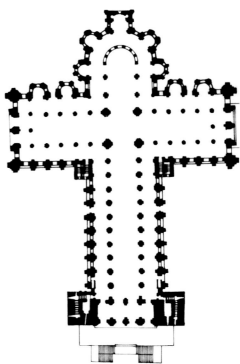

15–7 | **PLAN OF CATHEDRAL OF SAINT JAMES, SANTIAGO DE COMPOSTELA**

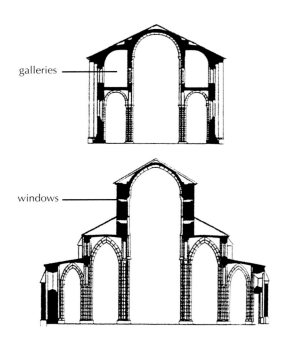

galleries

windows

15–8 | **CROSS SECTION OF THE CATHEDRAL OF SAINT JAMES, SANTIAGO DE COMPOSTELA (DRAWING AFTER CONANT)**

barrel vaults cover the nave; groin vaults span the side aisles; and half-barrel or quadrant vaults cover the galleries. Without a clerestory, light enters the nave only indirectly, through windows in the outer walls of the aisles and upper-level galleries that overlook the nave.

The building is made of local granite that has weathered to a golden brownish-gray color. In its own time, the cathedral was admired for the excellence of its construction—"not a single crack is to be found," according to the twelfth-century pilgrims' guide—"admirable and beautiful in execution . . . large, spacious, well-lighted, of fitting size, harmonious in width, length, and height . . ."

Pilgrims arrived at Santiago de Compostela weary after weeks of difficult travel through dense woods and mountains. Grateful to Saint James for his protection along the way, they entered a church that welcomed them with open portals. The cathedral had no doors to close—it was open day and night. Its portals displayed didactic sculpture, a notable feature of Romanesque churches. Santiago de Compostela was more than a pilgrimage center; it was a cathedral, the seat of a bishop and later an archbishop and consequently the administrative headquarters of the church in the northwest of the Iberian Peninsula.

The Monastery of Cluny in Burgundy

In 909 the Duke of Burgundy gave land for a monastery to Benedictine monks intent on strict adherence to the original rules of Saint Benedict. They established the reformed congregation of Cluny. From its foundation, Cluny had a special

independent status; its abbot answered directly to the pope in Rome rather than to the local bishop or feudal lord. This unique freedom, jealously safeguarded by a series of long-lived and astute abbots, enabled Cluny to keep the profits from extensive gifts of land and treasure. Independent, wealthy, and a center of learning, Cluny and its affiliates became important patrons of the arts.

Cluny was a city unto itself. By the second half of the eleventh century, there were some 200 monks at Cluny and troops of laymen on whom they depended for material support. As we have seen in the Carolingian Saint Gall plan for monasteries (SEE FIG. 14–14), the cloister lay at the center of the community, joining the church with the domestic buildings and workshops (FIG. 15–9). In wealthy monasteries the arcaded galleries of the cloister had elaborate carved capitals as well as relief sculpture on piers (SEE FIG. 15–1). The capitals may even have served as memory devices to direct the monks' thoughts and prayers.

Benedictine monks and nuns observed the eight Hours of the Divine Office (including prayers, scripture readings, psalms, and hymns) and the Mass, which was celebrated after the third hour (terce). Cluny's services were especially elaborate. During the height of its power, the plainsong (or Gregorian chant) filled the church with music twenty-four hours a day. When the monks were not in the choir, they dedicated themselves to study and the cloister crafts, including manuscript production.

The hallmark of Cluny—and Cluniac churches—was their functional design that combined the needs of the monks with the desire of pilgrims to visit shrines and relics, their fine stone masonry with rich sculptured and painted decoration, and their use of elements from Roman and Early Christian art, such as fluted pilasters and Corinthian capitals. Individual Cluniac monasteries were free to follow regional traditions and styles; consequently, Cluny III was widely influential, though not copied exactly.

THE ABBEY CHURCH OF SAINT PETER. The original church, a small barnlike building, was soon replaced by a basilica with two towers and narthex at the west and a choir with tower and chapels at the east. Hugh de Semur, abbot of Cluny for sixty years (1049–1109), began rebuilding for the third time at Cluny in 1088 (FIG. 15–10). Money paid in tribute by Muslims to victorious Christians in Spain financed the building. When King Alfonso VI of León and Castile captured Toledo in 1085, he sent 10,000 pieces of gold to Cluny. The church (known to art historians as Cluny III because it was the third building at the site) was the largest church in Europe when it was completed in 1130. Huge in size—550 feet long—with five aisles like Constantine's churches in Rome, built with superb masonry, and richly carved, painted, and furnished, Cluny III was a worthy home for the relics of Saint Peter and Saint Paul, which the monks acquired from Saint Paul's Outside the Walls in Rome.

15–9 | **RECONSTRUCTION DRAWING OF THE ABBEY AT CLUNY**
Burgundy, France. 1088–1130. View from the east.

The monastery of Cluny expanded to accommodate its increasing responsibilities and number of monks. In this reconstruction, Cluny III, the abbey church (on the right), dominates the complex. Other buildings are loosely organized around cloisters and courtyards. The cloisters link buildings and provide private space for the monks; the two principal cloisters—for choir monks and for novices—lie to the south of the church.

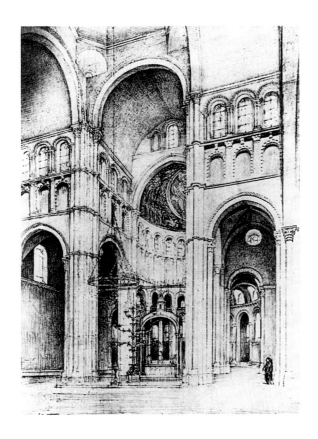

In simple terms, the church was a basilica with five aisles, double transepts with chapels, and an ambulatory and radiating chapels around the high altar. The large number of altars was required by the monks who celebrated Mass daily. Octagonal towers over the two crossings and additional towers over the transept arms created a dramatic pyramidal design at the east end. Pope Urban II, while in Burgundy in 1095 to preach the First Crusade, consecrated the high altar.

The nave of Cluny III had a three-part elevation like Saint Peter's in Rome. In the nave arcade tall compound piers with pilasters and engaged columns supported pointed arches. At the next level a blind arcade and pilasters created a triforium that resembled a classical Roman triumphal arch, and finally triple clerestory windows let sunlight directly into the church. A ribbed vault, which rose to the daring height of 98 feet with a span of about 40 feet, was made possible by giving the vaults a steep profile (rather than being round as at Santiago de Compostela) and slightly decreasing the width of the nave at the top of the wall.

15–10 | **THE CHURCH CHOIR FROM THE TRANSEPT AT CLUNY (DRAWING AFTER CONANT)**

RELICS AND RELIQUARIES

Christians turned to the heroes of the Church, the martyrs who had died for their faith, to answer their prayers and to intercede with Christ on their behalf at the Last Judgment. In the Byzantine church people venerated icons, that is, pictures of the saints, but Western Christians wanted to be close to the actual earthly remains of the saints. Scholars in the church assured the people that the veneration of icons or relics was not idol worship. Bodies of saints, parts of bodies, things associated with the Holy Family or the saints were kept in richly decorated containers called reliquaries. Reliquaries could be simple boxes, but they might also be given the shape of the relic—the head of Saint John the Baptist, the rib of Saint Peter, the sandal of Saint Andrew.

Churches were built in cemeteries, over and around the martyrs' tombs. By the eleventh century, many different arrangements of crypts, chapels, and passageways gave people access to the relics. When the Church decided that every altar required a relic, the saints' bodies and possessions were subdivided. Ingenious churchmen came up with the idea of the *brandea*, a strip of linen that took on the powers of the relic by touching it. In this way relics were multiplied; for example, hundreds of churches held relics of the true cross.

Owning and displaying these relics so enhanced the prestige and wealth of a community that people went to great lengths to acquire relics, not only by purchase but also by theft. In the ninth century, for example, the monks of Conques stole the relics of the child martyr Sainte Foy (Saint Faith) from her shrine at Agent. Such a theft was called "holy robbery," for the new owners insisted that the saint had encouraged them because she wanted to move. In the late ninth or tenth century the monks of Conques encased their relic—the skull of Sainte Foy—in a jewel-bedecked and gilt statue whose head was made from a Roman statue. Over the centuries, added jewels, cameos, and other gifts from pilgrims enhanced the splendor of the statue.

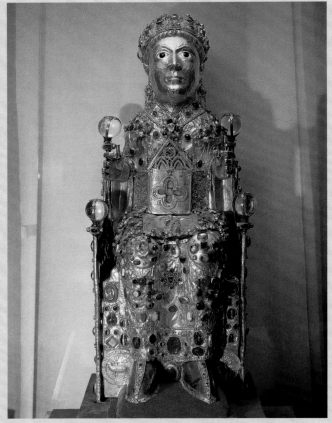

RELIQUARY STATUE OF SAINTE FOY (SAINT FAITH)
Abbey Church of Conques, Conques, France. Late 9th or 10th century with later additions. Silver gilt over a wood core, with added gems and cameos of various dates. Height 33″ (85 cm). Church Treasury, Conques, France.

The Church was consecrated in 1130, but building continued at Cluny. A narthex, added at the west end of the nave, was finished at the end of the twelfth century in early Gothic style. The monastery suffered during the French Revolution, and the church was sold and used as a stone quarry. Today the site is an archeological park.

The Cistercians

New religious orders devoted to an austere spirituality arose in the late eleventh and early twelfth centuries. Among these were the Cistercians, who spurned Cluny's elaborate liturgical practices and emphasis on the arts. The Cistercian reform began in 1098 with the founding of the Abbey of Cîteaux (*Cistercium* in Latin, hence the order's name). Led in the twelfth century by the commanding figure of Abbot Bernard of Clairvaux, the Cistercians advocated strict mental and physical discipline and a life devoted to prayer and intellectual pursuits combined with shared manual labor, although like the Cluniacs, they depended on the work of laypersons. To provide for their minimal physical needs, the Cistercians settled and reclaimed swamps and forests in the wilderness, where they then farmed and raised sheep. In time, their monasteries could be found from Russia to Ireland.

THE ABBEY AND CHURCH OF NOTRE-DAME AT FONTENAY.
Cistercian architecture reflects the ideals of the order—simplicity and austerity—in their building. Always practical, the

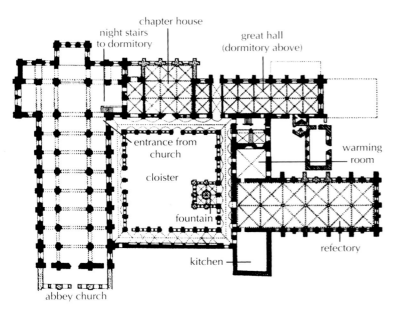

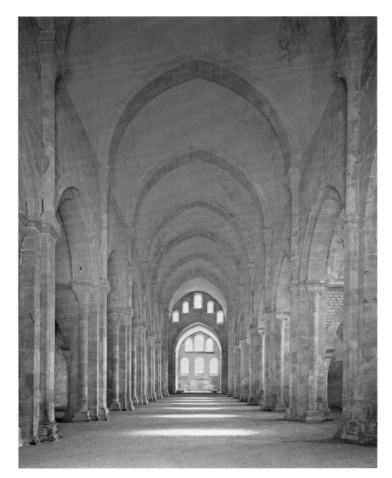

15–11 | **PLAN OF THE ABBEY OF NOTRE-DAME, FONTENAY**
Burgundy, France. 1139–47.

15–12 | **NAVE, ABBEY CHURCH OF NOTRE-DAME, FONTENAY** 1139–47.

Cistercians made a significant change to the already very efficient monastery plan. They placed key buildings such as the refectory at right angles to the cloister walk so that the building could easily be extended should the community grow. The cloister fountain was relocated from the center of the cloister to the side, conveniently in front of the refectory. The monks entered the church from the cloister into the south transept or from the dormitory by way of the "night stairs."

The Cistercians dedicated all their churches to Mary, to Notre Dame ("Our Lady"). The Abbey Church of Notre-Dame at Fontenay was begun in 1139. It has a simple geometric plan (FIG. 15–11): a long nave with rectangular chapels off the square-ended transept arms and a shallow choir with a straight east wall.

A feature of Fontenay often found in Cistercian architecture is the use of pointed ribbed barrel vaults over the nave and pointed arches in the nave arcade and side-aisle bays (FIG. 15–12). The pointed arch and vault may have derived from Islamic architecture. Pointed arches are structurally more stable than round ones, directing more weight down into the floor instead of outward to the walls. Consequently, they can span greater distances at greater heights without collapsing. Pointed arches have a special aesthetic effect, for they narrow the eye's focus and draw the eye upward, an effect intended to direct thoughts toward heaven.

The Cistercians relied on harmonious proportions and fine stonework, not elaborately carved and painted decoration, to achieve beauty in their architecture. Church furnishings included little else than altars with crosses and candles. The large windows in the end wall, rather than a clerestory, provided light. The sets of triple windows reminded the monks of the Trinity. Situated far from the distractions of the secular world, the building made few concessions to the popular taste for architectural adornment, either outside or inside. In other ways, however, Fontenay and other Cistercian monasteries fully reflect the architectural developments of their time in their masonry, vaulting, and proportions.

This simple architecture spread from the Cistercian homeland in Burgundy to become an international style. From Scotland and Germany to Spain and Italy, Cistercian designs and building techniques varied only slightly. The masonry vaults and harmonious proportions influenced the development of the Gothic style in the years leading to the twelfth century (Chapter 16).

Regional Styles in Romanesque Architecture

The Cathedral of Santiago de Compostela and the Abbey church at Cluny reflect the international aspirations of the pope and the impact of the Crusades and pilgrimages, but Europe remained a land divided by competing kingdoms, regions, and factions. Romanesque architecture reflects this regionalism in the wide variety of its styles and building techniques, only a few of which will be noted here.

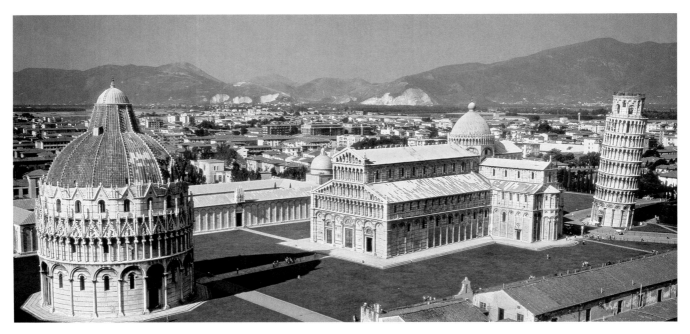

15–13 | **CATHEDRAL COMPLEX, PISA**
Tuscany, Italy. Cathedral, begun 1063; Baptistry, begun 1153; Campanile, begun 1174; Campo Santo, 13th century.

When finished in 1350, the Leaning Tower of Pisa stood 179 feet high. The campanile had begun to tilt while still under construction, and today it leans about 13 feet off the perpendicular. In the latest effort to keep it from toppling, engineers filled the base with tons of lead.

EARLY CHRISTIAN INSPIRATION IN PISA. Throughout Italy artists looked to the still-standing remains of imperial Rome. The influence remained especially strong in Pisa, on the west coast of Tuscany. Pisa became a maritime power, competing with Barcelona and Genoa as well as the Muslims for control of trade in the western Mediterranean. In 1063, after a decisive victory over the Muslims, the jubilant Pisans began an imposing new cathedral dedicated to the Virgin Mary (FIG. 15-13). The cathedral complex eventually included the cathedral building itself, a campanile (a freestanding bell tower—now known for obvious reasons as "the Leaning Tower of Pisa"), a baptistry, and the later Gothic Campo Santo, a walled burial ground. The cathedral was designed by the master builder Busketos, who adopted the plan of a cruciform basilica. A long nave with double side aisles (the five-aisle building always pays homage to Rome) is crossed by projecting transepts, designed like basilicas with aisles and apses. The builders added galleries above the side aisles, and a dome covers the crossing.

Unlike Early Christian basilicas, the exteriors of Tuscan churches were richly decorated with marble—either panels of green and white marble or with arcades. At Pisa, pilasters, blind arcades, and narrow galleries in white marble adorn the five-story façade. A trophy captured from the Muslims, a bronze griffin, stood atop the building until 1828 (SEE FIG. 8–19).

Other buildings in the complex soon followed the cathedral. The baptistry, begun in 1153, has arcading and galleries on the lower levels of its exterior that match those on the

cathedral (the baptistry's present exterior dome and ornate upper levels were built later). The campanile (bell tower) was begun in 1174 by the Master Bonanno. Built on inadequate foundations, it began to lean almost immediately. The cylindrical tower is encased in tier upon tier of marble columns. This creative reuse of the ancient, classical theme of the colonnade, turning it into a decorative arcade, is characteristic of Tuscan Romanesque art; artists and architects in Italy seem always to have been conscious of their Roman past.

MONTE CASSINO AND ROME; THE CHURCH OF SAN CLEMENTE, ROME. From 1058 to 1086 Abbot Desiderius ruled Monte Cassino, the mother house of the Benedictine order. At the end of his life he was elected pope, taking the name Victor III. He rebuilt the abbey church at Saint Benedict's monastery of Monte Cassino using Saint Peter's basilica in Rome as his model—with important modifications. Since a monastic church did not have to accommodate crowds of pilgrims, single aisles and a short transept provided sufficient space. A chapel off the transept, facing each aisle, produced a distinctive stepped, triple-apse plan. The eastern portion of the church was raised above the level of the nave to accommodate an open, partially underground crypt. The church, consecrated in 1071, set the pattern for Benedictine churches thereafter.

In the late eleventh century the Benedictines turned to Desiderius's church for technical assistance and inspiration to rebuild the Church of San Clemente in Rome. The new church, consecrated in 1128, was built on top of the previous

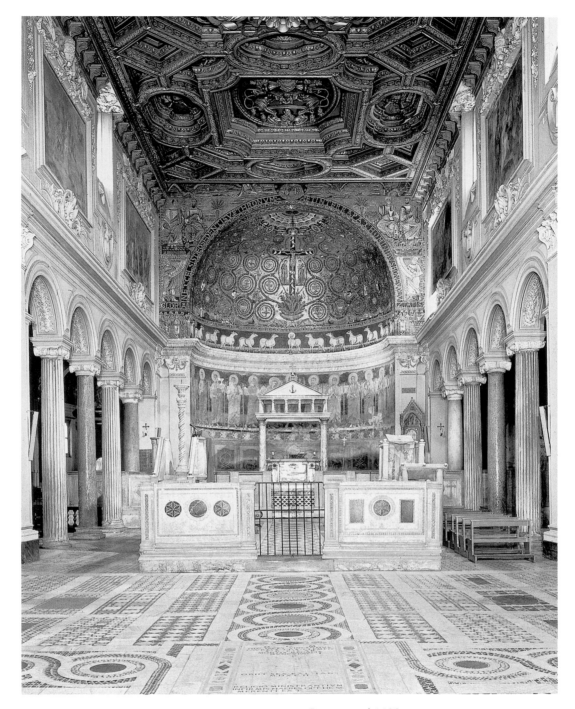

15–14 | **NAVE, CHURCH OF SAN CLEMENTE, ROME** Consecrated 1128.

San Clemente contains one of the finest surviving collections of early church furniture: choir stalls, pulpit, lectern, candlestick, and also the twelfth-century inlaid floor pavement. Ninth-century choir screens were reused from the earlier church on the site. The upper wall and ceiling decoration are eighteenth century.

church (which had been built over a Roman sanctuary of Mithras). Although the architecture and decoration reflect a conscious effort to reclaim the artistic and spiritual legacy of the early church (FIG. 15–14), a number of features mark San Clemente as a twelfth-century building. Early Christian basilicas, for example, have parallel rows of identical columns, which create a strong, regular horizontal movement down

the nave to the sanctuary. In the new church of San Clemente, however, rectangular piers interrupt the line of Ionic columns and divide the nave into bays. (As with the columns of Santa Sabina (SEE FIG. 7–13), the columns in San Clemente are *spolia;* that is, they were taken from ancient Roman buildings.) The church had a timber roof now disguised by an ornate ceiling. The construction of

timber-roofed buildings continued throughout the Middle Ages. Its advantage of being slightly easier and cheaper to build was offset by its vulnerability to fire.

The nave and aisles at San Clemente end in semicircular apses. The central apse was too small to accommodate the increased number of participants in the twelfth-century liturgy. As a result, the choir was extended into the nave and defined by a low barrier made up of ninth-century relief panels saved from the earlier church. In early Christian basilicas, the area in front of the altar had been enclosed by a screen wall (SEE FIG. 7–13, Santa Sabina), and the later builders may have wanted to revive what they considered a glorious early Christian tradition. A **baldachin** (*baldacchino* or *ciborium*), symbolizing the Holy Sepulchre, covers the main altar in the apse.

THE BARREL VAULTED CHURCH OF SAINT-SAVIN-SUR-GARTEMPE. At the Benedictine abbey church in Saint-Savin-sur-Gartempe in western France, a tunnel-like barrel vault runs the length of the nave and choir (FIG. 15–15). Supported directly by tall columns and consequently without galleries or clerestory windows, the nave at Saint Savin approaches the form of a "hall church," where the nave and aisles rise to an equal height. At Saint Savin the vault is unbroken. The continuous vault is ideally suited for paintings (see page 502, FIG. 15–31).

More often in Romanesque churches, transverse arches divide the space into bays, as at the Cathedral of Santigo de Compostela (SEE FIG. 15–5). These transverse arches provide little extra support for the vault once it is in place, but they allow the vault to be constructed in segments. They also enhance the rhythmic and "additive" aesthetic quality of the building.

FOUR-PART RIBBED VAULTS AT SANT'AMBROGIO, MILAN. About 1080, at the height of the struggles between the pope and the emperor, construction began in the city of Milan in Lombardy on a new Church of Sant'Ambrogio. The church had been founded by the city's first bishop, Saint Ambrose (d. 397), one of the Fathers of the Christian Church. This new church replaced a ninth-century building. Then, following an earthquake in 1117, masons had to rebuild the church again. This time they used a technically advanced system of four-part rib vaulting (FIG. 15–16). With a nave wider than that of Cluny III, but, at 60 feet, only a little more than half as high, the vault presented a challenge.

Massive compound piers support three huge ribbed groin vaults over the square bays of the nave. The Romans had used groin vaults, and the Romanesque Lombard builders added diagonal and transverse ribs that had supported scaffolds during construction and now also helped to stabilize the vault. Smaller intermediate piers support the small groin vaults over the side-aisle bays, and vaulted galleries buttress the walls and vaults. Since the builders used round arches throughout the construction, in each bay the diagonal ribs had a greater diameter and therefore greater

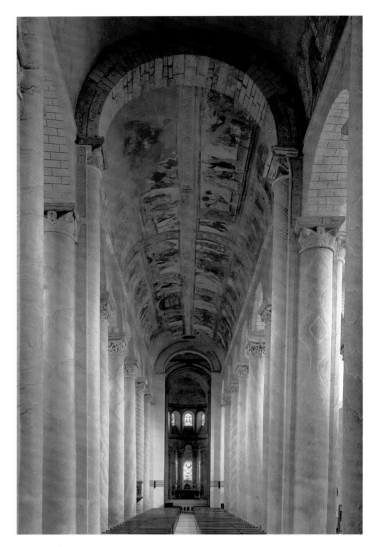

15–15 | **CHURCH OF SAINT-SAVIN-SUR-GARTEMPE, POITOU**
France. Choir c.1060-75; nave c. 1095-1115.

height than the transverse and lateral ribs, and each bay rises up into a domical form, emphatically defining each bay. The builders did not risk weakening the structure with window openings, so there is no clerestory. The dimly lit nave makes the light streaming down in front of the altar from the lantern tower all the more dramatic.

THE IMPERIAL CATHEDRAL OF SPEYER. Ties between northern Italy and Germany established by the Carolingian and Ottonian rulers remained strong, and the architecture of Switzerland, southern Germany, and especially the Rhine Valley is closely related to that of Lombardy. The Imperial Cathedral at Speyer in the Rhine River valley was a colossal structure rivalled only by Cluny III. The Ottonian wooden-roofed church built between 1030 and 1060 was given a masonry vault c. 1080–1106 (FIG. 15–17). Massive compound piers mark each nave bay and support the transverse ribs of a vault that rises to a height of over 100 feet. These

compound piers alternate with smaller piers that support the vaults of the aisle bays. This rhythmic pattern of heavy and light elements, first suggested for aesthetic reasons in Ottonian wooden-roofed architecture (SEE FIG. 14–27, Gernrode), became an important design element in Speyer. Since groin vaults concentrate the weight and thrust of the vault on the four corners of the bay, they relieve the stress on the side walls of the building. Windows can be safely inserted in each bay (something the builders of Sant'Ambrogio dared not do). The result is a building flooded with light.

The exterior of Speyer Cathedral emphasizes its Ottonian (and even Carolingian) qualities. Soaring towers and wide transepts mark both ends of the building, although a narthex, not an apse, stands at the west. Like the arrangement of the east end first seen at Saint Riquier (SEE FIG. 14–13), a large apse housing the high altar abuts the flat wall of the choir; transept arms project at each side; a large octagonal tower rises over the crossing; and a pair of tall slender towers flanks the choir (FIG. 15–18). A horizontal arcade forms an exterior gallery at the top of the apse and transept wall. Stepped niches follow the line of the choir roof, and arched corbel

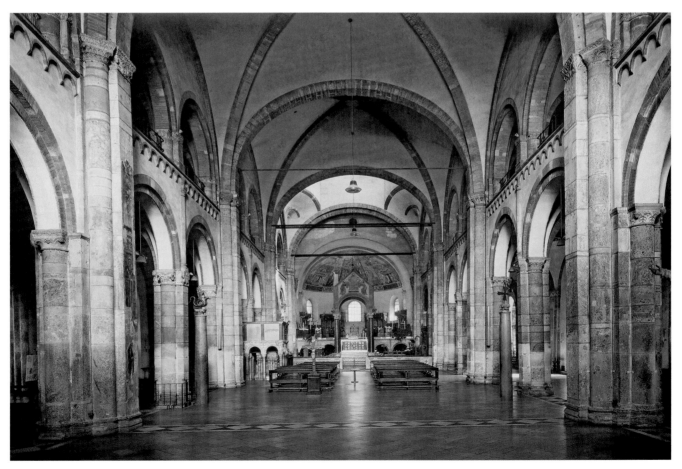

15–16 | **NAVE, CHURCH OF SANT'AMBROGIO, MILAN**
Lombardy, Italy. Begun 1080; vaulted after an earthquake in 1117.

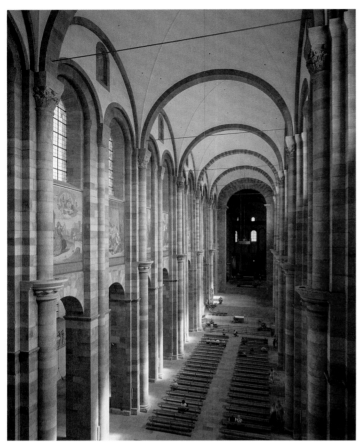

15–17 | **INTERIOR, SPEYER CATHEDRAL**
Speyer, Germany. As remodeled c. 1080–1106.

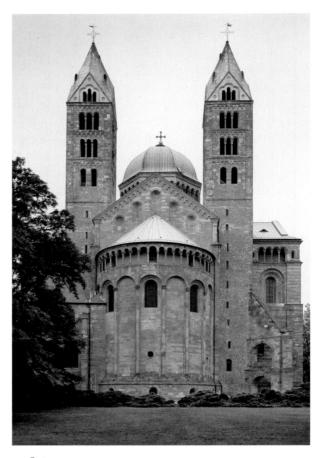

15–18 | **EXTERIOR, SPEYER CATHEDRAL**
c. 1080–1106 and second half of the 12th century.

tables also define the roof line and the stages of the towers. This decorative scheme has been adapted from the Lombard-Catalan builders. (The startling green copper roofs seen in the photograph are modern.)

EXPERIMENTAL VAULTS IN DURHAM. In Durham, a military outpost near the Scottish border, builders were experimenting with masonry vaults. When the British turned from timber architecture to stone and brick, they associated masonry buildings—whether church, feasting hall, or castle—with the power and glory of ancient Rome and to some extent with Charlemagne and the Continental powers. As a practical matter, they also appreciated the greater strength and resistance to fire of masonry walls, although they often continued to use wooden roofs.

In Durham, one man, a count-bishop, had both secular and religious authority. For his headquarters he chose a natural defensive site where the oxbow of the River Wear formed a natural moat. Durham grew into a powerful fortified complex including a castle, a monastery, and a cathedral. The great tower of the castle defended against attack from the land, and an open space between buildings served as the bailey of the castle and the cathedral green.

Durham Cathedral, begun in 1087 and vaulted beginning in 1093, is an impressive Norman church, but like most buildings that have been in continuous use, it has been altered several times (FIG. 15–19). The nave retains its Norman character, but the huge circular window lighting the choir is a later Gothic addition. The cathedral's size and decor are ambitious. Enormous compound piers alternating with robust columns form the nave arcade. The alternating circular and clustered piers establish the typical alternating rhythm. The columns are carved with chevrons, spiral fluting, and diamond patterns, and some have scalloped, cushion-shaped capitals. The arcades have multiple round moldings and chevron ornaments. All this carved ornamentation was originally painted.

Above the cathedral's massive piers and walls rise a new system of ribbed vaults and buttresses. Masons in Santiago de Compostela, Cluny, Milan, Speyer, and Durham were all experimenting with vaults—and reaching different conclusions. Unlike the masons at Sant' Ambrogio, the designers in Durham wanted a unified, well-lit space. In the vault, the Durham builders divided each bay with two pairs of diagonal crisscrossing ribs and so kept the crowns of the vaults close in height to the keystones of the transverse arches (FIG. 15–20).

I5–I9 | NAVE, DURHAM CATHEDRAL

England. 1087–1133. Original east end replaced by a Gothic choir, 1242–c. 1280. Vault height about 73′ (22.2 m).

Original

0 50 100
FEET
0 10 20 30
METERS

I5–20 | PLAN OF DURHAM CATHEDRAL
Showing original east end.

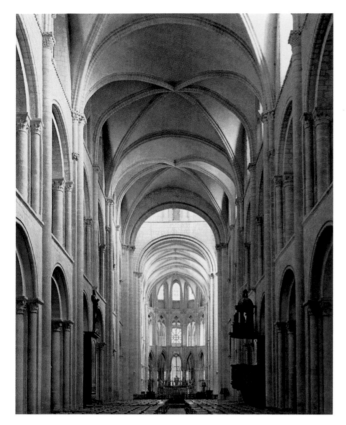

15–21 NAVE, CHURCH OF SAINT-ÉTIENNE, CAEN
Normandy, France c. 1060–77; vaulted c. 1130.

run unbroken the full height of the nave, emphasizing its height. The walls seem designed for a masonry vault, but in fact supported a timber roof.

Sometime after 1120—perhaps as late as 1130–35—Saint-Étienne's original timber roof was replaced by a masonry vault. The masons joined two bays to form square bays defined by the heavy piers (that is, the piers with the pilaster-backed columns) and by six-part vaults. The six-part vault combines two systems—transverse ribs crossing the space at every pier and ribbed groin vaults springing from the heavy piers. To accommodate the lower masonry vault under the timber roof, the triple arches of the clerestory were reduced to two.

Soaring height was a Norman architectural goal, and the façade towers continue the tradition of church towers begun by Carolingian builders. This preference for verticality is seen in the west façade of Saint-Étienne, which was designed at the end of the eleventh century, probably about 1096–1100 (FIG. 15–23). Wall buttresses divide the façade into three vertical sections corresponding to the nave and side aisles. Narrow **stringcourses** (unbroken horizontal moldings) at each window level suggest the three stories of the building's nave elevation. This concept of reflecting the plan and elevation of the church in the design of the façade was later adopted by Gothic builders. Norman builders, with their brilliant techni-

The eye runs smoothly down the length of the vault. In the transept, the builders divided the square bays in two to produce four-part ribbed vaults over rectangular bays. They also experimented with buttresses that resembled later Gothic systems (see Chapter 16). Although the buttresses were not a success, the germ of the idea was there.

THE CHURCH OF SAINT-ÉTIENNE, CAEN. The Benedictine abbey church of Saint-Étienne (FIG. 15–21) in Caen was originally built as a wooden-roofed basilica nearly a generation before Durham Cathedral. William the Conqueror, while still only Duke of Normandy, had founded the monastery and had begun the construction of its church before 1066. He dedicated the church in 1077 and was buried there in 1087. His wife, Queen Matilda, established an abbey for women and built a church dedicated to the Trinity.

William's original church provides the core of the building we see today (FIG. 15–22). The nave wall has a three-part elevation (nave arcade, gallery, and clerestory) with exceptionally wide arches both in the nave arcade and the gallery. At the clerestory level, an arcade of three small arches on colonettes runs in front of the windows, creating a passageway within the thickness of the wall. On each pier, engaged columns alternate with columns backed by pilasters. They

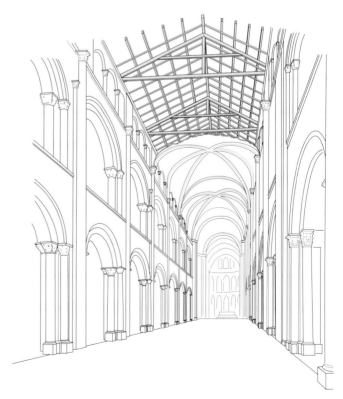

15–22 COMPOSITE DIAGRAM OF CHURCH OF SAINT-ÉTIENNE, CAEN
Showing original 11th-century timber roof and later 12th-century six-part vault inserted under the roof.

15–23 | **CHURCH OF SAINT-ÉTIENNE, CAEN**
Normandy, France. c. 1060–77; façade c.
1096–1100; spires 13th century.

cal innovations and sophisticated designs, prepared the way for the architectural feats accomplished by Gothic architects in the twelfth and thirteenth centuries. The elegant spires topping the tall towers are examples of the Norman Gothic style.

Secular Architecture: Dover Castle, England

The need to provide for personal security in a period of constant local warfare and political upheaval, as well as the desire to glorify the house of the lord and his saints, meant that communities used much of their resources for churches and castles. Fully garrisoned, castles were sometimes as large as cities. In the twelfth century, Dover Castle, safeguarding the coast of England from invasion, was a magnificent demonstration of military power (FIG. 15–24). It illustrates the way in which a key defensive position developed over the centuries. The Romans had built a lighthouse on the point where the English Channel separating England and France narrows. The Anglo-Saxons added a church (both lighthouse and church can be seen behind the tower, surrounded by the remains of earthen walls). In the early Middle Ages, earthworks topped by wooden walls provided a measure of security, and a wooden tower signified an important administrative building and residence. The advantage of fire-resistant walls was obvious, and in the twelfth and thirteenth centuries, military engineers replaced the timber tower and palisades with stone walls. They added the massive stone towers we see today.

The **Great Tower**, as it was called in the Middle Ages (but later known as a **keep** in England, and **donjon** in France), stood in a courtyard (called the **bailey**) surrounded by additional walls. Ditches outside the walls added to the height of the walls. In some castles, ditches were filled with water to form **moats**. A gatehouse—perhaps with a drawbridge—controlled the entrance. In all castles the bailey was filled with buildings, the most important of which was the lord's hall, which was used for a court and for feasts and ceremonial occasions. Timber buildings housed troops, servants, and animals. Barns and workshops, ovens and wells were also needed since the castle had to be self-sufficient.

If enemies broke through the outer walls, the castle's defenders retreated to the Great Tower. The landwalls of Constantinople (SEE FIG. 7–24) had demonstrated the value of defense in depth. In the thirteenth century, the builders at Dover doubled the walls and strengthened them with towers, even though the castle's position on cliffs overlooking the sea made scaling the walls nearly impossible. The garrison could be forced to surrender only by starving its occupants.

During Dover Castle's heyday improving agricultural methods and growing prosperity provided the resources for increased building activity in Europe. Churches, castles, halls, houses, barns, and monasteries proliferated. The buildings that still stand—despite the ravages of weather, vandalism, neglect, and war—testify to the technical skills of the builders and the power, local pride, and faith of the patrons.

15–24 | **DOVER CASTLE**
Dover, England

Air view overlooking the harbor and the English Channel. Center distance: Roman lighthouse tower, rebuilt Anglo-Saxon church, earthworks. Center: Norman Great Tower, surrounding earthworks and wall, twelfth century. Out-erwalls, thirteenth century. Modern buildings have red tile roofs. The castle was used in World War II and is now a museum.

THE DECORATION OF BUILDINGS

Like Cluny and unlike the severe churches of the Cistercians, many Romanesque churches have a remarkable variety of painting and sculpture. Christ Enthroned in Majesty in heaven may be carved over the entrance or painted in the half-dome of the apse. Stories of Jesus among the people or images of the lives and the miracles of the saints cover the walls; the art also reflects the increasing importance accorded to the Virgin Mary. Depictions of the prophets, kings, and queens of the Old Testament symbolically foretell people and events in the New Testament, but also represented are contemporary bishops, abbots, other noble patrons, and even ordinary folk. A profusion of monsters, animals, plants, geometric ornament, allegorical figures such as Lust and Greed, and depictions of real and imagined buildings surround the major works of sculpture. The elect rejoice in heaven with the angels; the damned suffer in hell, tormented by demons; biblical and historical tales come alive, along with scenes of everyday life. All these events seem to take place in a contemporary medieval setting.

Inside the building paintings covered walls, vaults, and even piers and columns with complex imagery that combined biblical narratives and Christian symbolism with legends, folklore, and history.

Architectural Sculpture

Architecture dominated the arts in the Romanesque period—not only because it required the material and human resources of an entire community but because, by providing the physical context for sculpture and painting, it also established the size and shape of images. Sculptured façades and large and richly carved portals with symbolic and didactic images are a significant innovation in Romanesque art.

The most important imagery is usually in the semicircular tympanum directly over the door. **Archivolts**—curved moldings composed of the wedge-shaped stone voussoirs of the arch—frame the tympanum. On both sides of the doors, the jambs and often a central pier (called the **trumeau**), which support the lintel and archivolts, may have figures or columns. The jambs form a shallow porch.

WILIGELMUS AT THE CATHEDRAL OF MODENA. The spirit of ancient Rome pervades the sculpture of Romanesque Italy. The sculptor Wiligelmus may have been inspired by ancient sarcophagi still visible in cemeteries when he carved the horizontal reliefs with heavy-set figures across the west façade of Modena Cathedral, c. 1099. Wiligelmus's work is some of the earliest narrative sculpture in Italy. He took his subjects from Genesis, beginning with the Creation and the Fall of Adam and Eve (**FIG. 15–25**). On the far left, God, in a mandorla supported by angels, appears in two persons as both the creator and Christ, identified by a cruciform halo. He brings Adam to life, then brings forth Eve from Adam's side. On the right, Adam and Eve cover their genitals in shame as they greedily eat the fruit of the forbidden tree, around which the serpent twists.

Wiligelmus's deft carving gives these low-relief figures a strong three-dimensionality. Adding to their tangibility is Wiligelmus's use of a miniature arcade to establish a stagelike setting. The rocks on which Adam lies, or the fatal tree of Paradise, seem like stage props for the figures. Adam and Eve stand awkwardly, with pot bellies and skinny arms and legs, but they exude a sense of life and personality that gives an emotional depth to the narrative. Bright paint, now almost all lost, increased the impact of the sculpture. An inscription reads: "Among sculptors, your work shines forth, Wiligelmus." This self-confidence turned out to be justified. Wiligelmus's influence can be traced throughout Italy and as far away as the Cathedral of Lincoln in England.

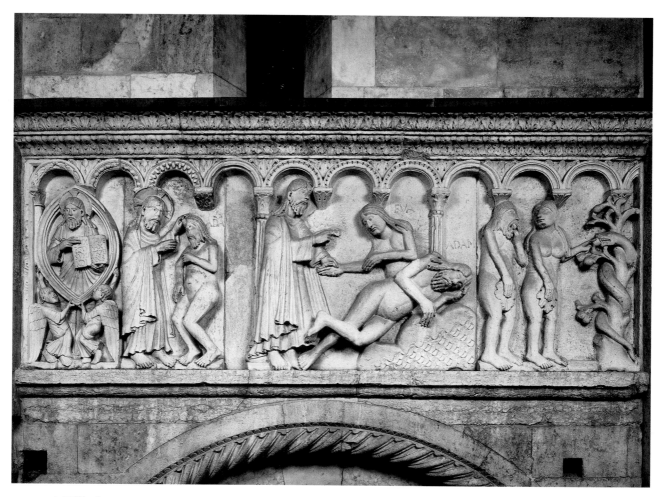

15–25 | Wiligelmus **CREATION AND FALL, WEST FAÇADE, MODENA CATHEDRAL**
Modena, Emilia, Italy. Building begun 1099; sculpture c. 1099. Height approx. 3′ (92 cm).

THE PRIORY CHURCH OF SAINT-PIERRE, MOISSAC. The Cluniac priory of Saint-Pierre at Moissac was a major pilgrimage stop and Cluniac administrative center on the route to Santiago de Compostela. The original shrine at the site was reputed to have existed in the Carolingian period. After joining the congregation of Cluny in 1047, the monastery prospered from the donations of pilgrims and the local nobility, as well as from its control of shipping on the nearby Garonne River. Moissac's monks launched an ambitious building campaign, and much of the sculpture from the cloister (c. 1100) and the church portal and porch (1100–30) has survived. Abbot Ansquetil (ruled 1085–1115) built the cloister and portal, which must have been finished by his death in 1115, and Abbot Roger (c. 1115–31) added a porch with sculpture. The sculpture of the portal represents a genuine departure from earlier works in both the quantity and the quality of the carving.

The image of Christ in Majesty dominates the huge tympanum (FIG. 15–26). The scene combines the description of the Second Coming of Christ in Chapters 4 and 5 of the Book of Revelation with Old Testament prophecies. A

15–27 | TRUMEAU, SOUTH PORTAL, PRIORY CHURCH OF SAINT-PIERRE, MOISSAC
Tarn-et-Garonne, France. c. 1115.

15–26 | SOUTH PORTAL AND PORCH, PRIORY CHURCH OF SAINT-PIERRE, MOISSAC
Tarn-et-Garonne, France. c. 1115.

gigantic Christ, like an awe-inspiring Byzantine Pantokrator, stares down at the viewer as he blesses. He is enclosed by a mandorla, and a cruciform halo rings his head. Four winged creatures symbolizing the evangelists—Matthew the Man (upper left), Mark the Lion (lower left), Luke the Ox (lower right), and John the Eagle (upper right)—frame Christ on either side, each holding a scroll or book representing his Gospel. Two elongated seraphim (angels) stand one on either side of the central group, each holding a scroll. Rippling bands represent the waves of the "sea of glass like crystal" (Revelation 4:6), defining three registers in which twenty-four elders with "gold crowns on their heads" are seated holding either a harp or a gold bowl of incense (Revelation 4:4 and 5:8). According to the medieval view, the elders were the kings and prophets of the Old Testament and, by extension, the ancestors and precursors of Christ.

The figures in the tympanum relief reflect a hierarchy of scale and location. Christ, the largest figure, sits at the top center, the spiritual heart of the scene. The evangelists and angels are smaller, and the elders, farthest from Christ, are roughly one-third his size. Despite this formality and the limitations forced on them by the architecture, the sculptors achieve variety by turning and twisting the gesturing figures, shifting their poses off-center, and avoiding rigid symmetry or mirror images. Foliate and geometric ornament covers every surface. Monstrous heads in the lower corners of the tympanum spew ribbon scrolls, and other creatures appear at each end of the lintel, their tongues growing into ropes encircling acanthus rosettes.

Two side jambs and a central trumeau support the weight of the lintel and tympanum. These elements have scalloped profiles (a motif inspired by Islamic art) that control the design of the sculpture. Saint Peter (holding his attribute, the key to the gates of heaven) and the prophet Isaiah are carved on the jambs. Peter, a tall, thin saint, steps away from the door but twists back to look through it. His shoulder, knees, and feet reflect the pointed cusps of the scalloped jamb; the vertical folds of his cloak repeat the framing colonettes. The trumeau depicts crisscrossing pairs of lions. A tall, thin figure of Saint Paul is on the left, and an Old Testament prophet, usually identified as Jeremiah, twists toward the viewer, with his legs crossed in the walking pose seen at Silos (FIG. 15–27). The sculptors placed him skillfully within the constraints of the scalloped trumeau; his head, pelvis, knees, and feet fall on the pointed cusps. This decorative scalloping as well as the rosettes, lions, and ribbons reveal a knowledge of Islamic art. Moissac was on the road to Compostella. Furthermore, it was being built shortly after the First Crusade when many Europeans first encountered the Islamic art and architecture of the Holy Land. People from the region around Moissac participated in the Crusade and presumably brought Eastern objects and ideas home with them.

GISLEBERTUS AND THE LAST JUDGMENT AT AUTUN. A different pictorial style is seen in the Last Judgment at Autun on the main portal of the Cathedral of Saint-Lazare (FIG. 15–28).

15–28 | Gislebertus **LAST JUDGMENT, TYMPANUM ON WEST PORTAL, CATHEDRAL (ORIGINALLY ABBEY CHURCH) OF SAINT-LAZARE, AUTUN**
Burgundy, France. c. 1120–30 or 1130–45.

15–29 | **CAPITAL: SUICIDE OF JUDAS.**
CATHEDRAL OF SAINT-LAZARE, AUTUN
Burgundy, France. c. 1125.

Christ has returned to judge the cowering, naked human souls at his feet. The damned writhe in torment, while the saved enjoy serene bliss. The inscribed message reads: "May this terror frighten those who are bound by worldly error. It will be true just as the horror of these images indicates" (translated by Petzold). A lengthy inscription identifies the Autun tympanum as the work of Gislebertus, who oversaw the sculpture and probably did much of the work himself.

The overall effect of the tympanum is less consciously balanced than the pattern-filled composition at Moissac. Christ dominates the composition, but the surrounding figures are arranged in less regular compartmentalized tiers than seen at Moissac. Thinner and taller, stretched out and bent at sharp angles, the stylized figures are powerfully expressive. They convey the terrifying urgency of the moment as they swarm around the magisterially detached Christ. Delicate weblike engraving on the robes seems inspired by metalwork or manuscript illumination. The scene is filled with human interest. Some angels trumpet the call to the Day of Judgment; others help the souls rise from their tombs and line up to await judgment. In the bottom register, two pilgrims—one to Jerusalem and one to Santiago de Compostela—can be identified by the cross and scallop-shell badges on their satchels. But, ominously, a pair of giant, pincerlike hands

scoops up a soul at the far right of the lintel. Above these hands, the archangel Michael competes with devils for souls being weighed on the scale. Michael shelters some souls in the folds of his robe and seems to be jiggling the scales. Another angel boosts a saved soul into heaven, bypassing the gate and Saint Peter. By far the most riveting players in the drama are the grotesquely decomposed, screaming demons grabbing at terrified souls and trying to cheat by pushing down souls and yanking the scales to favor damnation.

HISTORIATED CAPITALS. An important Romanesque contribution to architectural decoration was the ingenious compression of instructive narrative scenes into the geometric confines of column capitals, a feature known as the **historiated capital**. Gislebertus developed this idea into a series of personalized narratives, such as **THE SUICIDE OF JUDAS** (FIG. 15–29), illustrating the Bible and the lives of the saints.

Corinthian capitals (see Introduction, Fig. 3) from among the ruins of Roman cities inspired the design of Romanesque capitals, on which spiky acanthus leaves and ribbonlike volutes surround an inverted bell shape and support a wide abacus. The Romanesque sculptors such as Gislebertus, however, turned the capital into an educational or symbolic narrative.

Art and Its Context

THE ROLE OF WOMEN IN THE INTELLECTUAL AND SPIRITUAL LIFE OF THE TWELFTH CENTURY

One would expect women to have a subordinate position in this hierarchical, military society. On the contrary, aristocratic women took responsibility for managing estates in their male relatives' frequent absences during wars or while attending to duties at court. Among peasants and artisans, women and men worked side by side.

Women also achieved positions of authority and influence as the heads of religious communities. Convents of educated women lived under the direction of abbesses such as Hildegard of Bingen and Herrad of Landsberg, abbess of Hohenburg in Alsace. The original illuminated manuscripts containing their writings did not survive the wars of the nineteenth and twentieth centuries, but copies exist.

The *Liber Scivias* by Hildegard of Bingen (1098–1179) opened with a portrait of the author at work. Born into an aristocratic German family, Hildegard transcended the barriers that limited most medieval women. She began serving as leader of her convent in 1136, and about 1147 she founded a new convent near Bingen. With the assistance of the monk Volmar, she began to record her visions in a book, *Scivias* (from the Latin *scite vias lucis*, "know the ways of the light"). The opening page of this copy shows Hildegard receiving a flash of divine insight, represented by the tongues of flame encircling her head. She wrote, "a fiery light, flashing intensely, came from the open vault of heaven and poured through my whole brain." She records her visions on tablets, while Volmar, her scribe, writes to her dictation. Hildegard also wrote on medicine and natural science. A major figure in the intellectual life of her time, she corresponded with emperors, popes, and the Cistercian abbot Bernard of Clairvaux.

Herrad (1130–96), the Abbess of Hohenburg, wrote an encyclopaedia—*Hortus Deliciarum (The Garden of Delights)*—in which she combined a history of the world from its creation to the Last Judgment with a compendium of all human knowledge, using almost 1200 quotations from scholars as well as sermons

and poems. For example, when she told the story of the Magi following the star to Bethlehem she added a discussion of astronomy and astrology. She also devised a complex scheme of illustrations as part of her educational program. She explained her intentions: "Like a small active bee, I have extracted the sugar of the flowers of divine and philosophical literature. . ." for "my sisters in Jesus." Today, such books guide scholars who try to decode the meaning of medieval artworks.

HILDEGARD AND VOLMAR, LIBER SCIVIAS
1165–75. Facsimile frontispiece.

In the *Suicide of Judas* from Autun, flat split-leaf acanthus fronds curl up to form volutes and establish the architectural frame. Two demons string up Judas's limp ugly corpse. The strange noose they use has been identified as the bag of money Judas accepted for his betrayal of Christ or as a wrestler's belt, the symbol of useless worldly physical strength. The screaming demons with contorted faces, vicious teeth, and flaming hair embody evil. With scrawny limbs, bloated bodies, and upswept wings they reinforce the shape of the capital. The sculptors achieve a crispness and clarity by slightly undercutting the forms so that the edges are sharpened by shadows. This clarity was important when the capitals had to be seen at a distance.

Mosaics and Murals

Church interiors were not the bare expanses of stone we see today. Throughout Europe colorful murals glowed in flickering candlelight amid clouds of incense. Wall painting was subject to the same influences as the other visual arts; that is, the painters were inspired by illuminated manuscripts, or ivories, or enamels in their treasuries or libraries. Some must have seen examples of Byzantine art; others had Carolingian or even Early Christian models. During the Romanesque period, painted decoration largely replaced mosaics on the walls of churches. This change occurred at least partly because the growing demand by the greater number of churches led to the use of less expensive materials and techniques.

15–30 | CHRIST IN MAJESTY
Detail of apse, Church of San Climent, Taull, Catalunya, Spain.
1123. Museu Nacional d'Art de Catalunya, Barcelona.

THE MOSAICS OF SAN CLEMENTE, ROME. The apse of San Clemente, richly decorated with colored marbles and a gold mosaic in the semidome, recalls the lost mosaics of the church at Monte Cassino, south of Rome. Abbot Desiderius built a new headquarters Church for the Benedictine Order that he intended should rival the churches of Constantinople. He brought artists from Byzantium to create mosaics and to teach the technique to his most talented monks. In Rome, where Desiderius ruled briefly as Pope Victor III, mosaics were added to a few chapels and churches in spite of the difficulty getting the expensive materials and specialized artists. In the church of San Clemente (SEE FIG. 15–14), the mosaics seem to recapture the past, with the trees and rivers of Paradise, a vine scroll inhabited by figures surrounding the crucified Christ. Mary and Saint John stand below, and twelve doves on the cross and twelve sheep represent the apostles. Stags (symbols of resurrection) drink from streams flowing from the cross, the tree of life in Paradise.

Although the iconography of the mosaic is Early Christian, the style and technique are clearly Romanesque. The artists made no attempt to create an illusion of the natural world. The hard dark outlines and bright flat colors turn the figures into ornamental patterns typical of the twelfth century. The doves on the cross, the repeated circular vine scrolls ending in bunches of leaves and flowers, even the animals, birds, and humans among the leaves are reduced to elements in a formal design. When compared with Early Christian and Byzantine mosaics (see Chapter 7), the mosaic seems evidence of a decline in standards of craftsmanship. However, the irregular setting of tesserai in visibly rough plaster is intentional and actually heightens the color and increases the glitter of the gold. Light reflects off the irregular surface of the apse, causing the mosaic to sparkle.

These rich surfaces continue through the choir and across the pavement in San Clemente. As in other Italian churches of the period, inlaid geometric patterns in marble embellish the floors in an ornamental style known as Cosmati work, after the family who perfected the technique.

MURALS IN TAULL (TAHULL), CATALUNYA, SPAIN. Artists in Catalunya brilliantly combined the Byzantine style with their own Mozarabic and classical heritage. In the Church of San Climent in Taull (Tahull), consecrated in 1123, a magnificently expressive **CHRIST IN MAJESTY** fills the curve of the half-dome of the apse (FIG. 15–30). Christ's powerful presence recalls the Byzantine depiction of Christ Pantokrator, ruler and judge of the world. The iconography is traditional: Christ sits within a mandorla; the Greek letters alpha and omega hang from strings beside his head. He holds the open Gospel inscribed "*Ego sum lux mundi*" ("I am the light of the world," John 8:12). Four lively angels, each grasping an evangelist's symbol, appear beside him. In the arcade at Christ's feet are six apostles and the Virgin Mary.

The columns with stylized capitals have wavy lines of paint indicating marble shafts.

The San Climent artist was one of the finest Spanish painters of the Romanesque period, but where he came from and where he learned his art is unknown. His use of elongated oval faces, large staring eyes, and long noses, as well as the placement of figures against flat bands of color and his use of heavy outlines, reflect the Mozarabic style (Chapter 14). At the same time his work shows the prevailing influence of Byzantine art, although he simplified the style. His painting technique—modeling from light to dark—is Byzantine, accomplished through repeated colored lines of varying width in three shades—dark, medium, and light. But instead of blending the colors, he delights in the striped effect. Details of faces, hair, hands, and muscles also become elegant patterns. The intensity of the colors was created by building up many thin coats of paint, a technique called **glazing**.

MURALS IN THE CHURCH OF SAINT-SAVIN-SUR-GARTEMPE, FRANCE. The paintings in the Church of Saint-Savin (SEE FIG. 15–15) have survived almost intact. The nave vault has scenes from the Old and New Testaments, and the lives of two local saints, Savin and Cyprian, provide imagery for the crypt. The narthex was also painted, as were the columns.

The nave was built c. 1095–1115, and the painters seem to have followed the masons immediately in order to use the same scaffolding. Perhaps this intimate involvement with the building process accounts for the vividness with which they portrayed the biblical story of the **TOWER OF BABEL** (FIG. 15–31).

According to the account in Genesis (11:1–9), God punished the prideful people who tried to build a tower to heaven by scattering them and making their languages mutually unintelligible. The tower in the painting is a medieval structure, reflecting the practice of depicting distant or legendary events in contemporary settings. Workers haul heavy stone blocks to the tower, lifting them to masons on the top with a hoist. The giant Nimrod, on the far right, simply hands over the blocks. The paintings recall the energy and narrative drama of early medieval art. God confronts the people. He steps away from them even as he turns back to chastise them. The scene's dramatic action, large figures, strong outlines, broad areas of color, and simplified modeling all help make it intelligible to a viewer looking up at it in the dim light from far below. The painters did not use the wet-plaster fresco technique favored in Italy for its long-lasting colors, but they did moisten the walls before painting, which allowed some absorption of pigments into the plaster, making them more permanent than paint applied to a dry surface. Several artists, or teams of artists, worked on the church.

15–31 | **TOWER OF BABEL**
Detail of painting in nave vault, Abbey Church of Saint-Savin-sur-Gartempe, Poitou, France. c. 1115.

THE CLOISTER CRAFTS

Monastic *scriptoria* and other workshops continued to domi-
nate the production of works of art, although more and more
secular artists could be found producing high-quality pieces
in the towns and in workshops attached to courts. The clois-
ter crafts include a wide range of media from illuminated
manuscripts to goldsmithing, ivory carving, and embroidery;
and the designation "cloister crafts" replaces the term "deco-
rative arts," which suggests less important work. In the Mid-
dle Ages small precious objects, as well as works in readily
available material like wood, often carried profound mean-
ing. Neither the *Mayestat Batlló* nor the *Mary as the Throne of
Wisdom* can be categorized as "decorative."

Portable Sculpture

Painted wood was commonly used when abbey and local
parish churches of limited means commissioned statues. Wood
was not only cheap, it was lightweight, a consideration since
these devotional images were frequently carried in processions.

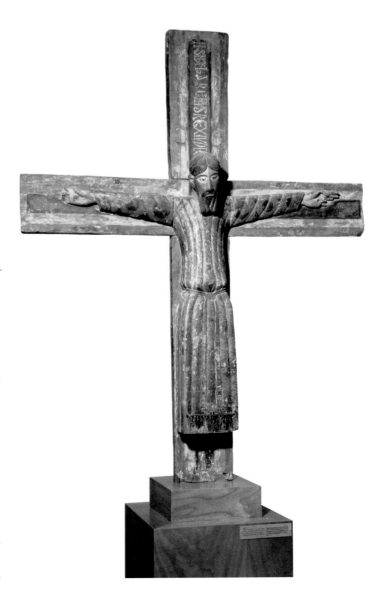

15–32 | **CRUCIFIX (MAJESTAT BATLLÓ)**
Catalunya, Spain. Mid-12th century. Polychromed wood,
height approx. 37¾" (96 cm). Museu Nacional d'Art de
Catalunya, Barcelona.

The cross was hung near the entrance or the altar and might be
carried in processions.

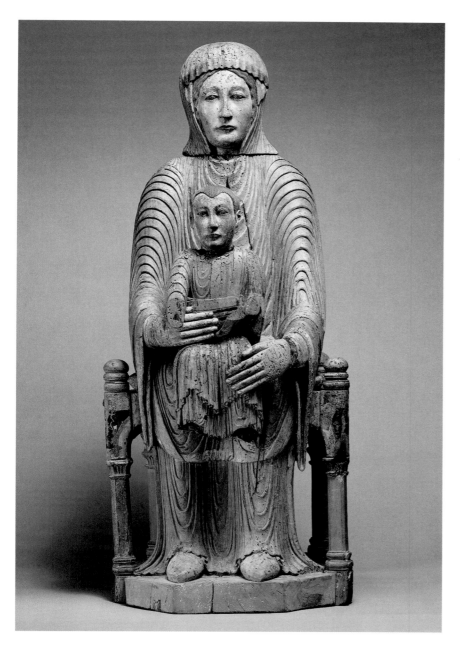

15–33 | VIRGIN AND CHILD
Auvergne region, France. Late 12th century.
Oak with polychromy, height 31″
(78.7 cm).
The Metropolitan Museum of Art,
New York.
Gift of J. Pierpont Morgan, 1916 (16.32.194)

CHRIST ON THE CROSS (*MAJESTAT BATLLÓ*). Sculptors—image makers—found sources and inspiration in Byzantine art. The image of Jesus in a mid–twelfth-century crucifix from Catalunya, known as the **MAJESTAT BATLLÓ** (FIG. 15–32), recalls the Volto Santo (Holy Face) of Lucca, thought to have been brought from Palestine to Italy in the eighth century. Legend had it that the sculpture had been carved by Nicodemus, who helped Joseph of Arimathea remove the body of Christ from the cross.

The Byzantine robed Christ, rather than the nude, tortured Jesus of Byzantine Daphni (SEE FIG. 7–43) or the Ottonian Gero Crucifix (SEE FIG. 14–29), inspired the Catalan sculptor. Christ wears royal robes that emphasize his kingship (SEE THE *Rabbula Gospels*, FIG. 7–36), although Jesus's bowed head, downturned mouth, and heavy-lidded eyes con-

vey a sense of deep sadness or contemplation. His long, medallion-patterned tunic has pseudo-kufic inscriptions—designs meant to resemble Arabic script—on the hem, a reminder that silks from Islamic Spain were highly prized in Europe at this time. Islamic textiles were widely used as cloths of honor hung behind thrones and around altars to designate royal and sacred places. They were used to wrap relics and to cover altars with apparently no concern for their Muslim source.

MARY AS THE THRONE OF WISDOM. Any image of Mary seated on a throne and holding the Christ Child on her lap is known as "The Throne of Wisdom." In a well-preserved example in painted wood dating from the second half of the twelfth century (FIG. 15–33), Mother and Child are frontally

THE ⊙BJECT SPEAKS

THE BAYEUX TAPESTRY

Rarely has art spoken more vividly than in **THE BAYEUX TAPESTRY**, a strip of embroidered linen that tells the history of the Norman conquest of England. On October 14, 1066, William, Duke of Normandy, after a hard day of fighting, became William the Conqueror, king of England. The story told in embroidery is a straightforward justification of the action, told with the intensity of an eyewitness account: The Anglo-Saxon nobleman Harold initially swears his feudal allegiance to William, Duke of Normandy, but later betraying his feudal vows, he accepts the crown of England for himself. Unworthy to be king, he dies in battle at the hands of William and the Normans.

At the beginning of the Bayeux story, Harold is a heroic figure. Then events overtake him. After his coronation, cheering crowds celebrate—until a flaming star crosses the sky. (We now know that it was Halley's Comet, which appeared shortly after Harold's coronation and evidently reached astonishing brightness.) The Anglo-Saxons see the comet as a portent of disaster; the crowd cringes and gestures at this ball of fire with a flaming tail, and a man rushes to inform the new king. Harold slumps on his throne in the Palace of Westminster. He foresees what

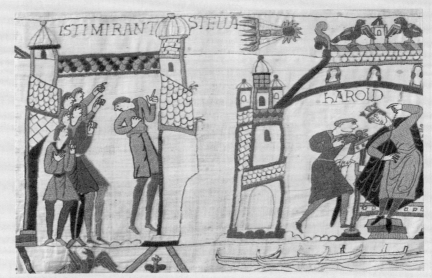

MESSENGERS SIGNAL THE APPEARANCE OF A COMET (HALLEY'S COMET), THE BAYEUX TAPESTRY Norman–Anglo-Saxon embroidery from Canterbury, Kent, England, or Bayeux, Normandy, France. c. 1066–82. Linen with wool, height 20″ (50.8 cm). Centre Guillaume le Conquérant, Bayeux, France.

is to come: Below his feet is his vision of a ghostly fleet of Norman ships already riding the waves. William, Duke of Normandy, has assembled the last great Viking flotilla on the Normandy coast.

The designer was a skillful storyteller who used a staggering number of images. In the fifty surviving scenes are more than 600 human figures; 700 horses, dogs, and other creatures; and 2,000 inch-high letters. Perhaps he or she was assisted by William's half-brother, Bishop Odo, who had fought beside William. As a man of God, he used a club, not a sword, to avoid spilling blood.

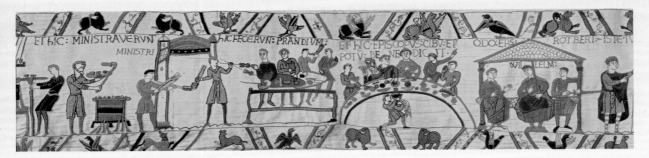

BISHOP ODO BLESSING THE FEAST, THE BAYEUX TAPESTRY
Norman–Anglo-Saxon embroidery from Canterbury, Kent, England, or Bayeux, Normandy, France. c. 1066–82. Linen with wool, height 20″ (50.8 cm). Centre Guillaume le Conquérant, Bayeux, France.

Odo and William are feasting before the battle. Attendants bring in roasted birds on skewers, placing them on a makeshift table made of the knights' shields set on trestles. The diners, summoned by the blowing of a horn, gather at a curved table laden with food and drink. Bishop Odo—seated at the center, head and shoulders above William to his right—blesses the meal while others eat. The kneeling servant in the middle proffers a basin and towel so that the diners may wash their hands. The man on Odo's left points impatiently to the next event, a council of war between William (now the central and tallest figure), Odo, and a third man labeled "Rotbert," probably Robert of Mortain, another of William's half-brothers.

Translation of text: ". . . and here the servants (*ministra*) perform their duty. /Here they prepare the meal (*prandium*) /and here the bishop blesses the food and drink (*cibu et potu*). Bishop Odo. William. Robert."

The tragic drama has spoken to audiences over the centuries. It is the story of a good man who, like Shakespeare's *Macbeth*, is overcome by his lust for power and so betrays his king. The images of this Norman invasion also spoke to people during the darkest days of World War II. When the Allies invaded Nazi-occupied Europe in June 1944, they took the same route in reverse from England to beaches on the coast of Normandy. The *Bayeux Tapestry* still speaks to us of the folly of human greed and ambition and of two battles that changed the course of history.

EMBROIDERY

The *Bayeux Tapestry* is really embroidery, not tapestry. In tapestry, colored threads are woven to form the image or pattern; embroidery consists of stitches applied to a woven ground. The embroiderers, probably Anglo-Saxon women, worked in tightly twisted wool that was dyed in eight colors. They used only two stitches: the quick, overlapping stem stitch that produced a slightly jagged line or outline, and the time-consuming laid-and-couched work used to form blocks of color. The embroiderer first "laid" a series of long, parallel covering threads; then anchored them with a second layer of regularly spaced crosswise stitches; and finally tacked all the strands down with tiny "couching" stitches. Some of the laid-and-couched work was done in contrasting colors to achieve particular effects. Some of the coloring was fanciful; for example, some horses have legs in four different colors. Skin and other light-toned areas were represented by the bare linen cloth that formed the ground of the work. The embroiderers of the *Bayeux Tapestry* probably followed drawings provided by a Norman, who may have been an eyewitness to some of the events depicted.

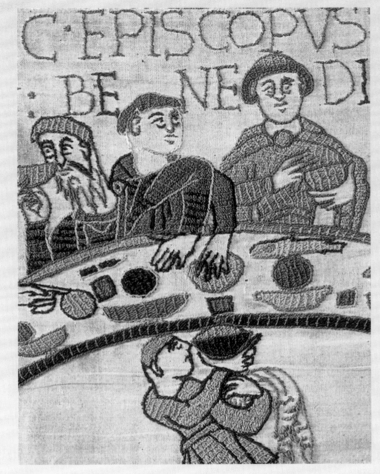

DETAIL, BISHOP ODO BLESSING FEAST, THE BAYEUX TAPESTRY
Norman–Anglo-Saxon embroidery from Canterbury, Kent, England, or Bayeux, Normandy, France. c. 1066–82. Linen with wool, embroidery, height 20″ (50.8 cm). Centre Guillaume le Conquérant, Bayeux, France.

stem stitching

crosswise stitches

laid threads

couching stitches

15–34 | TOMB COVER WITH EFFIGY OF RUDOLF OF SWABIA
Saxony, Germany. c. 1080. Bronze with niello, approx.
6′5½ × 2′2½″ (1.97 × 0.68 m). Cathedral of Merseburg, Germany.

erect, as rigid as they are regal. Mary's thronelike bench symbolized the lion-throne of Solomon, the Old Testament king who represented earthly wisdom in the Middle Ages. Mary, as Mother and "God-bearer" (the Byzantine Theotokos), gave Jesus his human nature. She forms a throne on which he sits in majesty. She also represents the Church. Although the Child's hands are missing, we can assume that the small but adult Jesus held a book—the Word of God—in his left hand and raised his right hand in blessing.

A statue of the Virgin and Child, like the sculpture here, could have played a role in the liturgical dramas being added to church services at that time. At the Feast of the Epiphany, which in the Western Church celebrates the arrival of the Magi to pay homage to the baby Jesus, participants representing the Magi acted out their journey by searching through the church for the newborn king. The roles of Mary and Jesus were "acted" by the sculpture, which the Magi discovered on the altar. In such simple ways theater and the performing arts returned to the West.

Metalwork

Three geographical areas—the Rhineland, the Meuse River valley, and German Saxony—continued to supply the best metalwork for aristocratic and ecclesiastical patrons. Metalworkers in these areas drew on a variety of stylistic sources, including the work of contemporary Byzantine and Italian artists, as well as classical precedents as reinterpreted by their Carolingian and Ottonian forebears.

TOMB OF RUDOLF OF SWABIA. In the late eleventh century, Saxon metalworkers, already known for their large-scale bronze casting, began making bronze tomb effigies (portraits of the deceased). The oldest known bronze tomb effigy is that of **KING RUDOLF OF SWABIA** (FIG. 15–34), who died in battle in 1080, having sided with the pope against the emperor during the Investiture Controversy. The spurs on his oversized feet identify him as a heroic warrior, and he holds a scepter and cross-surmounted orb, emblems of Christian kingship. Although the tomb is in the Cathedral of Merseburg, in Saxony, the effigy has been attributed to an artist originally from the Rhine Valley. Nearly life-size, it has fine linear detailing in **niello,** an incised design filled with a black alloy. The king's head has been modeled in high relief and stands out from his body like a detached shield.

REINER OF HUY. Renier of Huy (Huy is near Liège in present-day Belgium) worked in the Mosan region under the profound influence of ancient art as interpreted by Carolingian and Byzantine forebears. He was also influenced by the humanistic learning of Church scholars. Liege was called the "Athens of the North." Artists like Renier created a style that seems classical in its depiction of human figures with dignity, simplicity, and harmony (FIG. 15–35). Between 1107 and 1118 he cast a

15–35 Renier de Huy **BAPTISMAL FONT, NOTRE-DAME-AUX-FONTES**
Liège, France. 1107–18. Bronze, Height, 23⅝" (60 cm); diameter, 31¼" (79 cm). Now in the Church of St. Barthelemy, Liège.

Sequencing Works of Art
PAINTING IN TWELFTH-CENTURY EUROPE

Early 12th century	The Nun Guda, *Book of Homilies,* Westphalia, Germany
c. 1100	*Tower of Babel,* Abbey Church of Saint-Savin-sur-Gartempe, Poitou, France
c. 1123	*Christ in Majesty,* Church of San Climent, Taull, Catalunya, Spain
c. 1125	*Tree of Jesse* from the *Commentary on Isaiah,* Abbey of Cîteaux, Burgundy, France
c. 1150	*The Mouth of Hell, Winchester Psalter,* Winchester, England

bronze baptismal font for Notre-Dame-aux-Fonts in Liège (now in the Church of Saint Barthelemy) that was inspired by the basin carried by twelve oxen in Solomon's Temple in Jerusalem (I Kings 7:23–24). Christian philosophers identified the twelve oxen as the twelve apostles and the basin as the baptismal font. On the sides of the font, Renier placed images of Saint John the Baptist, preaching and baptizing Christ, Saint Peter baptizing Cornelius, and Saint John the Evangelist baptizing the philosopher Crato. Renier constructs sturdy idealized bodies—nude or with clinging drapery—that move and gesture with convincing reality. His intuitive understanding of anatomy required close observation of the people around him. These figures also convey a sense of space, however shallow, where landscape is reduced to rippling ground lines, a few miniature trees used to separate the scenes, and waves of water rising (in Byzantine fashion) to discreetly cover nude figures. Renier's bronze sculptures demonstrate the survival of a classical and humanistic art in northern Europe.

Illustrated Books

Illustrated books played a key role in the transmission of artistic styles and other cultural information from one region to another. The output of books increased dramatically in the twelfth century, despite the labor and materials involved. Monastic and convent *scriptoria* continued to be the centers of production. The *scriptoria* sometimes also employed lay scribes and artists who traveled from place to place. In addition to the books needed for the church services, scribes produced scholarly commentaries, lives of saints, collections of letters, and even histories (SEE FIG. 15–2). Liturgical works were often large and lavish; other works were more modest, their embellishment confined to initial letters.

SAINT MATTHEW IN THE CODEX COLBERTINUS. The portrait of Saint Matthew from the **CODEX COLBERTINUS**, in contrast to the Hiberno-Saxon and Carolingian author portraits, is an entirely Romanesque conception. Like the sculptured pier figures of Silos (SEE FIG. 15–1), he stands within an architectural frame that controls his size and form (FIG. 15–36). A compact figure, he blesses and holds his book—rather than writing it. His dangling feet bear no weight. Blocks of color fill in outlines without giving the figure any three-dimensional quality. The evangelist is almost part of the text—the opening lines *Liber Generationes.*

The L of *Liber* (Book) is formed of plants and animals and is called a historiated initial. The L established the size and shape of the figurative panel, just as the architectural elements controlled the figures and composition in historiated capitals. The geometric underpinnings are filled with acanthus leaves and interlacing vines. Dogs or catlike animals and long-necked birds twist, claw, and bite each other and themselves while, in the center, two humans—one dressed and one nude—clamber up the letter. This manuscript was made in the region of Moissac at about the same time that sculptors were working on the abbey church.

15–36 | **ST. MATTHEW, FROM THE CODEX COLBERTINUS**
c. 1100. Tempera on vellum, 7½ × 4″ (19 × 10.16 cm).
Bibliothèque National Paris.

THE HELLMOUTH IN THE WINCHESTER PSALTER. Religious texts dominated the work of the *scriptorium*. The **WINCHESTER PSALTER**, commissioned by the English king's brother, Henry of Blois, the Bishop of Winchester, contains a dramatic image of hell (FIG. 15–38). The page depicts the gaping jaws of hell, a monstrous head with dragons sprouting from its mane. Hell is filled with a tangled mass of sinners, among whom are kings and queens with golden crowns and monks with shaved heads, a daring reminder to powerful rulers and the clergy of the vulnerability of their own souls. Hairy, horned demons torment the lost souls, who tumble around in a dark void. An impassive and very elongated angel locks the door.

This vigorous narrative style had its roots in the Carolingian art of the *Utrecht Psalter* (SEE FIG. 14–18), a manuscript which was then in an English monastic library. Here, by comparison, the free pen work of the *Utrecht Psalter* has become controlled and hard. The composition of the intricate interlocking forms is carefully worked out using strong framing devices. For all its vicious energy, the page seems dominated by the ornamental frame.

15–37 | The Nun Guda **BOOK OF HOMILIES**
West, Germany. Early 12th century. Ink on parchment.
Stadtund Universitäts-Bibliothek, Frankfurt, Germany.
MS. Barth. 42, folio 110v

THE GERMAN NUN GUDA. In another historiated initial, this one from Westphalia in Germany, the nun Guda has a more modest role. In a book of homilies (sermons), she inserted her self-portrait into the letter D and signed it as scribe and painter, "Guda, the sinful woman, wrote and illuminated this book" (FIG. 15–37). A simple drawing with a little color in the background, Guda's self-portrait is certainly not a major work of art. Its importance lies in its demonstration that women were far from anonymous workers in German *scriptoria* in the Romanesque period. Guda's image is the earliest signed self-portrait by a woman in Western Europe. Throughout the Middle Ages, women were involved in the production of books as authors, scribes, painters, and patrons.

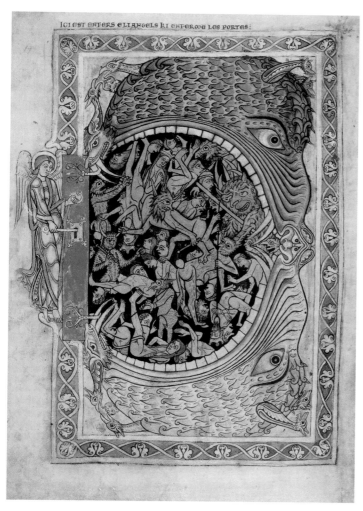

ICI EST ENFERS ELIANGELS RI ENFERCOS LES PORTES:

Winchester, England. c. 1150. Ink and tempera on vellum, 12¾ × 9⅛″ (32.5 × 23 cm). The British Library, London.

The inscription reads: "Here is hell and the angels who are locking the doors."

There are fascinating parallels between the images of the mouth of Hell and the liturgical dramas—known in English as "mystery plays"—that were performed throughout Europe from the tenth through the sixteenth century. On stage, voracious Hellmouth props featured prominently, to the delight of audiences. Carpenters made the infernal beast's head out of wood, papier-mâché, fabric, and glitter and placed it over a trapdoor onstage. The wide jaws of the most ambitious Hellmouths, operated by winches and cables, opened and closed on the actors while emitting smoke, flames, foul smells, and loud noises. Hell scenes, with their often scatological humor, were by far the most popular parts of the plays.

CISTERCIAN DEVOTION TO MARY, THE TREE OF JESSE. The Cistercians were particularly devoted to the Virgin and are also credited with popularizing themes such as the Tree of Jesse as a device for showing her position as the last link in the genealogy connecting Jesus Christ to King David. (Jesse, the father of King David, was an ancestor of Mary and, through her, of Jesus.) Saint Jerome's **COMMENTARY ON ISAIAH**, a manuscript made in the *scriptorium* of the Cistercian mother house at Cîteaux about 1125, contains an image known as the **TREE OF JESSE** (FIG. 15–39).

A monumental Mary, standing on the forking branches of the tree, dwarfs the sleeping patriarch, Jesse, a small tree trunk grows from his body. The Christ Child sits on her veiled right arm. The elongated but still human figure of Mary, emphasized by the vertical lines and V-shaped folds of the drapery and the soft colors, suggests a new sense of humanity. The artist has drawn, rather than painted, with colors, the subtle tints creating an image in keeping with Cistercian restraint. Following late Byzantine and Romanesque convention, Christ is portrayed as a miniature adult with his right hand raised in blessing. His cheek presses against Mary's, a display of affection similar to that shown in Byzantine icons of the time, like the *Virgin of Vladimir* (SEE FIG. 7–39). Mary holds a flowering sprig from the tree—another symbol for Christ.

The building held by the angel on the left equates Mary with the Church, and the crown held by the angel on the right is hers as Queen of Heaven. The dove above her halo represents the Holy Spirit. The jeweled hems of Mary's robes reflect her elevated status as Queen of Heaven. In the early decades of the twelfth century, Church doctrine came increasingly to stress the role of the Virgin Mary and the saints as intercessors who could plead for mercy on behalf of repentant sinners, and devotional images of Mary became increasingly popular during the later Romanesque period.

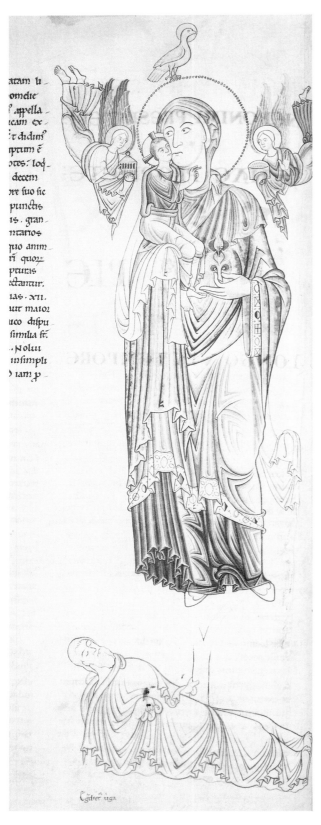

15–39 │ **PAGE WITH THE TREE OF JESSE,** *EXPLANATIO IN ISAIAM* **(SAINT JEROME'S COMMENTARY ON ISAIAH)**
Abbey of Cîteaux, Burgundy, France. c. 1125. Ink and tempera on vellum, 15 × 4¾″ (38 × 12 cm). Bibliothèque Municipale, Dijon, France.
MS 129, fol. 4v

IN PERSPECTIVE

Wiligelmus, Roger, Gislebertus, Guda, and many anonymous women and men of the eleventh and twelfth centuries created a new art that—although based on the Bible and the lives of the saints—focused on human beings, their stories, and their beliefs. The artists worked on a monumental scale in painting, sculpture, and even embroidery, and their art moved from the cloister to the public walls of churches.

The sheer size of churches, the austere majesty of their towers, their interior spaces often covered with masonry vaults, their marvelously functional plans and elevations reflect a culture that saw the church as not only the Heavenly Jerusalem but as a bulwark against the ever-present demonic forces of evil. Equally mighty castle walls stood against actual earthly enemies. A source of local and even regional pride, the cathedral, monastic church, or castle required the most creative and highest quality work, and rulers and communities contributed material resources and labor.

Many Romanesque churches have a remarkable variety of painting and sculpture. Christ enthroned in majesty may be carved over the entrance or painted in the half-dome of the apse. Scenes from the life of Christ or images of the lives and the miracles of the saints cover the walls. Romanesque art also reflects the increasing importance accorded to the Virgin Mary. The elect rejoice in heaven; the damned suffer in hell. A profusion of monsters, animals, plants, geometric ornament, and depictions of real and imagined buildings fill the spaces. While the artists emphasized the spiritual and intellectual concerns of the Christian Church, they also began to observe and record what they saw around them. In so doing they laid the groundwork for the art of the Gothic period.

CATHEDRAL COMPLEX,
PISA
CATHEDRAL BEGUN 1063

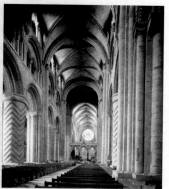

DURHAM CATHEDRAL,
NAVE
1087–1133

TRUMEAU SOUTH PORTAL,
MOISSAC
C. 1115

CRUCIFIX (MAJESTAT BATLLÓ)
MID 12TH CENTURY

THE MOUTH OF HELL,
WINCHESTER PSLATER
C. 1150

1050
1100
1120
1140
1150

ROMANESQUE ART

◄ **Henry IV Rules Germany and Holy Roman Empire** 1056–1106

◄ **William of Normandy Invades England** c. 1066

◄ **Investiture Controversy** c. 1075

◄ **First Crusade** 1095–99
◄ **Cistercian Order Founded** 1098

◄ **Eleonor of Aquitaine Queen of France with Louis VII** 1137–52

◄ **Hildegard of Bingen Writes *Scivias*** c. 1141–1151

◄ **Second Crusade** 1147–49

◄ **Eleanor of Aquitaine Queen of England with Henry II** 1154–1189

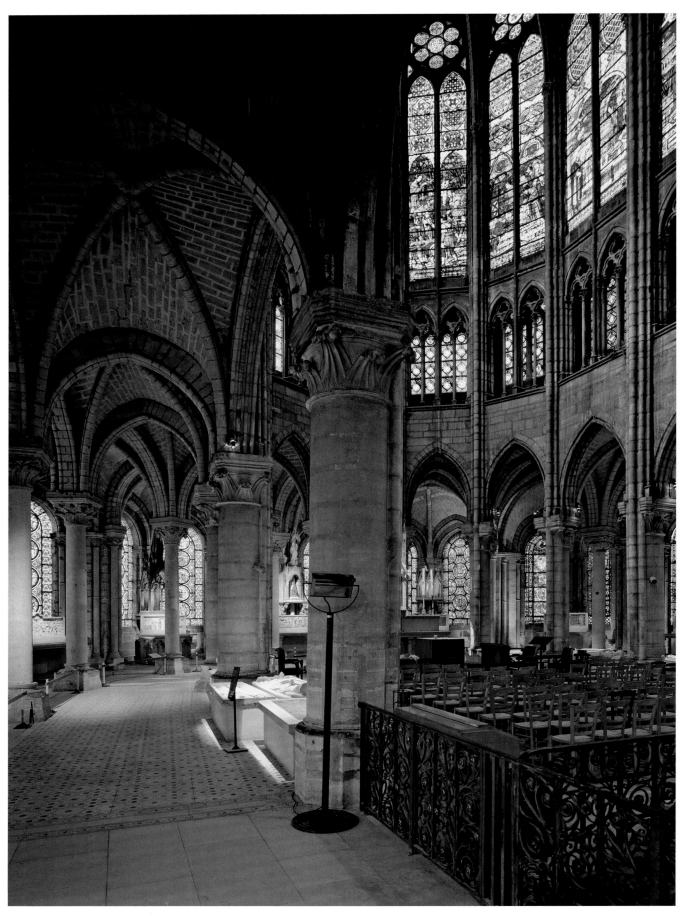

16–1 | **INTERIOR, ABBEY CHURCH OF SAINT-DENIS, CHOIR** France. 1140–44; 1231–81.

GOTHIC ART OF THE TWELFTH AND THIRTEENTH CENTURIES

The twelfth-century Abbot Suger of Saint-Denis (1081–1151) was, according to his biographer Willelmus, "small of body and family, constrained by twofold smallness, [but] he refused, in his smallness, to be a small man" (cited in Panofsky, page 33). Educated at the monastery of Saint-Denis, near Paris, he became a powerful and trusted adviser to kings Louis VI and Louis VII. Suger governed France as regent when Louis VII and Eleanor of Aquitaine were absent from France during the Second Crusade (1147–49). He also built what many consider the first Gothic church in Europe.

After Suger was elected abbot of Saint-Denis, he was determined to build a new church to replace the old Carolingian one. He waged a successful campaign to gain both royal and popular support for his rebuilding plans. The old building, he pointed out, had become inadequate. With a touch of exaggeration, he claimed that the crowds of worshipers had become so great that women were being crushed and monks sometimes had to flee with their relics by jumping through windows.

The abbot had traveled widely—in France, the Rhineland, and Italy, including four trips to Rome—and so he was familiar with the latest architecture and sculpture of Romanesque Europe. As he began planning the new church,

he also turned for inspiration to books in the monastery's library, including the writings of a late fifth-century Greek philosopher known as the Pseudo-Dionysius, who had identified radiant light with divinity (see "Abbot Suger on the Value of Art," page 516). Seeing the name "Dionysius," Suger thought he was reading the work of Saint Denis, also known as Dionysius the Aeropagite, the first-century convert of Saint Paul (Acts 17:34). Not unreasonably, he adapted the concept of divine luminosity into the redesign of the church dedicated to Saint Denis. In the choir of the new church, he created "a circular string of chapels by virtue of which the whole [church] would shine with the wonderful and uninterrupted light of most luminous windows, pervading the interior beauty" (cited in Panofsky, page 101).

Although Abbot Suger died before he was able to finish rebuilding Saint-Denis, his presence remained: The cleric had himself portrayed in a sculpture at Christ's feet in the central portal and in a stained-glass window in the apse. Suger is remembered not for these portraits, however, but for his inspired departure from traditional architecture in order to achieve a flowing interior space and an all-pervasive, colored interior light. His innovation led to the widespread use of large stained-glass windows that bathed the inside walls of French churches with sublime washes of color (FIG. 16–1).

THE EMERGENCE OF THE GOTHIC STYLE

In the middle of the twelfth century, a distinctive new architecture known today as Gothic emerged in the Île-de-France, the French king's domain around Paris (MAP 16–1). The appearance there of a new style and building technique coincided with the emergence of the monarchy as a powerful centralizing force in France. Soon, the Gothic style spread throughout Western Europe, gradually displacing Romanesque forms while taking on regional characteristics inspired by those forms. The term *Gothic* was first used by Italians in the fifteenth and the sixteenth centuries when they disparagingly attributed the style to the Goths, the Germanic invaders who had destroyed the classical civilization of the Roman Empire that they so admired. In its own day the Gothic style was simply called the "modern" style or the "French" style.

Gothic architecture sought to express the aspiration for divinity through a quest for height and luminosity. Its soaring stonework and elegance of line, and the light, colors, and sense of transparency produced by its great expanses of glass—all became more pronounced over time. The style was adapted to all types of structures—including town halls, meeting houses, market buildings, residences, synagogues, and palaces—and its influence extended beyond architecture and architectural sculpture to painting and other mediums.

The Rise of Urban Life

The Gothic period was an era of both communal achievement and social change. Although Europe remained rural, towns gained increasing prominence. Some cities were freed from obligations to local feudal lords, and, as protected centers of commerce, became sources of wealth and power for the king. Intellectual life was also stimulated by the interaction of so many people living side by side. Universities in Bologna, Padua, Paris, Cambridge, and Oxford supplanted rural monastic schools as centers of learning. Brilliant teachers like Peter Abelard (1079–1142) drew crowds of students, and in the thirteenth century a Dominican professor from Italy, the theologian Thomas Aquinas (1225–74), made Paris the intellectual center of Europe. This period saw the flowering of poetry and music as well as philosophy and theology.

As towns grew, they became increasingly important centers of artistic patronage. The production and sale of goods in many towns was controlled by **guilds**. Merchants and artisans of all types, from bakers to painters, formed these associations to advance their professional interests. Medieval guilds also played an important social role, safeguarding members' political interests, organizing religious celebrations, and looking after members and their families in times of trouble.

A town's walls enclosed streets, wells, market squares, shops, churches, and schools. Homes ranged from humble wood-and-thatch structures to imposing town houses of stone. Although wooden dwellings crowded together made fire an ever-present danger and although hygiene was rudimentary at best, towns fostered an energetic civic life. This strong communal identity was reinforced by public projects and ceremonies.

The Age of Cathedrals

Urban cathedrals, the seats of the ruling bishops, superseded rural monasteries as centers of religious patronage. So many of these churches were rebuilt between 1150 and 1400—often after fires—that the period has been called the "Age of Cathedrals." Cathedral precincts functioned almost as towns within towns. The great churches dominated their surroundings and were central fixtures of urban life (SEE FIG. 16–8). Their grandeur inspired admiration; their great expense and the intrusive power of their bishops inspired resentment. In the twelfth century, the laity experienced a decisive growth in religious involvement. In the early thirteenth century members of two new religious orders, the Franciscans and the Dominicans, known as mendicants (beggars) because they were meant to be free of wordly goods, went out into the world to preach and to minister to those in need, rather than secluding themselves in monasteries. (see "The Mendicant Orders: Franciscans and Dominicans" page 524).

Scholasticism and the Arts

The Crusades—which continued throughout the thirteenth century—and the trade that followed these military ventures

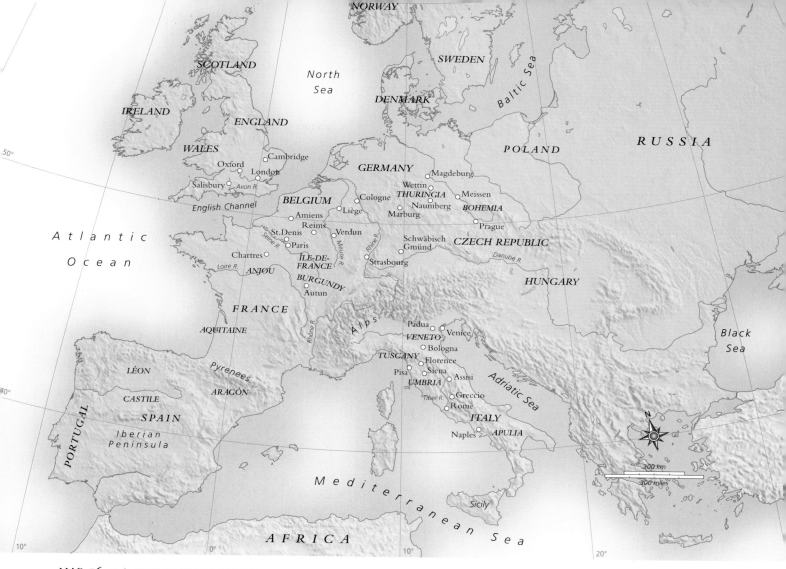

MAP 16–1 | **EUROPE IN THE GOTHIC ERA**

The Gothic period witnessed the emergence of England, France, Portugal, and Spain (Castile) as nations, while the pope wielded political as well as religious power throughout the West. The residents of cities rose to challenge the power of landed nobility.

brought Western Europeans into contact with the Byzantine and Islamic worlds, where—unlike in the West—literary works of classical antiquity had been preserved. The "rediscovery" of these works, particularly the philosophy of Aristotle, posed a challenge to Christian theology because they promoted rational inquiry rather than faith as the path to truth, and their conclusions did not always suit Church doctrine.

A system of reasoned analysis known as Scholasticism emerged to reconcile Christian theology with classical philosophy. Scholastic thinkers used a question-and-answer method of argument and arranged their ideas into logical outlines. Thomas Aquinas, the foremost Scholastic, applied Aristotelian logic to comprehend religion's supernatural aspects. His great philosophical work, the *Summa Theologica,* which attempted to reconcile rationalism with religious faith, has endured as a basis of Catholic thought to this day. Scholastic thinkers applied reasoned analysis to a vast range of subjects. Vincent de Beauvais, a thirteenth-century Parisian Dominican, organized his eighty-volume encyclopedia, the *Speculum Maius (Greater Mirror),* in which he intended to

encompass all human knowledge, into four categories: the Natural World, Doctrine, History, and Morality.

This all-pervasive intellectual approach had a profound influence on the arts. Like the philosophers, master builders saw divine order in geometric relationships and used these relationships as the underpinnings of architectural and sculptural programs. Sculptors and painters created naturalistic forms that reflected the combined idealism and analysis of Scholastic thought. Gothic religious imagery expanded to incorporate a wide range of subjects from the natural world, and like Romanesque imagery its purpose was to instruct and convince the viewer. In the Gothic cathedral, Scholastic logic intermingles with the mysticism of light and color to create for the worshiper the direct, emotional, ecstatic experience of the church as the embodiment of God's house, filled with divine light.

GOTHIC ART IN FRANCE

The initial flowering of the Gothic style took place in France against the backdrop of the growing power of the French Capetian monarchy. Louis VII (ruled 1137–80) and Philip

ABBOT SUGER ON THE VALUE OF ART

From *De administratione*, Ch. XXVII, Of the Cast and Gilded Doors:

Bronze casters having been summoned and sculptors chosen, we set up the main doors on which are represented the Passion of the Saviour and His Resurrection, or rather Ascension, with great cost and much expenditure for their gilding as was fitting for the noble porch. . . .

The verses on the door are these:

Whoever thou art, if thou seekest to extol the glory of these doors,
Marvel not at the gold and the expense but at the craftsmanship of the work,

Bright is the noble work; but being nobly bright, the work
Should lighten the minds, so that they may travel, through the true lights,
To the True Light where Christ is the true door,
In what manner it be inherent in this world the golden door defines:
The dull mind rises to truth through that which is material
And, in seeing this light, is resurrected from its former subversion.

Panofsky, Erwin. *Abbot Suger on the Abbey Church of St.-Denis and its Art Treasures.* 2nd ed. By Gerda Panofsky-Soergel. Princeton, NJ: Princeton University Press, 1979, pp. 47; 49.

Augustus (ruled 1180–1223) consolidated royal authority in the Île-de-France and began to exert control over powerful nobles in other regions. Before succeeding to the throne, Louis VII had married Eleanor of Aquitaine (heiress to all southwestern France). When the marriage was annulled, Eleanor took her lands and married Henry Plantagenet—count of Anjou, Duke of Normandy—who became King Henry II of England. The resulting tangle of conflicting claims kept France and England at odds for centuries. Through all the turmoil, the French kings continued to consolidate royal authority and to increase their domains and privileges at the expense of their vassals and the Church.

Early Gothic Architecture

The political events of the twelfth and thirteenth centuries were accompanied by energetic church building, often made necessary by the fires that constantly swept through towns. It has been estimated that during the Middle Ages several million tons of stone were quarried to build some eighty cathedrals, 500 large churches, and tens of thousands of parish churches and that within a hundred years some 2,700 churches were built in the Île-de-France region alone. This explosion of building began at a historic abbey church on the outskirts of Paris.

THE ABBEY CHURCH OF SAINT-DENIS. The Benedictine monastery of Saint-Denis, a few miles north of central Paris, had great symbolic significance for the French monarchy (SEE FIG. 16–1). It housed the tombs of the kings of France and their courts, regalia of the French Crown, and the relics of Saint Denis, the patron saint of France, who, according to tradition, had been the first bishop of Paris. In the 1130s, under the direction of Abbot Suger, construction began on a new abbey church (FIG. 16–2).

Suger described his administration of the abbey and the building of the Abbey Church of Saint-Denis in three books (see "Abbot Suger on the Value of Art," above). Suger prized magnificence. Having traveled widely, he combined design ideas from many sources. Suger invited masons and sculptors from other regions, making his abbey a center of artistic exchange. (Unfortunately, Suger did not record the names of the masters he employed, nor did he give information about them.) For the rebuilding, he received substantial annual revenues from the town's inhabitants, and he established free housing on abbey estates to attract peasant workers. For additional funds, he turned to the royal coffers and fellow clerics.

Suger began the rebuilding in 1135, with a new west façade and narthex (SEE FIG. 16–2). The design combined a Norman tripartite façade design, as seen in the abbey church in Caen (SEE FIG. 15–23), with sculptured portals like those at Autun (SEE FIG. 15–28). Two towers, a round window, and narrative sculpture over not one but three portals completed the magnificent composition. Within the narthex Suger's masons built highly experimental ribbed groin vaults over both square and rectangular bays (see "Rib Vaulting," page 521). (Much of the sculpture was destroyed or damaged in the eighteenth century, and the north tower had to be removed after it was struck by lightning in the nineteenth century.)

Suger's renovation of the choir at the east end of the church represented an equally momentous departure from the Romanesque style (SEE FIG. 16–1). Completed in three years and three months (1140–44), timing that the abbot found auspicious, the choir resembled a pilgrimage church, with a semicircular sanctuary surrounded by an ambulatory and seven radiating chapels (FIG. 16–3). Its large stained-glass windows, however, were new. While all the architectural elements of the choir—ribbed groin vaults springing from

Louis VII and Eleanor of Aquitaine attended the consecration of the new choir on June 14, 1144. Shortly thereafter the Second Crusade became the primary recipient of royal resources, leaving Suger without funds to replace the old nave and transept at Saint-Denis. After Suger died in 1151, his church remained unfinished for another century (see page 536).

The Abbey Church of Saint-Denis became the prototype for a new architecture of space and light based on a highly adaptable skeletal framework constructed from buttressed perimeter walls and pointed arch interior vaulting with masonry ribs. It initiated a period of competitive experimentation in France that resulted in ever larger churches, enclosing increasingly taller interior spaces, walled with ever greater expanses of colored glass. These great churches, with their unabashed decorative richness, were part of Abbot Suger's legacy to France.

AN EARLY GOTHIC CATHEDRAL: NOTRE DAME OF PARIS. The Cathedral of Paris, known simply as Notre Dame ("Our Lady," the Virgin Mary), bridges the period between Abbot Suger's rebuilding of his abbey church and the High Gothic

16–2 | **WEST FAÇADE, ABBEY CHURCH OF SAINT-DENIS**
France. 1135–44, engraving made before 1837.

round piers, pointed arches, wall buttresses to relieve stress on the walls, and adequate window openings—had already appeared in Romanesque buildings, the achievement of Suger's master mason was to combine these into a fully integrated architectural whole. Sanctuary, ambulatory, and chapels open into one another to create a feeling of open, flowing space. Walls of stained glass replace masonry, permitting colored light to permeate the interior. These effects rely on the masterful use of vaulting techniques, the culmination of half a century of experiment and innovation.

The choir of Saint-Denis represented a new architectural aesthetic based on open spaces rather than massive walls. Suger considered light and color to be a means of illuminating the soul and uniting it with God. For him, the colored lights of stained-glass windows, like the glint of gems and gold in the chalice he gave to his church transfixed the world with the splendor of Paradise

■ 12th Century
▨ 13th Century
▨ 14th Century
▧ 15th Century

16–3 | **ABBEY CHURCH OF SAINT-DENIS, PLAN**
West façade 1135–40; choir 1140–44; nave 1231–81.

16–4 | **CATHEDRAL OF NOTRE-DAME, PARIS**
Begun 1163; choir chapels, 1270s; crossing spire, 19th-century replacement. View from the south.

cathedrals of the thirteenth century (FIG. 16–4). As the city and royal court grew, Paris needed a larger cathedral. According to tradition, in 1163, Pope Alexander II laid the cornerstone of a new church.

The nave, with its massive walls and buttresses and six-part vaults adopted from Norman Romanesque architecture (SEE FIG. 15–19), dates to 1180–1200. The nave had four stories: an arcade surmounted by a gallery and two levels of rather small windows, including both lancets and round "bull's eye" windows (SEE FIG. 16–12). To increase the window size and secure the vault, the builders built the first true flying buttresses. The *flying buttress,* a gracefully arched, skeletal exterior support, counters the outward thrust of the nave vault by carrying the weight over the side aisles to the ground (see "Rib Vaulting," page 521). Although the nave was huge, it must have seemed very old fashioned by the thirteenth century. After 1225, new masters modernized the building by reworking the two upper levels into the large clerestory windows we see today. The huge flying buttresses rising dramatically to support the 115-foot high vault at Notre Dame are the result of later remodeling. (The 290-foot spire over the crossing is the work of the nineteenth-century architect Eugène-Emmanuel Viollet-le-Duc.)

From Early to High Gothic: Chartres Cathedral

The structural techniques and new conception of space applied at Saint-Denis and Notre Dame in Paris were taken one step further at Chartres Cathedral. It is here that the transition from Early to High Gothic is most eloquently

expressed. The great Cathedral of Notre-Dame in Chartres dominates this town southwest of Paris (SEE FIG. 16–8 and "The Gothic Church," page 522). For many people, Chartres Cathedral is a near-perfect embodiment of the Gothic spirit in stone and glass. Constructed in several stages beginning in the mid-twelfth century and extending into the mid-thirteenth, with additions such as the north spire as late as the sixteenth century, the cathedral reflects the transition from an experimental twelfth-century architecture to a mature thirteenth-century style.

FOUR HUNDRED YEARS AT CHARTRES. Chartres was the site of a pre-Christian virgin-goddess cult, and later, dedicated to the Virgin Mary, it became one of the oldest and most important Christian shrines in France. Its main treasure was a piece of linen believed to have been worn by Mary when she gave birth to Jesus. The so-called Tunic of the Virgin was a gift from the Byzantine Empress Irene to Charlemagne, whose grandson, Charles the Bald, donated it to the church in 876. The relic was kept below the high altar in a huge basement crypt. The healing powers attributed to the cloth made Chartres a major pilgrimage destination, especially as the cult of the Virgin grew in popularity in the twelfth and thirteenth centuries.

The theologians of Chartres tried to present all of Christian history in the sculpture and stained glass of their cathedral. On the west, in the Royal Portal, the sculpture is dedicated to Christ (FIG. 16–5). The north transept portal and the stained glass above it depict the world before Christ, with Saint Anne and the Virgin Mary. On the south transept, the

16–5 | **WEST FAÇADE, CHARTRES CATHEDRAL (THE CATHEDRAL OF NOTRE-DAME)**
Chartres, France. West façade begun c. 1134; cathedral rebuilt after a fire in 1194; building continued to 1260; north spire 1507–13.

viewers learn of later events in Christian history, including the lives of the saints and the Last Judgment.

Chartres' decoration also encompasses number symbolism. The number three represents the spiritual world of the Trinity, while the number four represents the material world (the four winds, the four seasons, the four rivers of Paradise). Combined, they form the perfect and all-inclusive number seven, expressed in the seven gifts of the Holy Spirit. References to three, four, and seven recur throughout the cathedral imagery. On the west façade, for example, the seven liberal arts surround the image of Mary and Jesus.

THE ROYAL PORTAL. From a distance, the most striking features of the west façade, constructed after a fire in 1134, are its prominent rose window—a huge circle of stained glass—and two towers with their spires. But up close, the western façade's three doorways—the so-called Royal Portal, inspired by the portal of the Church of Saint-Denis—capture the attention with their sculpture.

In the center of the west façade, on the central tympanum, Christ is enthroned in royal majesty with the four evangelists (**FIG. 16–6**). He appears imposing but more benign than at Autun. The apostles, organized into four groups of

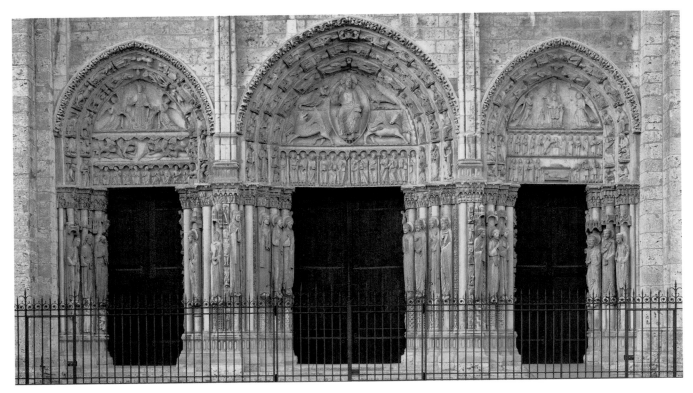

16–6 | ROYAL PORTAL, WEST FAÇADE, CHARTRES CATHEDRAL
c. 1145–55.

Right—Tympanum: Mary enthroned with Christ Child (Throne of Wisdom); Lintels: Annunciation, Visitation, Nativity and Shepherds, Presentation; Archivolts: The Liberal Arts. Center—Tympanum: The Second Coming, Christ and the Four Apostles; Lintels: Apostles; Archivolts: The Twenty-Four Elders. Left—Tympanum: Ascension; Lintels: Angels and Apostles; Archivolts: Zodiac and Labors of the Months; Capitals: Life of Christ; Statue Columns: Old Testament Kings and Queens.

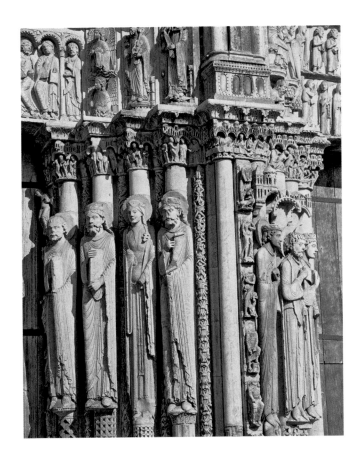

three, fill the lintel, and the twenty-four elders of the Apocalypse line the archivolts. The portal on Christ's left (the viewer's right) is dedicated to Mary and the early life of Christ, from the Annunciation to the Presentation in the Temple. On the left portal, Christ ascends heavenward in a cloud, supported by angels. Running across all three portals, storied capitals depict his earthly activities.

Flanking the doorways are monumental jamb figures (FIG. 16–7) depicting Old Testament kings and queens, the precursors of Christ. These figures convey an important message—just as the Old Testament supports and leads to the New Testament, so too these biblical kings and queens support Mary and Christ in the tympana above. They also lead the worshiper into the House of the Lord. The depiction of Old Testament kings and queens reminded people of the close ties between the Church and the French royal house. During the French Revolution, sculptures of kings and queens were removed from churches and destroyed. The Chartres figures are among the few that survived.

16–7 | ROYAL PORTAL, WEST FAÇADE, CHARTRES CATHEDRAL
Detail: Prophets and Ancestors of Christ (Kings and Queens of Judea). Right side, Central Portal, c. 1145–55.

Jamb figures became standard elements of Gothic church portals. They developed from shaftlike reliefs to fully three-dimensional figures that appear to interact. Earlier sculptors had achieved dramatic effects by compressing, elongating, and bending figures to fit an architectural framework. At Chartres, the sculptors sought to pose their figures naturally and comfortably in their architectural settings. The erect, frontal column statues, with their slender proportions and vertical drapery, echo the cylindrical shafts from which they seem to emerge. Their heads are finely rendered with idealized features. Calm and order prevails in all the elements of the portal, in contrast to the crowded imagery of the Romanesque churches.

REBUILDING CHARTRES. A fire in 1194 destroyed most of the church at Chartres but spared the Royal Portal and its windows and the crypt with its precious relics. A papal representative convinced reluctant local church officials to rebuild. He argued that the Virgin permitted the fire because she wanted a new and more beautiful church to be built in her honor. Between 1194 and about 1260, the chapter and people built a new cathedral (FIG. 16–8).

To erect such an enormous building required vast resources—money, raw materials, and skilled labor. A contemporary painting shows a building site with the masons at work (FIG. 16–9). Carpenters have built scaffolds, platforms, and a lifting machine. Master stone cutters measure and cut the stones, and in many cases sign their work with a "mason's mark." Workmen carry and hoist the blocks by hand or with a lifting wheel. Thousands of stones had to be accurately cut and placed. In the illustration a laborer carries mortar up a ladder to men working on the top of the wall, where the lifting wheel delivers cut stones.

The highly skilled men who carved capitals and portal sculpture were members of the masons' guild. Skilled stone cutters earned more than simple workmen, and the master usually earned at least twice what his men received (see "Master Builders," page 525).

Elements *of* Architecture
RIB VAULTING

An important innovation of Romanesque and Gothic builders was **rib vaulting**. Rib vaults are a form of **groin vault** (SEE "arch, vault, and dome," PAGE 172), in which the ridges (groins) formed by the intersecting vaults may rest on and be covered by curved moldings called ribs. After the walls and piers of the building reached the desired height, timber scaffolding to support the masonry ribs was constructed. After the ribs were set, the web of the vault was then laid on forms built on the ribs. After all the temporary forms were removed, the ribs provided strength at the intersections of the webbing to channel the vaults' thrust outward and downward to the foundations. In short, ribs formed the "skeleton" of the vault; the webbing, a lighter masonry "skin." In late Gothic buildings additional, decorative ribs give vaults a lacelike appearance.

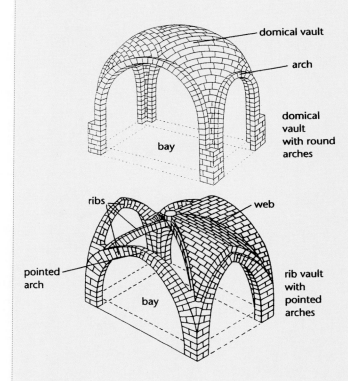

Elements *of* Architecture
THE GOTHIC CHURCH

ELEMENTS OF THE GOTHIC CHURCH

1 Portals
2 Jambs
3 Rose window
4 Gables
5 Pinnacles and finials
6 Lancets
7 Stringcourse
8 Buttress piers
9 Flying Buttress
10 Tracery
11 Nave

12 Side aisles
13 Compound pier with engaged colonettes
14 Triforium
15 Clerestory
16 Rib vaults
17 Crossing
18 Transept
19 Choir
20 Apse
21 Apsidal Chapels

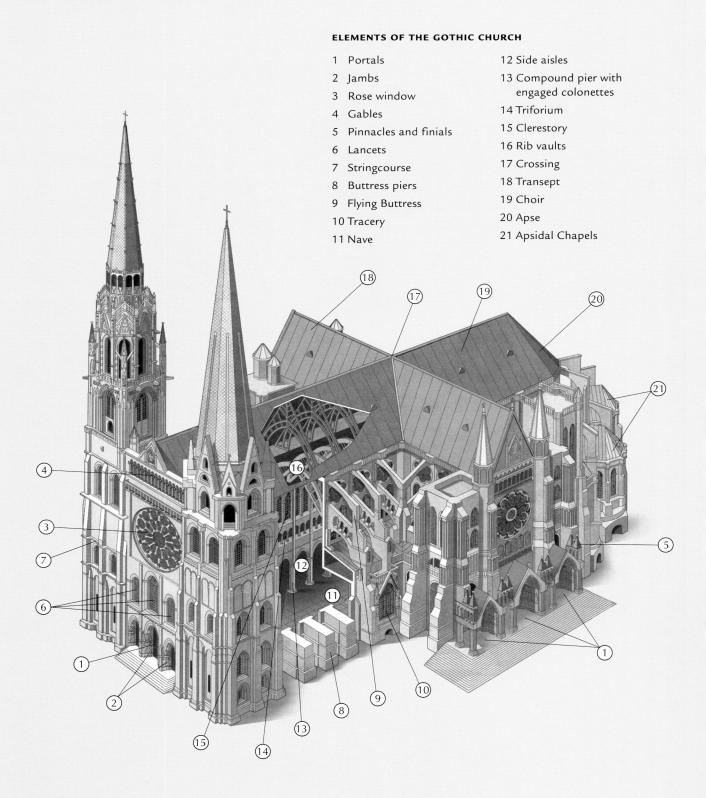

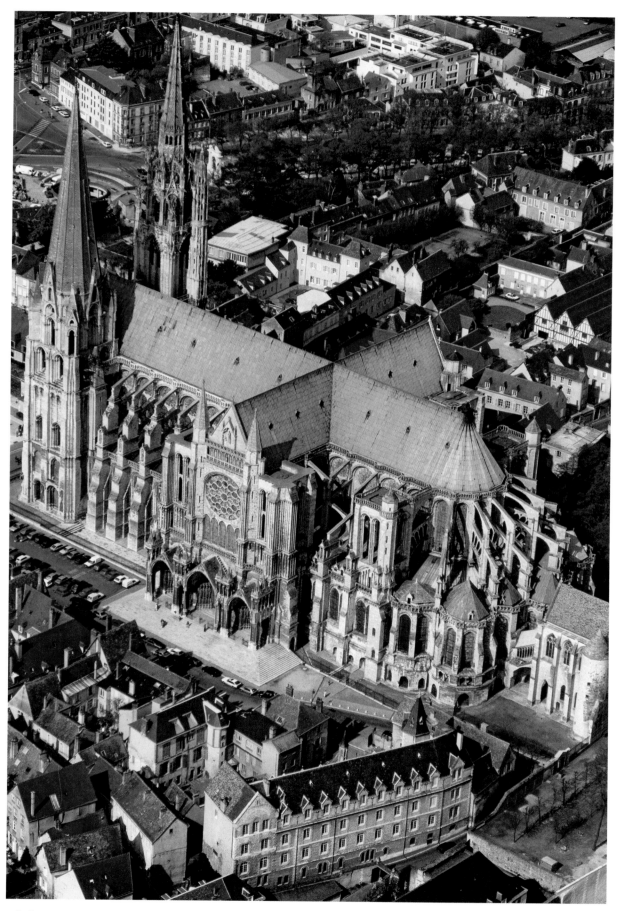

16–8 | **CHARTRES CATHEDRAL, AIR VIEW FROM SOUTHEAST**

Myth and Religion
THE MENDICANT ORDERS: FRANCISCANS AND DOMINICANS

In the thirteenth century new religious orders arose to meet the needs of the growing urban population. The mendicants (begging monks) lived among the urban poor. They espoused an ideal of poverty, charity, and love, and they dedicated themselves to teaching and preaching.

The first mendicant orders were the Franciscans and Dominicans. Saint Francis (Giovanni di Bernardone, (1182–1226; canonized in 1228) was born in Assisi, the son of wealthy merchants. Sensitive to the misery of others, he gave away his possessions and devoted his life to God and the poor. He was soon joined by others who also dedicated their lives to poverty, service, and love of all creatures. His love of Christ was so intense that the stigmata, or wounds suffered by Christ on the cross, are believed to have appeared on his own body.

Saint Francis wrote a simple rule for his followers, who were called brothers, or friars (from the Latin *frater*, meaning "brother"). The pope approved the new order in 1209–10. Franciscans can be recognized by their dark gray or brown robes tied with a rope, whose three knots symbolized their vows of poverty, chastity, and obedience.

The Dominican Order was established in 1216 by a Castilian nobleman, Domenico Guzman (1170–1221; canonized in 1234), as the Order of Friars Preachers. The Dominicans held their first general meeting in 1220. In order to combat heresy by combating ignorance, the Dominicans became teachers. Dominicans number among their members some of the greatest scholars of the thirteenth century: Vincent of Beauvais (c. 1190–1264) and Thomas Aquinas (c. 1225–74). Dominicans were also known as Black Friars because they wore a black cloak over a white tunic.

16–9 | **MASONS AT WORK**
Morgan Library, New York.
ms. M240 fol. 3

Art and Its Context
MASTER BUILDERS

Master masons oversaw all aspects of church construction in the Middle Ages, from design and structural engineering to decoration. The job presented formidable logistical challenges, especially at great cathedral sites. The master mason at Chartres coordinated the work of roughly 400 people scattered, with their equipment and supplies, at many locations, from distant stone quarries to high scaffolding. This work force set in place some 200 blocks of stone each day.

Funding shortages and technical delays, such as the need to let mortar harden for three to six months, made construction sporadic, so masters masons and their crews moved constantly from job to job, with several masters contributing to a single building. Fewer than 100 master builders are estimated to have been responsible for all the major architectural projects around Paris during the century-long building boom there, some of them working on parts of as many as forty churches. Today the names of more than 3,000 master masons are known to us, and the close study of differences in construction techniques can disclose the participation of specific masters.

Master masons gained in prestige during the thirteenth century as they increasingly differentiated themselves from the laborers they supervised. Their training was rigorous. By the standards of their time they were well read; they traveled widely.

They knew both aristocrats and high Church officials, and they earned as much as knights. In some cases their names were prominently inscribed in the labyrinths on cathedral floors. From the thirteenth century on, in what was then an exceptional honor, masters were buried, along with patrons and bishops, in the cathedrals they built.

Villard de Honnecourt **SHEET OF DRAWINGS WITH GEOMETRIC FIGURES AND ORNAMENTS**
From Paris. 1220–35. Ink on vellum, 9¼ × 6″
(23.5 × 15.2 cm). Bibliothèque Nationale, Paris.

Lodge books were an important tool of the master mason and his workshop (or lodge). Such books or collections of drawings provided visual instruction and inspiration for apprentices and assistants. Since the drawings received hard use, few have survived. One of the most famous architect's collections is the early thirteenth-century sketchbook of Villard de Honnecourt, a well-traveled master who recorded a variety of images and architectural techniques. A section labeled "help in drawing figures according to the lessons taught by the art of geometry" illustrates the use of geometric shapes to form images and how to copy and enlarge images by superimposing geometric shapes over them as guides.

The economy of Chartres revolved around trade fairs, especially cloth fairs held at the times of the church festivals honoring Mary, such as the day of her Assumption, August 15. Both merchants and the Church profited from sales and taxes at the fairs. To build the new cathedral, the bishop and cathedral officials pledged all or part of their incomes for three to five years. Royal and aristocratic patrons joined in the effort. In an ingenious scheme that seems very modern, the churchmen solicited contributions by sending the cathedral relics, including the Virgin's tunic, on tour as far away as England.

As the new structure rose higher during the 1220s, the work grew more costly and funds dwindled. But when the bishop and the cathedral clergy tried to make up the deficit by raising feudal and commercial taxes, the townspeople drove them into exile for four years. This action in Chartres was not unique; people often opposed the building of cathedrals because of the burden of new taxes. The economic privileges claimed by the Church for the cathedral sparked intermittent riots by townspeople and the local nobility throughout the thirteenth century.

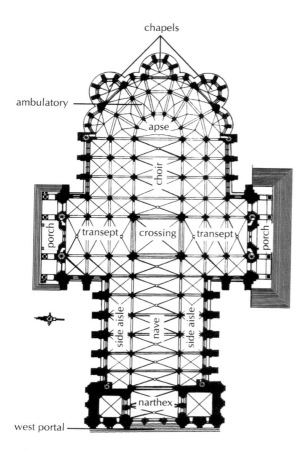

16–10 CHARTRES CATHEDRAL, PLAN
c. 1194–1220.

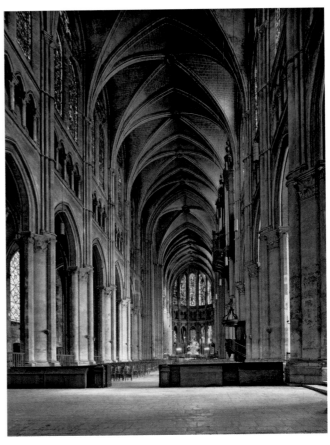

16–11 NAVE, CHARTRES CATHEDRAL
c. 1194–1220.

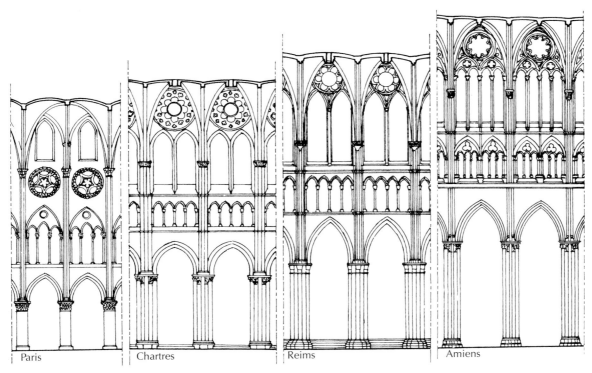

Paris Chartres Reims Amiens

16–12 COMPARATIVE CATHEDRAL NAVE ELEVATIONS
From Louis Grodecki, *Gothic Architecture,* New York, 1985. Paris, h. 115′ (35 m), w. 40′ (12 m); Chartres, h.
120′ (37 m), w. 45′ 6″ (17 m); Reims h. 125′ (38 m), w. 46′ (14 m); Amiens, h. 144′ (44 m), w. 48′ (15 m).

HIGH GOTHIC ARCHITECTURE AT CHARTRES, 1194 TO 1260.
Building on the concept pioneered at Saint-Denis of an elegant masonry shell enclosing a large open space, the masons at Chartres erected a church over 45 feet wide with vaults that soar approximately 120 feet above the floor. In the plan, the enlarged sanctuary with its ambulatory and chapels, a feature inspired by the church at Saint-Denis, occupied one-third of the building (FIG. 16–10). The actual cross section of the nave is an equilateral triangle measured from the outer line of buttresses to the keystone of the vault. The worshiper's gaze is drawn forward toward the choir where the high altar was situated behind a choir screen and at the same time upward to the clerestory windows and the soaring vaults (FIG. 16–11).

By making the open nave arcade and glowing clerestory nearly equal in height, the architect creates a harmonious elevation (FIG. 16–12). Relatively little interior architectural decoration interrupts the visual rhythm of compound piers with their engaged shafts supporting pointed arches. Four-part vaulting has replaced more complex systems found in churches such as Durham or Caen (SEE FIG. 15–21). The alternating heavy and light piers typical of Romanesque naves such as that at Speyer Cathedral (SEE FIG. 15–17) become a subtle alternation of round and octagonal compound piers. The gallery, now a narrow arcaded triforium passage, forms a horizontal band running the length of the nave. The large and luminous clerestory is formed by windows whose paired **lancets** are surmounted by small circular windows, or **oculi** (bull's-eye windows). The technique used is known as **plate tracery**; that is, holes are cut in the stone of the wall and filled with stained glass. Glass fills nearly half the wall surface. This lightening of the structure is made possible by the ingenious system of flying buttresses on the exterior.

THE GLORY OF STAINED GLASS. Chartres is unique among French Gothic buildings in that most of its stained-glass windows have survived. Stained glass is an expensive and difficult medium, but its effect on the senses and emotions makes the effort worthwhile. The light streaming in through these windows changes with the time of day, the seasons, and the movement of clouds.

Chartres was famous for its glassmaking workshops, which by 1260 had installed about 22,000 square feet of stained glass in 176 windows (see "Stained-Glass Windows," page 528). Most of the glass dates between about 1210 and 1250, but a few earlier windows, from around 1150 to 1170, survived the fire of 1194.

Among the twelfth-century works of stained glass in the west wall of the cathedral is the **TREE OF JESSE** window (FIG. 16–13). The treatment of this subject, much more complex than its depiction in an early twelfth-century Cistercian manuscript (SEE FIG. 15–39), was apparently inspired by a similar window at Saint-Denis. Jesse, the father of King David and an ancestor of Mary, lies at the base of the tree whose trunk grows out of his body, as described by the prophet Isaiah

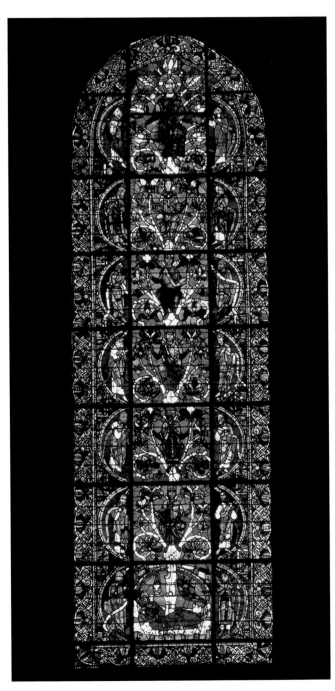

16–13 **TREE OF JESSE, WEST FAÇADE, CHARTRES CATHEDRAL**
c. 1150–70. Stained and painted glass.

Technique
STAINED-GLASS WINDOWS

The basic technique for making colored glass has been known since ancient Egypt. It involves the addition of metallic oxides—cobalt for blue, manganese for red and purple—to a basic formula of sand and ash or lime that is fused at high temperature. Such "stained" glass was used on a small scale in church windows during the Early Christian period and in Carolingian and Ottonian churches. Colored glass sometimes adorned Romanesque churches, but the art form reached a pinnacle of sophistication and popularity in the cathedrals and churches of the Gothic era.

Making a stained-glass image was a complex and costly process. A designer first drew a composition on a wood panel the same size as the opening of the window to be filled, noting the colors of each of the elements in it. Glassblowers produced sheets of colored glass, and artisans cut individual pieces from these large sheets and laid them out on the wood template. Painters added details with enamel emulsion, and the glass was reheated to fuse the enamel to it. Finally, the pieces were joined together with narrow lead strips, called **cames.** The assembled pieces were set into iron frames that had been made to fit the stonework of the window opening.

The colors of twelfth-century glass—mainly reds and blues with touches of dark green, brown, and orange-yellow—were so dark as to be nearly opaque, and early uncolored glass was full of impurities. But the demand for stained-glass windows stimulated technical experimentation to achieve new colors and greater purity and transparency. The Cistercians adorned their churches with *grisaille* windows, painting foliage and crosses onto a gray glass, and Gothic artisans developed a clearer material onto which elaborate narrative scenes could be drawn.

By the thirteenth century, many new colors were discovered, some accidentally, such as a sunny yellow produced by the addition of silver oxide. *Flashing*, in which a layer of one color was fused to a layer of another color, produced an almost infinite range of hues. Blue and yellow, for example, could be combined to make green. In the same way, clear glass could be fused to layers of colored glass in varying thicknesses to produce a range of hues from light to dark. The deep colors of early Gothic stained-glass windows give them a saturated and mysterious brilliance. The richness of some of these colors, particularly blue, has never been surpassed. Pale colors and large areas of *grisaille* glass became increasingly popular from the mid-thirteenth century on, making the windows of later Gothic churches bright and clear by comparison.

(11:1–3). The family tree literally connects Jesus with the house of David (Matthew 1:1–17). In the branches above him appear four kings of Judea (Christ's royal ancestors), then the Virgin Mary, and finally Christ himself. Seven doves, symbolizing the seven gifts of the Holy Spirit, encircle Christ, and fourteen prophets stand in the semicircles flanking the tree. The glass in the *Tree of Jesse* window is set within an iron framework visible as a rectilinear pattern of black lines.

Twelfth-century windows are remarkable for their simple geometric compositions—usually squares and circles and the intensity of the color of the glass. In the color symbolism of the time, blue signified heaven and fidelity; red, the Passion; white, purity; green, fertility and springtime. Yellow as a substitute for gold could represent the presence of God, the sun, or truth; but plain yellow could also mean deceit and cowardice. Stained-glass windows changed the color and quality of light to inspire devotion and contemplations. Their painted narratives also educated the viewers.

Most of the windows in the new church were glazed between 1210 and 1250. In the aisles and chapels where the windows were low enough to be easily seen, there were elaborate narratives using many small figures. Tracery—geometric decorative patterns in stone or wood that filled window openings—became increasingly intricate. In the clerestory windows, glaziers used single figures that could be seen at a distance because of their size, simple drawing, and strong colors. In the north transept, five lancets and a rose window (over 42 feet in diameter) fill the upper wall (FIG. 16–14).

The North transept windows may have been a royal commission, a gift from Queen Blanche of Castile (mother of Louis IX, regent, 1226–34), whose heraldic castles symbolizing the country of Castile (Spain) join the golden lilies of France in the spandrels. In the lancets, Saint Anne and the infant Mary have the place of honor. Saint Anne is flanked by Old Testament figures: the priests Mechizedek and Aaron and the kings David and Solomon. In the center of the rose window, Mary is enthroned with the Christ Child. Radiating from the holy pair are lattice-filled panels displaying four doves (the Gospels) and eight angels, the prophets, and the Old Testament ancestors of Christ.

High Gothic: Amiens and Reims Cathedrals

New cathedrals in other rich commercial cities of northern France reflected both the piety and civic pride of the citizens. The cathedrals of Chartres, Amiens, and Reims were being built at the same time, and the master masons at each site borrowed ideas from one another. Amiens was an important trading and textile-manufacturing center north of Paris. The cathedral housed relics of Saint John the Baptist. When Amiens burned in 1218, church officials devoted their resources to making its replacement as splendid as possible.

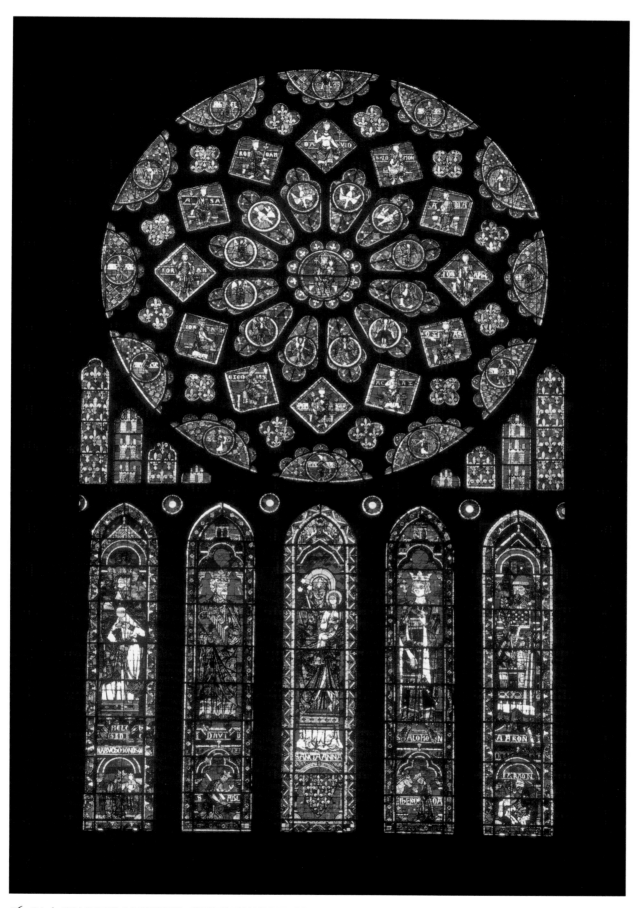

16–14 **CHARTRES CATHEDRAL, NORTH TRANSEPT, ROSE WINDOW AND LANCETS, KNOWN AS THE "ROSE OF FRANCE"**
North transept, Chartres Cathedral. c. 1220, stained and painted glass.

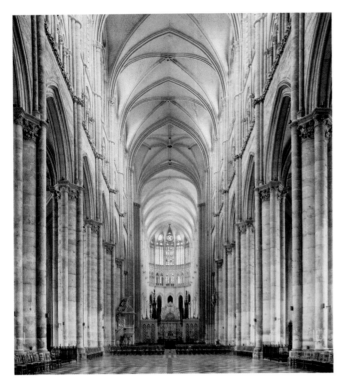

16–15 | **NAVE, AMIENS CATHEDRAL**
France. 1220–88; upper choir reworked after 1258.

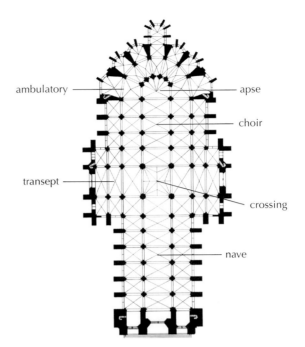

16–16 | Robert de Luzarches, Thomas de Cormont, and Renaud de Cormont **PLAN OF CATHEDRAL OF NOTRE-DAME, AMIENS**
1220–88.

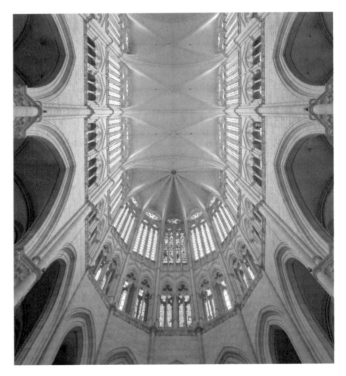

16–17 | **VAULTS, SANCTUARY, AMIENS CATHEDRAL**
France. Upper choir after 1258; vaulted by 1288.

Their funding came mainly from the cathedral's agricultural estates and from the city's important trade fairs. Construction on the new church began in 1220. The lower parts date from about 1220–36, with major work continuing until 1288. Robert de Luzarches (d. 1236) was the builder who established the overall design. He was succeeded by Thomas de Cormont, who was followed by his son Renaud.

NAVE AND CHOIR: AMIENS CATHEDRAL. The church at Amiens became the archetypical Gothic cathedral (FIG. 16–15). Robert de Luzarches made critical adjustments that simplified, clarified, and unified the plan of Amiens Cathedral as compared with Chartres Cathedral. He eliminated the narthex and expanded the transept and sanctuary (comprising the apse, ambulatory chapels, and choir), thus shortening the nave and creating a plan that seems to balance east and west around the crossing (FIG. 16–16). In the choir, chapels of the same size and shape enhance the clarity of the design. The nave elevation is also balanced and compact. Uniform and evenly spaced compound piers, with engaged half columns topped by foliage capitals, support the arcades. Tracery and colonnettes (small columns) unite the triforium and the clerestory, and together they equal the height of the nave arcade. An ornate floral molding below the triforium runs uninterrupted across the wall surfaces and the colonnettes, providing a horizontal counterpoint to the soaring verticality of the design. This sculptural detail adds an elegant note to the severe architecture.

Amiens is a supreme architectural statement of the Gothic desire for both actual and perceived height (FIG. 16–17). The nave, only 48 feet wide, soars upward 144 feet; consequently, not only is the nave in fact exceptionally tall, its narrow proportions (3:1, height to width) create an exaggerated sense of

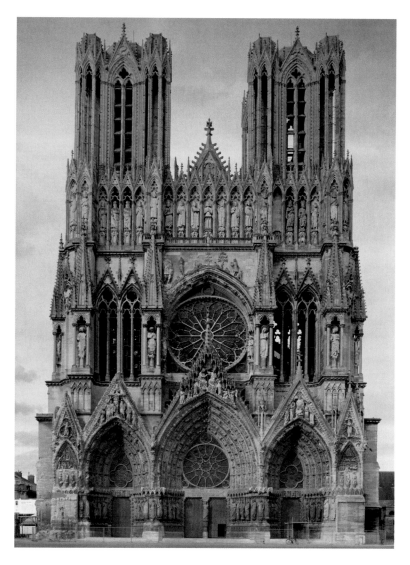

16–18 | **WEST FAÇADE, CATHEDRAL OF NOTRE-DAME, REIMS**

France. Rebuilding begun 1211; façade begun c. 1225; to the height of rose window by 1260; finished for the coronation of Philip the Fair in 1286; towers left unfinished in 1311; additional work 1406–28.

The cathedral was restored in the sixteenth century and again in the nineteenth and twentieth centuries. During World War I it withstood bombardment by some 3,000 shells, an eloquent testimony to the skills of its builders.

height. A comparison of Louis Grodecki's nave elevations of the cathedrals of Paris, Chartres, Reims, and Amiens—drawn to the same scale—demonstrates the change in height and design of cathedrals over time (SEE FIG. 16–12).

The lower portions of the church were substantially finished by about 1240. The vault and the light-filled choir date to the second phase of construction, directed by Thomas de Cormont, perhaps after a fire in 1258 (FIG. 16–17). The choir is illuminated by large windows subdivided by **bar tracery** (in bar tracery, thin stone strips, called **mullions,** form a lacy matrix for the glass). In the Amiens choir, the tracery divides the windows into slender lancets crowned by **trefoils** (three-lobed designs) and circular windows.

THE WEST FAÇADE AT REIMS CATHEDRAL. In the Church hierarchy, the bishop of Amiens was subordinate to the archbishop of Reims. Reims, northeast of Paris, was the coronation church of the kings of France and, like Saint-Denis, had been a cultural and educational center since Carolingian times. When in 1210 fire destroyed this vital building, the

community at Reims began to erect a new structure. The cornerstone was laid in 1211, and work on the cathedral continued throughout the century. The expense of the project sparked such local opposition that twice in the 1230s revolts drove the archbishop and canons into exile. At Reims five masters directed the work on the cathedral over the course of a century—Jean d'Orbais, Jean le Loup, Gaucher de Reims, Bernard de Soissons, and Robert de Coucy. If Amiens Cathedral has the ideal Gothic nave and choir, Reims Cathedral's west front takes pride of place among Gothic façades. The major portion of this magnificent structure must have been finished in time for the coronation of Philip the Fair in 1286 (FIG. 16–18). Its tall gabled portals form a broad horizontal base and project forward to display an expanse of sculpture. Their soaring peaks, the middle one reaching to the center of the rose window, unify the façade vertically. Large windows fill the tympana, instead of the sculpture usually found there. The deep porches are encrusted with sculpture that lacks the unity seen at Amiens, reflecting instead 100 years of changes in plan, iconography, and workshops.

16–19 | **NAVE, REIMS CATHEDRAL**
Looking west. Begun 1211; nave c. 1220.

In a departure from tradition, Mary rather than Christ dominates the central portal, a reflection of the popularity of her cult. Christ crowns her as Queen of Heaven in the central gable. The enormous rose window is the focal point of the façade. The towers were later additions, as was the row of carved figures that runs from the base of one tower to the other above the rose window. This "gallery of kings" is the only strictly horizontal element of the façade.

Inside the church, remarkable sculpture and stained glass fill the west wall (FIG. 16–19), which visually "dissolves" in colored light. The great rose window fills the clerestory level; a row of lancets illuminate the triforium; and a smaller rose window replaces the stone of the tympanum of the portal. This expanse of glass was made possible by bar tracery, a technique invented or at least perfected at Reims. The circles of the two rose windows are anchored visually by a masonry grid of tracery and sculpture covering the inner wall of the façade.

Here ranks of carved Old Testament prophets and Christ's royal ancestors serve as moral guides for the newly crowned monarchs who faced them after the coronation ceremonies.

High Gothic Sculpture

Like Greek sculpture, Gothic sculpture evolved from static forms to moving figures, from formal geometric abstraction though an idealized phase, to a surface realism that could be highly expressive. As in ancient art, Gothic sculpture was originally painted and sometimes gilded. The stone surfaces were not entirely covered but subtly colored and decorated to enhance the realism of the figures. Recent cleaning at Amiens and Reims has revealed remarkable amounts of color—borders of garments painted to indicate rich embroidery, gilded angel wings, colored foliage, and chevron-patterned colonettes.

AMIENS. The worshipers approaching the main entrance— the west portals—of Amiens Cathedral encountered an overwhelming array of images. Figures of apostles and saints line the door **jambs** and cover the projecting buttresses (FIG. 16–20). Most of them were produced by a large workshop in only twenty years, between about 1220 and perhaps 1236/40, making the façade stylistically more coherent than those of many other cathedrals. In the mid-thirteenth century, Amiens-trained sculptors traveled across Europe and carried their style into places like Spain and Italy.

The Amiens central portal is dedicated to Christ and the Apostles, with the Last Judgment in the tympanum above, surrounded by angels and saints in the voussoirs. At the right is Mary's portal, where she is depicted as Queen of Heaven. The left portal is dedicated to local saints with Saint Firmin, the first bishop of Amiens, in the **trumeau**. At Amiens the master designer introduced a new feature: At eye-level, on the base below the jamb figures, are **quatrefoils** (four-lobed medallions) containing lively illustrations of good (Virtues) and evil (Vices) in daily life, the seasons and labors of the months, the lives of the saints, and biblical stories (FIG. 16–21). At last the natural world enters the ideal Christian vision.

All this imagery revolves around Christ standing in front of the trumeau of the central portal. Known as the **BEAU DIEU,** meaning "Noble (or Beautiful) God," Christ as the teacher-priest bestows his blessing on the faithful (FIG. 16–22). This exceptionally fine sculpture may well be the work of the master of the Amiens workshop himself. The figure establishes an ideal for Gothic figures. The broad contours of the heavy drapery wrapped around Christ's right hip and bunched over his left arm lead the eye up to the Gospel book he holds and, following his right hand, raised in blessing, to his face, which is that of a young king. He stands on a lion and a dragonlike creature called a *basilisk,* symbolizing his kingship and his triumph over evil and death (Psalm 91:13).

16–20 | **WEST FAÇADE, AMIENS CATHEDRAL**
c. 1220–36/40 and continued through the 15th century.

With its clear, solid forms, elegantly cascading robes, and interplay of close observation with idealization, the *Beau Dieu* embodies the Amiens style and the Gothic spirit.

REIMS. At Reims, sculptors from major workshops, such as Chartres and Amiens, as well as local sculptors worked together for decades. Most of the sculpture was done in a twenty-year period between 1230 and 1250, although sculpture in the upper regions of the façade may be as late as 1285.

Complicating the study of the sculpture at Reims is the fact that many figures have been moved from their original locations. On the right jamb of the central portal of the western façade, a group of four figures—depicting the *Annunciation* and the *Visitation*—illustrates three of the characteristic

16–21 WEST FAÇADE, CENTRAL AND NORTH PORTALS.
AMIENS CATHEDRAL.
c. 1220–1236/40. Central portal: tympanum: Last Judgement; trumeau:
Christ (Beau Dieu); jambs: Apostles. Height of figures, 7-8′.

Reims styles (FIG. 16–23). Art historians have given names to the styles: the Classical Master (or the Master of Antique Figures), the Amiens Master, and the Master of the Smiling Angels. The pair on the right, the *Visitation,* is the work of the Classical Shop, which was active as early as the 1220s and 1230s. Mary (left), pregnant with Jesus, visits her older cousin Elizabeth (right), who is pregnant with John the Baptist.

The sculptors drew on classical sources—either directly from Roman sculpture (Reims had been an important center under ancient Rome) or indirectly through Mosan metal-work (SEE FIG. 16–35). The heavy figures have a solidity seen in Roman sculpture, and Mary's full face, gently waving hair, and heavy mantle recall imperial portrait statuary. The contrast between the features of the young Mary and the older

Elizabeth recall ancient Roman sculpture (compare the portrait of the Flavian woman in FIG. 6–45). The Classical Master of Reims used deftly modeled drapery not only to provide volume, but also to create a stance in which the apparent shift in weight of one bent knee allows the figures to seem to turn toward each other. The new freedom, movement, and sense of implied interaction inspired later Gothic artists toward ever greater realism.

In the *Annunciation* two other masters were at work, one probably from Amiens and the other a new artist whose antecedents are still unknown. The Amiens Master's Mary is a quiet, graceful figure, with a slender body and restrained gestures—a striking contrast to the bold tangibility of the Classical Master's Mary. The broad planes of simple drapery suggest

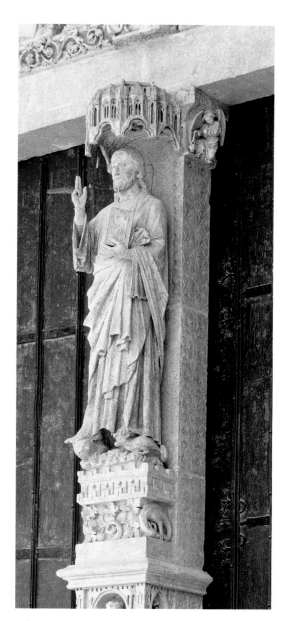

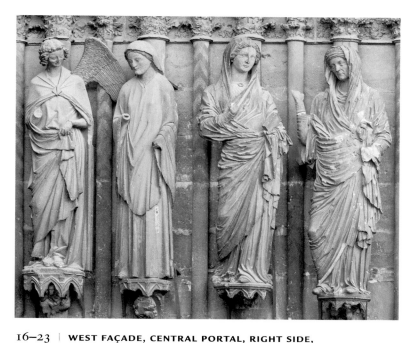

16–23 | WEST FAÇADE, CENTRAL PORTAL, RIGHT SIDE, REIMS CATHEDRAL
Annunciation (left pair: Mary [right] c. 1245, angel [left] c. 1255) and *Visitation* (right pair: Mary [left] and Elizabeth [right] c. 1230).

16–22 | CHRIST: BEAU DIEU
Trumeau, central portal, west façade, Amiens Cathedral. France. c. 1220–36/40.

the Amiens shop, but her pinched features are the sculptor's personal style. The sculptor here was one of a large team that made most of the other sculptures of the west entrance.

The figure of the angel Gabriel is the work of the Master of the Smiling Angels. This artist created tall, gracefully swaying figures that in body type, features, pose, and gestures suggest the fashionable refinement associated with the Parisian court at mid-century. The angel Gabriel is typical. His small, almost triangular head with a broad brow and pointed chin is framed by wavy hair; his puffy, almond-shaped eyes are set under arching brows; he has a well-shaped nose and thin lips curving into a slight smile. The cocked head, hint of a smile, and mannered gestures as he draws his voluminous drapery into elegant folds suggest aristocratic,

courtly elegance. Later in the century (and during the fourteenth century), artists from Paris to Prague imitated this style, as grace and refinement became a guiding ideal in sculpture and painting (see Chapter 17).

The Rayonnant Style

In the second half of the thirteenth century artists fell under the spell of the Master of the Smiling Angels of Reims as well as the luminous west façade of Reims and choir of Amiens. They created a new variation of the Gothic style of architecture, known today as the Rayonnant (Radiant) or Court Style (referring to the Parisian court). Using this style, they finished older buildings, such as the abbey church of Saint-Denis, and added transepts and chapels to Notre Dame in Paris.

16–24 | **UPPER CHAPEL, SAINTE-CHAPELLE**
Paris. 1243–48.

including a bit of the metal lance tip that pierced Christ's side, the vinegar-soaked sponge offered to wet Christ's lips, a nail used in the Crucifixion, and a fragment of the True Cross (or so people believed). He kept these treasures in the palace while he built a chapel to house them. Construction moved rapidly. The building may have been finished in 1246, and it was consecrated in 1248.

The Sainte-Chapelle resembles a giant reliquary, one made of stone and glass instead of gold and gems. Built in two stories, the ground-level chapel is accessible from a courtyard, and a private upper chapel is entered from the royal residence. The ground-level chapel has a nave and narrow side aisles, but the upper level is a single room with a western porch and a rounded east wall. The design of the exterior, with gables and wall buttresses framing huge windows, inspired the artist who created a psalter for the king (discussed on the facing page).

16–25 | **QUEEN BLANCHE OF CASTILE AND LOUIS IX, MORALIZED BIBLE**
Paris. 1226–34. Ink, tempera, and gold leaf on vellum, 15 × 10½″ (38 × 26.6 cm). The Pierpont Morgan Library, New York.
MS. M. 240, f. 8

This page was placed at the end of the manuscript as a colophon (comparable to a title page in a modern book). Thin sheets of gold leaf were painstakingly attached to the vellum and then polished to a high sheen with a tool called a burnisher. Gold was applied to paintings before pigments.

At Saint-Denis (SEE FIG. 16–1), work began in 1231 to complete Abbot Suger's church. The new nave, transept, and upper part of the choir attach seamlessly to the twelfth-century narthex and lower part of the choir (SEE FIG. 16–3). Its glazed triforium and tall clerestory windows filled with bar tracery and stained glass are visually united by the continuous shafts rising from the base of clustered columns to the rib vault. The builders achieved the effects of spatial unity and an interior filled with the jewel-like colored space dreamed of by Suger.

The remodeling and construction of the transepts at Paris, the choir at Amiens, and the façade at Reims all reflect a courtly style characterized by interlocking and overlapping forms, linear patterns, and above all, spatial unity and luminosity. The Rayonnant style continued through the fourteenth and into the fifteenth centuries and influenced the Gothic art of Germany, Italy, and Spain.

THE SAINTE-CHAPELLE IN PARIS. The masterpiece of Rayonnant style is the palace chapel in Paris—the Sainte-Chapelle, or Holy Chapel—ordered by Louis IX (FIG. 16–24). Louis IX (ruled 1226–70) avidly collected relics of Christ's Passion sold to him by his cousin, who was ruling Constantinople after the Fourth Crusade. In 1239 Louis acquired the crown of thorns and in 1241 other relics,

16–26 | **ABRAHAM, SARAH, AND THE THREE STRANGERS FROM THE PSALTER OF SAINT LOUIS**
Paris. 1253–70. Ink, tempera, and gold leaf on vellum,
5 × 3½″ (13.6 × 8.7 cm). Bibliothèque Nationale, Paris.

of books. The Court Style had enormous influence throughout northern Europe, spread by artists, especially manuscript illuminators, who flocked to Paris from other regions. There they joined workshops affiliated with the Confrérie de Saint-Jean (Guild of Saint John), supervised by university officials who controlled the production and distribution of books. These works ranged from practical manuals to elaborate devotional works illustrated with exquisite miniatures. Women played an important role in book production. Widows continued their husband's businesses; they even took oaths as commercial book producers.

LOUIS IX AND BLANCHE OF CASTILE. Paris was a major center of book production in the Gothic period, and the royal library in Paris was especially renowned. Not only the king, but his mother, Blanche of Castile, commissioned and collected books (**FIG. 16–25**). Blanche and the young king appear here seated on ornate thrones against a gold background. Colorful Gothic architecture suggests the royal palace, where the manuscript may actually have been made. Below, a scholar-monk dictates, and the scribe works on a page with a column of circles that will hold the illustrations. This compositional format derives from stained-glass lancets organized as columns of images in medallions. The illuminators show their debt to stained glass in their use of glowing red and blue colors and reflective gold surfaces.

THE PSALTER OF SAINT LOUIS. In the opulence, number, and style of its illustrations, the **PSALTER OF SAINT LOUIS** defines the Court style in manuscript illumination just as Louis' chapel does the architecture (**FIG. 16–26**). The book, containing seventy-eight full-page illuminations, was created for the king's private devotions, probably after his return from the Fourth Crusade in 1254. The illustrations fall at the back of the book, preceded by Psalms and other readings. Intricate scrolled borders frame the narratives, and figures are rendered in a style that reflects the sculpture of the Master of the Smiling Angels of Reims.

Whether entering the upper level, walking through the palace halls, or climbing up the narrow spiral stairs from the lower level, the visitor emerges into a kaleidoscopic jewel box. The walls have been reduced to clusters of slender colonnettes framing tall windows filled with shimmering glass. Bar tracery in the windows is echoed in the blind arcading and tracery decorating the lower walls. The stone surfaces are painted and gilded—red, blue, and gold—so that stone and glass seem to merge in the multicolored light. Painted statues of the twelve apostles stand between window sections, linking the walls and the stained glass. The windows contain narrative and symbolic scenes. Those in the curve of the sanctuary behind the altar and relics, for example, illustrate the Nativity and Passion of Christ, the Tree of Jesse, and the life of Saint John the Baptist. The story of Louis' acquisition of his relics is told, and the Last Judgment appeared in the original rose window on the west.

Illuminated Manuscripts

France gained renown in the thirteenth century not only for its new architecture and sculpture but also for the production

Depicted here is the Old Testament story of Abraham and Sarah's hospitality to three strangers, that is, God in the three persons (compare the later Byzantine icon, FIG. 7–51). Sarah watches from the entryway of their tent, while the strangers—angels representing God—tell the elderly couple that Sarah will bear a child, Isaac. The story is yet another instance of the Old Testament prefiguring the New. To the medieval reader, the three strangers were symbols of the Trinity, and God's promise to Sarah foreshadowed the angel's annunciation of the Christ Child's birth to Mary.

The architectural frame, depicting gables, pinnacles, and windows modeled on the Sainte-Chapelle, establishes a narrow stage on which the story unfolds. Wavy clouds floating within the arches under the gables indicate an outdoor setting. The oak tree, representing the biblical oaks of Mamre (Genesis 18:1), has stylized but recognizable oak leaves and acorns. The oak establishes the specific location of the story. At the same time, the angel's blessing gesture and Sarah's pres- ence indicate a specific moment. This new awareness of time and place, as well as the oak leaves and acorns, reflect a tentative move toward the representation of the natural world that will gain momentum in the following centuries.

GOTHIC ART IN ENGLAND

Plantagenet kings ruled England from the time of Henry II and Eleanor of Aquitaine until 1485. Many of the kings, especially Henry III (ruled 1216–72), were great patrons of the arts. During this period, London grew into a large city, but most people continued to live in rural villages and bustling market towns. Textile production dominated manufacture and trade, and fine embroidery continued to be an English specialty. The French Gothic style influenced English architecture and manuscript illumination. However, these influences were tempered by local materials, methods, and artistic traditions such as an expressive use of line and an interest in surface decoration.

16–27 | PSALM 1 (BEATUS VIR) FROM THE WINDMILL PSALTER
London. c. 1270–80. Ink, pigments, and gold on vellum, each page 12¾ × 8¾″ (32.3 × 22.2 cm).
The Pierpont Morgan Library, New York.
M. 102, f. lv-2

Manuscript Illumination

The universities of Oxford and Cambridge dominated intellectual life, but monasteries continued to house active *scriptoria,* in contrast to France, where book production became centralized in the professional workshops of Paris. By the end of the thirteenth century, secular workshops became increasingly active in England, reflecting a demand for books from newly literate landowners, townspeople, and students. These people read books for entertainment and general knowledge as well as for religious enlightenment.

The dazzling artistry and delight in ambiguities that had marked early medieval manuscripts in the British Isles reappear in the **WINDMILL PSALTER** (FIG. 16–27). The elegance of French Gothic visible in the elongated proportions and dainty heads of the figures is combined with the English tradition of draftsmanship visible in the interlaced tendrils and stylized drapery folds.

Psalm 1 begins with the words *"Beatus vir qui non abiit"* ("Blessed is the man who does not follow [the counsel of the wicked]," Psalm 1:1). The letter *B,* the first letter of the Psalm, fills the left-hand page, and an *E* occupies the top at the right. The rest of the opening words appear on a banner carried by an angel at the bottom of the *E.* The *B* outlines a densely interlaced Tree of Jesse. The *E* is formed from large tendrils that escape from delicate background vegetation to support characters in the story of the Judgment of Solomon (I Kings 3:16–27). The story, seen as a prefiguration of the Last Judgment and an illustration to the phrase "his delight is in the law of the Lord" (Psalm 1:2), relates how two women (at the right) claiming the same baby came before King Solomon (on the crossbar) to settle their dispute. The king ordered his knight to slice the baby in half and give each woman her share. This trick revealed the real mother, who hastened to give up her claim in order to save the child's life.

Realistic and surprising images appear everywhere—note how the knight hooks his toe under the cross bar of the *E* to maintain his balance. Visual puns on the text abound. The meaning of the pheasant at the bottom of the page remains a mystery, but the windmill at the top of the letter *E* (which gives the name to the *Windmill Psalter*) is typical of this new realism. It illustrates the verse that tells how wicked people would not survive the Judgment but would be "like chaff driven away by the wind" (Psalm 1:4). The imagery thus encouraged further thought on the text's familiar messages.

Architecture

The Gothic style in architecture appeared early in England under the influence of local Cistercian and Norman builders and by traveling master builders. A typical thirteenth-century English cathedral seems to hug the earth more like a Cistercian monastery (see Fontenay in Burgundy, FIG. 15–12)

than compact and vertical French cathedrals like Chartres (SEE FIG. 16–8). English builders also favored a screenlike façade that does not usually reflect the interior distribution of space, a characteristic that is at odds with the architectural logic of French Gothic.

SALISBURY CATHEDRAL. The thirteenth-century cathedral in Salisbury is an excellent example of English interpretation of the Gothic style. It had an unusual origin. The first Salisbury Cathedral had been built within the castle complex of the local lord. In 1217, Bishop Richard Poore petitioned the pope to relocate the church, claiming the wind on the hilltop howled so loudly that the clergy could not hear themselves sing the Mass. A more pressing concern was probably his desire to escape the lord's control. As soon as he moved, the bishop established a new town, called Salisbury. Material from the old church carted down the hill was used in the new cathedral, along with dark, fossil-filled Purbeck stone from quarries in southern England and limestone imported from Caen. Building began in 1220, and most of the cathedral was finished by 1258, an unusually short period for such an undertaking (FIG. 16–28).

A general comparison between the major features of French High Gothic cathedrals and Salisbury is instructive, for the builders took very different means to achieve their goal of creating the Heavenly Jerusalem on earth. In contrast to French cathedral façades, whose mighty towers flanking deep portals suggest monumental gateways to Paradise, English façades have a horizontal emphasis suggesting the jeweled walls of the celestial city.

At Salisbury, the west façade was completed by 1265. The small flanking towers of the west front project beyond the side walls and buttresses, giving the façade an increased width, underscored by tier upon tier of blind tracery and arcaded niches. Instead of a western rose window floating over triple portals (as seen in France), the English masters placed tall lancet windows above rather insignificant doorways. A mighty crossing tower (the French preferred a slender spire) became the focal point of the building. (The huge crossing tower and its 400-foot spire are a fourteenth-century addition at Salisbury, as are the flying buttresses, which were added to stabilize the tower.) The slightly later cloister and chapter house provided for the cathedral's clergy.

Salisbury has an equally distinctive plan, with wide projecting double transepts, a square east end with a single chapel, and a spacious sanctuary—like a monastic church (FIG. 16–29). The nave interior reflects the Norman building tradition of heavy walls and a tall nave arcade surmounted by a gallery and a clerestory with simple lancet windows (FIG. 16–30). The walls alone are enough to buttress the four-part ribbed vault. The emphasis on the horizontal movement of the arcades, unbroken by colonnettes,

directs worshipers' attention forward toward the altar behind the choir screen, rather than upward into the vaults, as preferred in France (SEE FIG. 16–15). The use of color in the stonework is reminiscent of Romanesque interiors: The shafts supporting the four-part rib vaults are made of dark Purbeck stone that contrasts with the lighter limestone of the rest of the interior. The stonework was originally painted and gilded.

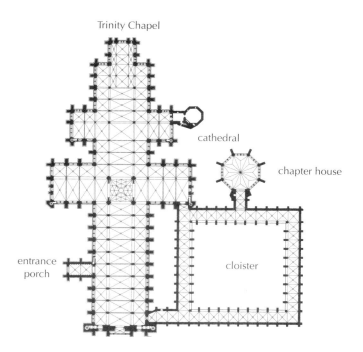

16–29 | **SALISBURY CATHEDRAL, PLAN**

16–28 | **SALISBURY CATHEDRAL**
Salisbury, England. 1220–58; west façade finished 1265; spire c. 1320–30; cloister and chapter house 1263–84.

16–30 | **NAVE, SALISBURY CATHEDRAL**

In the eighteenth century, the English architect James Wyatt subjected the building to radical renovations, during which the remaining stained glass and figure sculpture were removed or rearranged. Similar campaigns to refurbish medieval churches were common at the time. The motives of the restorers were complex and their results far from our notions of historical authenticity today.

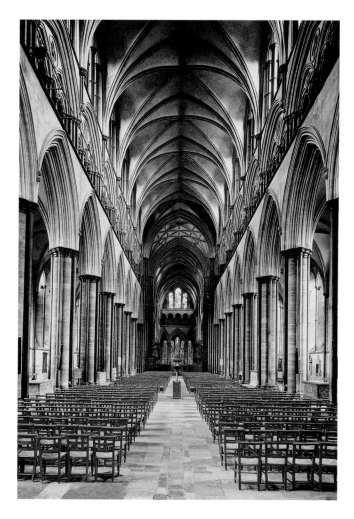

MILITARY AND DOMESTIC ARCHITECTURE. Cathedrals were not the only structures that underwent development during the Early and High Gothic periods. Western European knights who traveled east during the Crusades were inspired by the architectural forms they saw employed in Muslim castles and the mighty defensive land walls of Constantinople (SEE FIG. 7–24). When they returned home, Europeans built their own versions of these fortifications. Castle gateways now became complex, nearly independent fortifications often guarded by twin towers rather than just one. New D-shaped and round towers eliminated the corners that had made earlier square towers vulnerable to battering rams; and crenellations (notches) were added to tower tops in order to provide stone shields for more effective defense. The outer, enclosing walls of the castles were strengthened. The open, interior space was enlarged and filled with more comfortable living quarters for the lord and wooden buildings to house the garrison and the staff necessary to repair armor and other equipment. Barns and stables for animals, including the extremely valuable war horses, were also erected within the enclosure (SEE FIG. 15–24).

STOKESAY CASTLE. Military structures were not the only secular buildings outfitted for defense. In uncertain times, the manor (a landed estate), which continued to be an important economic basis in the thirteenth century, also had to fortify its buildings. A country house that was equipped with a tower and crenellated rooflines became a status symbol as well as a necessity. Stokesay Castle, a remarkable fortified manor house, survives in England near the Welsh border. In 1291 a wool merchant, Lawrence of Ludlow, acquired the property of Stokesay and secured permission from King Edward I to fortify his dwelling—officially known as a "license to crenellate" (FIG. 16–31). He built two towers, including a massive crenellated south tower and a great hall. The defense walls of Stokesay are gone, but the two towers and the great hall survive.

Life in the Middle Ages revolved around the hall. Windows on each side of Stokesay's hall open both toward the courtyard and out across a moat toward the countryside. By the thirteenth century people began to expect some privacy as well as security; therefore at both ends of the hall are two-story additions that provided retiring rooms for the family and workrooms for women to spin and weave. Rooms on the north end could be reached from the hall, but the upper chamber at the south was accessible only by means of an exterior stairway. A tiny window—a peephole—let women and members of the household observe the often rowdy activities in the hall below.

Furnishings defined and dignified the rooms. Of prime importance were textiles in the form of wall hangings, cushions, and coverlets (see *Christine de Pizan and the Queen of France* for an example of a furnished room, Introduction, Fig. 21). In both layout and décor, there was essentially no

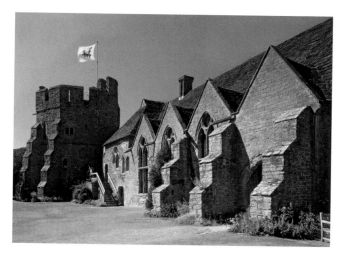

16–31 | **EXTERIOR OF THE TOWER AND GREAT HALL, STOKESAY CASTLE**
Late 13th century. Royal permission to build granted in 1291.

difference between this manor far from the London court and the mansions built by the nobility in the city. A palace followed the same pattern of hall and retiring rooms; it was simply larger than a manor. The great hall was also the characteristic domestic architectural feature on the Continent.

GOTHIC ART IN GERMANY AND THE HOLY ROMAN EMPIRE

The Holy Roman Empire, weakened by internal strife and a prolonged struggle with the papacy, ceased to be a significant power in the thirteenth century. England and France were becoming strong nation-states, and the empire's hold on southern Italy and Sicily ended at midcentury with the death of Emperor Frederick II, who was also king of Sicily. The emperors—who were elected—had only nominal authority over a loose union of Germanic states. After Frederick, German lands increasingly became a conglomeration of independent principalities, bishoprics, and free cities. As in England, the French Gothic style, avidly embraced in the western Germanic territories, shows regional adaptations and innovations.

Architecture

In the thirteenth century, the increasing importance of the sermon in church services led architects in Germany to further develop the **hall church**, a type of open, light-filled interior space that appeared in Europe in the early Middle Ages but was particularly popular in Germany. The hall church is characterized by a nave and side aisles whose vaults all reach the same height. Large windows in the outer walls create a well-lit interior. The spacious and open design of the hall church provided accommodation for the large crowds drawn by charismatic preachers.

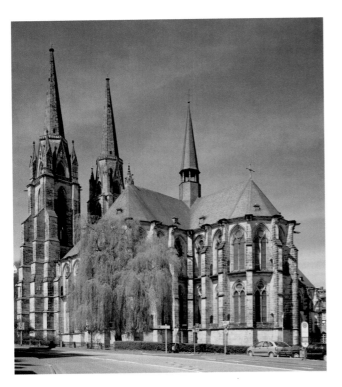

16–32 | **EXTERIOR, CHURCH OF SAINT ELIZABETH**
Marburg, Germany. 1235–83.

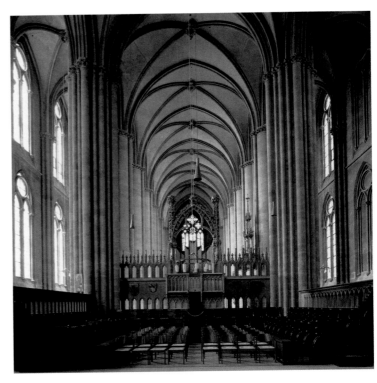

16–33 | **INTERIOR, CHURCH OF SAINT ELIZABETH**
Marburg, Germany. 1235–83.

CHURCH OF SAINT ELIZABETH IN MARBURG. Perhaps the first true Gothic hall church, and one of the earliest Gothic buildings in Germany, was the Church of Saint Elizabeth of Hungary in Marburg (**FIG. 16–32**). The Hungarian princess Elizabeth (1207–31) had been sent to Germany at the age four to marry the ruler of Thuringia. He soon died of the plague, and she devoted herself to caring for people with incurable diseases. It was said that she died at the age of twenty-four from exhaustion, and she was canonized in 1235. Between 1235 and 1283, knights of the Teutonic Order (who had moved to Germany from Jerusalem) built a church to serve as her mausoleum and a center of pilgrimage.

The plan of the church is an early German form, a trefoil with choir and transepts of equal size. The elevation of the building, however, is new—the nave and aisles are of equal height. On the exterior wall, buttresses run the full height of the building and emphasize its verticality. The two rows of windows suggest a two-story building, which is not the case. Inside, the closely spaced piers of the nave support the ribbed vault and, as with the buttresses, give the building a vertical, linear quality (**FIG. 16–33**). Light from the two stories of tall windows fills the interior, unimpeded by walls, galleries, or triforia. Both the circular piers with slender engaged columns and the window tracery resemble those of the cathedral of Reims. The hall church design was adopted widely for civic and residential buildings in Germanic lands and also for Jewish architecture.

THE ALTNEUSCHUL. Built in the third quarter of the thirteenth century, Prague's Altneuschul ("Old-New Synagogue") is the oldest functioning synagogue in Europe and one of two principal synagogues serving the Jews of Prague (**FIG. 16–34**). The Altneuschul demonstrates the adaptability of the Gothic hall-church design for non-Christian use. Like a hall church, the vaults of the synagogue are all the same height. Unlike a basilican church, with its division into nave and side aisles, the Altneuschul has only two aisles, each with three bays. The six bays are supported by the walls and two octagonal piers. The bays have Gothic four-part ribbed vaulting to which a nonfunctional fifth rib has been added. Some say that this fifth rib was added to remove the cross form made by the ribs.

The medieval synagogue was both a place of prayer and a communal center of learning and inspiration where men gathered to read and discuss the Torah. The synagogue had two focal points, the *aron,* or shrine for the Torah scrolls, and a raised reading platform called the *bimah.* The congregation faced the *aron,* which was located on the east wall, in the direction of Jerusalem. The *bimah* stood in the center of the hall, straddling the two center bays, and in Prague it was surrounded by a fifteenth-century ironwork open screen. The single entrance was placed off-center in a corner bay at the west end. Men worshiped and studied in the principal space; women had to worship in annexes on the north and west sides.

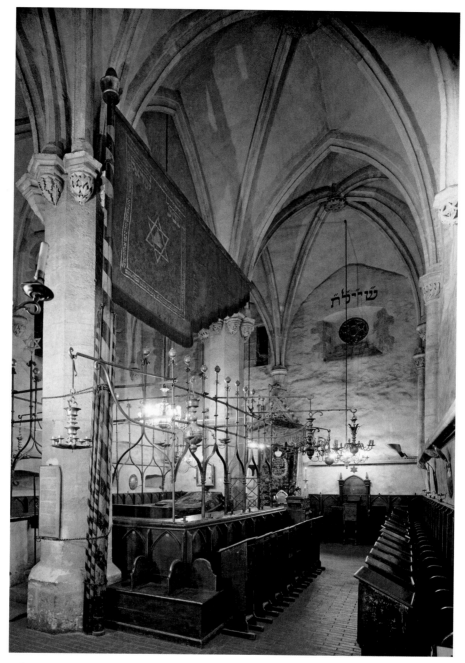

16–34 | **INTERIOR, ALTNEUSCHUL**
Prague, Bohemia (Czech Republic). c. late 13th century; *bimah* after 1483.

Sculpture

Germanic lands had a distinguished tradition of sculpture and metalwork. One of the creative centers of Europe since the eleventh century had been the Rhine River valley and the region known as the Mosan (from the Meuse River, in present-day Belgium), with centers in Liège and Verdun. Ancient Romans built their camps and cities in this area, and classical influence lingered on through the Middle Ages. Nicholas of Verdun was a pivotal figure in the development of Gothic sculpture. He and his fellow goldsmiths inspired a

new classicizing style in the arts. Masters of the Classical Shop at Reims, for example, must have known his work.

SHRINE OF THE THREE KINGS. For the archbishop of Cologne, Nicholas created a magnificent reliquary to hold what were believed to be relics of the Three Magi (c. 1190–1205/10). Called the **SHRINE OF THE THREE KINGS**, the reliquary has the shape of a basilican church (**FIG. 16–35**). It is made of gilded bronze and silver, set with gemstones and dark blue enamel plaques that accentuate its architectural

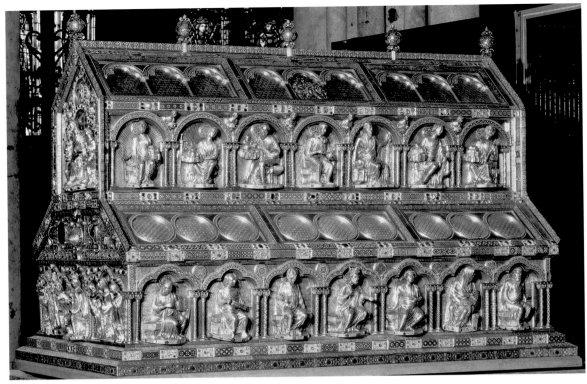

16–35 Nicholas of Verdun and workshop **SHRINE OF THE THREE KINGS**
Cologne (Köln) Cathedral, Germany c. 1190–c. 1205/10. Silver and gilded bronze with enamel and gemstones,
5′8″ × 6′ × 3′8″ (1.73 × 1.83 × 1.12 m).

details. Nicholas and other Mosan artists were inspired by
ancient Roman art still found in the region. Their figures are
fully and naturalistically modeled and swathed in voluminous
but revealing drapery. The three Magi and the Virgin fill the
front gable end, and prophets and apostles sit in the niches in
the two levels of arcading on the sides. The work combines
robust, expressively mobile sculptural forms with a jeweler's
exquisite ornamental detailing to create an opulent, monu-
mental setting for its precious contents.

STRASBOURG CATHEDRAL. At the cathedral in Strasbourg (a
border city variously claimed by France and Germany over
the centuries), sculpture in the south transept portal reflects
the Mosan style as interpreted by Reims masters. A relief (c.
1240) depicting the death and Assumption of Mary fills the
tympanum (FIG. 16–36). While Mary lies on her deathbed
surrounded by distraught apostles, Christ has received her soul
(the doll-like figure in his arms) and will carry her directly to
heaven. The theme is Byzantine, where the subject is known
as the Dormition (Sleep) of the Virgin. The apostles are
dynamically expressive figures with large heads, their grief
vividly rendered. Their short bodies are clothed in fluid drap-

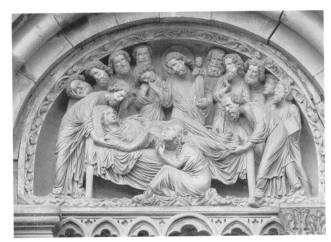

16–36 **DORMITION OF THE VIRGIN**
South transept portal tympanum, Strasbourg Cathedral,
Strasbourg, France. c. 1240.

ery. Deeply undercut, each stands out dramatically in the
crowded scene. Strasbourg sculpture has an emotional expres-
siveness unknown earlier, and this depiction of intense emo-
tion became characteristic of German medieval sculpture.

16–37 | SAINT MAURICE
Magdeburg Cathedral, Magdeburg, Germany. c. 1240–50.
Dark sandstone with traces of polychromy.

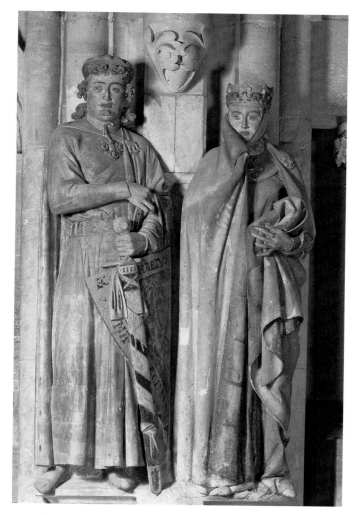

16–38 | EKKEHARD AND UTA
West chapel, Naumburg Cathedral, Naumburg, Germany.
c. 1245–60. Stone, originally polychromed, approx. 6′2″
(1.88 m).

SAINT MAURICE. In addition to emotional expressionism, a powerful current of realism runs through German Gothic sculpture. Some works suggest a living model, among them a statue of Saint Maurice in Magdeburg Cathedral, where his relics were preserved. Carved about 1240–50 (FIG. 16–37), Maurice, the commander of Egyptian Christian troops in the Roman army, was martyred together with his men in 286. As patron saint of Magdeburg, he was revered by Ottonian emperors and became a favorite saint of military aristocrats. Because he came from Egypt, Saint Maurice was commonly portrayed with black African features. Dressed in a full suit of chain mail covered by a sleeveless coat of leather, he represents a distinctly different military ideal (SEE FIG. 14–26).

NAUMBURG. As portraitlike as medieval figure sculpture sometimes seems, the figures represented ideal types, not actual individuals. Such is the case in the portrayal of the ancestors of the bishop of Wettin, Dietrich II. About 1245 he ordered sculptures for the family funeral chapel, built at the west end of Naumburg Cathedral. Bishop Dietrich had life-size statues of twelve of his ancestors, who had been patrons of the church, placed on pedestals around the chapel.

In the representations of Margrave Ekkehard of Meissen and his Polish-born wife, Uta (FIG. 16–38), the sculptor created extraordinarily lifelike and individualized figures and faces. The Margrave seems to be a proud warrior and no-nonsense administrator (a *margrave*—count of the march or border—was a territorial governor whose duty it was to

THE ◉BJECT SPEAKS

THE CHURCH OF ST. FRANCIS AT ASSISI

Shortly after Saint Francis's death, the church in his birthplace, Assisi, was begun (1228). It was nearly finished in 1239 but was not dedicated until 1253. Unusually elaborate in its design with upper and lower sections in two stories and a crypt, it is set into the hillside. Both upper and lower churches have a single nave of four square vaulted bays, and both end in a transept and a single apse. The lower church has massive walls and a narrow nave flanked by side chapels. The upper church is a spacious, well-lit hall designed to accommodate crowds. People went there to listen to the friars preach as well as to participate in church rituals, so Franciscan churches had to provide lots of space and excellent visibility and acoustics. The friars' educational mission utilized visual as well as spoken messages, so their churches had expanses of unbroken wall space suitable for educational and inspirational paintings.

Wall painting became a preeminent art form in Italy. The growing demand for painting reflected the educational mission of the mendicant orders—the Franciscans and the Dominicans—as well as the new sources of patronage created by Italy's burgeoning economy and urban society. Art proclaimed a patron's status as much as it did his or her piety.

The Church of Saint Francis is much more richly decorated than most Franciscan churches, although the architecture itself is simple. Typical Franciscan churches were barnlike structures with wooden roofs, but in the Church of Saint Francis the nave is divided by slender clustered, engaged columns that rise unbroken to Gothic ribbed vaults. At the window level, the walls are set back to make walkways down the nave. Single two-light windows pierce the upper walls of each bay. Painting covers every surface, even the vaults where large figures float against a bright blue heaven. The amount of decoration is surprising in the mother church of a monastic order dedicated to poverty and service.

On the morning of September 27, 1997, tragedy struck. An earthquake convulsed the small town of Assisi. It shook the Church of Saint Francis, causing great damage to the architecture and paintings. The vault collapsed in two places, causing priceless frescoes to shatter and plunge to the floor. The photographer Ghigo Roli had just finished recording every painted surface of the interior when the sound of the first earthquake was heard in the basilica. As the building shook, the paintings on the vaults fell. "I wanted to cry," Ghigo Roli later wrote.

When such a disaster happens, the whole world seems to respond. Volunteers immediately established organizations to raise money to restore the frescoes, with the hope and intention of paying the costs of repairing and strengthening the basilica, reassembling the paintings from millions of tiny pieces, and finally reinstalling the restored treasures. So successful was the effort that visitors today would not guess that an earthquake had brought down the vaults only a decade ago.

Church of Saint Francis, Assisi, Italy during the 1997 earthquake. (Above)

Church of Saint Francis, Assisi, Italy restored. (Right)
1228–53.

Caught by a television camera during the quake, some of the vaults and archivolts in the upper church plunged to the floor, killing four people. The camera operator eventually emerged, covered with the fine dust of the shattered brickwork and plaster, as a "white, dumbfounded phantom."

defend the frontier). Uta, coolly elegant and courtly, seems to draw her cloak artfully to her cheek. Traces of color indicate that painting added to the realistic impact of the figures. Such realism became characteristic of German Gothic art and ultimately had a profound impact on later art, both within Germany and beyond.

GOTHIC ART IN ITALY

The thirteenth century was a period of political division and economic expansion for the Italian peninsula. Part of southern Italy and Sicily was controlled by Frederick II von Hohenstaufen (1194–1250), king of Sicily from 1197 and Holy Roman emperor from 1220. Called by his contemporaries "the wonder of the world," Frederick was a politically unsettling force. He fought with a league of north Italian cities and briefly controlled the Papal States. On his death, Germany and the Holy Roman Empire ceased to be an important factor in Italian politics and culture. Instead, France and Spain began to vie for control of parts of the peninsula and the island of Sicily.

In northern Italy, in particular, organizations of successful merchants created communal governments in their prosperous and independent city-states and struggled against powerful families for control of them. Growing individual power and wealth inspired patronage of the arts. Artisans began to emerge as artists in the modern sense, both in their own eyes and the minds of their patrons. They joined together in urban guilds and independently contracted with wealthy clients and with civic and religious groups.

Sculpture: The Pisano Family

During his lifetime, the culturally enlightened Holy Roman emperor Frederick II had fostered a classical revival. He was a talented poet, artist, and naturalist, and an active patron of the arts and sciences. In the Romanesque period, artists in southern Italy had sometimes relied on ancient sculpture for inspiration. But Frederick, mindful of his imperial status as Holy Roman emperor, commissioned artists who turned to ancient Roman sculpture to help communicate a message of power. He also encouraged artists to look anew at the natural world around them. Nicola Pisano (active in Tuscany c. 1258–78), who came from the southern region of Apulia, one of the territories where imperial patronage under Frederick had flourished, became the leading exponent of the style that had developed in southern Italy.

NICOLA PISANO'S PULPIT AT PISA. An inscription identifies the marble pulpit in the Pisa Baptistry as Nicola's work (FIG. 16–39). Clearly proud of his skill, he wrote: "In the year 1260 Nicola Pisano carved this noble work. May so gifted a hand be praised as it deserves." Columns topped with leafy Corinthian capitals support standing figures and Gothic

16–39 | Nicola Pisano **PULPIT, BAPTISTRY, PISA**
1260. Marble; height approx. 15′ (4.6 m).

trefoil arches, which in turn provide a base for the six-sided pulpit. The columns rest on high bases carved with crouching figures, domestic animals, and shaggy-maned lions. The panels illustrate New Testament subjects, each framed as an independent composition.

Panels illustrate several scenes in a continuous narrative—the Annunciation, Nativity, and Adoration of the Shepherds. The Virgin reclines in the middle of the composition (FIG. 16–40). The upper left-hand corner holds the Annunciation, and the scene in the upper right combines the annunciation to the shepherds with their adoration of the Child. In the foreground, midwives wash the infant Jesus as Joseph looks on. The viewer's attention moves from group to group within the shallow space, always returning to the regally detached Mother of God. The format, style, and technique of Roman sarcophagus reliefs—readily accessible in the burial ground near the Baptistry (SEE FIG. 15–13)—may have provided models for carving. The sculptural treatment of the deeply cut, full-bodied forms is classically inspired, as are their

16–40 | Nicola Pisano **NATIVITY**
Detail of pulpit, Baptistry, Pisa, Italy. 1260. Marble,
33½ × 44½" (85 × 113 cm).

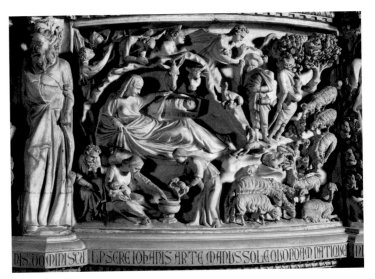

16–41 | Giovanni Pisano **NATIVITY**
Detail of pulpit, Pisa Cathedral, Pisa. 1302–10. Marble,
34⅜ × 43" (87.2 × 109.2 cm).

heavy, placid faces. The closely packed composition recalls the Ludovisi Battle Sarcophagus (FIG. 6–69), although the shifts in scale are typically Gothic.

GIOVANNI PISANO'S PULPIT AT PISA. Nicola's son Giovanni (active c. 1265–1314) both assisted his father and learned from him, and he may also have worked or studied in France. By the end of the thirteenth century Giovanni emerged as a versatile artist in his own right. Between 1302 and 1310, he and his shop carved a huge pulpit for Pisa Cathedral that is similar to his father's in conception but significantly different in style and execution. In his **NATIVITY** panel Giovanni places graceful, animated figures in an uptilted, deeply carved landscape (FIG. 16–41). He replaces Nicola's impassive Roman matron with a slender young Mary who, sheltered by a shell-like cave, gazes delightedly at her baby. Below her, the

16–42 | **SIENA CATHEDRAL**
Siena, Italy. Lower west façade, 1284–99.

16–43 | Coppo di Marcovaldo **CRUCIFIX**
Tuscany, Italy. c. 1250–70. Tempera and gold on wood panel, 9′7⅜″ × 8′1¼″
(2.93 × 2.47 m). Pinacoteca, San Gimignano, Italy.

midwife who doubted the virgin birth has her withered hand restored by the baby's bath water. Sheep, shepherds, and angels spiral up through the trees at the right and more angelic onlookers replace the Annunciation. Giovanni's sculpture is as dynamic as Nicola's is static.

THE CATHEDRAL FAÇADE AT SIENA. Between 1284 and 1299 Giovanni Pisano worked as architect, designer, and sculptor of the façade of the Cathedral of Our Lady in the central Italian city of Siena (**FIG. 16–42**). He incorporated elements of the French Style, such as Gothic gables with classical columns and moldings, to produce a richly ornamented screen independent of the building behind. High on the façade he placed figural sculptures, including dramatically gesturing and expressive prophets and sibyls. (The sculpture is now in the museum and has been replaced by copies.) Rather than the complex narrative sculptural programs typical of French Gothic façades, in Italy there was often an emphasis on architectural detailing of lintels and on narrative

door panels, as well as on figural sculpture placed across the façade. Inside, the focus was on furnishings such as pulpits, tomb monuments, baptismal fonts, and on paintings (see "The Church of Saint Francis at Assisi," page 546).

Painting

The capture of Constantinople by Crusaders in 1204 that brought relics to France also resulted in an influx of Byzantine art and artists to Italy. The imported style of painting, the *maniera greca* ("in the Greek manner"), influenced thirteenth- and fourteenth-century Italian painting in style and technique and introduced a new emphasis on pathos and emotion.

A "HISTORIATED CRUCIFIX." One example, the large wooden crucifix attributed to the thirteenth-century Florentine painter Coppo di Marcovaldo (**FIG. 16–43**), represents the *Christus patiens,* or suffering Christ: a Byzantine type with closed eyes and bleeding, slumped body that emphasized emotional realism (SEE FIGS. 7–43, 14–29). The cross is also a "historiated

16–44 | **LIFE OF SAINT FRANCIS, MIRACLE OF THE CRIB AT GRECCIO**
Church of Saint Francis, Assisi, Italy. Fresco, late 13th century?

crucifix," with scenes at each side that tell the Passion story. Such crosses were mounted on the choir screen that separated the clergy in the sanctuary from the lay people in the nave (one can be seen with its wooden bracing in FIG. 16–44).

MURAL PAINTING AT ASSISI. Colorful, educational paintings covered the walls of Italian churches. The *Life of Saint Francis,* a series of narratives depicting the saint's life in the upper church of Saint Francis in Assisi, provides a vivid example of Gothic mural painting. Scholars differ on whether the murals were painted as early as 1290. Many have adopted the neutral designation of the artist as the "Saint Francis Master." **THE MIRACLE OF THE CRIB AT GRECCIO** (FIG. 16–44) portrays Saint Francis making the first Christmas manger scene in the church at Greccio and also vividly documents the appearance

of an Italian Gothic church. A large wooden crucifix, similar to the one by Coppo di Marcovaldo, has been suspended from a stand on top of a screen separating the sanctuary from the nave. The cross has been reinforced on the back and tilted forward to hover over people in the nave, whom we see through an open door in the choir screen. A pulpit, with stairs leading up to its entrance and candlesticks at its corners, rises above the screen at the left. An elaborate carved *baldacchino* (canopy) surmounts the altar at the right, and an adjustable wooden lectern stands in front of the altar.

Other small but telling touches include a seasonal liturgical calendar posted on the lectern, foliage swags decorating the *baldacchino,* and an embroidered altar cloth. Candles in tall candlesticks stand on the top of the screen and on wire frames above the lectern and altar. Saint Francis, in the foreground, reverently holds the Holy Infant above a plain, box-like crib next to representations of various animals that might have been present at the Nativity. The scene depicts the astonishing moment when, it was said, the Christ Child appeared in the manger. The tableau is recreated at Christmas by many families and communities today.

IN PERSPECTIVE

From its beginnings in France, Gothic art spread throughout Europe. In media as diverse as tiny book illustrations and enormous stained-glass windows, Gothic artists proclaimed the Christian message. These works were both educational and decorative. Inspired by biblical accounts of the jeweled walls of heaven and the golden gates of Paradise, Christian patrons and builders labored to erect glorious dwelling places for God and the saints on Earth. In order to intensify the effects of light and color, they constructed ever-larger buildings with higher vaults and thinner walls that permitted the insertion of huge windows. The glowing, back-lit colors of stained glass and the soft sheen of mural paintings dissolved the solid forms of masonry, while within the church the reflection of gold, enamels, and gems on altars and gospel book covers, on crosses and candlesticks, captured the splendor of Paradise on Earth. Subtle light and dazzling color created a mystical visual pathway to heaven as artists gave tangible form to the unseen and unknowable.

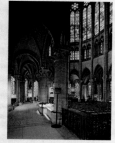

ABBEY CHURCH OF ST. DENIS
1140–44; 1231–81

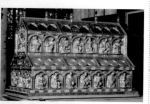

NICHOLAS OF VERDUN AND
WORKSHOP.
SHRINE OF THE THREE KINGS
C. 1190–1205/10

CHARTRES.
**NORTH TRANSEPT, ROSE WINDOW
AND LANCETS**
ABOUT 1220

COPPO DI MARCOVALDO.
CRUCIFIX
C. 1250–1270

PSALM1 (BEATUS VIR).
WINDMILL PLASTER
C. 1270–80

GIOVANNI PISANO.
NATIVITY, DETAIL OF PULPIT
1302–10

1140

1200

1250

1300

GOTHIC ART OF THE TWELFTH AND THIRTEENTH CENTURIES

◄ **Second Crusade** 1147–49
◄ **Plantagenet Dynasty Ruled England**
1154–1485

◄ **Third Crusade** 1188–92

◄ **Fourth Crusade Takes Constantinople**
1204
◄ **Franciscan Order Founded** 1209

◄ **Western Control of Constantinople
Ends** 1261

◄ **Thomas Aquinas Begins Writing**
Summa Theologica 1266

17–1 | Andrea Orcagna **TABERNACLE** Orsanmichele, Florence, Probably begun 1355, completed 1359. Marble, mosaic, gold, lapis lazuli.
Bernardo Daddi **MADONNA AND CHILD** 1346–7. Tempera and gold on wood panel.

FOURTEENTH-CENTURY ART IN EUROPE

17

One of the many surprises greeting the modern visitor to Florence is a curious blocky building with statue-filled niches. Originally a **loggia** (a covered, open-air gallery), today its dark interior is dominated by a huge and ornate tabernacle built to house the important **MADONNA AND CHILD** (FIG. 17-1) by Bernardo Daddi. Daddi was commissioned to create this painting in 1346/47, just before the Black Death swept through the city in the summer of 1348.

Daddi's painting was the second replacement of a late thirteenth-century miracle-working image of the Madonna and Child. The original image had occupied a simple shrine in the central grain market, known as *Orsanmichele* (Saint Michael in the Garden). The original painting may have been irreparably damaged in the fire of 1304 that also destroyed the first market loggia, built at the end of the thirteenth century. A second painting, also lost, was made sometime later, but it was believed that the healing power of the image passed from painting to painting with continued potency.

Florence grew rapidly in the late Middle Ages. By the fourteenth century two-thirds of the city's grain supply had to be imported. The central grain market and warehouse established at Orsanmichele, as insurance against famine, made that site the economic center of the city. The Confraternity (charitable society) of Orsanmichele was created to honor the image of the Madonna and Child and to collect and distribute alms to needy citizens. In 1337 a new loggia was built to protect the miracle-working image, and two upper stories were added to the loggia to store the city's grain reserves.

Orsanmichele remained Florence's central grain market for about ten years after Daddi painted the newest miracle-working *Madonna and Child* in 1346/47. As a reflection of its wealth and piety, the Confraternity of Orsanmichele commissioned Andrea di Cione, better known as Orcagna (active c. 1343–68), to create a new and rich tabernacle for Daddi's painting. A member of the stone- and woodworkers guild, Orcagna was in charge of building and decorating projects at Orsanmichele. To protect and glorify the *Madonna and Child*, he created a tour-de-force of architectural sculpture in marble, encrusted with gold and glass mosaics. In Orcagna's shrine, Daddi's *Madonna and Child* seems to be revealed by a flock of angels drawing back carved curtains. Sculpted saints stand on the pedestals against the piers, and reliefs depicting the life of the Madonna occupy the structure's base. The tabernacle was completed in 1359, and a protective railing was added in 1366.

Orsanmichele answered practical economic and social needs (granary and distribution point for alms), as well as religious and spiritual concerns (a shrine to the Virgin Mary), all of which characterized the complex society of the fourteenth century. In addition, Orsanmichele was a civic rallying point for the city's guilds. The significance of the guilds in the life of cities in the later Middle Ages cannot be overestimated. In

Florence, guild members were not simple artisans; the major guilds, composed of rich and powerful merchants and entrepreneurs, dominated the government and were key patrons of the arts. For example, the silk guild oversaw the construction of Orsanmichele. In 1380, the arches of the loggia were walled up. At that time, fourteen of the most important Florentine guilds were each assigned an exterior niche on the ground level in which to erect an image of their patron saint.

The cathedral, the Palazzo della Signoria, and Orsanmichele, three great buildings in the city center, have come to symbolize power and patronage in the Florentine Republic. But of the three, the miraculous Madonna in her shrine at Orsanmichele witnessed the greatest surge of interest in the years following the Black Death. Pilgrims flocked to Orsanmichele, and those who had died during the plague left their estates in their wills to the shrine's confraternity. On August 13, 1365, the Florentine government gathered the people together to proclaim the Virgin of Orsanmichele the special protectress of the city.

CHAPTER-AT-A-GLANCE

- **EUROPE IN THE FOURTEENTH CENTURY**
- **ITALY** | Florentine Architecture and Sculpture | Florentine Painting | Sienese Painting
- **FRANCE** | Manuscript Illumination | Sculpture
- **ENGLAND** | Embroidery: Opus Anglicanum | Architecture
- **THE HOLY ROMAN EMPIRE** | The Supremacy of Prague | Mysticism and Suffering
- **IN PERSPECTIVE**

EUROPE IN THE FOURTEENTH CENTURY

By the middle of the fourteenth century, much of Europe was in crisis. Earlier prosperity had fostered population growth, which by about 1300 had begun to exceed food production. A series of bad harvests then meant that famines became increasingly common. To make matters worse, a prolonged conflict known as the Hundred Years' War (1337–1453) erupted between France and England. Then, in the middle of the fourteenth century, a lethal plague known as the Black Death swept across Europe, wiping out as much as 40 percent of the population (see "The Triumph of Death," page 556). By depleting the labor force, however, the plague gave surviving peasants increased leverage over their landlords and increased the wages of artisans.

The papacy had emerged from its conflict with the Holy Roman Empire as a significant international force. But its temporal success weakened its spiritual authority and brought it into conflict with growing secular powers. In 1309, after the election of a French pope, the papal court moved from Rome to Avignon, in southern France. Italians disagreed, and during the Great Schism from 1378 to 1417, there were two popes, one in Rome and one in Avignon, each claiming legitimacy. The Church provided some solace but little leadership, as rival popes in Rome and Avignon excommunicated each other's followers. Secular rulers took sides: France, Scotland, Aragon, Castile, Navarre, and Sicily supported the pope in Avignon; England, Flanders, Scandinavia, Hungary, and Poland supported the pope in Rome. Meanwhile, the Church experienced great strain from challenges from reformers like John Hus (c. 1370–1415) in Bohemia. The cities and states that composed present-day Germany and the Italian Peninsula were divided among different factions.

The literary figures Dante, Petrarch, and Boccaccio (see "A New Spirit in Fourteenth-Century Literature," page 561) and the artists Cimabue, Duccio, and Giotto fueled a cultural explosion in fourteenth-century Italy. In literature, Petrarch (Francesco Petrarca, 1304–74) was a towering figure of change, a poet whose love lyrics were written not in Latin but in Italian, marking its first use as a literary language. A similar role was played in painting by the Florentine Giotto di Bondone (c. 1277–1337). In deeply moving mural paintings, Giotto not only observed the people around him, he ennobled the human form by using a weighty, monumental style, and he displayed a new sense of dignity in his figures' gestures and emotions

This new orientation toward humanity, combined with a revived interest in classical learning and literature, we now designate as *humanism*. Humanism embodied a worldview that focused on human beings; an education that perfected individuals through the study of past models of civic and personal virtue; a value system that emphasized personal effort and responsibility; and a physically active life that was directed toward the common good as well as individual

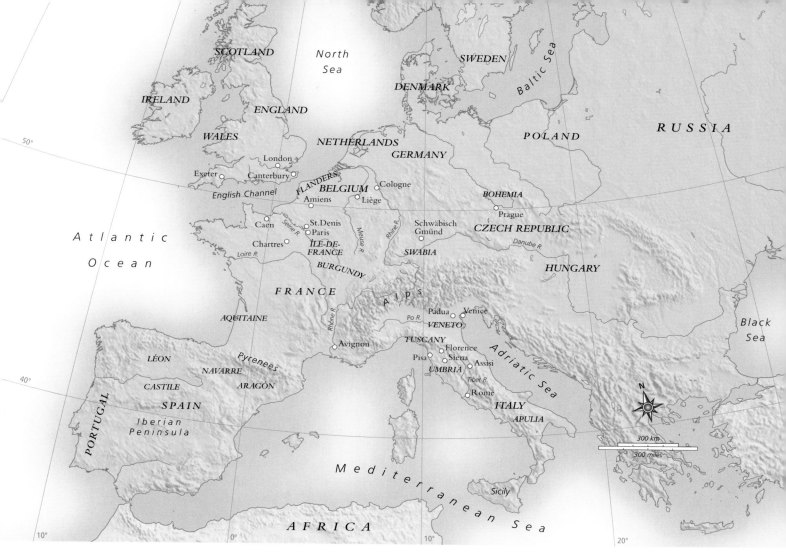

MAP 17–1 | Europe in the Fourteenth Century

Avignon in Southern France, Prague in Bohemia, and Exeter in Southern England joined Paris, Florence, and Siena as centers of art patronage in the late Gothic period.

nobility. For Petrarch and his contemporaries an appreciation of Greek and Roman writers became the defining element of the age. Humanists mastered the Greek and Latin languages so that they could study the classical literature—including newly rediscovered works of history, biography, poetry, letters, and orations.

In architecture, sculpture, and painting, the Gothic style—with its soaring vaults, light, colorful glass, and linear qualities—persisted in the fourteenth century, with regional variations. Toward the end of the century, devastation from the Hundred Years' War and the Black Death meant that large-scale construction gradually ceased, ending the great age of cathedral building. The Gothic style continued to develop, however, in smaller churches, municipal and commercial buildings, and private residences. Many churches were modernized or completed in this late Gothic period.

From the growing middle class of artisans and merchants, talented and aggressive leaders assumed economic and in some places political control. The artisan guilds—organized by occupation—exerted quality control among members and supervised education through an apprenticeship sys-

tem. Admission to the guild came after examination and the creation of a "masterpiece"—literally, a piece fine enough to achieve master's status. The major guilds included cloth finishers, wool merchants, and silk manufacturers, as well as pharmacists and doctors. Painters belonged to the pharmacy guild, perhaps because they used mortars and pestles to grind their colors. Their patron saint, Luke, who was believed to have painted the first image of the Virgin Mary (see Chapter 7, page 266), was also a physician—or so they thought. Sculptors who worked in wood and stone had their own guild, while those who worked in metals belonged to another guild. Guilds provided social services for their members, including care of the sick and funerals for the deceased. Each guild had its patron saint and maintained a chapel and participated in religious and civic festivals.

Complementing the economic power of the guilds was the continuing influence of the Dominican and Franciscan religious orders (see Chapter 16), whose monks espoused an ideal of poverty, charity, and love and dedicated themselves to teaching and preaching. The new awareness of societal needs manifested itself in the

THE TRIUMPH OF DEATH

The Four Horsemen of the Apocalypse—Plague, War, Famine, and Death—stalked the people of Europe during the fourteenth century. France, England, and Germany pursued their seemingly endless wars, and roving bands of soldiers and brigands looted and murdered unprotected peasants and villagers. Natural disasters—fires, droughts, floods, and wild storms—took their toll. Disease spread rapidly through a population already weakened by famine and physical abuse.

Then a deadly plague, known as the Black Death, spread by land and sea from Asia. The plague soon swept from Italy and France across the British Isles, Germany, Poland, and Scandinavia. Half the urban population of Florence and Siena—some say 80 percent—died in the summer of 1348. To people of the time the Black Death seemed to be an act of divine wrath against sinful humans.

In their panic, some people turned to escapist pleasures; others to religious fanaticism. Andrea Pisano and Ambrogio Lorenzetti were probably among the many victims of the Black Death. But the artists who survived had work to do—chapels and hospitals, altarpieces and votive statues. The sufferings of Christ, the sorrows as well as the joys of the Virgin, the miracles of the saints, and new themes—"The Art of Dying Well," and "The Triumph of Death"—all carried the message "Remember, you too will die." An unknown artist, whom we call the Master of the Triumph of Death, painted such a theme in the cemetery of Pisa (Camposanto).

The horror and terror of impending death are vividly depicted in the huge mural, **THE TRIUMPH OF DEATH**. In the center of the wall dead people lie in a heap while devils and angels carry their souls to hell or heaven. Only the hermits living in the wilderness escape the holocaust. At the right, wealthy young people listen to music under the orange trees, unaware of Death flying toward them with a scythe. At the left of the painting, a group on horseback who have ridden out into the wilderness discover three open coffins. A woman recoils at the sight of her dead counterpart. A courtier covers his nose, gagging at the smell, while his wild-eyed horse is terrified by the bloated, worm-riddled body in the coffin. The rotting corpses remind them of their fate, a medieval theme known as "The Three Living and the Three Dead."

Perhaps the most memorable and touching images in the huge painting are the crippled beggars who beg Death to free them from their earthly miseries. Their words appear on the scroll: "Since prosperity has completely deserted us, O Death, you who are the medicine for all pain, come to give us our last supper!"* The painting speaks to the viewer, delivering its message in words and images. Neither youth nor beauty, wealth nor power, but only piety like that of the hermits provides protection from the wrath of God.

Strong forces for change were at work in Europe. For all the devastation caused by the Four Horsemen, those who survived found increased personal freedom and economic opportunity.

* Translated by John Paoletti and Gary Radke, *Art in Renaissance Italy*, 3rd ed. Upper Saddle River, New Jersey. Pearson Prentice Hall, 2005. p. 154.

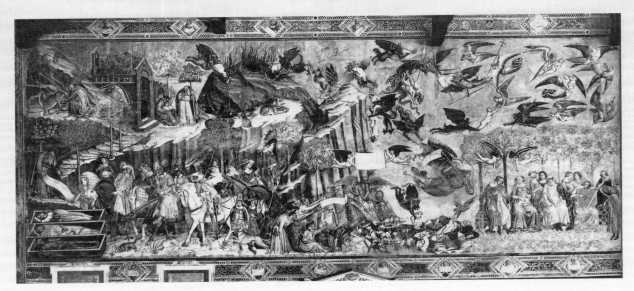

Master of the Triumph of Death (Buffalmacco?) **THE TRIUMPH OF DEATH**
Camposanto, Pisa. 1330s. Fresco, 18′6″ × 49′2″ (5.6 × 15 m).

Reproduced here in black and white, photo taken before the fresco was damaged by American shells during World War II.

17–2 | **PIAZZA DELLA SIGNORIA WITH PALAZZO DELLA SIGNORIA (TOWN HALL)**
1299–1310 and **LOGGIA DEI LANZI (LOGGIA OF THE LANCERS)**
Florence. 1376–82. Speakers' platform and since the sixteenth century a guard station and sculpture gallery.

architecture of churches designed for preaching as well as liturgy, and in new religious themes that addressed personal or sentimental devotion.

ITALY

Great wealth and a growing individualism promoted art patronage in northern Italy. Artisans began to emerge as artists in the modern sense, both in their own eyes and in the eyes of patrons. Although their methods and working conditions remained largely unchanged, artisans in Italy contracted freely with wealthy townspeople and nobles and with civic and religious bodies. Their ambition and self-confidence reflect their economic and social freedom.

Florentine Architecture and Sculpture

The typical medieval Italian city was a walled citadel on a hilltop. Houses clustered around the church and an open city square. Powerful families added towers to their houses both for defense and out of family pride. In Florence, by contrast, the ancient Roman city—with its rectangular plan, major north–south and east–west streets, and city squares—remained the foundation for civic layout. The cathedral stood northeast of the ancient forum. The north–south street joining the cathedral and the Piazza della Signoria followed the Roman line.

THE PALAZZO DELLA SIGNORIA. The governing body of the city (the Signoria) met in the **PALAZZO DELLA SIGNORIA,** a massive fortified building with a tall bell tower 300 feet (91 m) high (FIG. 17–2). The building faces a large square, or piazza, which became the true civic center. Town houses often had seats along their walls to provide convenient public seating. In 1376 (finished in 1381/82), a huge loggia was built at one side to provide a covered space for ceremonies and speeches. After it became a sculpture gallery and guard station in the sixteenth century, the loggia became known as the **LOGGIA OF THE LANCERS.** The master builders were Berici di Cione and Simone Talenti. Michelangelo's *David* (SEE FIG. 20–10) once stood in front of the Palazzo della Signoria facing the loggia (it is replaced today by a modern copy).

THE CATHEDRAL. In Florence, the cathedral *(duomo)* (FIGS. 17–3, 17–4) has a long and complex history. The original plan, by Arnolfo di Cambio (c. 1245–1302), was approved in 1294, but political unrest in the 1330s brought construction to a halt until 1357. Several modifications of the design were made, and the cathedral we see today was built between 1357 and 1378. (The façade was given its veneer of white and green marble in the nineteenth century to coordinate it with the rest of the building and the nearby Baptistry of San Giovanni.)

Sculptors and painters rather than masons were often responsible for designing Italian architecture, and as the Florence Cathedral reflects, they tended to be more concerned with pure design than with engineering. The long, square-bayed nave ends in an octagonal domed crossing, as wide as the nave and side aisles. Three polygonal apses, each with five radiating chapels, surround the central space. This symbolic Dome of Heaven, where the main altar is located, stands apart from the worldly realm of the congregation in the nave. But the great ribbed dome, so fundamental to the planners' conception, was not begun until 1420, when the architect Filippo Brunelleschi (1377–1446) solved the engineering problems involved in its construction (see Chapter 19).

THE BAPTISTRY DOORS. In 1330, Andrea Pisano (c.1290–1348) was awarded the prestigious commission for a pair of gilded bronze doors for the Florentine Baptistry of San Giovanni. (Although his name means "from Pisa," Andrea was not related to Nicola and Giovanni Pisano.) The Baptistry doors were completed within six years and display

17–3 FLORENCE CATHEDRAL (DUOMO)
Plan 1294, costruction begun 1296, redisegned 1357 and 1366, drum and dome 1420–36.
Illustration by Philipe Biard in Guide Gallimard Florence © Gallimard Loisirs.

17–4 | Arnolfo di Cambio, Francesco Talenti, Andrea Orcagna, and others **FLORENCE CATHEDRAL (DUOMO)**
1296-1378; drum and dome by **Brunelleschi**, 1420–36; bell tower (Campanile) by **Giotto, Andrea Pisano,** and **Francesco Talenti,** c. 1334–50.

The Romanesque Baptistry of San Giovanni stands in front of the *Duomo*.

twenty scenes from the life of John the Baptist (San Giovanni) set above eight personifications of the Virtues (FIG. 17–5). The reliefs are framed by quatrefoils, the four-lobed decorative frames introduced at the Cathedral of Amiens in France (SEE FIG. 16–21). The figures within the quatrefoils are in the monumental, classicizing style inspired by Giotto then current in Florentine painting, but they also reveal the soft curves of northern Gothic forms in their gestures and draperies, and a quiet dignity of pose particular to Andrea. The individual scenes are elegantly natural. The figures' placement, on shelflike stages, and their modeling create a remarkable illusion of three-dimensionality, but the overall effect created by the repeated barbed quatrefoils is two-

dimensional and decorative, and emphasizes the solidity of the doors. The bronze vine scrolls filled with flowers, fruits, and birds on the lintel and jambs framing the door were added in the mid-fifteenth century.

Florentine Painting

Florence and Siena, rivals in so many ways, each supported a flourishing school of painting in the fourteenth century. Both grew out of the Italo-Byzantine style of the thirteenth century, modified by local traditions and by the presence of individual artists of genius. The Byzantine influence, also referred to as the *maniera greca* ("Greek manner"), was characterized by dramatic pathos and complex iconography and showed

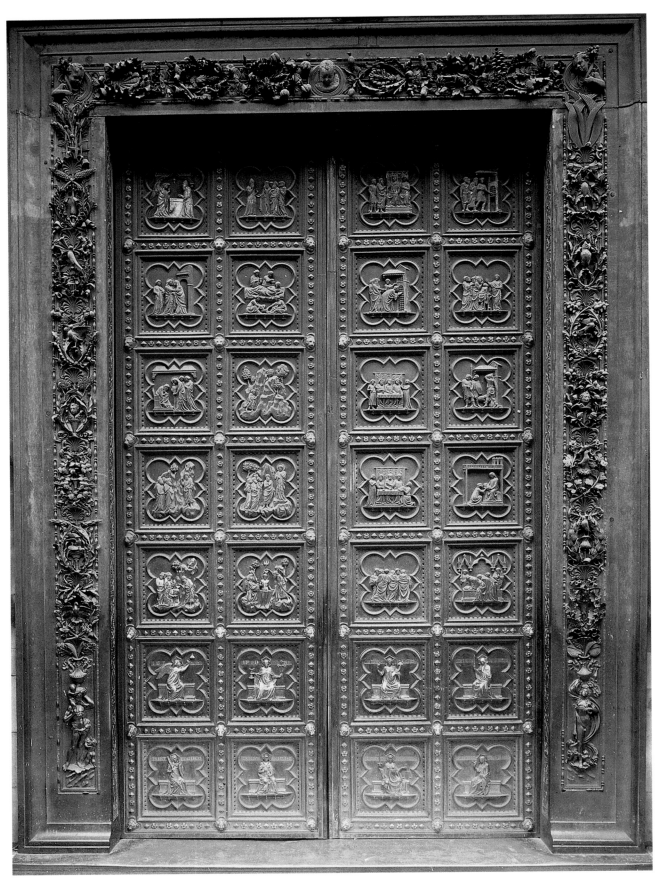

17–5 | Andrea Pisano **LIFE OF JOHN THE BAPTIST**
South doors, Baptistry of San Giovanni, Florence. 1330–36. Gilded bronze, each panel 19¼ × 17″ (48 × 43 cm).
Frame, Ghiberti workshop, mid-15th century.

itself in such elements as elongated figures, often exaggerated, iconic gestures, stylized features including the use of gold for drapery folds, and striking contrasts of highlights and shadows in the modeling of individual forms. By the end of the fourteenth century, the painter and commentator Cennino Cennini (see "Cennino Cennini [c. 1370–1440] on Painting," page 564) would be struck by the accessibility and modernity of Giotto's art, which, though it retained traces of the "Greek manner," was moving toward the depiction of a humanized world anchored in three-dimensional form.

CIMABUE. In Florence, the transformation of the Italo-Byzantine style began a little earlier than in Siena. About 1280, a painter named Cenni di Pepi (active c. 1272–1302), better known by his nickname "Cimabue," painted the **VIRGIN AND CHILD ENTHRONED** (FIG. 17–6), perhaps for the main altar of the Church of Santa Trinita in Florence. At almost 12 feet tall, this enormous panel painting set a new precedent for monumental altarpieces. Cimabue uses the traditional Byzantine iconography of the "Virgin Pointing the Way," in which Mary holds the infant Jesus in her lap and points to him as the path to salvation. Mother and child are surrounded by saints, angels, and Old Testament prophets.

A comparison with a Byzantine icon (SEE FIG. 7–51) shows that Cimabue employed Byzantine formulas in determining the proportions of his figures, the placement of their schematic features, and even the tilt of their haloed heads. Mary's huge throne, painted to resemble gilded bronze with inset enamels and gems, provides an architectural framework for the figures. To render her drapery and that of the infant Jesus, Cimabue used the Italo-Byzantine technique of highlighting drapery with thin lines of gold to indicate divinity. The viewer seems suspended in space in front of the image, simultaneously looking down on the projecting elements of the throne and Mary's lap, while looking straight ahead at the prophets at the base of the throne and the angels at each side. These spatial ambiguities, the subtle asymmetries within the centralized composition, the Virgin's thoughtful gaze, and the individually conceived faces of the old men enliven the picture with their departure from Byzantine tradition. Cimabue's concern for spatial volumes, solid forms delicately modeled in light and shade, and warmly naturalistic human figures contributed to the course of later Italian painting.

GIOTTO DI BONDONE. Compared to Cimabue's *Virgin and Child Enthroned*, Giotto's painting of the same subject (FIG. 17–7), done about 1310 for the Church of the Ognissanti (All Saints) in Florence, exhibits a groundbreaking spatial consistency and sculptural solidity while retaining some of Cimabue's conventions. The central and overtly symmetrical composition and the position of the figures reflect Cimabue's influence. Gone, however, are Mary's modestly inclined head and the delicate gold folds in her drapery. Instead, her face is

Art and Its Context
A NEW SPIRIT IN FOURTEENTH-CENTURY LITERATURE

For Petrarch and his contemporaries—Boccaccio, Chaucer, Christine de Pizan—the essential qualifications for a writer were an appreciation of Greek and Roman authors and an ability to observe and appreciate people from every station in life. Although fluent in Latin, they chose to write in the language of their own daily life—Italian, English, French. Leading the way was Dante Alighieri (1265–1321), who wrote *The Divine Comedy,* his great summation of human virtue and vice, and ultimately human destiny, in Italian. Dante established the Italian language as worthy of great themes in literature.

Francesco Petrarca, called simply Petrarch (1304–74), raised the status of secular literature with his sonnets (love lyrics) to his unobtainable, beloved Laura; his histories and biographies; and his discovery of the ancient Roman writings on the joys of country life. Petrarch's imaginative updating of classical themes in a work called *The Triumphs*—which examines the themes of Chastity triumphant over Love, Death over Chastity, Fame over Death, Time over Fame, and Eternity over Time—provided later Renaissance poets and painters with a wealth of allegorical subject matter.

More earthy, Giovanni Boccaccio (1313–75) perfected the art of the short story in *The Decameron,* a collection of amusing and moralizing tales told by a group of young Florentines who moved to the countryside to escape the Black Death. With wit and sympathy, Boccaccio presents the full spectrum of daily life in Italy. Such secular literature, including the discovery and translation of ancient authors (for some of the tales had a long lineage), written in Italian as it was then spoken in Tuscany, provided a foundation for the Renaissance of the fifteenth century.

In England, Geoffrey Chaucer (c. 1342–1400) was inspired by Boccaccio to write his own series of short stories, *The Canterbury Tales,* told by pilgrims traveling to the shrine of Saint Thomas à Becket (1118?–1170) in Canterbury. Observant and witty, Chaucer depicted the pretensions and foibles, as well as the virtues, of humanity.

Christine de Pizan (1364–c. 1431), born in Venice but living and writing at the French court, became an author out of necessity when she was left a widow with three young children and an aged mother to support. Among her many works are a poem in praise of Joan of Arc and a history of famous women—including artists—from antiquity to her own time. In *The Book of the City of Ladies* she defended women's abilities and argued for women's rights and status. These writers, as surely as Giotto, Duccio, Peter Parler, and Master Theodoric, led the way into a new era.

individualized, and her action—holding her child's leg instead of merely pointing to him—seems entirely natural. This colossal Mary seems too large for the slender Gothic tabernacle, where figures peer through the openings and haloes overlap the faces. In spite of the formal, enthroned image and flat, gold background, Giotto renders the play of light and shadow across these substantial figures to create a sense that they are fully three-dimensional beings inhabiting real space. Details of the Virgin's solid torso can be glimpsed under her thin tunic, and Giotto's angels, unlike those of Cimabue, have ample wings that fold over in a resting position.

According to the sixteenth-century chronicler Vasari, "Giotto obscured the fame of Cimabue, as a great light out-shines a lesser." Vasari also credited Giotto with "setting art upon the path that may be called the true one [for he] learned to draw accurately from life and thus put an end to the crude Greek [i.e., Italo-Byzantine] manner" (translated by J. C. and P. Bondanella).

Giotto may have collaborated on murals at the prestigious Church of Saint Francis in Assisi (see "The Church of Saint Francis at Assisi," page 546). Certainly he worked for the Franciscans in Florence and reacted to their teaching. Saint Francis's message of simple, humble devotion, direct experience of God, and love for all creatures was gaining followers throughout Western Europe, and it had a powerful impact on thirteenth- and fourteenth-century Italian literature and art.

17–6 | Cimabue **VIRGIN AND CHILD ENTHRONED**
Most likely painted for the high altar of the Church of Santa Trinita, Florence. c. 1280. Tempera and gold on wood panel, 12'17" × 7' 4" (3.53 × 2.2 m). Galleria degli Uffizi, Florence.

Early in the fourteenth century Giotto traveled to northern Italy. While working at the Church of Saint Anthony in Padua, he was approached by a local banker, Enrico Scrovegni, to decorate a new family chapel. He agreed, and the **SCROVEGNI CHAPEL** was dedicated in 1305 to the Virgin of Charity and the Virgin of the Annunciation. (The chapel is also called the "Arena Chapel" because it and the family palace were built on and in the ruins of an ancient Roman arena.) The building is a simple, barrel-vaulted room (**FIG. 17–8**). As viewers look toward the altar, they see the story of Mary and Jesus unfolding before them in a series of rectangular panels. On the entrance wall Giotto painted the Last Judgment.

Sequencing Events
MARCH OF THE BLACK DEATH

1346	Plague enters the Crimian Peninsula
1347	Plague arrives in Sicily
1348	Plague reaches port cities of Genoa, Italy, and Marseilles, France
1349	First recorded cases of plague in Cologne and Vienna
1350	Plague reaches Bergen, Norway, via England

17–7 | Giotto di Bondone **VIRGIN AND CHILD ENTHRONED**
Most likely painted for the high altar of the Church of the Ognissanti (All Saints), Florence. 1305–10. Tempera and gold on wood panel, 10'8" × 6' 8¼" (3.53 × 2.05 m). Galleria degli Uffizi, Florence.

Technique

CENNINO CENNINI (c. 1370–1440) ON PAINTING

Cennino Cennini's *Il Libro dell' Arte (The Book of Art)* is a handbook of Florentine and north Italian painting techniques from about 1400. Cennini includes a description of the artist's life as well as step-by-step painting instructions.

"You, therefore, who with lofty spirit are fired with this ambition, and are about to enter the profession, begin by decking yourselves with this attire: Enthusiasm, Reverence, Obedience, and Constancy. And begin to submit yourself to the direction of a master for instruction as early as you can, and do not leave the master until you have to" (Chapter III).*

The first step in preparing a panel for painting is to cover its surface with clean white linen strips soaked in a **gesso** made from gypsum. Gesso provides a ground, or surface, on which to paint. Cennini specified that at least nine layers of gesso should be applied. The gessoed surface should then be burnished until it resembles ivory. The artist can now sketch the composition of the work with charcoal. At this point, advised Cennini, "When you have finished drawing your figure, especially if it is in a very valuable [altarpiece], so that you are counting on profit and reputation from it, leave it alone for a few days, going back to it now and then to look it over and improve it wherever it still needs something . . . (and bear in mind that you may copy and examine things done by other good masters; that it is no shame to you). The final version of the design should be inked in with a fine squirrel-hair brush, and the charcoal brushed off with a feather. Gold leaf should be affixed on a humid day, the tissue-thin sheets carefully glued down with a mixture of fine powdered clay and egg white, on the reddish clay ground (called bole). Then the gold is burnished with a gemstone or the tooth of a carnivorous animal. Punched and incised patterning should be added to the gold leaf later."*

Italian painters at this time worked in **tempera** paint, powdered pigments mixed most often with egg yolk, a little water, and an occasional touch of glue.

Cennini specified a detailed and highly formulaic painting process. Faces, for example, were always to be done last, with flesh tones applied over two coats of a light greenish pigment and highlighted with touches of red and white. The finished painting was to be given a layer of varnish to protect it and enhance its colors. An elaborate frame, which included the panel or panels on which the painting would be executed, would have been produced by a specialist according to the painter's specifications and brought fully assembled to the studio.

Cennini claimed that panel painting was a gentleman's job, but given its laborious complexity, that was wishful thinking. The claim does, however, reflect the rising social status of painters.

* Cennino Cennini, *The Craftsman's Handbook (Il Libro dell' Arte)*. Trans. by Daniel V. Thompson. New York: Dover, 1960. pp. 3, 16, 75.

A base of faux marble and allegorical *grisaille* (gray monochrome) paintings of the Virtues and Vices support vertical bands painted to resemble marble inlay and carved relief and containing quatrefoil portrait medallions. The central band of medallions spans the vault, crossing a brilliant, lapis blue, star-spangled sky in which large portrait disks float like glowing moons. Set into this framework are the rectangular narrative scenes juxtaposing the life of the Virgin with that of Jesus (FIG. 17–9).

Both the individual scenes and the overall program display Giotto's genius for distilling a complex narrative into a coherent visual experience. The life of the Virgin Mary begins the series and fills the upper band of images. Following in historical sequence, events in the life and ministry of Jesus circle the chapel in the middle band, while scenes of the Passion (the arrest, trial, and Crucifixion of Jesus) fill the lowest band. Read vertically, however, each set of three scenes foreshadows or comments on the others.

The first miracle, when Jesus changes water to wine during the wedding feast at Cana, recalls that his blood will become the wine of the Eucharist, or Communion. The raising of Lazarus becomes a reference to Jesus's Resurrection. Below, the Lamentation over the body of Jesus by those closest to him leads to the Resurrection, indicated by angels at the empty tomb and his appearance to Mary Magdalen in the *Noli Me Tangere* ("Do not touch me"). The juxtaposition of dead and live trees in the two scenes also becomes a telling detail of death and resurrection. Giotto used only a few large figures and essential props in settings that never distract the viewer by their intricate detail. The scenes are reminiscent of *tableaux vivants* ("living pictures"), in which people dressed in costume re-created poses from familiar works of art—scenes that were played out in the city square in front of the chapel in Padua.

Among Giotto's achievements was his ability to model form with color. He rendered his bulky figures as pure color masses, painting the deepest shadows with the most intense hues and highlighting shapes with lighter shades mixed with white. These sculpturally modeled figures enabled Giotto to convey a sense of depth in landscape settings without relying on the traditional convention of an architectural framework.

In one of the most moving works, **LAMENTATION** (FIG. 17–10), in the lowest **register** (horizontal band) of the Arena Chapel, Giotto focused the composition off center for maximum emotional effect, concentrating on the faces of Mary and the dead Jesus. A great downward-swooping ridge—its barrenness emphasized by a single dry tree, a medieval

17–8 | Giotto di Bondone **SCROVEGNI (ARENA) CHAPEL,** Frescoes, Padua. 1305–6. View toward east wall.

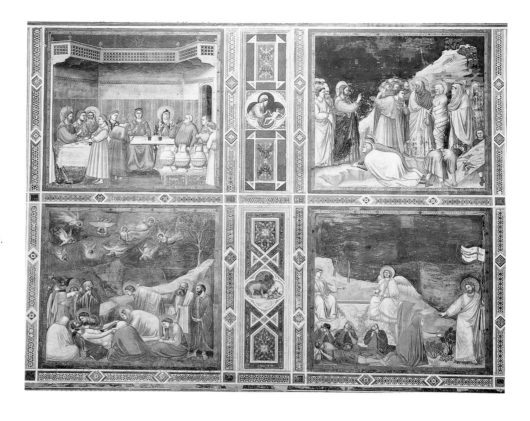

17–9 | Giotto di Bondone
**MARRIAGE AT CANA,
RAISING OF LAZARUS,
RESURRECTION,** and **NOLI ME
TANGERE** and **LAMENTATION**
Frescoes on north wall of
Scrovegni (Arena) Chapel,
Padua. 1305–6. Each scene
approx. 6′5″ × 6′ (2 × 1.85 m).

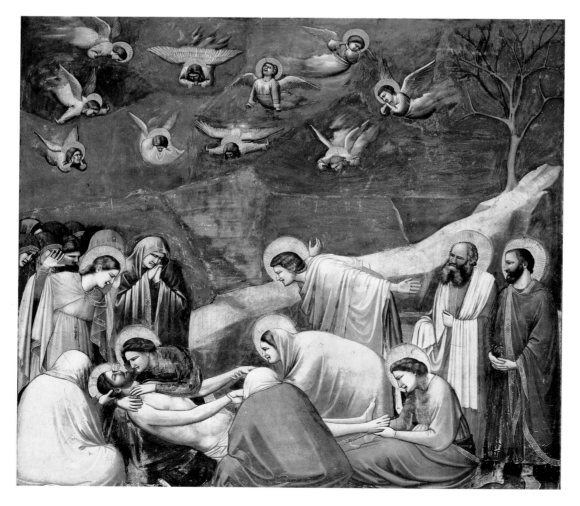

17–10 | Giotto di
Bondone **LAMENTATION**
Fresco in the Scrovegni
(Arena) Chapel, Padua.
1305–6. Approx.
6′5″ × 6′ (2 x 1.85 m).

symbol of death—carries the psychological weight of the scene to its expressive core. Mourning angels hovering overhead mirror the anguish of Jesus's followers. The stricken Virgin communes with her dead son with mute intensity, while John the Evangelist flings his arms back in convulsive despair and other figures hunch over the corpse. Instead of symbolic sorrow, more typical of art from the early Middle Ages, Giotto conveys real human suffering, drawing the viewer into the circle of personal grief. The direct, emotional appeal of his art, as well as its deliberate plainness, seems to embody Franciscan values.

BERNARDO DADDI. Giotto dominated Florentine painting in the first half of the fourteenth century. His combination of humanism and realism was so memorable that other artists' work paled beside his. The artists who worked in his studio picked up the mannerisms but not the essence of his style. Bernardo Daddi (active c. 1312–48), who painted the *Madonna and Child* in Orsanmichele (SEE FIG. 17–1), typifies the group with his personal reworking of Giotto's powerful figures. Daddi's talent lay in the creation of sensitive, lyrical images rather than the majestic realistic figures. He may have

been inspired by courtly French art, which he would have known from luxury goods, such as imported ivory carvings. The artists of the school of Giotto were responsible for hundreds of panel paintings. They also frescoed the walls of chapels and halls (see "Buon Fresco," page 569).

Sienese Painting

Like their Florentine rivals, the Sienese painters at first worked in a strongly Byzantine style. Sienese painting continued to emphasize abstract decorative qualities and a love of applied gold and brilliant colors. Consequently, Sienese art often seems slightly conservative.

DUCCIO DI BUONINSEGNA. Siena's foremost painter in the later Gothic period was Duccio di Buoninsegna (active 1278–1318). Duccio knew thirteenth-century Byzantine art, with its elongated figures, stacks of angels, patterned textiles, and lavish use of gold. Between 1308 and 1311, Duccio painted a huge altarpiece for the high altar of Siena Cathedral. The **MAESTÀ (MAJESTY)** was dedicated, like the town itself, to the Virgin (FIGS. 17–11, 17–12).

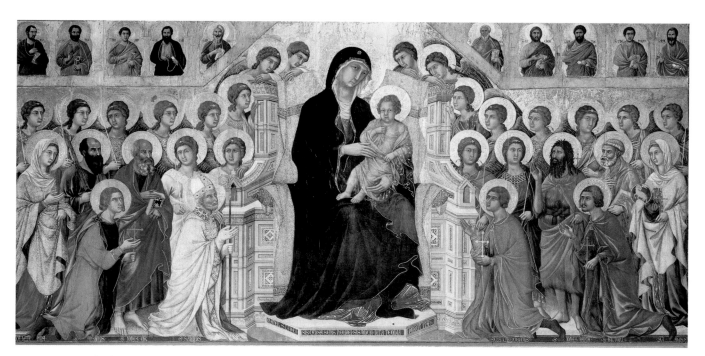

17–11 | Duccio di Buoninsegna **VIRGIN AND CHILD IN MAJESTY,** Central Panel from Maestà Altarpiece
Siena Cathedral. 1308–11. Tempera and gold on wood panel, 7′ × 13′6″ (2.13 × 3.96 m).
Museo dell'Opera del Duomo, Siena.

"On the day that it was carried to the [cathedral] the shops were shut, and the bishop conducted a great and devout company of priests and friars in solemn procession, accompanied by . . . all the officers of the commune, and all the people, and one after another the worthiest with lighted candles in their hands took places near the picture, and behind came the women and children with great devotion. And they accompanied the said picture up to the [cathedral], making the procession around the Campo [square], as is the custom, all the bells ringing joyously, out of reverence for so noble a picture as is this" (Holt, page 69).

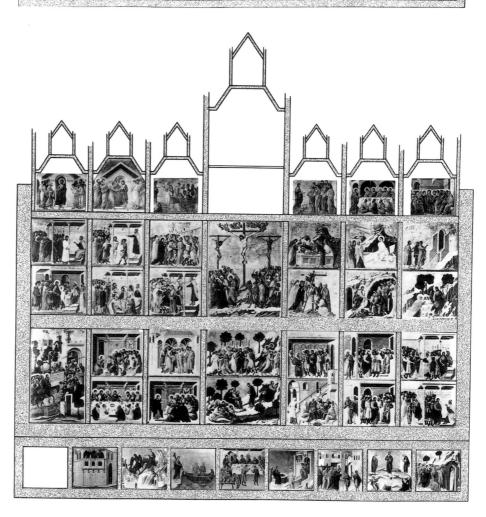

17–12 | **PLAN OF FRONT AND BACK OF THE MAESTÀ ALTARPIECE**

Creating this altarpiece was an arduous undertaking. The central panel alone was 7 by 13 ½ feet, and it had to be painted on both front and back, because it was meant to be seen from both sides. The main altar for which it was designed stood beneath the dome in the center of the sanctuary. Inscribed on Mary's throne are the words, "Holy Mother of God be thou the cause of peace for Siena and, because he painted thee thus, of life for Duccio" (cited in Hartt and Wilkins 4.2, page 104).

Mary and Christ, adored by angels and the four patron saints of Siena—Ansanus, Savinus, Crescentius, and Victor—kneeling in front, fill the large central panel. This *Virgin and Child in Majesty* represents both the Church and its specific embodiment, Siena Cathedral. Narrative scenes from the early life of the Virgin and the infancy of the Christ Child appear below the central image. The **predella** (the lower zone of the altarpiece) was entirely painted with the events in the childhood of Jesus. The back of this immense work was dedicated to scenes of his adult life and the miracles. The entire composition was topped by pinnacles—on the front, angels and the later life of the Virgin, and on the back, events after the Passion.

Duccio created a personal style that combines a softened Italo-Byzantine figure style with the linear grace and the easy relationship between figures and their settings characteristic of French Gothic. This subtle blending of northern and southern elements can be seen in the haloed ranks of angels around Mary's architectonic throne. The central, most holy figures retain a solemnity and immobility with some realistic touches, such as the weighty figure of the child; the adoring saints reflect a more naturalistic, courtly Gothic style that became the hallmark of the Sienese school for years to come. The brilliant palette, which mingles pastels with primary hues, the delicately patterned textiles that shimmer with gold, and the ornate **punchwork**—tooled designs in gold leaf on the haloes—are characteristically Sienese.

In 1771 the altarpiece was broken up, and individual panels were sold. One panel—the **NATIVITY WITH PROPHETS ISAIAH AND EZEKIEL**—is now in Washington, D.C. Duccio represented the Nativity in the tradition of Byzantine icons. Mary lies on a fat mattress within a cave hollowed out of a jagged, stylized mountain (**FIG. 17–13**). Jesus appears twice: first lying in the manger and then with the midwife below. However, Duccio followed Western tradition by placing the scene in a shed. Rejoicing angels fill the sky, and the shepherds and sheep add a realistic touch in the lower right corner. The light, intense colors, the calligraphic linear quality, even the meticulously rendered details recall Gothic manuscripts (see Chapter 16). The tentative move toward a defined space in the shed as well as the subtle modeling of the figures point the way toward future development in representing people and their world. Duccio's graceful, courtly art contrasts with Giotto's austere monumentality.

Technique
BUON FRESCO

The two techniques used in mural painting are **buon** ("true") **fresco** ("fresh"), in which paint is applied with water-based paints on wet plaster, and **fresco secco** ("dry"), in which paint is applied to a dry plastered wall. The two methods can be used on the same wall painting.

The advantage of *buon fresco* is its durability. A chemical reaction occurs as the painted plaster dries, which bonds the pigments into the wall surface. In *fresco secco,* by contrast, the color does not become part of the wall and tends to flake off over time. The chief disadvantage of *buon fresco* is that it must be done quickly without mistakes. The painter plasters and paints only as much as can be completed in a day. In Italy, each section is called a **giornata,** or day's work. The size of a *giornata* varies according to the complexity of the painting within it. A face, for instance, can occupy an entire day, whereas large areas of sky can be painted quite rapidly.

In medieval and Renaissance Italy, a wall to be frescoed was first prepared with a rough, thick undercoat of plaster. When this was dry, assistants copied the master painter's composition onto it with charcoal. The artist made any necessary adjustments. These drawings, known as **sinopia,** have an immediacy and freshness lost in the finished painting. Work proceeded in irregularly shaped sections conforming to the contours of major figures and objects. Assistants covered one section at a time with a fresh, thin coat of very fine plaster over the *sinopia,* and when this was "set" but not dry, the artist worked with pigments mixed with water. Painters worked from the top down so that drips fell on unfinished portions. Some areas requiring pigments such as ultramarine blue (which was unstable in *buon fresco*), as well as areas requiring gilding, would be added after the wall was dry using the *fresco secco* method.

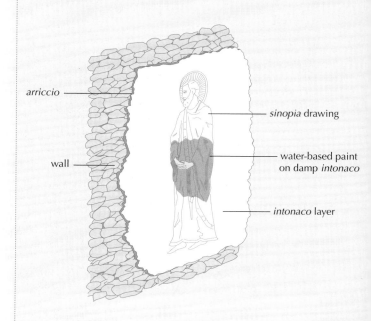

arriccio

wall

sinopia drawing

water-based paint on damp *intonaco*

intonaco layer

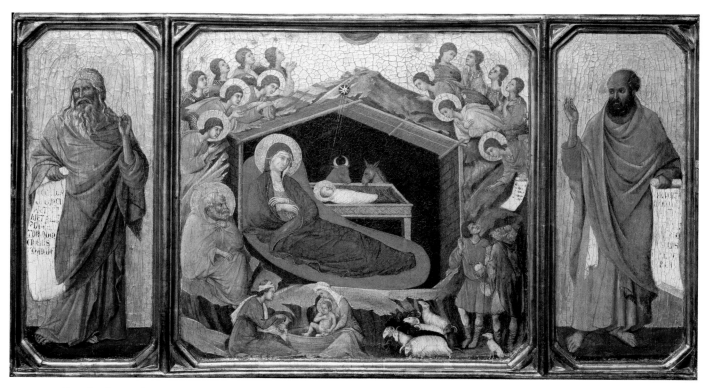

17–13 | Duccio di Buoninsegna **NATIVITY WITH PROPHETS ISAIAH AND EZEKIEL**
Predella of the Maestà Altarpiece, 17 × 17½″ (44 × 45 cm); Prophets, 17¼″ × 6½″ (44 × 16.5 cm).
National Gallery, Washington, D.C.

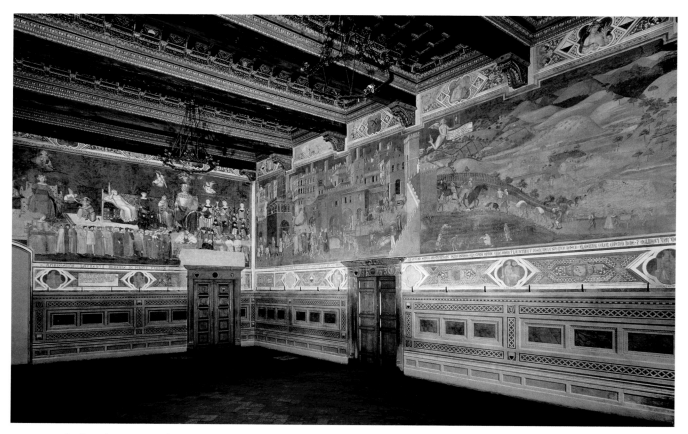

17–14 | Ambrogio Lorenzetti **FRESCO SERIES OF THE SALA DELLA PACE, PALAZZO PUBBLICO**
Siena city hall, Siena, Italy. 1338–40. Length of long wall about 46′ (14 m).

AMBROGIO LORENZETTI. In Siena, a strain of seemingly native realism also began to emerge. In 1338, the Siena city council commissioned Ambrogio Lorenzetti to paint in fresco the council room of the Palazzo Pubblico (city hall) known as the **SALA DELLA PACE (CHAMBER OF PEACE)** (**FIG. 17–14**). The murals were to depict the results of good and bad government. On the short wall Ambrogio painted a figure symbolizing the Commune of Siena, enthroned like an emperor holding an orb and scepter and surrounded by the Virtues. Justice, assisted by Wisdom and Concord, oversees the local magistrates. Peace lounges on a bench against a pile

of armor, having defeated War. The figure is based on a fragment of a Roman sarcophagus still in Siena.

Ambrogio painted the results of both good and bad government on the two long walls. For the **ALLEGORY OF GOOD GOVERNMENT,** and in tribute to his patrons, Ambrogio created an idealized but recognizable portrait of the city of Siena and its immediate environs (**FIG. 17–15**). The cathedral dome and the distinctive striped campanile (see Chapter 16) are visible in the upper left-hand corner; the streets are filled with productive citizens. The Porta Romana, Siena's gateway leading to Rome, divides the city from the country. Over the portal

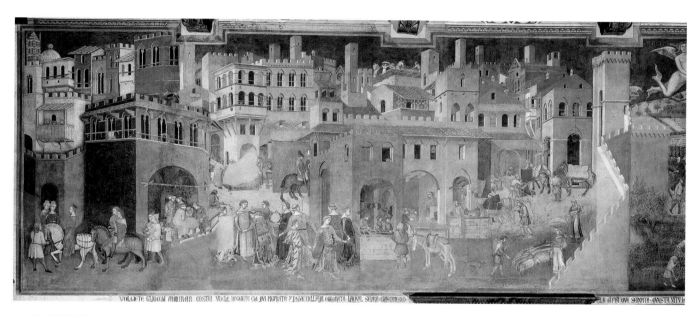

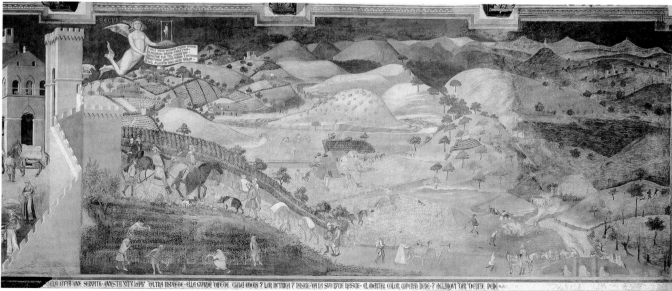

17–15 | Ambrogio Lorenzetti **ALLEGORY OF GOOD GOVERNMENT IN THE CITY AND IN THE COUNTRY**
Sala della Pace, Palazzo Pubblico, Siena, Italy. 1338–40. Fresco, total length about 46′ (14 m).

stands the statue of the wolf suckling Romulus and Remus, the legendary founders of Rome. Representations of these twin boys were popular in Siena because of the legend that Remus's son Senus founded Siena. Hovering above outside the gate is a woman clad in a wisp of transparent drapery, a scroll in one hand and a miniature gallows complete with a hanged man in the other. She represents Security, and her scroll bids those entering the city to come in peace. The gallows is a sharp reminder of the consequences of not doing so.

Ambrogio's achievement in this fresco was twofold. First, despite the shifts in vantage point and scale, he maintained an overall visual coherence and kept all parts of the flowing composition intelligible. Second, he maintained a natural relationship between the figures and the environment. Ambrogio conveys a powerful vision of an orderly society, of peace and plenty, from the circle of young people dancing to a tambourine outside a shoemaker's shop to the well-off peasants tending fertile fields and lush vineyards. Sadly, plague struck in the next decade. Famine, poverty, and disease overcame Siena just a few years after this work was completed.

The world of the Italian city-states—which had seemed so full of promise in Ambrogio Lorenzetti's *Good Government* fresco—was transformed into uncertainty and desolation by epidemics of the plague. Yet as dark as those days must have seemed to the men and women living through them, beneath the surface profound, unstoppable changes were taking place. In a relatively short span of time, the European Middle Ages gave way to what is known as the Renaissance.

FRANCE

At the beginning of the fourteenth century the royal court in Paris was still the arbiter of taste in Western Europe, as it had been in the days of Saint Louis. During the Hundred Years' War, however, the French countryside was ravaged by armed struggles and civil strife. The power of the old feudal nobility, weakened significantly by warfare, was challenged by townsmen, who took advantage of new economic opportunities that opened up in the wake of the conflict. Leadership in the arts and architecture moved to the duchy of Burgundy, to England, and—for a brief golden moment—to the court of Prague.

Gothic sculptors found a lucrative new outlet for their work in the growing demand among wealthy patrons for religious art intended for homes as well as churches. Busy urban workshops produced large quantities of statuettes and reliefs in wood, ivory, and precious metals, often decorated with enamel and gemstones. Much of this art was related to the cult of the Virgin Mary. Architectural commissions were smaller—chapels rather than cathedrals, and additions to already existing buildings, such as towers, spires, and window tracery.

In the second half of the thirteenth century, architects working at the royal court in Paris (see Chapter 16) introduced a new style, which continued into the first part of the fourteenth century. Known as the French Court style, or Rayonnant style or Rayonnant Gothic in France, the art is characterized by elegance and refinement achieved through extraordinary technical virtuosity. In sculpture and painting, elegant figures move gracefully through a narrow stage space established by miniature architecture and elements of landscape. Sometimes a focus on the details of nature suggests the realism that appears in the fourteenth century.

Manuscript Illumination

By the late thirteenth century, literacy had begun to spread among laypeople. Private prayer books became popular among those who could afford them. Because they contained special prayers to be recited at the eight canonical "hours" between morning and night, an individual copy of one of these books came to be called a Book of Hours. Such a book included everything the lay person needed—psalms, prayers to the Virgin and the other saints, a calendar of feast days, the office of the Virgin, and even the offices of the dead. During the fourteenth century, a richly decorated Book of Hours was worn or carried like jewelry and was among a noble person's most important portable possessions.

THE BOOK OF HOURS OF JEANNE D'EVREUX. Shortly after their marriage in 1325, King Charles IV gave his queen, Jeanne d'Evreux, a tiny, exquisite **BOOK OF HOURS,** the work of the illuminator Jean Pucelle (FIG. 17–16). This book was precious to the queen, who mentioned it in her will. She named its illuminator, Jean Pucelle, an unusual tribute.

In this manuscript, Pucelle worked in the *grisaille* technique—monochromatic painting in shades of gray with faint touches of color (here, blue and pink). The subtle shades emphasized his accomplished drawing. Queen Jeanne appears in the initial below the *Annunciation,* kneeling before a lectern and reading, perhaps, from her Book of Hours. This inclusion of the patron in prayer within a scene conveyed the idea that the scenes were visions inspired by meditation rather than records of historical events. In this case, the young queen would presumably have identified with Mary's joy at Gabriel's message.

Jeanne d'Evreux's Book of Hours combines two narrative cycles in its illuminations. One, the Hours of the Virgin, juxtaposes scenes from the Infancy and Passion of Christ, a form known as the Joys and Sorrows of the Virgin. The other is dedicated to the recently canonized king, Saint Louis. In the opening shown here, the joy of the *Annunciation* on the

17–16 | Jean Pucelle **PAGES WITH BETRAYAL AND ARREST OF CHRIST,** folio 15v. (left), and **ANNUNCIATION,** folio 16r. (right), **BOOK OF HOURS OF JEANNE D'EVREUX**
Paris c. 1325–28. *Grisaille* and color on vellum, each page 3½ × 2¼″ (8.9 × 6.2 cm).
The Metropolitan Museum of Art, New York. The Cloisters Collection 1954 (54.1.2).

right is paired with the "sorrow" of the *Betrayal and Arrest of Christ* on the left. In the *Annunciation,* Mary is shown receiving the archangel Gabriel in a Gothic building, while rejoicing angels look on from windows under the eaves. The group of romping children at the bottom of the page (known as the **bas-de-page** in French) at first glance seems to echo the joy of the angels. They might be playing "love tag," which would surely relate to Mary as the chosen one of the Annunciation. Folklorists have suggested, however, that the children are playing "froggy in the middle," or "hot cockles," games in which one child was tagged by the others. To the medieval reader the game symbolized the mocking of Christ or the betrayal of Judas, who "tags" his friend, and it evokes a darker mood by foreshadowing Jesus's death even as his life is beginning. In the *Betrayal* on the opposite page, Judas Iscariot embraces Jesus, thus identifying him to the Roman soldiers. The traitor sets in motion the events that lead to the Crucifixion. Saint Peter, on the left, realizing the danger, draws his sword to defend Jesus and slices off the ear of the high priest's servant Malchus. The *bas-de-page* on this side shows knights riding goats and jousting at a barrel stuck on a pole, a spoof of the military that may comment on the lack of valor of the soldiers assaulting Jesus.

Pucelle's work represents a sophisticated synthesis of contemporary French, English, and Italian art. From English illuminators he borrowed the merging of Christian narrative with allegory, the use of foliate borders filled with real and grotesque creatures (instead of the standard French vine scrolls), and his lively *bas-de-page* illustrations. His presentation of space, with figures placed within coherent architectural settings, suggests a firsthand knowledge of Sienese art: The small angels framed by the rounded arches of the attic are reminiscent of the half-length saints who appear above the front panel of Duccio's *Maestà.* Pucelle also adapted to manuscript illumination the Parisian Court style in sculpture, with its softly modeled, voluminous draperies gathered around tall, elegantly curved figures with curly hair and delicate features.

Sculpture

Sculpture in the fourteenth century is exemplified by its intimate character. Religious subjects became more emotionally expressive. In the secular realm, the cult of chivalry was revived just as the era of the knight on horseback was being rendered obsolete. Tales of love and valor were carved on luxury items to delight the rich, middle class, and aristocracy alike. Precious metals—gold, silver, and ivory—were preferred.

17–17 | **VIRGIN AND CHILD**
c. 1339. Silver gilt and enamel, height 27⅛″ (69 cm).
Musée du Louvre, Paris.

Given by Jeanne d'Evreux to the Abbey Church of Saint-Denis,
France.

THE VIRGIN AND CHILD FROM SAINT-DENIS. A silver-gilt image of a standing **VIRGIN AND CHILD** (FIG. 17–17) was once among the treasures of the Abbey Church of Saint-Denis (see Chapter 16). An inscription on the base bears the date 1339 and the donor's name, Queen Jeanne d'Evreux. The Virgin holds Jesus in her left arm, her weight on her left leg, creating the graceful S-curve pose that became characteristic of the period. Fluid drapery, suggesting the consistency of heavy silk, covers her body. She originally wore a crown, and she holds a scepter topped with a large enameled and jeweled *fleur-de-lis,* the heraldic symbol of French royalty. The scepter served as a reliquary for a few strands of Mary's hair. The Virgin's sweet, youthful face and simple clothing, although based on thirteenth-century sculpture, anticipate the so-called Beautiful Mother imagery of fourteenth-century Prague (SEE FIG. 17–25), Flanders, and Germany. The Christ Child reaching out to touch his mother's lips is babylike in his proportions and gestures, a hint of realism. The image is not entirely joyous, however; on the enameled base, scenes of Christ's Passion remind us of the suffering to come.

COURTLY LOVE: AN IVORY BOX. A strong market also existed for personal items like boxes, mirrors, and combs with secular scenes inspired by popular literature and folklore. A box—perhaps a gift from a lover—made in a Paris workshop around 1330–50 provides a delightful example of such a work (FIG. 17–18). In its ivory panels, the God of Love shoots his arrows; knights and ladies throw flowers as missiles and joust with flowers. The subject is the **ATTACK ON THE CASTLE OF LOVE,** but what the owner kept in the box—jewelry? love tokens?—remains a mystery.

A tournament takes place in front of the Castle of Love. The tournament—once a mock battle, designed to keep knights fit for war—has become a lovers' combat. In the center panel, women watch jousting knights charge to the blare of the heralds' trumpets. In the scene on the left, knights use crossbows and a catapult to hurl roses at the castle, while the God of Love helps the women by aiming his arrows at the attackers. The action concludes in the scene on the right, where the tournament's victor and his lady love meet in a playful joust of their own.

Unlike the aristocratic marriages of the time, which were essentially business contracts based on political or financial exigencies, romantic love involved passionate devotion. Images of gallant knights serving ladies, who bestowed tokens of affection on their chosen suitors or cruelly withheld their love on a whim, captured the popular imagination. Tales of romance were initially spread by the musician-poets known as troubadours. Twelfth-century troubadour poetry marked a shift away from the usually negative way in which women had previously been portrayed as sinful daughters of Eve.

17–18 | **ATTACK ON THE CASTLE OF LOVE**
Lid of a box. Paris. c. 1330–50. Ivory box with iron mounts, panel 4½ × 9¹¹⁄₁₆″ (11.5 × 24.6 cm).
The Walters Art Museum, Baltimore.

ENGLAND

Fourteenth-century England prospered in spite of the ravages of the Black Death and the Hundred Years' War with France. Life in medieval England is described in the rich store of Middle English literature. The brilliant social commentary of Geoffrey Chaucer in the *Canterbury Tales* (see "A New Spirit in Fourteenth-Century Literature," page 561) includes all classes of society. The royal family, especially Edward I—the castle builder—and many of the nobles and bishops were generous patrons of the arts.

Embroidery: Opus Anglicanum

An English specialty, pictorial needlework in colored silk and gold thread, gained such fame that it came to be called *opus anglicanum (English work)*. Among the collectors of this luxurious textile art were the popes, who had more than 100 pieces in the Vatican treasury. The names of several prominent embroiderers are known, but few names can be connected to specific pieces.

Opus anglicanum was employed for court dress, banners, cushions, bed hangings, and other secular items, as well as for the vestments worn by the clergy to celebrate the Mass (see Introduction Fig. 3, *Christine de Pizan Presenting a Book to the Queen of France*). Few secular pieces survive, since clothing and furnishings were worn out and discarded when fashions changed. But some vestments have survived, stored in church treasuries.

A liturgical vestment (that is, a special garment worn by the priest during mass), the red velvet **CHICHESTER-CONSTABLE**

CHASUBLE (FIG. 17–19) was embroidered with colored silk, gold threads forming the images as subtly as painting. Where gold threads were laid and couched (tacked down with colored silk), the effect resembles the burnished gold-leaf backgrounds of manuscript illuminations. The Annunciation, the Adoration of the Magi, and the Coronation of the Virgin are set in cusped, crocketed **ogee** (S-shaped) arches amid twisting branches sprouting oak leaves, seed-pearl acorns, and animal masks. Because the star and crescent moon in the Coronation of the Virgin scene are heraldic emblems of Edward III (ruled 1327–77), perhaps he or a family member ordered this luxurious vestment.

During the celebration of the Mass, garments of *opus anglicanum* would have glinted in the candlelight amid treasures on the altar. Court dress was just as rich and colorful, and at court such embroidered garments established the rank and

Sequencing Events

c. 1307–21	Dante writes *The Divine Comedy*
1309–77	Papacy transferred from Rome to Avignon
1348	Arrival of Black Death on European mainland
1378–1417	Great Schism in Catholic Church
1396	Greek studies instituted in Florence; beginning of the revival of Greek literature

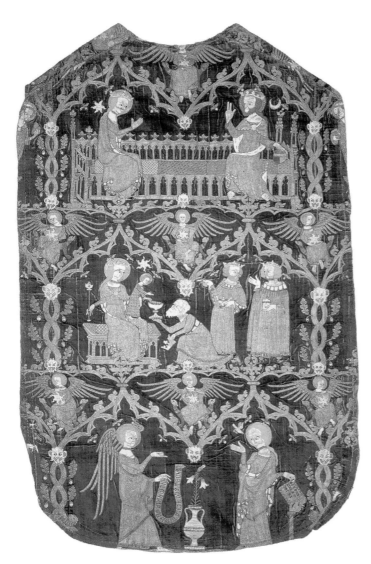

17–19 | **LIFE OF THE VIRGIN, BACK OF THE CHICHESTER-CONSTABLE CHASUBLE**
From a set of vestments embroidered in *opus anglicanum* from southern England. 1330–50. Red velvet with silk and metallic thread and seed pearls; length 4′3″ (129.5 cm), width 30″ (76 cm). The Metropolitan Museum of Art, New York.
Fletcher Fund, 1927 (27 162.1).

status of the wearer. So heavy did such gold and bejeweled garments become that their wearers often needed help to move.

Architecture

In the later years of the thirteenth century and early years of the fourteenth, a distinctive and influential style, popularly known as the "Decorated style," which corresponded to the Rayonnant style in France (see Chapter 16), developed in England. This change in taste has been credited to Henry III's ambition to surpass his brother-in-law, Saint Louis (Louis IX) of France, as a royal patron of the arts.

THE DECORATED STYLE AT EXETER. The most complete Decorated style building is the **EXETER CATHEDRAL.** Thomas of Witney began work at Exeter in 1313 and was the master

mason from 1316 until 1342. He supervised construction of the nave and redesigned upper parts of the choir. He left the towers of the original Norman cathedral but turned the interior into a dazzling stone forest of colonnettes, moldings, and vault ribs (FIG. 17–20). From diamond-shaped piers covered with colonnettes rise massed moldings that make the arcade seem to ripple. Bundled colonnettes spring from sculptured **corbels** (supporting brackets that project from a wall) between the arches to support conical clusters of thirteen ribs that meet at the summit of the vault, a modest 69 feet above the floor. The basic structure here is the four-part vault with intersecting cross-ribs, but the designer added additional ribs, called **tiercerons,** to create a richer linear pattern. Elaborately carved **bosses** (decorative knoblike elements) cover the intersections where ribs meet. Large clerestory windows with bar-tracery mullions (slender vertical elements dividing the windows into subsections) illuminate the 300-foot-long nave. Unpolished gray marble shafts, yellow sandstone arches, and a white French stone, shipped from Caen, used in the upper walls add subtle graduations of color to the many-rayed space.

Detailed records survive for the building of Exeter Cathedral. They extend over the period from 1279 to 1514, with only two short breaks. Included is such mundane information as where the masons and carpenters were housed (in a hostel near the cathedral) and how they were paid (some by the day with extra for drinks, some by the week, some for each finished piece); how materials were acquired and transported (payments for horseshoes and fodder for the horses); and of course payments for the building materials (not only stone and wood but rope for measuring and parchment on which to draw forms for the masons). The bishops contributed generously to the building funds. Building was not an anonymous labor of love as imagined by romantic nineteenth-century historians.

Thomas of Witney also designed the bishop's throne. Richard de Galmeton and Walter of Memburg led a team of a dozen carpenters to build the throne and the intricate canopy, 57 feet high. The canopy is like a piece of embroidery translated into wood, revealing characteristic forms of the Decorated style: S-curves, nodding arches (called "nodding ogee arches" because they curve outward—and nod—as well as upward) lead the eye into a maze of pinnacles, bursting with leafy **crockets** and tiny carved animals and heads. To finish the throne in splendor, Master Nicolas painted and gilded the wood. When the bishop was seated on his throne wearing embroidered vestments like the *Chichester-Constable Chasuble,* he must have resembled a golden image in a shrine rather than a living man. Enthroned, he represented the power and authority of the Church.

THE PERPENDICULAR STYLE AT EXETER. During years following the Black Death, work at Exeter Cathedral came to a

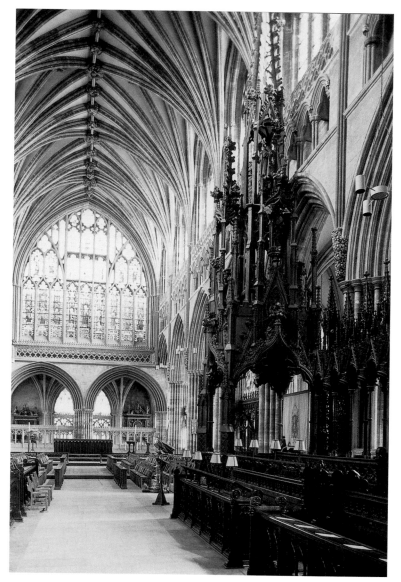

17–20 | EXETER CATHEDRAL
Exeter, Devon, England. Thomas of Witney, Choir, 14th century and Bishop's Throne, 1313–17; Robert Lesyngham, East Window, 1389–90.

standstill. The nave had been roofed but not vaulted, and the windows had no glass. When work could be resumed, taste had changed. The exuberance of the Decorated style gave way to an austere style in which rectilinear patterns and sharp angular shapes replaced intricate curves, and luxuriant foliage gave way to simple stripped-down patterns. This phase is known as the Perpendicular style.

In 1389–90, well-paid master mason Robert Lesyngham rebuilt the great East Window (FIG. 17–20), and he designed the window tracery in the new Perpendicular style. The window fills the east wall of the choir like a glowing altarpiece. A single figure in each light stands under a tall painted canopy that flows into and blends with the stone tracery. The Virgin with the Christ Child stands in the center over the high altar,

with four female saints at the left and four male saints, including Saint Peter, to whom the church is dedicated, on the right. At a distance the colorful figures silhouetted against the silver *grisaille* glass become a band of color, reinforcing the rectangular pattern of the mullions and transoms. The combination of *grisaille*, silver stain (creating shades of gold), and colored glass produces a cool silvery light.

The Perpendicular style produces a decorative scheme that heralds the Renaissance style (see Chapter 19) in its regularity, its balanced horizontal and vertical lines, and its plain wall or window surfaces. When Tudor monarchs introduced Renaissance art into the British Isles, builders did not have to rethink the form and structure of their buildings; they simply changed the ornament from the pointed cusped and

crocketed arches of the Gothic style to the round arches and ancient Roman columns and capitals of the classical era. The Perpendicular style, used throughout the Late Gothic period in the British Isles, became England's national style. It remains popular today in the United States for churches and college buildings.

THE HOLY ROMAN EMPIRE

By the fourteenth century, the Holy Roman Empire existed more as an ideal fiction than a fact. The Italian territories had established their independence, and in contrast to England and France, Germany had become further divided into multiple states with powerful regional associations and princes. The Holy Roman Emperors, now elected by Germans, concentrated on securing the fortunes of their families. They continued to be patrons of the arts, promoting local styles.

The Supremacy of Prague

Charles IV of Bohemia (ruled 1346–75), whose admiration for the French king Charles IV was such that he changed his own name from Wenceslas to Charles, had been raised in France. He was officially crowned king of Bohemia in 1347 and Holy Roman Emperor in 1355.

Charles established his capital in Prague, which, in the view of its contemporaries, replaced Constantinople as the "New Rome." Prague had a great university, a castle, and a cathedral overlooking a town that spread on both sides of a river joined by a stone bridge, a remarkable structure itself.

When Pope Clement VI made Prague an archbishopric in 1344, construction began on a new cathedral in the Gothic style—to be named for Saint Vitus—which would also serve as the coronation church and royal pantheon. At Charles's first coronation, however, the choir remained unfinished. Charles, deeply involved in his projects, brought Peter Parler from Swabia to complete the building. Peter came from a distinguished family of architects.

THE PARLER FAMILY. In 1317 Heinrich Parler, a former master of works on the Cologne Cathedral, designed and began building the **CHURCH OF THE HOLY CROSS** in Schwäbisch Gmünd, in southwest Germany. In 1351, his son Peter (c. 1330–99), the most brilliant architect of this talented family, joined the shop. Peter designed the choir **(FIG. 17–21)** in the manner of a hall church in which a triple-aisled form was enlarged by a ring of deep chapels between the buttresses

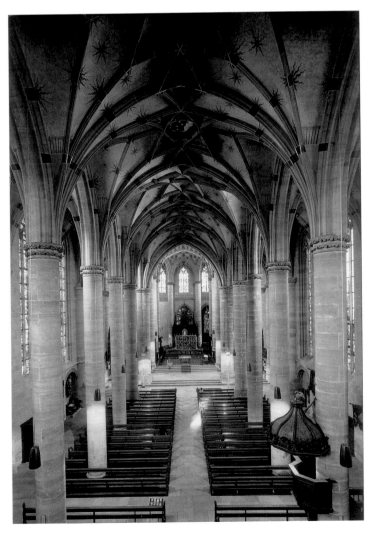

17–21 | Heinrich and Peter Parler **CHURCH OF THE HOLY CROSS**
Schwäbisch Gmünd, Germany. Interior. Begun in 1317 by Henrich Parler; choir by Peter Parler begun in 1351; vaulting completed 16th century.

17–22 | **PLAN OF CHURCH OF THE HOLY CROSS**
Schwäbisch Gmünd.

of the choir. The unity of the entire space was enhanced by the complex net vault—a veritable web of ribs created by eliminating transverse ribs and ridge ribs. Seen clearly in the plan (FIG. 17–22), the contrast between Heinrich's nave and Peter's choir illustrates the increasing complexity of rib patterns, a complexity that in fact finally led to the unified interior space of the Renaissance.

Called by Charles IV to Prague in 1353, Peter turned the unfinished Saint Vitus Cathedral into a "glass house," adding a vast clerestory and glazed triforium supported by double flying buttresses, all covered by net vaults that created a continuous canopy over the space. Photos do not do justice to the architecture; but the small, gilded icon shrine suggests the richness and elaborateness of Peter's work. The shrine stands in the reliquary chapel of Saint Wenceslas (FIG. 17–23)—once a freestanding Romanesque chapel, now incorporated into the cathedral—on the south side of the church. The chapel itself, with walls encrusted with semiprecious stones, recalls a reliquary (c. 1370–71).

Peter, his family, and heirs became the most successful architects in the Holy Roman Empire. Their concept of space, luxurious decoration, and intricate vaulting dominated central European architecture for three generations.

MASTER THEODORIC AND THE "BEAUTIFUL STYLE." At Karlstejn Castle, a day's ride from Prague, the emperor built another chapel and again covered the walls with gold and precious stones as well as with paintings. One hundred thirty paintings of the saints also served as reliquaries, for they had relics inserted into their frames. Master Theodoric, the court painter, provided drawings on the wood panels, and he painted about thirty images himself (FIG. 17–24). These figures are crowded into—and even extend over—the frames,

17–23 | Peter Parler and workshop **SAINT WENCESLAS CHAPEL, CATHEDRAL OF SAINT VITUS**
Prague. Begun 1356. In 1370–71, the walls were encrusted with slabs of jasper, amethyst, and gold, forming crosses. Tabernacle, c. 1375: gilded iron. Height 81 ⅞″ (208 cm).

The spires, pinnacles, and flying buttresses of the tabernacle may have been inspired by Peter Parler's drawings for the cathedral.

17–24 | Master Theodoric **SAINT LUKE** Holy Cross Chapel, Karlstejn Castle, near Prague. 1360-64. Paint and gold on panel. 45¼ × 37" (115 × 94 cm).

emphasizing their size and power. Master Theodoric was head of the Brotherhood of Saint Luke, the patron saint of painters, and his painting of **SAINT LUKE,** accompanied by his symbol, the ox, looks out at the viewer, suggesting that this may really be a self-portrait of Master Theodoric. Master Theodoric's personal style—heavy bodies, oversized heads and hands, dour and haunted faces, and soft, deeply modeled drapery—merged with the French Gothic style to become what is known as the Beautiful style of the end of the century. The chapel, consecrated in 1365, so pleased the emperor that in 1367 he gave the artist a farm in appreciation for his work.

Like the architecture of the Parler family, the style created by Master Theodoric spread through central and northern Europe. Typical of this Beautiful style is the sweet-faced Virgin and Child, as seen in the **"BEAUTIFUL" VIRGIN AND CHILD** (FIG. 17–25), engulfed in swaths of complex drapery.

Cascades of V-shaped folds and clusters of vertical folds ending in rippling edges surround a squirming infant to create the feeling of a fleeting movement. Emotions are restrained, and grief as well as joy become lost in a naive piety. Yet, this art emerges against a background of civil and religious unrest. The Beautiful style seems like an escape from the realities of fourteenth-century life.

Mysticism and Suffering

The ordeals of the fourteenth century—famines, wars, and plagues—helped inspire a mystical religiosity that emphasized both ecstatic joy and extreme suffering. Devotional images, known as *Andachtsbilder* in German, inspired the worshiper to contemplate Jesus's first and last hours, especially during evening prayers, or vespers (giving rise to the term *Vesperbild* for the image of Mary mourning her son).

17–25 | **"BEAUTIFUL" VIRGIN AND CHILD**
Probably from the Church of Augustinian Canons, Sternberk. c. 1390. Limestone with original paint and gilding; height 33⅛" (84 cm).

17–26 | **VESPERBILD**
From Middle Rhine region,
Germany. c. 1330. Wood,
height 34½″ (88. 4 cm).
Landesmuseum, Bonn.

Through such religious exercises, worshipers hoped to achieve understanding of the divine and union with God. In the well-known example shown here **(FIG. 17–26)**, blood gushes from the hideous rosettes that are the wounds of an emaciated Jesus. The Virgin's face conveys the intensity of her ordeal, mingling horror, shock, pity, and grief. Such images had a profound impact on later art, both within Germany and beyond.

Prague and the Holy Roman Empire under Charles IV had become a multicultural empire where people of different religions (Christians and Jews) and ethnic heritage (German and Slav) lived side by side. Charles died in 1378, and without his strong central government, political and religious dissent overtook the empire. Jan Hus, dean of the philosophy faculty at Prague University and a powerful reforming preacher, denounced the immorality he saw in the Church. He was burned at the stake, becoming a martyr and Czech national hero. The Hussite Revolution in the fifteenth century ended Prague's—and Bohemia's—leadership in the arts.

IN PERSPECTIVE

The emphasis on suffering and on supernatural power inspired many artists to continue the formal, expressive styles of earlier medieval and Byzantine art. At the same time, the humanism emerging in the paintings of Giotto and his school at the beginning of the fourteenth century could not be denied. Painters began to combine the flat, decorative, linear quality of Gothic art with the new representation of forms defined by light and space. In Italy they created a distinctive new Gothic style that continued through the fourteenth century. North of the Alps, Gothic elements survived in the arts well into the fifteenth century.

The courtly arts of manuscript illumination, embroidery, ivory carving, and of jewel, enamel, gold, and silver work flourished, becoming ever richer, more intricate and elaborate. Stained glass filled the ever-larger windows, while paintings or tapestries covered the walls. In Italy, artists inspired by ancient Roman masters and by Giotto looked with fresh eyes at the natural world. The full impact of their new vision was not fully assimilated until the beginning of the fifteenth century.

GIOTTO DI BONDONE
VIRGIN AND CHILD ENTHRONED
1305–10

AMBROGIO LORENZETTI.
**ALLEGORY OF GOOD GOVERNMENT IN THE CITY
AND IN THE COUNTRY**
SALA DELLA PACE, PALAZZO PUBBLICO, SIENA, ITALY
1338–40

LIFE OF THE VIRGIN
BACK OF THE
CHICHESTER-CONSTABLE CHASUBLE,
SOUTHERN ENGLAND
1330–50

PETER PARLER AND WORKSHOP.
ST. WENCESLAS CHAPEL
BEGUN 1356

MASTER THEODORIC
ST. LUKE
1360–64

FOURTEENTH-CENTURY ART IN EUROPE

1300

◄ **Papacy resides in Avignon** 1309–77

1320

◄ **Hundred Years' Wars** 1337–1453

1340

◄ **Black Death begins** 1348
◄ **Boccaccio begins writing**
The Decameron 1349–51

1360

◄ **Great Schism** 1378–1417

1380

◄ **Chaucer starts work on**
The Canterbury Tales 1387

1400

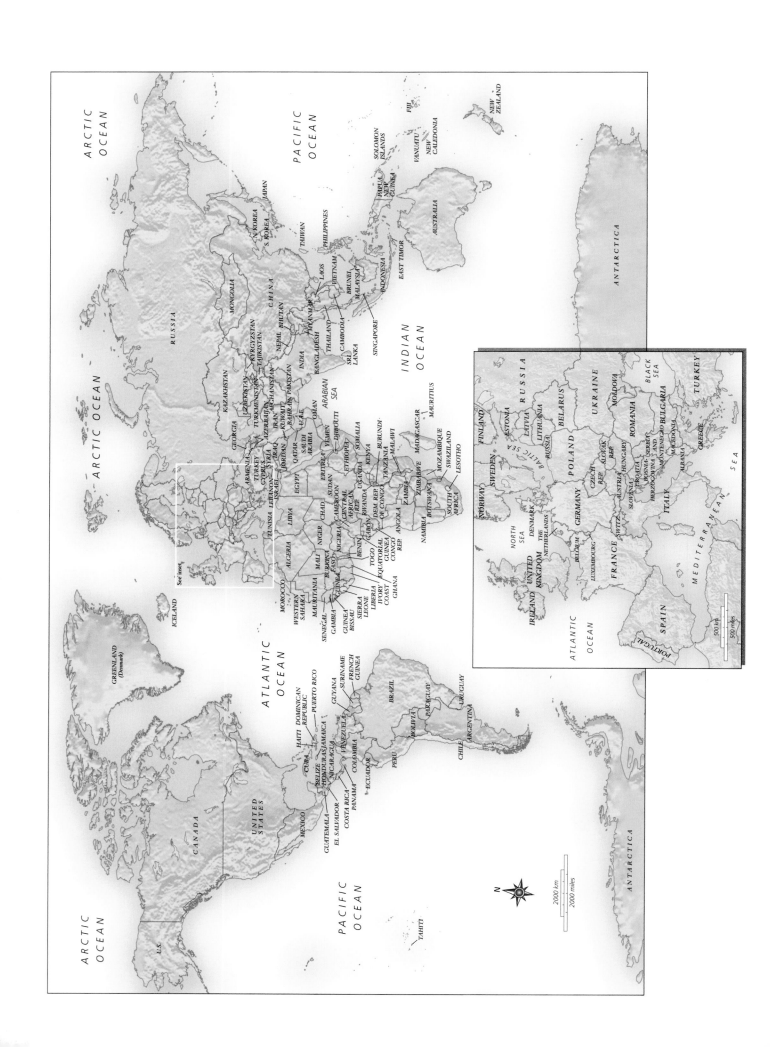

GLOSSARY

abacus The flat slab at the top of a **capital**, directly under the **entablature**.

absolute dating A method of assigning a precise historical date to periods and objects based on known and recorded events in the region as well as technically extracted physical evidence (such as carbon-14 disintegration). See also **radiometric dating, relative dating**.

abstract, abstraction Any art that does not represent observable aspects of nature or transforms visible forms into a stylized image. Also: the formal qualities of this process.

acropolis The **citadel** of an ancient Greek city, located at its highest point and housing temples, a treasury, and sometimes a royal palace. The most famous is the Acropolis in Athens.

acroterion (acroteria) An ornament at the corner or peak of a roof.

adobe Sun-baked blocks made of clay mixed with straw. Also: the buildings made with this material.

adyton The back room of a Greek temple. At Delphi, the place where the **oracles** were delivered. More generally, a very private space or room.

aedicula (aediculae) A decorative architectural frame, usually found around a niche, door, or window. An aedicula is made up of a **pediment** and **entablature** supported by **columns** or **pilasters**.

agora An open space in a Greek town used as a central gathering place or market. See also forum.

aisle Passage or open corridor of a church, hall, or other building that parallels the main space, usually on both sides, and is delineated by a row, or **arcade**, of **columns** or piers. Called side aisles when they flank the **nave** of a church.

album A book consisting of a series of painting or prints (album leaves) mounted into book form.

all'antica Meaning, "in the ancient manner."

allegory In a work of art, an image (or images) that symbolically illustrates an idea, concept, or principle, often moral or religious.

alloy A mixture of metals; different metals melted together.

amalaka In Hindu architecture, the circular or square-shaped element on top of a spire (*shikhara*), often crowned with a **finial**, symbolizing the cosmos.

ambulatory The passage (walkway) around the **apse** in a basilican church or around the **central space in a central-plan building**.

amphiprostyle Term describing a building, usually a temple, with **porticoes** at each end but without **columns** along the other two sides.

amphora An ancient Greek jar for storing oil or wine, with an egg-shaped body and two curved handles.

aniconic A symbolic representation without images of human figures, very often found in Islamic art.

animal interlace Decoration made of interwoven animals or serpents, often found in Celtic and early medieval Northern European art.

ankh A looped cross signifying life, used by ancient Egyptians.

appropriation Term used to describe an artist's practice of borrowing from another source for a new work of art. While in previous centuries artists often copied one another's figures, motifs, or compositions, in modern times the sources for appropriation extend from material culture to works of art.

apse, apsidal A large semicircular or polygonal (and usually vaulted) niche protruding from the end wall of a building. In the Christian church, it contains the altar. Apsidal is an adjective describing the condition of having such a space.

arabesque A type of linear surface decoration based on foliage and **calligraphic** forms, usually characterized by flowing lines and swirling shapes.

arcade A series of **arches**, carried by **columns** or **piers** and supporting a common wall or lintel. In a blind arcade, the arches and supports are engaged (attached to the wall) and have a decorative function.

arch In architecture, a curved structural element that spans an open space. Built from wedge-shaped stone blocks called **voussoirs**, which, when placed together and held at the top by a trapezoidal **keystone**, form an effective space-spanning and weight-bearing unit. Requires buttresses at each side to contain the outward thrust caused by the weight of the structure. **Corbel** arch: arch or **vault** formed by **courses** of stones, each of which projects beyond the lower course until the space is enclosed; usually finished with a **capstone**. Horseshoe arch: an arch of more than a half-circle; typical of western Islamic architecture. Ogival arch: a pointed arch created by S curves. Relieving arch: an arch built into a heavy wall just above a post-and-lintel structure (such as a gate, door, or window) to help support the wall above by transferring the load to the side walls.

archaic smile The curved lips of an ancient Greek statue, usually interpreted as an attempt to animate the features.

architrave The bottom element in an **entablature**, beneath the **frieze** and the **cornice**.

art brut French for "raw art." Term introduced by Jean Dubuffet to denote the often vividly **expressionistic** art of children and the insane, which he considered uncontaminated by culture.

articulated Joined; divided into units; in architecture, divided intoparts tomake spatial organization intelligible.

ashlar A highly finished, precisely cut block of stone. When laid in even **courses**, ashlar masonry creates a uniform face with fine joints. Often used as a facing on the visible exterior of a building, especially as a veneer for the **façade**. Also called **dressed stone**.

assemblage Artwork created by gathering and manipulating two and/or three-dimensional found objects.

astragal A thin convex decorative **molding**, often found on classical **entablatures**, and usually decorated with a continuous row of beadlike circles.

atelier The studio or workshop of a master artist or craftsperson, often including junior associates and apprentices.

atmospheric perspective See **perspective**.

atrial cross The cross placed in the atrium of a church. In Colonial America, used to mark a gathering and teaching place.

atrium An unroofed interior courtyard or room in a Roman house, sometimes having a pool or garden, sometimes surrounded by columns. Also: the open courtyard in front of a Christian church; or an entrance area in modern architecture.

automatism A technique whereby the usual intellectual control of the artist over his or her brush or pencil is foregone. The artist's aim is to allow the subconscious to create the artwork without rational interference.

avant-garde Term derived from the French military word meaning "before the group," or "vanguard." Avant-garde denotes those artists or concepts of a strikingly new, experimental, or radical nature for the time.

axis mundi A concept of an "axis of the world," which marks sacred sites and denotes a link between the human and celestial realms. For example, in Buddhist art, the axis mundi can be marked by monumental freestanding decorative pillars.

baldachin A canopy (whether suspended from the ceiling, projecting from a wall, or supported by columns) placed over an honorific or sacred space such as a throne or church altar.

bargeboards Boards covering the rafters at the gable end of a building; bargeboards are often carved or painted.

barrel vault See **vault**.

bar tracery See **tracery**.

bas-de-page French: bottom of the page; a term used in manuscript studies to indicate pictures below the text, literally at the bottom of the page.

base Any support. Also: masonry supporting a statue or the **shaft** of a **column**.

basilica A large rectangular building. Often built with a **clerestory**, side **aisles** separated from the center **nave** by **colonnades**, and an **apse** at one or both ends. Roman centers for administration, later adapted to Christian church use. Constantine's architects added a transverse aisle at the end of the nave called a **transept**.

bay A unit of space defined by architectural elements such as **columns**, **piers**, and walls.

beehive tomb A **corbel-vaulted** tomb, conical in shape like a beehive, and covered by an earthen mound.

Benday dots In modern printing and typesetting, the individual dots that, together with many others, make up lettering and images. Often machine- or computer-generated, the dots are very small and closely spaced to give the effect of density and richness of tone.

bestiary A book describing characteristics, uses, and meaning illustrated by moralizing tales about real and imaginary animals, especially popular during the Middle Ages in western Europe.

bi A jade disk with a hole in the center.

biomorphic Adjective used to describe forms that resemble or suggest shapes found in nature.

black-figure A style or technique of ancient Greek pottery in which black figures are painted on a red clay ground. See also **red-figure**.

bodhisattva In Buddhism, a being who has attained enlightenment but chooses to remain in this world in order to help others advance spiritually. Also defined as a potential Buddha.

boss A decorative knoblike element. Bosses can be found in many places, such as at the intersection of a Gothic vault rib. Also buttonlike projections in decorations and metalwork.

bracket, bracketing An architectural element that projects from a wall to support a horizontal part of a building, such as beams or the eaves of a roof.

brandea An object, such as a linen strip, having contact with a relic and taking on the power of the relic.

buon fresco See **fresco**.

cairn A pile of stones or earth and stones that served both as a prehistoric burial site and as a marker of underground tombs.

calligraphy Handwriting as an art form.

calyx krater See **krater**.

came (cames) A lead strip used in the making of leaded or **stained-glass** windows. Cames have an indented vertical groove on the sides into which the separate pieces of glass are fitted to hold the design together.

cameo Gemstone, clay, glass, or shell having layers of color, carved in **low relief** to create an image and ground of different colors.

camera obscura An early cameralike device used in the Renaissance and later for recording images of nature. Made from a dark box (or room) with a hole in one side (sometimes fitted with a lens), the camera obscura operates when bright light shines through the hole, casting an upside-down image of an object outside onto the inside wall of the box.

canon of proportions A set of ideal mathematical ratios in art based on measurements of the human body.

capital The sculpted block that tops a **column**. According to the conventions of the orders, capitals include different decorative elements. See **order**. Also: a historiated capital is one displaying a narrative.

capriccio A painting or print of a fantastic, imaginary landscape, usually with architecture.

capstone The final, topmost stone in a **corbel arch** or vault, which joins the sides and completes the structure.

cartoon A full-scale drawing used to transfer the outline of a design onto a surface (such as a wall, canvas, panel, or tapestry) to be painted, carved, or woven.

cartouche A frame for a **hieroglyphic** inscription formed by a rope design surrounding an oval space. Used to signify a sacred or honored name. Also: in architecture, a decorative device or plaque, usually with a plain center used for inscriptions or epitaphs.

caryatid A sculpture of a draped female figure acting as a column supporting an **entablature**.

catacomb A subterranean burial ground consisting of tunnels on different levels, having niches for urns and **sarcophagi** and often incorporating rooms (cubiculae).

celadon A high-fired, transparent **glaze** of pale bluish-green hue whose principal coloring agent is an oxide of iron. In China and Korea, such glazes typically were applied over a pale gray **stoneware** body, though Chinese potters some-

times applied them over **porcelain** bodies during the Ming (1368-1644) and Qing (1644-1911) dynasties. Chinese potters invented celadon glazes and initiated the continuous production of celadon-glazed wares as early as the third century CE.

cella The principal interior room at the center of a Greek or Roman temple within which the cult statue was usually housed. Also called the **naos**.

cenotaph A funerary monument commemorating an individual or group buried elsewhere.

centering A temporary structure that supports a masonry **arch** and **vault** or **dome** during construction until the mortar is fully dried and the masonry is self-sustaining.

centrally planned building Any structure designed with a primary central space surrounded by symmetrical areas on each side. For example, **Greek-cross plan** (equal-armed cross).

ceramics A general term covering all types of wares made from fired clay, including **porcelain** and **terra cotta**.

chaitya A type of Buddhist temple found in India. Built in the form of a hall or **basilica**, a chaitya hall is highly decorated with sculpture and usually is carved from a cave or natural rock location. It houses a sacred shrine or stupa for worship.

chamfer The slanted surface produced when an angle is trimmed or beveled, common in building and metalwork.

chasing Ornamentation made on metal by incising or hammering the surface.

chattri (*chattris*) A decorative pavilion with an umbrella-shaped **dome** in Indian architecture.

chevron A decorative or heraldic motif of repeated Vs; a zigzag pattern.

chiaroscuro An Italian word designating the contrast of dark and light in a painting, drawing, or print. Chiaroscuro creates spatial depth and volumetric forms through gradations in the intensity of light and shadow.

chiton A thin sleeveless garment, fastened at waist and shoulders, worn by men and women in ancient Greece.

citadel A fortress or defended city, if possible placed in a high, commanding location.

clapboard Horizontal overlapping planks used as protective siding for buildings, particularly houses in North America.

clerestory The topmost zone of a wall with windows in a **basilica** extending above the **aisle** roofs. Provides direct light into the central interior space (the **nave**).

cloisonné An enamel technique in which metal wire or strips are affixed to the surface to form the design. The resulting areas (cloisons) are filled with enamel (colored glass).

cloister An open space, part of a monastery, surrounded by an **arcaded** or **colonnaded** walkway, often having a fountain and garden, and dedicated to nonliturgical activities and the secular life of the religious. Members of a cloistered order do not leave the monastery or interact with outsiders.

codex (codices) A book, or a group of **manuscript** pages (folios), held together by stitching or other binding on one side.

coffer A recessed decorative panel that is used to reduce the weight of and to decorate ceilings or **vaults**. The use of coffers is called coffering.

colonnade A row of **columns**, supporting a straight lintel (as in a **porch** or **portico**) or a series of arches (an **arcade**).

colophon The data placed at the end of a book listing the book's author, publisher, illuminator, and other information related to its production. Also, in East Asian handscrolls, the inscriptions which follow the painting are called colophons.

column An architectural element used for support and/or decoration. Consists of a rounded or polygonal vertical **shaft** placed on a **base** and topped by a decorative **capital**. In classical architecture, built in accordance with the rules of one of the architectural **orders**. Columns can be freestanding or attached to a background wall (**engaged**).

complementary color The primary and secondary colors across from each other on the color wheel (red and green, blue and orange, yellow and purple). When juxtaposed, the intensity of both colors increases. When mixed together, they negate each other to make a neutral graybrown.

Composite order See **order**.

cong A square or octagonal jade tube with a cylindrical hole in the center. A symbol of the earth, it was used for ritual worship and astronomical observations in ancient China.

connoisseurship A term derived from the French word connoisseur, meaning "an expert," and signifying the study and evaluation of art based primarily on formal, visual, and stylistic analysis. A connoisseur studies the style and technique of an object to deduce its relative quality and possible maker. This is done through visual association with other, similar objects and styles. See also **contextualism**; **formalism**.

contextualism An interpretive approach in art history that focuses on the culture surrounding an art object. Unlike **connoisseurship**, contextualism utilizes the literature, history, economics, and social developments (among other things) of a period, as well as the object itself, to explain the meaning of an artwork. See *also* **connoisseurship**.

contrapposto An Italian term mearing "set against," used to describe the twisted pose resulting from parts of the body set in opposition to each other around a central axis.

corbel, corbeling An early roofing and **arching** technique in which each course of stone projects slightly beyond the previous layer (a corbel) until the uppermost corbels meet. Results in a high, almost pointed **arch** or **vault**. A corbel table is a ledge supported by corbels.

corbeled vault See **vault**.

Corinthian order See **order**.

cornice The uppermost section of a Classical **entablature**. More generally, a horizontally projecting element found at the top of a building wall or **pedestal**. A raking cornice is formed by the junction of two slanted cornices, most often found in **pediments**.

course A horizontal layer of stone used in building.

crenellation Alternating high and low sections of a wall, giving a notched appearance and creating permanent defensive shields in the walls of fortified buildings.

crockets A stylized leaf used as decoration along the outer angle of spins, pinnacles, gables, and around **capitals** in Gothic architecture.

cuneiform An early form of writing with wedge-shaped marks impressed into wet clay with a stylus, primarily used by ancient Mesopotamians.

curtain wall A wall in a building that does not support any of the weight of the structure. Also: the freestanding outer wall of a castle, usually encircling the inner bailey (yard) and keep (primary defensive tower).

cyclopean construction or **masonry** A method of building using huge blocks of rough-hewn stone. Any large-scale, monumental building project that impresses by sheer size. Named after the Cyclopes (sing. Cyclops) one-eyed giants of legendary strength in Greek myths.

cylinder seal A small cylindrical stone decorated with incised patterns. When rolled across soft clay or wax, the resulting raised pattern or design (**relief**) served in Mesopotamian and Indus Valley cultures as an identifying signature.

dado (dadoes) The lower part of a wall, differentiated in some way (by a **molding** or different coloring or paneling) from the upper section.

daguerreotype An early photographic process that makes a positive print on a light-sensitized copperplate; invented and marketed in 1839 by Louis-Jacques-Mandé Daguerre.

demotic writing The simplified form of ancient Egyptian hieratic writing, used primarily for administrative and private texts.

dharmachakra Sanskrit for "wheel" (*chakra*) and "law" or "doctrine" (*dharma*); often used in Buddhist iconography to signify the "wheel of the law."

diptych Two panels of equal size (usually decorated with paintings or reliefs) hinged together.

dogu Small human figurines made in Japan during the Jomon period. Shaped from clay, the figures have exaggerated expressions and are in contorted poses. They were probably used in religious rituals.

dolmen A prehistoric structure made up of two or more large upright stones supporting a large, flat, horizontal slab or slabs.

dome A round **vault**, usually over a circular space. Consists of a curved masonry vault of shapes and cross sections that can vary from hemispherical to bulbous to ovoidal. May use a supporting vertical wall (**drum**), from which the vault springs, and may be crowned by an open space (**oculus**) and/or an exterior **lantern**. When a dome is built over a square space, an intermediate element is required to make the transition to a circular drum. There are two types: A dome on **pendentives** (spherical triangles) incorporates **arched**, sloping intermediate sections of wall that carry the weight and thrust of the dome to heavily buttressed supporting **piers**. A dome on **squinches** uses an arch built into the wall (squinch) in the upper corners of the space to carry the weight of the dome across the corners of the square space below. A half-dome or conch may cover a semicircular space.

domino construction System of building construction introduced by the architect Le Corbusier in which reinforced concrete floor slabs are floated on six freestanding posts placed as if at the positions of the six dots on a domino playing piece.

Doric order See **order**.

dressed stone See **ashlar**.

drum The wall that supports a **dome**. Also: a segment of the circular **shaft** of a **column**.

drypoint An **intaglio** printmaking process by which a metal (usually copper) plate is directly inscribed with a pointed instrument (**stylus**). The resulting design of scratched lines is inked, wiped, and printed. Also: the print made by this process.

earthenware A low-fired, opaque **ceramic** ware that is fired in the range of 800 to 900 degrees Celsius. Earthenware employs humble clays that are naturally heat resistant; the finished wares remain porous after firing unless **glazed**. Earthenware occurs in a range of earth-toned colors, from white and tan to gray and black, with tan predominating.

echinus A cushionlike circular element found below the **abacus** of a Doric **capital**. Also: a similarly shaped **molding** (usually with egg-and-dart motifs) underneath the **volutes** of an Ionic **capital**.

electron spin resonance techniques Method that uses magnetic field and microwave irradiation to date material such as tooth enamel and its surrounding soil.

emblema (emblemata) In a mosaic, the elaborate central motif on a floor, usually a self-contained unit done in a more refined manner, with smaller **tesserae** of both marble and semiprecious stones.

encaustic A painting technique using pigments mixed with hot wax as a medium.

engaged column A **column** attached to a wall. See also column.

engraving An intaglio printmaking process of inscribing an image, design, or letters onto a metal or wood surface from which a print is made. An engraving is usually drawn with a sharp implement (burin) directly onto the surface of the plate. Also: the print made from this process.

entablature In the **Classical orders**, the horizontal elements above the **columns** and **capitals**. The entablature consists of, from bottom to top, an **architrave**, a **frieze**, and a **cornice**.

entasis A slight swelling of the **shaft** of a Greek column. The optical illusion of entasis makes the column appear from afar to be straight.

exedra (exedrae) In architecture, a semicircular niche. On a small scale, often used as decoration, whereas larger exedrae can form interior spaces (such as an **apse**).

expressionism, expressionistic Terms describing a work of art in which forms are created primarily to evoke subjective emotions rather than to portray objective reality.

façade The face or front wall of a building.

faience Type of **ceramic** covered with colorful, opaque glazes that form a smooth, impermeable surface. First developed in ancient Egypt.

fang ding A square or rectangular bronze vessel with four legs. The fang ding was used for ritual offerings in ancient China during the Shang dynasty.

fête galante A subject in painting depicting well-dressed people at leisure in a park or country setting. It is most often associated with eighteenth-century French Rococo painting.

filigree Delicate, lacelike ornamental work.

fillet The flat ridge between the carved out flutes of a **column shaft**. See also **fluting**.

finial A knoblike architectural decoration usually found at the top point of a spire, pinnacle, canopy, or gable. Also found on furniture; also the ornamental top of a staff.

fluting In architecture, evenly spaced, rounded parallel vertical grooves **incised** on **shafts** of **columns** or columnar elements (such as **pilasters**).

foreshortening The illusion created on a flat surface in which figures and objects appear to recede or project sharply into space. Accomplished according to the rules of **perspective**.

formal analysis See **formalism**.

formalism, formalist An approach to the understanding, appreciation, and valuation of art based almost solely on considerations of form. This approach tends to regard an artwork as independent of its time and place of making. See also **connoisseurship**.

four-iwan mosque See **iwan** and **mosque**.

fresco A painting technique in which waterbased pigments are applied to a surface of wet plaster (called **buon fresco**). The color is absorbed by the plaster, becoming a permanent part of the wall. **Fresco secco** is created by painting on dried plaster, and the color may flake off. Murals made by both these techniques are called frescoes.

fresco secco See **fresco**.

frieze The middle element of an **entablature**, between the **architrave** and the **cornice**. Usually decorated with sculpture, painting, or **moldings**. Also: any continuous flat band with **relief sculpture** or painted decorations.

frottage A design produced by laying a piece of paper over a textured surface and rubbing with charcoal or other soft medium.

fusuma Sliding doors covered with paper, used in traditional Japanese construction. Fusuma are often highly decorated with paintings and colored backgrounds.

galleria See **gallery**.

gallery In church architecture, the story found above the side **aisles** of a church, usually open to and overlooking the nave. Also: in secular architecture, a long room, usually above the ground floor in a private house or a public building used for entertaining, exhibiting pictures, or promenading. *Also*: a building or hall in which art is displayed or sold. Also: *galleria*.

garbhagriha From the Sanskrit word meaning "womb chamber," a small room or shrine in a Hindu temple containing a holy image.

genre A type or category of artistic form, subject, technique, style, or medium. See also genre painting.

gesso A ground made from glue, gypsum, and/or chalk forming the ground of a wood panel or the priming layer of a canvas. Provides a smooth surface for painting.

gilding The application of paper-thin **gold leaf** or gold pigment to an object made from another medium (for example, a sculpture or painting). Usually used as a decorative finishing detail.

giornata (giornate) Adopted from the Italian term meaning "a day's work," a giornata is the section of a **fresco** plastered and painted in a single day.

glaze See **glazing**.

glazing An outermost layer of vitreous liquid (**glaze**) that, upon firing, renders **ceramics** waterproof and forms a decorative surface. In painting, a technique particularly used with oil mediums in which a transparent layer of paint (**glaze**) is laid over another, usually lighter, painted or glazed area.

gloss A type of clay **slip** used in **ceramics** by ancient Greeks and Romans that, when fired, imparts a colorful sheen to the surface.

golf foil A thin sheet of gold.

gold leaf Paper-thin sheets of hammered gold that are used in **gilding**. In some cases (such as Byzantine **icons**), also used as a ground for paintings.

gopura The towering gateway to an Indian Hindu temple complex. A temple complex can have several different gopuras.

Grand Manner An elevated style of painting popular in the eighteenth century in which the artist looked to the ancients and to the Renaissance for inspiration; for portraits as well as history painting, the artist would adopt the poses, compositions, and attitudes of Renaissance and antique models.

Grand Tour Popular during the eighteenth and nineteenth centuries, an extended tour of cultural sites in southern Europe intended to finish the education of a young upper-class person from Britain or North America.

grattage A pattern created by scraping off layers of paint from a canvas laid over a textured surface. See also *frottage*.

Greek-cross plan See **centrally planned building**.

Greek-key pattern A continuous rectangular scroll often used as a decorative border. Also called a **meander pattern**.

grid A system of regularly spaced horizontally and vertically crossed lines that gives regularity to an architectural plan. Also: in painting, a grid enables designs to be enlarged or transferred easily.

grisaille A style of monochromatic painting in shades of gray. Also: a painting made in this style.

groin vault See **vault**.

guild An association of craftspeople. The medieval guild had great economic power, as it set standards and controlled the selling and marketing of its members' products, and as it provided economic protection, group solidarity, and training in the craft to its members.

hall church A church with a **nave** and **aisles** of the same height, giving the impression of a large, open hall.

handscroll A long, narrow, horizontal painting or text (or combination thereof) common in Chinese and Japanese art and of a size intended for individual use. A handscroll is stored wrapped tightly around a wooden pin and is unrolled for viewing or reading.

hanging scroll In Chinese and Japanese art, a vertical painting or text mounted within sections of silk. At the top is a semicircular rod; at the bottom is a round dowel. Hanging scrolls are kept rolled and tied except for special occasions, when they are hung for display, contemplation, or commemoration.

haniwa Pottery forms, including cylinders, buildings, and human figures, that were placed on top of Japanese tombs or burial mounds.

hemicycle A semicircular interior space or structure.

henge A circular area enclosed by stones or wood posts set up by Neolithic peoples. It is usually bounded by a ditch and raised embankment.

hieratic In painting and sculpture, a formalized style for representing rulers or sacred or priestly figures.

hieratic scale The use of different sizes for significant or holy figures and those of the everyday world to indicate importance. The larger the figure, the greater the importance.

high relief Relief sculpture in which the image projects strongly from the background. See also **relief sculpture**.

himation In ancient Greece, a long loose outer garment.

historicism The strong consciousness of and attention to the institutions, themes, styles, and forms of the past, made accessible by historical research, textual study, and archaeology.

history painting Paintings based on historical, mythological, or biblical narratives. Once considered the noblest form of art, history paintings generally convey a high moral or intellectual idea and are often painted in a grand pictorial style.

hollow-casting See **lost-wax casting**.

hypostyle hall A large interior room characterized by many closely spaced **columns** that support its roof.

icon An image in any material representing a sacred figure or event in the Byzantine, and later in the Orthodox, Church. Icons were venerated by the faithful, who believed them to have miraculous powers to transmit messages to God.

iconoclasm The banning or destruction of images, especially icons and religious art. Iconoclasm in eighth- and ninth-century Byzantium and sixteenth- and seventeenth-century Protestant territories arose from differing beliefs about the power, meaning, function, and purpose of imagery in religion.

iconographic See **iconography**.

iconography The study of the significance and interpretation of the subject matter of art.

iconostasis The partition screen in a Byzantine or Orthodox church between the **sanctuary** (where the Mass is performed) and the body of the church (where the congregation assembles). The iconostasis displays **icons**.

idealism *See* idealization.

idealization A process in art through which artists strive to make their forms and figures attain perfection, based on pervading cultural values and/or their own mental image of beauty.

ideograph A written character or symbol representing an idea or object. Many Chinese characters are ideographs.

ignudi Heroic figures of nude young men.

illumination A painting on paper or **parchment** used as illustration and/or decoration for **manuscripts** or **albums**. Usually done in rich colors, often supplemented by gold and other precious materials. The illustrators are referred to as illuminators. Also: the technique of decorating manuscripts with such paintings.

impasto Thick applications of pigment that give a painting a palpable surface texture.

impost, impost block A block, serving to concentrate the weight above, imposed between the **capital** of a **column** and the springing of an arch above.

in antis Term used to describe the position of columns set between two walls, as in a **portico** or a **cella**.

incising A technique in which a design or inscription is cut into a hard surface with a sharp instrument. Such a surface is said to be incised.

ink painting A monochromatic style of painting developed in China using black ink with gray **washes**.

inlay To set pieces of a material or materials into a surface to form a design. *Also:* material used in or decoration formed by this technique.

installation art Artworks created for a specific site, especially a gallery or outdoor area, that create a total environment.

intaglio Term used for a technique in which the design is carved out of the surface of an object, such as an engraved seal stone. In the graphic arts, intaglio includes **engraving**, etching, and **drypoint**—all processes in which ink transfers to paper from incised, ink-filled lines cut into a metal plate.

intarsia Decoration formed through wood **inlay**.

intuitive perspective See **perspective**.

Ionic order See **order**.

iwan A large, **vaulted** chamber in a **mosque** with a monumental arched opening on one side.

jamb In architecture, the vertical element found on both sides of an opening in a wall, and supporting an **arch** or lintel.

japonisme A style in French and American nineteenth-century art that was highly influenced by Japanese art, especially prints.

jasperware A fine-grained, unglazed, white **ceramic** developed by Josiah Wedgwood, often colored by metallic oxides with the raised designs ramaining white.

jataka **tales** In Buddhism, stories associated with the previous lives of Shakyamuni, the historical Buddha.

joined-wood sculpture A method of constructing large-scale wooden sculpture developed in Japan. The entire work is constructed from smaller hollow blocks, each individually carved, and assembled when complete. The joined-wood technique allowed the production of larger sculpture, as the multiple joints alleviate the problems of drying and cracking found with sculpture carved from a single block.

joggled voussoirs Interlocking voussoirs in an arch or lintel, often of contrasting materials for colorful effect.

kantharos A type of Greek vase or goblet with two large handles and a wide mouth.

key block A key block is the master block in the production of a colored **woodblock print**, which requires different blocks for each color. The key block is a flat piece of wood with the entire design carved or drawn on its surface. From this, other blocks with partial drawings are made for printing the areas of different colors.

keystone The topmost **voussoir** at the center of an **arch**, and the last block to be placed. The pressure of this block holds the arch together. Often of a larger size and/or decorated.

kiln An oven designed to produce enough heat for the baking, or firing, of clay.

kinetic art Artwork that contains parts that can be moved either by hand, air, or motor.

kondo The main hall inside a Japanese Buddhist temple where the images of Buddha are housed.

kore (korai) **An Archaic** Greek statue of a young woman.

kouros (kouroi) An Archaic Greek statue of a young man or boy.

krater An ancient Greek vessel for mixing wine and water, with many subtypes that each have a distinctive shape. **Calyx krater:** a bell-shaped vessel with handles near the base that resemble a flower calyx. Volute krater: a type of krater with handles shaped like scrolls.

kufic An ornamental, angular Arabic script.

kylix A shallow Greek vessel or cup, used for drinking, with a wide mouth and small handles near the rim.

lacquer A type of hard, glossy surface varnish used on objects in East Asian cultures, made from the sap of the Asian sumac or from shellac, a resinous secretion from the lac insect. Lacquer can be layered and manipulated or combined with pigments and other materials for various decorative effects.

lakshana Term used to designate the thirty-two marks of the historical Buddha. The lakshana include, among others, the Buddha's golden body, his long arms, the wheel impressed on his palms and the soles of his feet, and his elongated ear-lobes.

lamassu Supernatural guardian-protector of ancient Near Eastern palaces and throne rooms, often represented sculpturally as a combination of the bearded head of a man, powerful body of a lion or bull, wings of an eagle, and the horned headdress of a god, and usually possessing five legs.

lancet A tall narrow window crowned by a sharply pointed **arch**, typically found in Gothic architecture.

lantern A turretlike structure situated on a roof, **vault**, or **dome**, with windows that allow light into the space below.

lekythos (lekythoi) A slim Greek oil vase with one handle and a narrow mouth.

limner An artist, particularly a portrait painter, in England during the sixteenth and seventeenth centuries and in New England during the seventeenth and eighteenth centuries.

lingam shrine A place of worship centered on an object or representation in the form of a phallus (the lingam), which symbolizes the power of the Hindu god Shiva.

literati The English word used for the Chinese wenren or the Japanese bunjin, referring to well-educated artists who enjoyed literature, **calligraphy**, and painting as a pastime. Their painting are termed **literati painting**.

literati painting A style of painting that reflects the taste of the educated class of East Asian intellectuals and scholars. Aspects include an appreciation for the antique, small scale, and an intimate connection between maker and audience.

lithograph See **lithography**.

lithography Process of making a print (**lithograph**) from a design drawn on a flat stone block with greasy crayon. Ink is applied to the wet stone and adheres only to the greasy areas of the design.

loggia Italian term for a covered open-air. **gallery**. Often used as a corridor between buildings or around a courtyard, loggias usually have **arcades** or **colonnades**.

lost-wax casting A method of casting metal, such as bronze, by a process in which a wax mold is covered with clay and plaster, then fired, melting the wax and leaving a hollow form. Molten metal is then poured into the hollow space and slowly cooled. When the hardened clay and plas-ter exterior shell is removed, a solid metal form remains to be smoothed and polished.

low relief Relief sculpture whose figures project slightly from the background. See also **relief sculpture**.

lunette A semicircular wall area, framed by an arch over a door or window. Can be either plain or decorated.

lusterware Ceramic pottery decorated with metallic **glazes**.

madrasa An Islamic institution of higher learning, where teaching is focused on theology and law.

maenad In ancient Greece, a female devotee of the wine god Dionysos who participated in orgiastic rituals. She is often depicted with swirling drapery to indicate wild movement or dance. (Also called a Bacchante, after Bacchus, the Roman name of Dionysos.)

majolica Pottery painted with a tin glaze that, when fired, gives a lustrous and colorful surface.

mandala An image of the cosmos represented by an arrangement of circles or concentric geometric shapes containing diagrams or images. Used for meditation and contemplation by Buddhists.

mandapa In a Hindu temple, an open hall dedicated to ritual worship.

mandorla Light encircling, or emanating from, the entire figure of a sacred person.

manuscript A handwritten book or document.

maqsura An enclosure in a Muslim mosque, near the mihrab, designated for dignitaries.

martyrium (martyria) In Christian architecture, a church, chapel, or shrine built over the grave of a martyr or the site of a great miracle.

mastaba A flat-topped, one-story structure with slanted walls over an ancient Egyptian underground tomb.

matte Term describing a smooth surface that is without shine or luster.

mausoleum A monumental building used as a tomb. Named after the tomb of Mausolos erected at Halikarnassos around 350 BCE.

meander See **Greek-key pattern**.

medallion Any round ornament or decoration. Also: a large medal.

megalith A large stone used in prehistoric building. Megalithic architecture employs such stones.

megaron The main hall of a Mycenaean palace or grand house, having a columnar **porch** and a room with a central fireplace surrounded by four **columns**.

memento mori From Latin for "remember that you must die." An object, such as a skull or extinguished candle, typically found in a *vanitas* image, symbolizing the transience of life.

memory image An image that relies on the generic shapes and relationships that readily spring to mind at the mention of an object.

menorah A Jewish lamp-stand with seven or nine branches; the nine-branched menorah is used during the celebration of Hanukkah. Representations of the seven-branched menorah, once used in the Temple of Jerusalem, became a symbol of Judaism.

metope The carved or painted rectangular panel between the **triglyphs** of a **Doric frieze**.

mihrab A recess or niche that distinguishes the wall oriented toward Mecca (*qibla*) in a **mosque**.

minaret A tall slender tower on the exterior of a mosque from which believers are called to prayer.

minbar A high platform or pulpit in a **mosque**.

miniature Anything small. In painting, miniatures may be illustrations within **albums** or **manuscripts** or intimate portraits.

mirador In Spanish and Islamic palace architecture, a very large window or room with windows, and sometimes balconies, providing views to interior courtyards or the exterior landscape.

mithuna The amorous male and female couples in Buddhist sculpture, usually found at the entrance to a sacred building. The mithuna symbolize the harmony and fertility of life.

moat A large ditch or canal dug around a castle or fortress for military defense. When filled with water, the moat protects the walls of the building from direct attack.

mobile A sculpture made with parts suspended in such a way that they move in a current of air.

modeling In painting, the process of creating the illusion of three-dimensionality on a two-dimensional surface by use of light and shade. In sculpture, the process of molding a three-dimensional form out of a malleable substance.

module A segment or portion of a repeated design. Also: a basic building block.

molding A shaped or sculpted strip with varying contours and patterns. Used as decoration on architecture, furniture, frames, and other objects.

monolith A single stone, often very large.

mortise-and-tenon joint A method of joining two elements. A projecting pin (tenon) on one element fits snugly into a hole designed for it (mortise) on the other. Such joints are very strong and flexible.

mosaic Images formed by small colored stone or glass pieces (tesserae), affixed to a hard, stable surface.

mosque An edifice used for communal Muslim worship.

mudra A symbolic hand gesture in Buddhist art that denotes certain behaviors, actions, or feelings.

mullion A slender vertical element or **colonnette** that divides a window into subsidiary sections.

muqarnas Small nichelike components stacked in tiers to fill the transition between differing vertical and horizontal planes.

naos The principal room in a temple or church. In ancient architecture, the **cella**. In a Byzantine church, the **nave** and **sanctuary**.

narthex The vestibule or entrance porch of a church.

naturalism, naturalistic A style of depiction that seeks to imitate the appearance of nature. A naturalistic work appears to record the visible world.

nave The central space of a **basilica**, two or three stories high and usually flanked by **aisles**.

necking The molding at the top of the **shaft** of the **column**.

necropolis A large cemetery or burial area; literally a "city of the dead."

nemes headdress The royal headdress of Egypt.

niello A metal technique in which a black sulfur alloy is rubbed into fine lines engraved into a metal (usually gold or silver). When heated, the alloy becomes fused with the surrounding metal and provides contrasting detail.

nishiki-e A multicolored and ornate Japanese print.

nocturne A night scene in painting, usually lit by artificial illumination.

nonrepresentational art An **abstract** art that does not attempt to reproduce the appearance of objects, figures, or scenes in the natural world. Also called nonobjective art.

oculus (oculi) In architecture, a circular opening. Oculi are usually found either as windows or at the apex of a **dome**. When at the top of a dome, an oculus is either open to the sky or covered by a decorative exterior lantern.

ogee An S-shaped curve. See **arch**.

olpe Any Greek vase or jug without a spout.

one-point perspective See **perspective**.

opithodomos In greek temples, the entrance porch or room at the back.

oracle A person, usually a priest or priestess, who acts as a conduit for divine information. Also: the information itself or the place at which this information is communicated.

orant The representation of a standing figure praying with outstretched and upraised arms.

orchestra The circular performance area of an ancient Greek theater. In later architecture, the section of seats nearest the stage or the entire main floor of the theater.

order A system of proportions in Classical architecture that includes every aspect of the building's plan, elevation, and decorative system. Composite: a combination of the Ionic and the Corinthian orders. The **capital** combines acanthus leaves with **volute** scrolls. **Corinthian:** the most ornate of the orders, the Corinthian includes a **base**, a fluted **column shaft** with a capital elaborately decorated with acanthus leaf carvings. Its **entablature** consists of an **architrave** decorated with **moldings**, a **frieze** often containing **sculptured reliefs**, and a **cornice** with dentils. Doric: the column shaft of the Doric order can be fluted or smooth-surfaced and has no base. The Doric capital consists of an undecorated **echinus** and **abacus**. The Doric entablature has a plain architrave, a frieze with **metopes** and **triglyphs**, and a simple cornice. Ionic: the column of the Ionic order has a fluted shaft, and a capital decorated with volutes. The Ionic entablature consists of an architrave of three panels and moldings, a frieze usually containing sculpted relief ornament, and a cornice with dentils. **Tuscan:** a variation of Doric characterized by a smooth-surfaced column shaft with a base, a plain architrave, and an undecorated frieze. A colossal order is any of the above built on a large scale, rising through several stories in height and often raised from the ground by a **pedestal**.

orthogonal Any line running back into the represented space of a picture perpendicular to the imagined picture plane. In linear perspective, all orthogonals converge at a single **vanishing point** in the picture and are the basis for a **grid** that maps out the internal space of the image. An orthogonal plan is any plan for a building or city that is based exclusively on right angles, such as the grid plan of many modern cities.

pagoda An East Asian **reliquary** tower built with successively smaller, repeated stories. Each story is usually marked by an elaborate projecting roof.

palace complex A group of buildings used for living and governing by a ruler and his or her supporters, usually fortified.

palmette A fan-shaped ornament with radiating leaves.

parapet A low wall at the edge of a balcony, bridge, roof, or other place from which there is a steep drop, built for safety. A parapet walk is the passageway, usually open, immediately behind the uppermost exterior wall or battlement of a fortified building.

parchment A writing surface made from treated skins of animals. Very fine parchment is known as **vellum**.

parterre An ornamental, highly regimented flowerbed. An element of the ornate gardens of seventeenth-century palaces and châteaux.

pastel Dry pigment, chalk, and gum in stick or crayon form. Also: a work of art made with pastels.

pedestal A platform or **base** supporting a sculpture or other monument. Also: the block found below the base of a Classical **column** (or **colonnade**), serving to raise the entire element off the ground.

pediment A triangular gable found over major architectural elements such as Classical Greek **porticoes**, windows, or doors. Formed by an **entablature** and the ends of a sloping roof or a raking **cornice**. A similar architectural element is often used decoratively above a door or window, sometimes with a curved upper **molding**. A broken pediment is a variation on the traditional pediment, with an open space at the center of the topmost angle and/or the horizontal cornice.

pendentive The concave triangular section of a **vault** that forms the transition between a square or polygonal space and the circular base of a **dome**.

peplos A loose outer garment worn by women of ancient Greece. A cloth rectangle fastened on the shoulders and belted below the bust or at the waist.

peripteral A term used to describe any building (or room) that is surrounded by a single row of columns. When such **columns** are engaged instead of freestanding, called pseudo-peripteral.

peristyle A surrounding **colonnade** in Greek architecture. A peristyle building is surrounded on the exterior by a colonnade. Also: a peristyle court is an open colonnaded courtyard, often having a pool and garden.

perspective A system for representing three-dimensional space on a two-dimensional surface. **Atmospheric** perspective: A method of rendering the effect of spatial distance by subtle variations in color and clarity of representation. **Intuitive perspective:** A method of giving the impression of recession by visual instinct, not by the use of an overall system or program. Oblique perspective: An intuitive spatial system in which a building or room is placed with one corner in the picture plane, and the other parts of the structure recede to an imaginary vanishing point on its other side. Oblique perspective is not a comprehensive, mathematical system. **One-point** and multiple-point **perspective** (also called linear, scientific or mathematical perspective): A method of creating the illusion of three-dimensional space on a two-dimensional surface by delineating a horizon line and multiple orthogonal lines. These recede to meet at one or more points on the horizon (called **vanishing** points), giving the appearance of spatial depth. Called scientific or mathematical because its use requires some

knowledge of geometry and mathematics, as well as optics. **Reverse perspective:** A Byzantine perspective theory in which the orthogonals or rays of sight do not converge on a vanishing point in the picture, but are thought to originate in the viewer's eye in front of the picture. Thus, in reverse perspective the image is constructed with orthogonals that diverge, giving a slightly tipped aspect to objects.

photomontage A photographic work created from many smaller photographs arranged (and often overlapping) in a composition.

picture plane The theoretical spatial plane corresponding with the actual surface of a painting.

picture stone A medieval northern European memorial stone covered with figural decoration. See also **rune stone**.

picturesque A term describing the taste for the familiar, the pleasant, and the pretty, popular in the eighteenth and nineteenth centuries in Europe. When contrasted with the sublime, the picturesque stood for all that was ordinary but pleasant.

piece-mold casting A casting technique in which the mold consists of several sections that are connected during the pouring of molten metal, usually bronze. After the cast form has hardened, the pieces of the mold are disassembled, leaving the completed object.

pier A masonry support made up of many stones, or rubble and concrete (in contrast to a **column shaft** which is formed from a single stone or a series of **drums**), often square or rectangular in plan, and capable of carrying very heavy architectural loads.

pietra dura Italian for "hard stone." Semi-precious stones selected for color variation and cut in shapes to form ornamental designs such as flowers or fruit.

pietra serena A gray Tuscan limestone used in Florence.

pilaster An **engaged** columnar element that is rectangular in format and used for decoration in architecture.

pillar In architecture, any large, freestanding vertical element. Usually functions as an important weight-bearing unit in buildings.

plate tracery See **tracery**.

plinth The slablike **base** or **pedestal** of a **column**, statue, wall, building, or piece of furniture.

pluralism A social structure or goal that allows members of diverse ethnic, racial, or other groups to exist peacefully within the society while continuing to practice the customs of their own divergent cultures. Also: an adjective describing the state of having many valid contemporary styles available at the same time to artists.

podium A raised platform that acts as the foundation for a building, or as a platform for a speaker.

polychrome See **polychromy**.

polychromy The multicolored painted decoration applied to any part of a building, sculpture, or piece of furniture.

polyptych An altarpiece constructed from multiple panels, sometimes with hinges to allow for movable wings.

porcelain A high-fired, vitrified, translucent, white **ceramic** ware that employs two specific clays—kaolin and petuntse—and that is fired in the range of 1,300 to 1,400 degrees Celsius. The

relatively high proportion of silica in the body clays renders the finished porcelains translucent. Like **stonewares**, porcelains are glazed to enhance their aesthetic appeal and to aid in keeping them clean. By definition, porcelain is white, though it may be covered with a **glaze** of bright color or subtle hue. Chinese potters were the first in the world to produce porcelain, which they were able to make as early as the eighth century.

porch The covered entrance on the exterior of a building. With a row of **columns** or **colonnade**, also called a **portico**.

portal A grand entrance, door, or gate, usually to an important public building, and often decorated with sculpture.

portico In architecture, a projecting roof or porch supported by columns, often marking an entrance. See also porch.

post-and-lintel construction An architectural system of construction with two or more vertical elements (posts) supporting a horizontal element (lintel).

potassium-argon dating Technique used to measure the decay of a radioactive potassium isotope into a stable isotope of argon, an inert gas.

potsherd A broken piece of ceramic ware.

Prairie Style A style of architecture initiated by the American Frank Lloyd Wright (1867–1959), in which he sought to integrate his structures in an "organic" way into the surrounding natural landscape, often having the lines of the building follow the horizontal contours of the land. Since Wright's early buildings were built in the Prairie States of the Midwest, this type of architecture became known as the Prairie Style.

primitivism The borrowing of subjects or forms usually from non-Western or prehistoric sources by Western artists. Originally practiced by Western artists as an attempt to infuse their work with the naturalistic and expressive qualities attributed to other cultures, especially colonized cultures, primitivism also borrowed from the art of children and the insane.

pronaos The enclosed vestibule of a Greek or Roman temple, found in front of the **cella** and marked by a row of **columns** at the entrance.

proscenium The stage of an ancient Greek or Roman theater. In modern theater, the area of the stage in front of the curtain. Also: the framing **arch** that separates a stage from the audience.

psalter In Jewish and Christian scripture, a book containing the psalms, or songs, attributed to King David.

punchwork Decorative designs that are stamped onto a surface, such as metal or leather, using a punch (a handheld metal implement).

putto (putti) A plump, naked little boy, often winged. In classical art, called a cupid; in Christian art, a cherub.

pylon A massive gateway formed by a pair of tapering walls of oblong shape. Erected by ancient Egyptians to mark the entrance to a temple complex.

qibla The mosque wall oriented toward Mecca indicated by the mihrab.

quatrefoil A four-lobed decorative pattern common in Gothic art and architecture.

quincunx A building in which five **domed** bays are arranged within a square, with a central unit and four corner units. (When the central unit has similar units extending from each side, the form becomes a **Greek cross**.)

quoin A stone, often extra large or decorated for emphasis, forming the corner of two walls. A vertical row of such stones is called quoining.

radiometric dating A method of dating prehistoric works of art made from organic materials, based on the rate of degeneration of radiocarbons in these materials. *See also* **relative dating, absolute dating**.

raigo A painted image that depicts the Amida Buddha and other Buddhist deities welcoming the soul of a dying worshiper to paradise.

raku A type of **ceramic** pottery made by hand, coated with a thick, dark **glaze**, and fired at a low heat. The resulting vessels are irregularly shaped and glazed, and are highly prized for use in the Japanese tea ceremony.

readymade An object from popular or material culture presented without further manipulation as an artwork by the artist.

realism In art, a term first used in Europe around 1850 to designate a kind of **naturalism** with a social or political message, which soon lost its didactic import and became synonymous with naturalism.

red-figure A style and technique of ancient Greek vase painting characterized by red clay-colored figures on a black background. (The figures are reversed against a painted ground and details are drawn, not engraved, as in black-figure style.) See also **black-figure**.

register A device used in systems of spatial definition. In painting, a register indicates the use of differing **groundlines** to differentiate layers of space within an image. In sculpture, the placement of self-contained bands of **reliefs** in a vertical arrangement. In printmaking, the marks at the edges used to align the print correctly on the page, especially in multiple-block color printing.

registration marks In Japanese **woodblock** printing, these were two marks carved on the blocks to indicate proper alignment of the paper during the printing process. In multicolor printing, which used a separate block for each color, these marks were essential for achieving the proper position or registration of the colors.

relative dating See also **radiometric dating**.

relief sculpture A three-dimensional image or design whose flat background surface is carved away to a certain depth, setting off the figure. Called high or **low (bas) relief** depending upon the extent of projection of the image from the background. Called **sunken relief** when the image is carved below the original surface of the background, which is not cut away.

reliquary A container, often made of precious materials, used as a repository to protect and display sacred relics.

repoussé A technique of hammering metal from the back to create a protruding image. Elaborate reliefs are created with wooden armatures against which the metal sheets are pressed and hammered.

reverse perspective See **perspective**.

rhyton A vessel in the shape of a figure or an animal, used for drinking or pouring liquids on special occasions.

rib vault See **vault**.

ridgepole A longitudinal timber at the apex of a roof that supports the upper ends of the rafters.

rosette A round or oval ornament resembling a rose.

rotunda Any building (or part thereof) constructed in a circular (or sometimes polygonal) shape, usually producing a large open space crowned by a **dome**.

round arch See **arch**.

roundel Any element with a circular format, often placed as a decoration on the exterior of architecture.

rune stone A stone used in early medieval northern Europe as a commemorative monument, which is carved or inscribed with runes, a writing system used by early Germanic peoples.

running spirals A decorative motif based on the shape formed by a line making a continuous spiral.

rustication In building, the rough, irregular, and unfinished effect deliberately given to the exterior facing of a stone edifice. Rusticated stones are often large and used for decorative emphasis around doors or windows, or across the entire lower floors of a building. Also, masonry construction with conspicuous, often beveled joints.

salon A large room for entertaining guests; a periodic social or intellectual gathering, often of prominent people; a hall or **gallery** for exhibiting works of art.

sanctuary A sacred or holy enclosure used for worship. In ancient Greece and Rome, consisted of one or more temples and an altar. In Christian architecture, the space around the altar in a church called the chancel or presbytery.

sarcophagus (sarcophagi) A stone coffin. Often rectangular and decorated with **relief sculpture**.

scarab In Egypt, a stylized dung beetle associated with the sun and the god Amun.

scarification Ornamental decoration applied to the surface of the body by cutting the skin for cultural and/or aesthetic reasons.

school of artists An art historical term describing a group of artists, usually working at the same time and sharing similar styles, influences, and ideals. The artists in a particular school may not necessarily be directly associated with one another, unlike those in a workshop or **atelier**.

scribe A writer; a person who copies texts.

scriptorium (scriptoria) A room in a monastery for writing or copying manuscripts.

scroll painting A painting executed on a rolled support. Rollers at each end permit the horizontal scroll to be unrolled as it is studied or the vertical scroll to be hung for contemplation or decoration.

seals Personal emblems usually carved of stone in **intaglio** or **relief** and used to stamp a name or legend onto paper or silk. They traditionally employ the archaic characters appropriately known as "seal script," of the Zhou or Qin. Cut in stone, a seal may state a formal givem name, or it may state any of the numerous personal names that China's painters and writers adopted throughout their lives. A treasured work of art often bears not only the seal of its maker but also those of collectors and admirers through the centuries. In the Chinese view, these do not disfigure the work but add another layer of interest.

seraph (seraphim) An angel of the highest rank in the Christian hierarchy.

serdab In Egyptian tombs, the small room in which the ka statue was placed.

sfumato Italian term meaning "smoky," soft, and mellow. In painting, the effect of haze in an image. Resembling the color of the atmosphere at dusk, sfumato gives a smoky effect.

sgraffito Decoration made by incising or cutting away a surface layer of material to reveal a different color beneath.

shaft The main vertical section of a column between the capital and the base, usually circular in cross section.

shaftgrave A deep pit used for burial.

shikhara In the architecture of northern India, a conical (or pyramidal) spire found atop a Hindu temple and often crowned with an **amalaka**.

shoji A standing Japanese screen covered in translucent rice paper and used in interiors.

sinopia The preparatory design or underdrawing of a **fresco**. Also: a reddish chalklike earth pigment.

site-specific sculpture A sculpture commissioned and/or designed for a particular spot.

slip A mixture of clay and water applied to a **ceramic** object as a final decorative coat. Also: a solution that binds different parts of a vessel together, such as the handle and the main body.

spandrel The area of wall adjoining the exterior curve of an arch between its **springing** and the **keystone**, or the area between two arches, as in an **arcade**.

springing The point at which the curve of an arch or vault meets with and rises from its support.

squinch An **arch** or lintel built across the upper corners of a square space, allowing a circular or polygonal **dome** to be more securely set above the walls.

stained glass Molten glass is given a color that becomes intrinsic to the material. Additional colors may be fused to the surface (flashing). Stained glass is most often used in windows, for which small pieces of differently colored glass are precisely cut and assembled into a design, held together by **cames**. Additional painted details may be added to create images.

stele (stelae) A stone slab placed vertically and decorated with inscriptions or reliefs. Used as a grave marker or memorial.

stereobate A foundation upon which a Classical temple stands.

still life A type of painting that has as its subject inanimate objects (such as food, dishes, fruit, or flowers).

stoa In Greek architecture, a long roofed walkway, usually having columns on one long side and a wall on the other.

stoneware A high-fired, vitrified, but opaque **ceramic** ware that is fired in the range of 1,100 to 1,200 degrees Celsius. At that temperature, particles of silica in the clay bodies fuse together so that the finished vessels are impervious to liquids, even without **glaze**. Stoneware pieces are glazed to enhance their aesthetic appeal and to aid in keeping them clean (since unglazed ceramics are easily soiled). Stoneware occurs in a range of earth-toned colors, from white and tan to gray and black, with light gray predominating. Chinese potters were the first in the world to produce stoneware, which they were able to make as early as the Shang dynasty.

stucco A mixture of lime, sand, and other ingredients into a material that can be easily molded or modeled. When dry, produces a very durable surface used for covering walls or for architectural sculpture and decoration.

stupa In Buddhist architecture, a bell-shaped or pyramidal religious monument, made of piled earth or stone, and containing sacred relics.

stylobate In Classical architecture, the stone foundation on which a temple **colonnade** stands.

stylus An instrument with a pointed end (used for writing and printmaking), which makes a delicate line or scratch. Also: a special writing tool for **cuneiform** writing with one pointed end and one triangular wedge end.

sublime Adjective describing a concept, thing, or state of high spiritual, moral, or intellectual value; or something awe-inspiring. The sublime was a goal to which many nineteenth-century artists aspired in their artworks.

sunken relief See **relief sculpture**.

syncretism In religion or philosophy, the union of different ideas or principles.

taotie A mask with a dragon or animal-like face common as a decorative motif in Chinese art.

tapestry Multicolored pictorial or decorative weaving meant to be hung on a wall or placed on furniture.

tatami Mats of woven straw used in Japanese houses as a floor covering.

tempera A painting medium made by blending egg yolks with water, pigments, and occasionally other materials, such as glue.

tenebrism The use of strong **chiaroscuro** and artificially illuminated areas to create a dramatic contrast of light and dark in a painting.

terra cotta A medium made from clay fired over a low heat and sometimes left unglazed. Also: the orange-brown color typical of this medium.

tessera (tesserae) The small piece of stone, glass, or other object that is pieced together with many others to create a mosaic.

tetrarchy Four-man rule, as in the late Roman Empire, when four emperors shared power.

thatch A roof made of plant materials.

thermo-luminescence dating A technique that measures the irradiation of the crystal structure of material such as flint or pottery and the soil in which it is found, determined by luminescence produced when a sample is heated.

tholos A small, round building. Sometimes built underground, as in a Mycenaean tomb.

thrust The outward pressure caused by the weight of a vault and supported by buttressing. See **arch**.

tierceron In **vault** construction, a secondary rib that arcs from a **springing** point to the rib that runs lengthwise through the vault, called the ridge rib.

tokonoma A niche for the display of an art object (such as a screen, scroll, or flower arrangement) in a Japanese hall or tearoom.

tondo A painting or **relief sculpture** of circular shape.

torana In Indian architecture, an ornamented gateway arch in a temple, usually leading to the stupa.

toron In West African **mosque** architecture, the wooden beams that project from the walls. Torons are used as support for the scaffolding erected annually for the replastering of the building.

tracery Stonework or woodwork applied to wall surfaces or filling the open space of windows. In **plate tracery**, opening are cut through the wall. In **bar tracery**, **mullions** divide the space into vertical segments and form decorative patterns at the top of the opening or panel.

transept The arm of a cruciform church, perpendicular to the **nave**. The point where the nave and transept cross is called the crossing. Beyond the crossing lies the **sanctuary**, whether **apse**, choir, or chevet.

travertine A mineral building material similar to limestone, typically found in central Italy.

trefoil An ornamental design made up of three rounded lobes placed adjacent to one another.

triglyph Rectangular block between the **metopes** of a **Doric frieze**. Identified by the three carved vertical grooves, which approximate the appearance of the end of a wooden beam.

triptych An artwork made up of three panels. The panels may be hinged together so the side segments (**wings**) fold over the central area.

trompe l'oeil A manner of representation in which the appearance of natural space and objects is re-created with the express intention of fooling the eye of the viewer, who may be convinced that the subject actually exists as three-dimensional reality.

trumeau A column, pier, or post found at the center of a large portal or doorway, supporting the lintel.

tugra A calligraphic imperial monogram used in Ottoman courts.

Tuscan order See **order**.

twisted perspective A convention in art in which every aspect of a body or object is represented from its most characteristic viewpoint.

ukiyo-e A Japanese term for a type of popular art that was favored from the sixteenth century, particularly in the form of color **woodblock prints**. Ukiyo-e prints often depicted the world of the common people in Japan, such as courtesans and actors, as well as landscapes and myths.

urna In Buddhist art, the curl of hair on the forehead that is a characteristic mark of a buddha. The urna is a symbol of divine wisdom.

ushnisha In Asian art, a round turban or tiara symbolizing royalty and, when worn by a buddha, enlightenment.

vanishing point In a **perspective** system, the point on the horizon line at which **orthogonals** meet. A complex system can have multiple vanishing points.

vanitas An image, especially popular in Europe during the seventeenth century, in which all the objects symbolize the transience of life. Vanitas paintings are usually of **still lifes** or **genre** subjects.

vault An **arched** masonry structure that spans an interior space. Barrel or tunnel vault: an elongated or continuous semicircular vault, shaped like a half-cylinder. **Corbeled** vault: a vault made by projecting courses of stone. **Groin** or cross vault: a vault created by the intersection of two barrel vaults of equal size which creates four side compartments of identical size and shape. Quadrant or half-barrel vault: as the name suggests, a half-barrel vault. Rib vault: ribs (extra masonry) demarcate the junctions of a groin vault. Ribs may function to reinforce the groins or may be purely decorative. See also **corbeling**.

veduta (vedute) Italian for "vista" or "view."

Paintings, drawings, or prints often of expansive city scenes or of harbors.

vellum A fine animal skin prepared for writing and painting. See also parchment.

veneer In architecture, the exterior facing of a building, often in decorative patterns of fine stone or brick. In decorative arts, a thin exterior layer of finer material (such as rare wood, ivory, metal, and semiprecious stones) laid over the form.

verism A style in which artists concern themselves with capturing the exterior likeness of an object or person, usually by rendering its visible details in a finely executed, meticulous manner.

vihara From the Sanskrit term meaning "for wanderers." A vihara is, in general, a Buddhist monastery in India. It also signifies monks' cells and gathering places in such a monastery.

vimana The main element of a Southern Indian Hindu temple, usually in the shape of a pyramidal or tapering tower raised on a **plinth**.

volute A spiral scroll, as seen on an Ionic **capital**.

votive figure An image created as a devotional offering to a god or other deity.

voussoirs The oblong, wedge-shaped stone blocks used to build an **arch**. The topmost voussoir is called a **keystone**.

warp The vertical threads in a weaver's loom. Warp threads make up a fixed framework that provides the structure for the entire piece of cloth, and are thus often thicker than **weft** threads. See also **weft**.

wash A diluted watercolor or ink. Often washes are applied to drawings or prints to add tone or touches of color.

wattle and daub A wall construction method combining upright branches, woven with twigs (wattles) and plastered or filled with clay or mud (daub).

weft The horizontal threads in a woven piece of cloth. Weft threads are woven at right angles to and through the **warp** threads to make up the bulk of the decorative pattern. In carpets, the weft is often completely covered or formed by the rows of trimmed knots that form the carpet's soft surface. See also **warp**.

white-ground A type of ancient Greek pottery in which the background color of the object is painted with a slip that turns white in the firing process. Figures and details were added by painting on or **incising** into this **slip**. White-ground wares were popular in the Classical period as funerary objects.

wing A side panel of a **triptych** or **polyptych** (usually found in pairs), which was hinged to fold over the central panel. Wings often held the depiction of the donors and/or subsidiary scenes relating to the central image.

woodblock print A print made from one or more carved wooden blocks. In Japan, woodblock prints were made using multiple blocks carved in relief, usually with a block for each color in the finished print. See also **woodcut**.

woodcut A type of print made by carving a design into a wooden block. The ink is applied to the block with a roller. As the ink remains only on the raised areas between the carved-away lines, these carved-away areas and lines provide the white areas of the print. Also: the process by which the woodcut is made.

x-ray style In Aboriginal art, a manner of representation in which the artist depicts a figure or animal by illustrating its outline as well as essential internal organs and bones.

yaksha, yakshi The male (yaksha) and female (yakshi) nature spirits that act as agents of the Hindu gods. Their sculpted images are often found on Hindu temples and other sacred places, particularly at the entrances.

ziggurat In Mesopotamia, a tall stepped tower of earthen materials, often supporting a shrine.

BIBLIOGRAPHY

Susan V. Craig

This bibliography is composed of books in English that are appropriate "further reading" titles. Most items on this list are available in good libraries, whether college, university, or public institutions. I have emphasized recently published works so that the research information would be current. There are three classifications of listings: general surveys and art history reference tools, including journals and Internet directories; surveys of large periods that encompass multiple chapters (ancient art in the Western tradition, European medieval art, European Renaissance through eighteenth-century art, modern art in the West, Asian art, and African and Oceanic art and art of the Americas); and books for individual chapters 1 through 32.

General Art History Surveys and Reference Tools

Adams, Laurie Schneider. *Art across Time*. 2nd ed. New York: McGraw-Hill, 2002.

Barnet, Sylvan. *A Short Guide to Writing about Art*. 8th ed. New York: Pearson/Longman, 2005.

Boströöm, Antonia. *Encyclopedia of Sculpture*. 3 vols. New York: FitzroyDearborn, 2004.

Broude, Norma, and Garrard, Mary D., eds. *Feminism and Art History: Questioning the Litany*. Icon Editions. New York: Harper & Row, 1982.

Chadwick, Whitney. *Women, Art, and Society*. 3rd ed. New York: Thames and Hudson, 2002.

Chilvers, Ian, ed. *The Oxford Dictionary of Art*. 3rd ed. New York: Oxford Univ. Press, 2004.

Curl, James Stevens. *A Dictionary of Architecture and Landscape Architecture*. 2nd ed. Oxford: Oxford Univ. Press, 2006.

Davies, Penelope J.E., et al. *Janson's History of Art: The Western Tradition*. 7th ed. Upper Saddle River, NJ: Prentice Hall, 2006.

Dictionary of Art, The. 34 vols. New York: Grove's Dictionaries, 1996.

Encyclopedia of World Art. 16 vols. New York: McGraw-Hill, 1972–83.

Frank, Patrick, Duane Preble, and Sarah Preble. *Preble's Artforms*. 8th ed. Upper Saddle River, NJ: Prentice Hall, 2006.

Gardner, Helen. *Gardner's Art through the Ages*. 12th ed. Ed. Fred S. Kleiner & Christin J. Mamiya. Belmont, CA: Thomson/Wadsworth, 2005.

Gaze, Delia, ed. *Dictionary of Women Artists*. 2 vols. London: Fitzroy Dearborn Publishers, 1997.

Griffiths, Antony. *Prints and Printmaking: An Introduction to the History and Techniques*. 2nd ed. London: British Museum Press, 1996.

Hadden, Peggy. *The Quotable Artist*. New York: Allworth Press, 2002.

Hall, James. *Illustrated Dictionary of Symbols in Eastern and Western Art*. New York: Icon Editions, 1994.

Holt, Elizabeth Gilmore, ed. *A Documentary History of Art*. 3 vols. New Haven: Yale Univ. Press, 1986.

Honour, Hugh, and John Fleming. *The Visual Arts: A History*. 7th ed. Upper Saddle River, NJ: Prentice Hall, 2005.

Hults, Linda C. *The Print in the Western World: An Introductory History*. Madison: Univ. of Wisconsin Press, 1996.

Johnson, Paul. *Art: A New History*. New York: Harper-Collins, 2003.

Kaltenbach. G. E. *Pronunciation Dictionary of Artists' Names*. 3rd ed. Rev. Debra Edelstein. Boston: Little, Brown, and Co., 1993.

Kemp, Martin. *The Oxford History of Western Art*. Oxford: Oxford Univ. Press, 2000.

Kostof, Spiro. *A History of Architecture: Settings and Rituals*. 2nd ed. Rev. Greg Castillo. New York: Oxford Univ. Press, 1995.

Mackenzie, Lynn. *Non-Western Art: A Brief Guide*. 2nd ed. Upper Saddle River, NJ: Prentice Hall, 2001.

Marmor, Max, and Alex Ross, eds. *Guide to the Literature of Art History 2*. Chicago: American Library Association, 2005.

Onians, John, ed. *Atlas of World Art*. New York: Oxford Univ. Press, 2004.

Roberts, Helene, ed. *Encyclopedia of Comparative Iconography: Themes Depicted in Works of Art*. 2 vols. Chicago: Fitzroy Dearborn, 1998.

Rogers, Elizabeth Barlow. *Landscape Design: A Cultural and Architectural History*. New York: Harry N. Abrams, 2001.

Sayre, Henry M. *Writing about Art*. 5th ed. Upper Saddle River, NJ: Pearson/Prentice Hall, 2006.

Sed-Rajna, Gabrielle. *Jewish Art*. Trans. Sara Friedman and Mira Reich. New York: Abrams, 1997.

Slatkin, Wendy. *Women Artists in History: From Antiquity to the Present*. 4th ed. Upper Saddle River, NJ: Prentice Hall, 2000.

Sutton, Ian. *Western Architecture: From Ancient Greece to the Present*. World of Art. New York: Thames and Hudson, 1999.

Trachtenberg, Marvin, and Isabelle Hyman. *Architecture: From Prehistory to Postmodernity*. 2nd ed. Upper Saddle River, NJ: Prentice Hall, 2001.

Tufts, Eleanor. *Our Hidden Heritage: Five Centuries of Women Artists*. New York: Paddington Press, 1974.

West, Shearer. *Portraiture*. Oxford History of Art. Oxford: Oxford Univ. Press, 2004.

Wilkins, David G., Bernard Schultz, and Katheryn M. Linduff. *Art Past, Art Present*. 5th ed. Upper Saddle River, NJ: Prentice Hall, 2005.

Watkin, David. *A History of Western Architecture*. 4th ed. New York: Watson-Guptill Publications, 2005.

Art History Journals: A Select List of Current Titles

African Arts. Quarterly. Los Angeles: Univ. of California at Los Angeles, James S. Coleman African Studies Center, 1967–

American Art: The Journal of the Smithsonian American Art Museum. 3/year. Chicago: Univ. of Chicago Press, 1987–

American Indian Art Magazine, Quarterly. Scottsdale, AZ: American Indian Art Inc, 1975–

American Journal of Archaeology. Quarterly. Boston: Archaeological Institute of America, 1885–

Antiquity: A Periodical of Archaeology. Quarterly. Cambridge, UK: Antiquity Publications Ltd, 1927–

Apollo: The International Magazine of the Arts. Monthly. London: Apollo Magazine Ltd, 1925–

Architectural History. Annually. Farnham, UK: Society of Architectural Historians of Great Britain, 1958–

Archives of American Art Journal. Quarterly. Washington, D.C.: Archives of American Art, Smithsonian Institution, 1960–

Archives of Asian Art. Annually. New York: Asia Society, 1945–

Ars Orientalis: The Arts of Asia, Southeast Asia, and Islam. Annually. Ann Arbor: Univ. of Michigan Dept. of Art History, 1954–

Art Bulletin. Quarterly. New York: College Art Association, 1913–

Art History: Journal of the Association of Art Historians. 5/year. Oxford: Blackwell Publishing Ltd, 1978–

Art in America. Monthly. New York: Brant Publications Inc, 1913–

Art Journal. Quarterly. New York: College Art Association, 1960–

Art Nexus. Quarterly. Bogata, Colombia: Arte en Colombia Ltda, 1976–

Art Papers Magazine. Bi-monthly. Atlanta: Atlanta Art Papers Inc, 1976–

Artforum International. 10/year. New York: Artforum International Magazine Inc, 1962–

Artnews. 11/year. New York: Artnews LLC, 1902–

Bulletin of the Metropolitan Museum of Art. Quarterly. New York: Metropolitan Museum of Art, 1905–.

Burlington Magazine. Monthly. London: Burlington Magazine Publications Ltd, 1903–

Dumbarton Oaks Papers. Annually. Locust Valley, NY: J. J. Augustin Inc, 1940–

Flash Art International. Bimonthly. Trevi, Italy: Giancarlo Politi Editore, 1980–

Gesta. Semiannually. New York: International Center of Medieval Art, 1963–

History of Photography. Quarterly. Abingdon, UK: Taylor & Francis Ltd, 1976–

International Review of African American Art. Quarterly. Hampton, VA: International Review of African American Art, 1976–

Journal of Design History. Quarterly. Oxford: Oxford Univ. Press, 1988–

Journal of Egyptian Archaeology. Annually. London: Egypt Exploration Society, 1914–

Journal of Hellenic Studies. Annually. London: Society for the Promotion of Hellenic Studies, 1880–

Journal of Roman Archaeology. Annually. Portsmouth, RI: Journal of Roman Archaeology LLC, 1988–

Journal of the Society of Architectural Historians. Quarterly. Chicago: Society of Architectural Historians, 1940–

Journal of the Warburg and Courtauld Institutes. Annually. London: Warburg Institute, 1937–

Leonardo: Art, Science and Technology. 6/year. Cambridge, MA: MIT Press, 1968–

Marg. Quarterly. Mumbai, India: Scientific Publishers, 1946–

Master Drawings. Quarterly. New York: Master Drawings Association, 1963–

October. Cambridge, MA: MIT Press, 1976–

Oxford Art Journal. 3/year. Oxford: Oxford Univ. Press, 1978–

Parkett. 3/year. Züürich, Switzerland: Parkett Verlag AG, 1984–

Print Quarterly. Quarterly. London: Print Quarterly Publications, 1984–

Similous: Netherlands Quarterly for the History of Art. Quarterly. Apeldoorn, Netherlands: Stichting voor Nederlandse Kunsthistorische Publicaties, 1966–

Woman's Art Journal. Semiannually. Philadelphia: Old City Publishing Inc, 1980–

Internet Directories for Art History Information

ARCHITECTURE AND BUILDING
http://library.nevada.edu/arch/rsrce/webrsrce/contents.html

A directory of architecture websites collected by Jeanne Brown at the Univ. of Nevada at Las Vegas. Topical lists include architecture, building and construction, design, history, housing, planning, preservation, and landscape architecture. Most entries include a brief annotation and the last date the link was accessed by the compiler.

ART HISTORY RESOURCES ON THE WEB
http://witcombe.sbc.edu/ARTHLinks.html

Authored by Christopher L. C. E. Witcombe of Sweet Briar College in Virginia since 1995, the site includes an impressive number of links for various art historical eras as well as links to research resources, museums, and galleries. The content is frequently updated.

ART IN FLUX: A DIRECTORY OF RESOURCES FOR RESEARCH IN CONTEMPORARY ART
http://www.boisestate.edu/art/artinflux/intro.html

Cheryl K. Shutleff of Boise State Univ. in Idaho has authored this directory, which includes sites selected according to their relevance to the study of national or international contemporary art and artists. The subsections include artists, museums, theory, reference, and links.

ARTCYCLOPEDIA: THE FINE ARTS SEARCH ENGINE
With over 2,100 art sites and 75,000 links, this is one of the most comprehensive web directories for artists and art topics.
The primary searching is by artist's name but access is also available by artistic movement, nation, timeline and medium.

MOTHER OF ALL ART HISTORY LINKS PAGES
http://www.art-design.umich.edu/mother/
Maintained by the Dept. of the History of Art at the Univ. of Michigan, this directory covers art history departments, art museums, fine arts schools and departments as well as links to research resources. Each entry includes annotations.

VOICE OF THE SHUTTLE
http://vos.ucsb.edu
Sponsored by Univ. of California, Santa Barbara, this directory includes over 70 pages of links to humanities

and humanities-related resources on the Internet. The structured guide includes specific sub-sections on architecture, on art (modern & contemporary), and on art history. Links usually include a one sentence explanation and the resource is frequently updated with new information.

YAHOO! ARTS>ART HISTORY
http://dir.yahoo.com/Arts/Art_History/
Another extensive directory of art links organized into subdivisions with one of the most extensive being "Periods and Movements." Links include the name of the site as well as a few words of explanation.

European Medieval Art, General

Backman, Clifford R. *The Worlds of Medieval Europe*. New York: Oxford Univ. Press, 2003.

Bennett, Adelaide Louise, et al. *Medieval Mastery: Book Illumination from Charlemagne to Charles the Bold: 800-1475*. Trans. Lee Preedy and Greta Arblaster-Holmer. Turnhout: Brepols, 2002.

Benton, Janetta Rebold. *Art of the Middle Ages. World of Art*. New York: Thames & Hudson, 2002.

Binski, Paul. *Painters*. Medieval Craftsmen. London: British Museum Press, 1992.

Brown, Sarah, and David O'Connor. *Glass-painters*. Medieval Craftsmen. London: British Museum Press, 1992.

Calkins, Robert C. *Medieval Architecture in Western Europe: From A.D. 300 to 1500*. 1v. CD-ROM. New York: Oxford Univ. Press, 1998.

Cherry, John F. *Goldsmiths*. Medieval Craftsmen. London: British Museum Press, 1992.

Clark, William W., *Medieval Cathedrals*. Greenwood Guides to Historic Events of the Medieval World. Westport, CT: Greenwood Press, 2006.

Coldstream, Nicola. *Masons and Sculptors*. Medieval Craftsmen. London: British Museum Press, 1991.

———. *Medieval Architecture*. Oxford History of Art. Oxford: Oxford Univ. Press, 2002.

De Hamel, Christopher. *Scribes and Illuminators*. Medieval Craftsmen. London: British Museum Press, 1992.

Duby, Georges. *Art and Society in the Middle Ages*. Trans. Jean Birrell. Malden, MA: Blackwell Publishers, 2000.

———. *Sculpture: The Great Art of the Middle Ages from the Fifth to the Fifteenth Century*. New York: Skira/Rizzoli, 1990.

Eames, Elizabeth S. *English Tilers*. Medieval Craftsmen. London: British Museum Press, 1992.

Fossier, Robert, ed. *The Cambridge Illustrated History of the Middle Ages*. Trans. Janet Sondheimer & Sarah Hanbury Tenison. 3 vols. Cambridge, U.K.: Cambridge Univ. Press, 1986–97.

Hurlimann, Martin, and Jean Bony. *French Cathedrals*. Rev. & enlg. London: Thames and Hudson, 1967.

Jotischky, Andrew, and Caroline Susan Hull. *The Penguin Historical Atlas of the Medieval World*. New York: Penguin, 2005.

Kenyon, John. *Medieval Fortifications*. Leicester: Leicester Univ. Press, 1990.

Labarge, Margaret Wade. *A Small Sound of the Trumpet: Women in Medieval Life*. London: Hamilton, 1990.

Pfaffenbichler, Matthias. *Armourers*. Medieval Craftsmen. London: British Museum Press, 1992.

Rebold Benton, Janetta. *Art of the Middle Ages. World of Art*. New York: Thames & Hudson, 2002.

Sekules, Veronica. *Medieval Art*. Oxford History of Art. New York: Oxford Univ. Press, 2001.

Snyder, James, Henry Luttikhuizen, and Dorothy Verkerk. *Art of the Middle Ages*. 2nd ed. Upper Saddle River, NJ: Prentice Hall, 2006.

Staniland, Kay. *Embroiderers*. Medieval Craftsmen. London: British Museum Press, 1991.

Stokstad, Marilyn. *Medieval Art*. 2nd ed. New York: Westview, 2004.

———. *Medieval Castles*. Greenwood Guides to Historic Events of the Medieval World. Westport, CT: Greenwood Press, 2005.

Wixom, William D., ed. *Mirror of the Medieval World*. New York: Metropolitan Museum of Art, 1999.

CHAPTER 7
Jewish, Early Christian, and Byzantine Art

Age of Spirituality: Late Antique and Early Christian Art, Third to Seventh Century. New York: Metropolitan Museum of Art, 1979.

Beckwith, John. *The Art of Constantinople: An Introduction to Byzantine Art 330–1453*. 2nd ed. London: Phaidon, 1968.

———. *Early Christian and Byzantine Art*. 2nd ed. Pelican History of Art. Harmondsworth, UK: Penguin, 1979.

Carr, Annemarie Weyl. *Byzantine Illumination, 1150–1250: The Study of a Provincial Tradition*. Chicago: Univ. of Chicago Press, 1987.

Cioffarelli, Ada. *Guide to the Catacombs of Rome and Its Surroundings*. Rome: Bonsignori, 2000.

Cormack, Robin. *Byzantine Art*. Oxford History of Art. Oxford: Oxford Univ. Press, 2000.

Cutler, Anthony. *The Hand of the Master: Craftsmanship, Ivory, and Society in Byzantium (9th–11th Centuries)*. Princeton: Princeton Univ. Press, 1994.

Demus, Otto. *The Mosaic Decoration of San Marco, Venice*. Ed. Herbert L. Kessler. Chicago: Univ. of Chicago Press, 1988.

Durand, Jannic. *Byzantine Art*. Paris: Terrail, 1999.

Eastmond, Antony, and Liz James, ed. *Icon and Word: The Power of Images in Byzantium: Studies Presented to Robin Cormack*. Burlington, VT: Ashgate, 2003.

Evans, Helen C., ed. *Byzantium: Faith and Power (1261-1557)*. New York: Metropolitan Museum of Art, 2004.

———, and William D. Wixom, eds. *The Glory of Byzantium: Art and Culture of the Middle Byzantine era, A.D. 843-1261*. New York: Abrams, 1997.

Fine, Steven. *Art and Judaism in the Greco-Roman World: Toward a New Jewish Archaeology*. New York: Cambridge Univ. Press, 2005.

Gerstel, Sharon E. J. *Beholding the Sacred Mysteries: Programs of the Byzantine Sanctuary*. Monograph on the Fine Arts, 56. Seattle: Published by College Art Association in assoc. with Univ. of Washington Press, 1999.

Grabar, Andrée. *Byzantine Painting: Historical and Critical Study*. Trans. Stuart Gilbert. New York: Rizzoli, 1979.

Jensen, Robin Margaret. *Understanding Early Christian Art*. New York: Routledge, 2000.

Kitzinger, Ernst. *Byzantine Art in the Making: Main Lines of Stylistic Development in Mediterranean Art, 3rd–7th Century*. Cambridge, MA: Harvard Univ. Press, 1977.

Krautheimer, Richard, and Slobodan Curcic. *Early Christian and Byzantine Architecture*. 4th ed. Pelican History of Art. New Haven: Yale Univ. Press, 1992.

Levine, Lee I. and Zeev Weiss, eds. *From Dura to Sepphoris: Studies in Jewish Art and Society in Late Antiquity*. Journal of Roman Archaeology: Supplementary Series, no. 40. Portsmouth, R.I.: Journal of Roman Archaeology, 2000.

Lowden, John. *Early Christian and Byzantine Art*. Art & Ideas. London: Phaidon, 1997.

Maguire, Henry. *The Icons of Their Bodies: Saints and their Images in Byzantium*. Princeton: Princeton Univ. Press, 1996.

Mainstone, R. J. *Hagia Sophia: Architecture, Structure and Liturgy of Justinian's Great Church*. London: Thames and Hudson, 1988.

Mango, Cyril. *Art of the Byzantine Empire, 312–1453: Sources and Documents*. Upper Saddle River, NJ: Prentice Hall, 1972.

Mathew, Gervase. *Byzantine Aesthetics*. London: J. Murray, 1963.

Mathews, Thomas P. *Byzantium: From Antiquity to the Renaissance*. Perspectives. New York: Abrams, 1998.

———. *The Clash of Gods: A Reinterpretation of Early Christian Art*. Rev. & exp. ed. Princeton: Princeton Univ. Press, 1999.

Milburn, R. L. P. *Early Christian Art and Architecture*. Berkeley: Univ. of California Press, 1988.

Olin, Margaret. *The Nation without Art: Examining Modern Discourses on Jewish Art*. Lincoln: Univ. of Nebraska Press, 2001.

Olsson, Birger and Magnus Zetterholm, eds. *The Ancient Synagogue from Its Origins until 200 C.E.: Papers Presented at an International Conference at Lund University, October 14-17, 2001*. Coniectanea Biblica: New Testament Series, 39. Stockholm: Almqvist & Wiksell International, 2003.

Ousterhout, Robert. *Master Builders of Byzantium*. Princeton: Princeton Univ. Press, 1999.

Rodley, Lyn. *Byzantine Art and Architecture: An Introduction*. Cambridge, U.K.: Cambridge Univ. Press, 1994.

Rutgers, Leonard Victor. *Subterranean Rome: In Search of the Roots of Christianity in the Catacombs of the Eternal City*. Leuven: Peeters, 2000.

Tadgell, Christopher. *Imperial Space: Rome, Constantinople and the Early Church*. New York: Whitney Library of Design, 1998.

Teteriatnikov, Natalia. *Mosaics of Hagia Sophia, Istanbul: The Fossati Restoration and the Work of the Byzantine Institute*. Washington, D.C.: Dumbarton Oaks Research Library and Collection, 1998.

Tronzo, William. *The Cultures of his Kingdom: Roger II and the Cappella Palatina in Palermo*. Princeton: Princeton Univ. Press, 1997.

Vio, Ettore. *St. Mark's: The Art and Architecture of Church and State in Venice*. New York: Riverside Book Co., 2003.

Webb, Matilda. *The Churches and Catacombs of Early Christian Rome: A Comprehensive Guide*. Brighton, UK: Sussex Academic Press, 2001.

Weitzmann, Kurt. *Late Antique and Early Christian Book Illumination*. New York: Braziller, 1977.

———. *Place of Book Illumination in Byzantine Art*. Princeton: Art Museum, Princeton Univ., 1975.

Wharton, Annabel Jane. *Refiguring the Post Classical City: Dura Europe, Jerash, Jerusalem and Ravenna*. New York: Cambridge Univ. Press, 1995.

White, L. Michael. *The Social Origins of Christian Architecture*. 2 vols. Baltimore: Johns Hopkins Univ. Press, 1990.

CHAPTER 8
Islamic Art

Al-Faruqi, Ismail R., and Lois Lamya'al Faruqi. *Cultural Atlas of Islam*. New York: Macmillan, 1986.

Atasoy, Nurhan. *Splendors of the Ottoman Sultans*. Ed. and Trans. Tulay Artan. Memphis, TN: Lithograph, 1992.

Atil, Esin. *The Age of Sultan Suleyman the Magnificent*. Washington, D.C.: National Gallery of Art, 1987.

Baer, Eva. *Islamic Ornament*. New York: New York Univ. Press, 1998.

Baker, Patricia L. *Islam and the Religious Arts*. New York: Continuum, 2004.

Barry, Michael. *Figurative Art in Medieval Islam and the Riddle of Bihzââd of Herâât (1465-1535)*. Paris: Flammarion, 2004.

Blair, Sheila S., and Jonathan Bloom. *The Art and Architecture of Islam 1250–1800*. Pelican History of Art. New Haven: Yale Univ. Press, 1994.

Carboni, Stefano, and David Whitehouse. *Glass of the Sultans*. New York: Metropolitan Museum of Art, 2001.

Denny, Walter B. *Iznik: The Artistry of Ottoman Ceramics*. New York: Thames & Hudson, 2004.

Dodds, Jerrilynn D., ed. al-Andalus: The Art of Islamic Spain. New York: Metropolitan Museum of Art, 1992.

Ecker, Heather. *Caliphs and Kings: The Art and Influence of Islamic Spain*. Washington, D.C.: Arthur M. Sackler Gallery, Smithsonian Institution, 2004.

Ettinghausen, Richard, Oleg Grabar, and Marilyn Jenkins-Madina. *Islamic Art and Architecture, 650–1250*. 2nd ed. Yale Univ. Press Pelican History of Art. New Haven: Yale Univ. Press, 2001. Reissue ed. 2003.

Frishman, Martin, and Hasan-Uddin Khan. *The Mosque: History, Architectural Development and Regional Diversity*. London: Thames and Hudson, 1994.

Grabar, Oleg. *The Formation of Islamic Art*. Rev. ed. New Haven: Yale Univ. Press, 1987.

———. *The Great Mosque of Isfahan*. New York: New York Univ. Press, 1990.

———. *Mostly Miniatures: An Introduction to Persian Painting*. Princeton: Princeton Univ. Press, 2000.

———, Mohammad al-Asad, Abeer Audeh, and Said Nuseibeh. *The Shape of the Holy; Early Islamic Jerusalem*. Princeton: Princeton Univ. Press, 1996.

Hillenbrand, Robert. *Islamic Art and Architecture*. World of Art. London: Thames and Hudson, 1999.

Irwin, Robert. *The Alhambra*. Cambridge, MA: Harvard Univ. Press, 2004.

Khatibi, Abdelkebir, and Mohammed Sijelmassi. *The Splendour of Islamic Calligraphy*. Rev. & exp. ed. New York: Thames and Hudson, 1996.

Komaroff, Linda, and Stefano Carboni, eds. *The Legacy of Genghis Khan: Courtly Art and Culture in Western Asia, 1256- 1353*. New York: Metropolitan Museum of Art, 2002.

Lentz, Thomas W., and Glenn D. Lowry. *Timur and the Princely Vision: Persian Art and Culture in the Fifteenth Century*. Los Angeles: Los Angeles County Museum of Art, 1989.

Necipo lu, Güülru. *The Age of Sinan: Architectural Culture in the Ottoman Empire*. Princeton: Princeton Univ. Press, 2005.

Petruccioli, Attilio, and Khalil K. Pirani, eds. *Understanding Islamic Architecture*. New York: Routledge Curzon, 2002.

Roxburgh, David J., ed. *Turks: A Journey of a Thousand Years, 600-1600*. London: Royal Academy of Arts, 2005.

Sims, Eleanor, Boris I. Marshak, and Ernest J. Grube. *Peerless Images: Persian Painting and Its Sources*. New Haven: Yale Univ. Press, 2002.

Stanley, Tim, Mariam Rosser-Owen, and Stephen Vernoit. *Palace and Mosque: Islamic Art from the Middle East*. London: V & A Publications, 2004.

Steele, James. *An Architecture for People: The Complete Works of Hassan Fathy*. New York: Whitney Library of Design, 1997.

Stierlin, Henri. *Islamic Art and Architecture: From Isfahan to the Taj Mahal*. New York: Thames & Hudson, 2002.

Suhrawardy, Shahid. *The Art of the Mussulmans in Spain*. New York: Oxford Univ. Press, 2005.

Tadgell, Christopher. *Four Caliphates: The Formation and Development of the Islamic Tradition*. London: Ellipsis, 1998.

Ward, R. M. *Islamic Metalwork*. New York: Thames and Hudson, 1993.

Watson, Oliver. *Ceramics from Islamic Lands*. New York: Thames & Hudson in assoc. with the al-Sabah Collection, Dar al-Athar al-Islamiyyah, Kuwait National Museum, 2004.

CHAPTER 14
Early Medieval Art in Europe

Alexander, J. J. G. *Medieval Illuminators and Their Methods of Work*. New Haven: Yale Univ. Press, 1992.

The Art of Medieval Spain, A.D. 500–1200. New York: Metropolitan Museum of Art, 1993.

Backhouse, Janet, D. H. Turner, and Leslie Webster. *The Golden Age of Anglo-Saxon Art, 966–1066*. Bloomington: Indiana Univ. Press, 1984.

Bandman, Gunter. *Early Medieval Architecture as Bearer of Meaning*. New York: Columbia Univ. Press, 2005.

Beckwith, John. *Early Medieval Art: Carolingian, Ottonian, Romanesque*. World of Art. New York: Oxford Univ. Press, 1974.

Calkins, Robert G. *Illuminated Books of the Medieval Ages*. Ithaca, NY: Cornell Univ. Press, 1983.

Carver, Martin. *Sutton Hoo: A Seventh-Century Princely Burial Ground and Its Context*. London: British Museum Press, 2005.

Davis-Weyer, Caecilia. *Early Medieval Art, 300–1150: Sources and Documents*. Upper Saddle River, NJ: Prentice Hall, l971.

Diebold, William J. *Word and Image: An Introduction to Early Medieval Art*. Boulder, CO: Westview Press, 2000.

Dodwell, C. R. *Pictorial Arts of the West 800–1200*. Yale Univ. Press Pelican History of Art. New Haven: Yale Univ. Press, 1993.

Farr, Carol. *The Book of Kells: Its Function and Audience*. London: British Library, 1997.

Fernie, E. C. *The Architecture of the Anglo-Saxons*. London: Batsford, 1983.

Fitzhugh, William W., and Elisabeth I. Ward, eds. *Vikings: The North Atlantic Saga*. Washington, D.C.: Smithsonian Institution Press, 2000.

Harbison. Peter. *The Golden Age of Irish Art: The Medieval Achievement, 600–1200*. London: Thames and Hudson, 1998.

Henderson, George. *From Durrow to Kells: The Insular Gospel-Books, 650–800*. London: Thames and Hudson, 1987.

Horn, Walter W., and Ernest Born. *Plan of Saint Gall: A Study of the Architecture and Economy of and Life in a Paradigmatic Carolingian Monastery*. California Studies in the History of Art, 19. 3 vols. Berkeley: Univ. of California Press, 1979.

Lasko, Peter. *Ars Sacra, 800–1200*. 2nd ed. Pelican History of Art. New Haven: Yale Univ. Press, 1994.

McClendon, Charles B. *The Origins of Medieval Architecture: Building in Europe, A.D 600-900*. New Haven: Yale Univ. Press, 2005.

Mayr-Harting, Henry. *Ottoman Book Illumination: An Historical Study*. 2nd rev. ed. 2 vols. London: Harvey Miller, 1999.

Mentréé, Mireille. *Illuminated Manuscripts of Medieval Spain*. New York: Thames and Hudson, 1996.

Nees, Lawrence. *Early Medieval Art*. Oxford History of Art. Oxford: Oxford Univ. Press, 2002.

Nordenfalk, Carl Adam Johan. *Early Medieval Book Illumination*. New York: Rizzoli, 1988.

Richardson, Hilary, and John Scarry. *An Introduction to Irish High Crosses*. Dublin: Mercier, 1990.

Stalley, R. A. *Early Medieval Architecture*. Oxford History of Art. Oxford: Oxford Univ. Press, 1999.

Wickham, Chris. *Framing the Early Middle Ages: Europe and the Mediterranean 400-800*. New York: Oxford Univ. Press, 2005.

Williams, John, ed. *Imaging the Early Medieval Bible*. The Penn State Series in the History of the Book. University Park: Pennsylvania State Univ. Press, 1999.

Wilson, David M. *Anglo-Saxon Art: From the Seventh Century to the Norman Conquest*. London: Thames and Hudson, 1984.

——, and Ole Klindt-Jensen. *Viking Art*. 2nd ed. Minneapolis: Univ. of Minnesota Press, 1980.

CHAPTER 15
Romanesque Art

Armi, C. Edson. *Design and Construction in Romanesque Architecture: First Romanesque Architecture and the Pointed Arch in Burgundy and Northern Italy*. New York: Cambridge Univ. Press, 2004.

Barral i Altet, Xavier. *The Romanesque: Towns, Cathedrals and Monasteries. Taschen's World Architecture*. New York: Taschen, 1998.

Cahn, Walter. *Romanesque Manuscripts: The Twelfth Century*. A Survey of Manuscripts Illuminated in France. 2 vols. London: H. Miller, 1996.

"Cloister Symposium, 1972" in *Gesta*, v.12 #1/2, 1973, pgs. v-132.

Davis-Weyer, Caecilia. *Early Medieval Art, 300–1150*. Sources and Documents. Upper Saddle River, NJ: Prentice Hall, 1971.

Dimier, Anselme. *Stones Laid before the Lord: A History of Monastic Architecture*. Trans. Gilchrist Lavigne. Cistercian Studies Series, no. 152. Kalamazoo, MI: Cistercian Publications, 1999.

Evans, Joan. *Cluniac Art of the Romanesque Period*. Cambridge, U.K.: Cambridge Univ. Press, 1950.

Fergusson, Peter. *Architecture of Solitude: Cistercian Abbeys in Twelfth-Century England*. Princeton: Princeton Univ. Press, 1984.

Forsyth, Ilene H. *The Throne of Wisdom: Wood Sculptures of the Madonna in Romanesque France*. Princeton: Princeton Univ. Press, 1972.

Gaud, Henri, and Jean-Franççois Leroux-Dhuys. *Cistercian Abbeys: History and Architecture*. Kööln: Köönnemann, 1998

Hawthorne, John G. and Cyril S. Smith, eds. *On Divers Arts: The Treatise of Theophilus*. New York: Dover Press, 1979.

Hearn, M. F. *Romanesque Sculpture: The Revival of Monumental Stone Sculptures in the Eleventh and Twelfth Centuries*. Ithaca, NY: Cornell Univ. Press, 1981.

Hicks, Carola. *The Bayeux Tapestry: The Life Story of a Masterpiece*. London: Chatto & Windus, 2006

Kubach, Hans Erich. *Romanesque Architecture*. History of World Architecture. New York: Electa/Rizzoli, 1988.

Mââle, Emile. *Religious Art in France, the Twelfth Century: A Study of the Origins of Medieval Iconography*. Bollingen Series. Princeton: Princeton Univ. Press, 1978.

Minne-Sèève, Viviane, and Hervéé Kergall. *Romanesque and Gothic France: Architecture and Sculpture*. Trans. Jack Hawkes & Lory Frankel. New York: Harry N. Abrams, 2000.

O'Neill, John Philip, ed. *Enamels of Limoges: 1100-1350*. Trans. Sophie Hawkes, Joachim Neugroschel, & Patricia Stirneman. New York: Metropolitan Museum of Art, 1996.

Petzold, Andreas, *Romanesque Art*. Perspectives. New York: Abrams, 1995.

Radding, Charles M., and William W. Clark. *Medieval Architecture, Medieval Learning: Builders and Masters in the Age of Romanesque and Gothic*. New Haven: Yale Univ. Press, 1992.

Schapiro, Meyer. *The Romanesque Sculpture of Moissac*. New York: Braziller, 1985.

Seidel, Linda. *Legends in Limestone: Lazarus, Gislebertus, and the Cathedral of Autun*. Chicago: Univ. of Chicago Press, 1999.

Stones, Alison, Jeanne Krochalis, Paula Gerson, and Annie Shaver-Crandell. *The Pilgrim's Guide: A Critical Edition*. 2 vols. London: Harvey Miller, 1998.

Swanson, R. N. *The Twelfth-Century Renaissance*. Manchester: Manchester Univ. Press, 1999.

Toman, Rolf, ed. *Romanesque: Architecture, Sculpture, Painting*. Trans. Fiona Hulse & Ian Macmillan. Kööln: Köönemann, 1997.

The Year 1200. 2 vols. New York: Metropolitan Museum of Art, 1970

Zarnecki, George, Janet Holt, and Tristam Holland, eds. *English Romanesque Art, 1066–1200*. London: Weidenfeld and Nicolson, 1984.

CHAPTER 16
Gothic Art of the Twelfth and Thirteenth Centuries

Armi, C. Edson. *The "Headmaster" of Chartres and the Origins of "Gothic" Sculpture*. University Park: Pennsylvania State Univ. Press, 1994.

Binding, Güünther. *High Gothic: The Age of the Great Cathedrals*. Taschen's World Architecture. London: Taschen, 1999.

Binski, Paul. *Becket's Crown: Art and Imagination in Gothic England, 1170-1350*. New Haven: Yale Univ. Press, 2004.

Bony, Jean. *French Gothic Architecture of the 12th and 13th Centuries*. California Studies in the History of Art. Berkeley: Univ. of California Press, 1983.

Camille, Michael. *Gothic Art: Glorious Visions*. Perspectives. New York: Abrams, 1996.

Cennini, Cennino. *The Craftsman's Handbook (Il libro dell'arte)*. Trans. D.V. Thompson. New York: Dover, 1954.

Crosby, Sumner McKnight. *The Royal Abbey of Saint-Denis from Its Beginnings to the Death of Suger, 475–1151. Yale Publications in the History of Art*. New Haven: Yale Univ. Press, 1987.

Erlande-Brandenburg, Alain. *Gothic Art*. Trans. I. Mark Paris. New York: Abrams, 1989.

——. *Notre-Dame de Paris*. New York: Abrams, 1998.

Favier, Jean. *The World of Chartres*. Trans. Francisca Garvie. New York: Abrams, 1990.

Frankl, Paul. *Gothic Architecture*. Rev. Paul Crossley. Yale Univ. Press Pelican History of Art. New Haven: Yale Univ. Press, 2000.

Frisch, Teresa G. *Gothic Art, 1140–c.1450: Sources and Documents*. Upper Saddle River, NJ: Prentice Hall, 1971.

Grodecki, Louis, and Catherine Brisac. *Gothic Stained Glass, 1200–1300*. Ithaca, NY: Cornell Univ. Press, 1985.

Kren, Thomas, and Mark Evans, eds. *A Masterpiece Reconstructed: The Hours of Louis XII*. Los Angeles: The J. Paul Getty Museum, 2005.

Moskowitz, Anita Fiderer. *Nicola & Giovanni Pisano: The Pulpits: Pious Devotion, Pious Diversion*. London: Harvey Miller Publishers, 2005.

Murray, Stephen. *Notre-Dame, Cathedral of Amiens: The Power of Change in Gothic*. New York: Cambridge Univ. Press, 1996.

Nussbaum, Norbert. *German Gothic Church Architecture*. Trans. Scott Kleager. New Haven: Yale Univ. Press, 2000.

Panofsky, Erwin. *Abbot Suger on the Abbey Church of St.-Denis and Its Art Treasures*. 2nd ed. Ed. Gerda Panofsky-Soergel. Princeton: Princeton Univ. Press, 1979.

——. *Gothic Architecture and Scholasticism*. Latrobe, PA: Archabbey 1951.

Parry, Stan. *Great Gothic Cathedrals of France*. New York: Viking Studio, 2001.

Sauerlander, Willibald. *Gothic Sculpture in France, 1140–1270*. Trans. Janet Sandheimer. London: Thames and Hudson, 1972.

Scott, Robert A. *The Gothic Enterprise: A Guide to Understanding the Medieval Cathedral*. Berkeley: Univ. of California Press, 2003.

Simsom Otto Georg von. *The Gothic Cathedral: Origins of Gothic Architecture and the Medieval Concept of Order*. 3rd ed. Bollingen Series. Princeton: Princeton Univ. Press, 1988.

Smart, Alastair. *The Dawn of Italian Painting, 1250–1400*. Ithaca, NY: Cornell Univ. Press, 1978.

Suckale, Robert, and Matthias Weniger. *Painting of the Gothic Era*. Ed. Ingo F. Walther. New York: Taschen, 1999.

Villard, de Honnecourt. *The Sketchbook of Villard de Honnecourt*. Ed. Theodore Bowie. Bloomington: Indiana Univ., 1960.

Wieck, Roger S. *Time Sanctified: The Book of Hours in Medieval Art and Life*. New York: Braziller, 1988.

Williamson, Paul. *Gothic Sculpture 1140–1300*. Pelican History of Art. New Haven: Yale Univ. Press, 1995.

CHAPTER 17
Fourteenth-Century Art in Europe

Alexander, Jonathan, and Paul Binski, eds. *Age of Chivalry: Art in Plantagenet England, 1200–1400*. London: Royal Academy of Arts, 1987.

Art from the Court of Burgundy: The Patronage of Philip the Bold and John the Fearless 1364–1419. Cleveland: The Cleveland Museum of Art, 2004.

Backhouse, Janet. *Illumination from Books of Hours*. London: British Library, 2004.

Boehm, Barbara Drake, and Jifíí Fajt, eds. *Prague: The Crown of Bohemia, 1347–1437*. New York: Metropolitan Museum of Art, 2005.

Bony, Jean. *The English Decorated Style: Gothic Architecture Transformed, 1250–1350*. The Wrightsman Lecture, 10th. Oxford: Phaidon Press Limited, 1979.

Borsook, Eve. *The Mural Painters of Tuscany: From Cimabue to Andrea del Sarto*. 2nd ed. rev. & enlg. Oxford Studies in the History of Art and Architecture. Oxford: Clarendon Press 1980.

Branner, Robert. *St. Louis and the Court Style in Gothic Architecture*. Studies in Architecture, v. 7. London, A. Zwemmer, 1965.

Bruzelius, Caroline Astrid. *The 13th-Century Church at St-Denis. Yale Publications in the History of Art, 33*. New Haven: Yale University Press, 1985.

Fajt, Jiříí, ed. *Magister Theodoricus, Court Painter to Emperor Charles IV: The Pictorial Decoration of the Shrines at Karlstejn Castle*. Prague : National Gallery, 1998.

Ladis, Andrew. ed, *The Arena Chapel and the Genius of Giotto: Padua*. Giotto and the World of Early Italian Art, 2. New York: Garland Pub., 1998.

Moskowitz, Anita Fiderer. *Italian Gothic Sculpture: c. 1250-c. 1400*. New York: Cambridge Univ. Press, 2001.

Norman, Diana, ed. Siena, *Florence, and Padua: Art, Society, and Religion 1280-1400*. 2 vols. New Haven: Yale Univ. Press in assoc. with the Open Univ., 1995.

Paolucci, Antonio. *The Origins of Renaissance Art: The Baptistry Doors, Florence*. Trans. Franççoise Pouncey Chiarini. New York: George Braziller, 1996.

Poeschke, Joachim. *Italian Frescoes, the Age of Giotto, 1280-1400*. New York: Abbeville Press, 2005.

Welch, Evelyn S. *Art in Renaissance Italy, 1350-1500*. New Ed. Oxford: Oxford Univ. Press, 2000.

White, John. *Art and Architecture in Italy, 1250 to 1400*. 3rd ed. Pelican History of Art. Harmondsworth, UK: Penguin, 1993.

Wieck, Roger S. *Painted Prayers: The Book of Hours in Medieval and Renaissance Art*. New York: George Braziller in assoc. with the Pierpont Morgan Library, 1997.

CREDITS

INDEX

Notes

Notes

Notes

Notes

Notes